How to Enter & Win
Color Photography Contests

How to Enter & Win Color Photography Contests

By
ALAN GADNEY

Executive Editor
CAROLYN PORTER

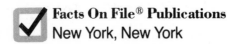
Facts On File® Publications
New York, New York

How to Enter and Win Color Photography Contests

© Alan Gadney 1982

Published by Facts On File, Inc.
460 Park Ave. South, New York, N.Y. 10016

In cooperation with Festival Publications

Library of Congress Cataloging in Publication Data

Gadney, Alan.
How to enter and win color photography contests.

Includes indexes.
1. Color photography—Competitions. I. Title.
TR510.G25 778.6'079 81-12591
ISBN 0-87196-572-0 AACR2
ISBN 0-87196-578-X (pbk.)

PRINTED IN THE UNITED STATES OF AMERICA
9 8 7 6 5 4 3 2 1
Computer Programming and Typesetting by Datagraphics Inc.

TO MARY M. GADNEY
whose confidence, love, and hard work
helped to make this series possible.
Thanks Mom.

EDITORIAL STAFF

Managing Editor: Peter Betcher

Senior Editors: Chris Moose
 Lois Smith

Assistant Editors: Dennis J. Isemonger
 Alice Ober
 Monica Olofsson

Second Assistant Editors: Deborah Elder
 Linda Huggins

Editorial Assistant: Christine Conrad

Research Assistants: Holly Christos
 Nancy Ward

CONTENTS

INTRODUCTION

WELCOME ... to How to Enter and Win COLOR PHOTOGRAPHY CON-TESTS, an all new, completely up-to-date sourcebook for the contest competitor and grant seeker in the color photography field (prints, slides, stereo slides, slide shows and photojournalism) ... one of an ongoing series of contest-grant books covering photography and other related arts fields.

Each book in the series focuses in detail on an individual art or medium (Color Photography, Black & White Photography, Film, Video-Audio-TV/Radio Broadcasting, Fiction Writing, Nonfiction Writing & Journalism, Fine Arts & Sculpture, Design & Commercial Art, Crafts, and so on).

And each book in the series lists complete entrance information for anyone wanting to:

- Enter their work in national and international contests, festivals, competitions, salons, shows, exhibitions, markets, tradefairs, and other award events and sales outlets.

- Apply for grants, loans, scholarships, fellowships, residencies, apprenticeships, internships, training and benefit programs, and free aids and services.

The books also have: ALPHABETICAL INDEXES listing each event, sponsor, and award by its various names. SUBJECT/CATEGORY INDEXES to the entrants' specific areas of interest. Extensive CROSS-REFERENCES and DEFINITIONS throughout. And introductory HELPFUL HINTS on how to analyze and enter the events, and possibly come up a winner!

HOW THE BOOKS BEGAN

This series of contest-grant guides actually began several years ago with the first release print of *West Texas* (a one-hour featurette I made while completing my graduate work at the USC Cinema Department). One week after our first showing, I sent our premiere print off to the first film festival, and the contest entry process started to grow from there ... with one major problem, however: The festival contact information was almost impossible to find.

After extensive research, all I could come up with were names and addresses (and an occasional brief blurb) of intriguingly titled film events in far-off places, but with no hard facts as to their entry requirements, eligibility restrictions, awards, deadlines, fees, statistics, judging procedures, etc. That sort of vital information was practically nonexistent, unless you took the time and postage to write away to every contest you discovered an address for ... which I did.

Through several years of continuous address researching, blindly writing off for contest entry information and periodically submitting the film, *West Texas* won 48 international film awards, and a large file of information had been collected on about 180 international festivals—quite a few of which were not even open to *West Texas* for a variety of reasons (wrong gauge, length, category, the event turned out not to be a film festival, etc.).

The need was evident for an accurate, up-to-date, and detailed entry informa-

tion source to the world's Contests, Festivals and Grants . . . Thus evolved the two editions of my previous book (GADNEY'S GUIDE TO INTERNATIONAL CONTESTS, FESTIVALS & GRANTS). Their first-of-a-kind success ultimately lead to this all new series of contest-grant guides.

ABOUT THE COLOR PHOTOGRAPHY BOOK

This book (devoted solely to the field of COLOR PHOTOGRAPHY is a single-source reference guide, providing you with vital entry information and statistics about a contest/grant before you even have to send away for the entry forms and shipping regulations (which you must always eventually do, as most require their own entry forms, and some have rather intricate shipping and customs requirements).

The 363 separate events listed in this volume were compiled through 3 years of active research on my earlier book, an additional year of research on this book, and thousands of questionnaires sent to worldwide photography events (many requiring repeated mailings to obtain complete and up-to-date entry information). During this process, we have totally updated, revised, and expanded the scope of the original color photography listings, added new competitions, and deleted a few which were too restricted or no longer in existence. (Black & White Photography and Filmstrip sections of photographic events have been included in a companion volume covering Black & White Photography contests and grants.)

The individual events have been further grouped into 32 special-interest subcategories (an increase in the number of subject categories over the earlier book, particularly in the areas of color photography scholarships, fellowships, and grants). These subcategories are further divided and cross-referenced in the SUBJECT/CATEGORY INDEX at the back of the book.

We have included two general types of events:

- Those AWARD EVENTS and SALES OUTLETS to which entrants may submit their works in order to receive SOMETHING OF VALUE in return, such as contests, festivals, competitions, salons, shows, exhibitions, markets, tradefairs, and various other award and sales programs primarily for new and unknown works.

- And BENEFIT PROGRAMS to which individuals or organizations may apply for some type of AID or SERVICE, such as grants, money and equipment loans, scholarships, fellowships, residencies, apprenticeships, internships, training programs, and so on.

Due to page length restrictions we have omitted those events that (1) are restricted to members of a specific organization (unless you can join that organization upon entering the contest), or limited to residents of a small city or geographical area (usually of less than state size), or (2) are not open to general entry but whose participants are nominated or invited by the sponsors or national selecting organizations. Workshops, seminars, conferences, schools, service programs, and the like, have only been listed if they are free, have free benefits attached, or encompass a contest, festival, grant, scholarship, fellowship, residency, etc.

We have listed as much detailed information about each separate event as possible (that is, as much as could be culled from the materials provided us by the event—usually including current addresses, dates, deadlines, complete entry

requirements, eligibility and fee information, awards available, judging aspects, catch clauses, purpose, theme, sponsors, average statistics, where held, and various historical aspects). All information was transcribed from the questionnaires and entry materials provided us and edited to fit the format of the book. (See HOW TO USE THE BOOK for description of format.)

The information listed is the most current we could obtain, and will normally be revised and updated every two or three years in this continuing reference series.

We have also included older events when there was no direct confirmation that the events had gone out of existence. Many events come and go in an on-again, off-again manner, depending on their finances, administration changes, and other factors . . . again, good reason to ALWAYS WRITE TO AN EVENT BEFORE ENTERING YOUR WORK. Most events require entry forms, which they provide. Many have special shipping regulations. And, as we have condensed and edited their rules and regulations, it is best to write for the complete versions (especially important in interpreting the meanings of occasional tricky "catch clauses" about the use and ownership of winning entries). Also remember to send along a self-addressed, stamped return envelope (SASE), particularly to smaller events operating on tight postage budgets.

It would be almost impossible to give an exact figure for the total amount of money offered through this book. Some events give cash, others give equipment (of varying value depending on how badly you need the equipment or how much you can sell it for), and others give trophies, cups, plaques, medals, certificates, etc. (all of great value to the winner, but of little real monetary worth). Grant sources, on the other hand, may offer millions of dollars in direct financial aid. Probably the safest thing to say about the total amount of money offered through this book is that it is well into the millions.

HOW TO USE THIS BOOK

In the TABLE OF CONTENTS you will find that this volume has been divided into a series of "special-interest" SUBCATEGORIES. Each contains all those events whose primary emphasis is within that particular subcategory. The listing is usually alphabetical—first those in the United States, followed by other countries in alphabetical order.

At the start of each subcategory is an italicized INTRODUCTORY SECTION giving (1) specific contents of that subcategory, (2) definitions, and (3) "also see" CROSS-REFERENCES to similar events in other subcategories in the book.

To find additional events accepting entries in your specific interest area (but which may be listed in other subcategories because their primary emphasis is stronger in those areas), use the SUBJECT/CATEGORY INDEX at the back of the book. This lists subjects of special interest by an identifying code number for each event. The code number is located in the box above each event.

To find a specific event, sponsor, or award by name, use the ALPHABETICAL EVENT/SPONSOR/AWARD INDEX at the back of the book (again listing entries by identifying code number). In this index, sponsors and events are usually listed by full names, abbreviations, and unique titles.

EACH EVENT consists of (1) a current address and telephone number; (2) month/season held; (3) introductory paragraph, including entry restrictions, date

of establishment, former names, purpose, theme, motto, sponsors, average statistics, historical information, facilities and other aspects; (4) technical entry regulations and categories; (5) eligibility requirements; (6) awards; (7) judging aspects and catch clauses; (8) sales terms; (9) entry fees; (10) deadlines. All have a similar format designed for easy use, with the five most important aspects of each event noted in bold type:

1. Identifying Code Number (in box)
2. Name of event
3. Month/Season of event
4. Entrant restrictions
5. Type of event and subject-category

With these five main points in mind, a potential entrant can quickly skim through a series of events to find those of particular interest.

HOW TO ANALYZE AN EVENT

We have usually provided enough information about each event to help you in making various determinations before you send away for entry forms, shipping regulations, and additional instructions. These are some of the points you should consider in your analysis.

• **When is the event held?** The month/season held is designated by bold type immediately following the address.

• **When is the entry deadline?** Months of entry are found in the DEADLINES section at the end of each event listing, and are usually well in advance of the month held. However, as deadlines do vary, the event should always be contacted about the specific entry date for the year you are applying.

• **Do I qualify?** Entrant restrictions are listed in bold type in the first sentence, and may be further clarified in the ELIGIBILITY section.

• **Does my work qualify?** The type of event and specific subject categories are listed in bold type at the beginning of the second and subsequent paragraphs. Various technical entry requirements follow each.

• **How much does it cost?** Costs and hidden costs are found in the ENTRY FEE section. The reason most events charge entry fees is usually to pay for the awards, operating costs, judges, and attendance of well-known persons. Contests and festivals can be extremely expensive to operate, and the size and scope of the event usually dictates the fee structure. Amateur competitions can range from no entry fees to very nominal ones, while the fees for more professional contests are considerably higher.

• **What are the prizes?** Found in the AWARDS section are prizes varying from trophies, cups, plaques, and medallions (of personal value), to cash, trips, equipment, and services (of a more material value—meaning you may be able to resell them at a later date if you already have better equipment, cannot take the trip, or do not want the services). Exhibition, distribution, broadcast, sale, and publication may also be offered, but should always be analyzed in terms of their financial and legal implications (what you get for what you have to give in return, and how valuable your entry may become in the future).

• **What are the catch clauses?** A few events have tricky qualifying clauses, condensed in the JUDGING section. These may involve claims to use and ownership (sometimes of all entries, and on an extensive basis), or responsibility in the event of loss, damage, nonreturn, etc.

Occasionally the actual entry forms and regulations may be rather vague as to whether the sponsors just keep a copy of your winning entry or whether they receive full ownership of the work (and for what use). Possibly, in these instances, you should write to the sponsors for further clarification.

• **How is my work judged?** The number of judges, judging procedures, and criteria are listed in the JUDGING section. It is important to understand that during preliminary judging (sometimes performed by the event's staff and aides), many entries may be immediately disqualified because of failure to adhere to the various contest regulations, or eliminated because of technical flaws or oversights (good reason always to send away for, and to read carefully, the latest rules). This is especially true of large contests that thousands enter. Sponsors have to narrow the competition as rapidly and efficiently as possible, and the first to go are the rule breakers and sloppy entries.

A program of the event or listing of past winners may give you an overall feel for the event (if it is conservative or liberal, oriented in certain directions, etc.). There is the possibility of talking to past entrants and winners in order to get an idea of specific likes and dislikes of the event and its judges. Or if you know who the judges will be, you may be able to make an educated guess as to what they will choose. However, I have found that it is almost impossible to predict how judges will act on anything other than the widest of generalities. Judges change from year to year, the philosophy of the event may alter, and single-judge contests put you at the mercy of that particular year's judge. So, you can never really outguess the judges.

• **How old is the event?** Usually included in the first sentence is the founding date, the inference being that the older the event, the more stable and reputable it is.

• **How large is the event?** Average attendance, distribution, and sales figures can often be found in the first paragraph, indicating the potential promotional and sales values of participating in the event.

• **What is the duration of an event, and how long will it tie up my entry materials?** The number of days the event is usually held is found in the first paragraph; the entry and return-of-material dates are in the DEADLINES section.

• **What is the competition?** Average statistics on number of entries, entrants, countries competing, acceptances into final competition, and winners can be found in the first paragraph, giving some idea of possible competition in future events.

• **How legitimate is the event?** This can be determined to some extent by the names of familiar sponsors, cosponsors, financial supporters, and those organizations that officially recognize the event—again, all found in the opening paragraph, and giving some idea of reputability. Also important may be the purpose, theme, and motto.

These are just a few of the aspects to examine before writing away for further information, entry forms, the most current regulations . . . and before sending

away your work.

YEARLY PLANNING GUIDE

This book can also serve as a planning guide for your contest entries throughout the year. By using the SUBJECT/CATEGORY INDEX, you can get an overall picture of the various world events accepting entries in your areas of interest. We would then suggest setting up a calendar, listing those events you wish to enter by (1) the date you should write away for entry forms and current rules (several months before the actual entry month), (2) the entry dates, and (3) the dates the event is held, which will give you some indication of when the sponsor will be announcing the winners and returning your materials.

HELPFUL HINTS ON HOW TO WIN

Here are a few recommendations to enhance your chances of winning:

• ANALYZE THE STATISTICS—Look at the average statistics (found in the first paragraph of an event listing) to determine the size of your competition. Remember, you should always calculate the number of awards/honors given against the number of entrants, and not just analyze on total entrants alone. Larger events with a greater number of entrants and more awards may in reality have a higher winner-ratio than smaller events with only one award. You may also stand a better chance of winning in newer events which have not yet built up their patronage.

• ANALYZE THE TYPE OF EVENT—Based on past winner/award listings, is the event consistently conservative or liberal in its selections (or does it change moods from one year to the next)? If a contest says it leans toward contemporary or experimental works, you should take this into account before entering. You may also wish to try and analyze how the judges will vote, again based on past records and who the current judges are. (See HOW TO ANALYZE AN EVENT for additional information.)

• PATRONIZE THE SPECIALIZED EVENTS—If you have a specialized entry, while it will normally qualify for more generalized contests, you might begin by concentrating on those events which have a special interest in, or specific subject categories for your particular entry. Because of their highly specialized nature, these contests may get fewer entries, and if your work fits their interests, you should stand a better chance of winning. You might also consider patronizing those events that have changing annual themes by designing your entry to fit that particular year's needs.

• FOLLOW THE RULES—The contest rules (obtained directly from the event) should be studied carefully, first to find hidden clauses, and second to ensure you will not be inadvertently excluded because you entered the wrong category, sent an incorrect entry fee or no return postage, entered with improper technical aspects, or not enough supplementary information, etc. So read the rules and follow them, and fill out the entry forms completely. Rule breakers usually are disqualified, sometimes even before the preliminary judging. Then, to further cut down the number of competitors, most judges go strictly by the regulations, automatically discarding those entries that in any way deviate from the rules.

• KEEP IT CLEAN—Keep it technically perfect. Again, judges will usually

reject sloppy entries (sometimes these don't even reach the judges, but are weeded out by the contest staff). So send only clean entries in good condition. No dirty, faded, or discolored prints; smudged, scratched, or spotted slides. All of these reflect badly on your entry's artistic content. And if the sponsors tell you they want an entry mounted or framed, you had better follow their instructions. Also, it is best to send a duplicate rather than your original work (unless they request the original, in which case you should study their rules carefully to see if you will ever get your original back).

• SEND IT AHEAD OF TIME—Send your materials well in advance of the entry deadlines. Last-minute entries may get abbreviated handling by judges who have already looked over the earlier entries and have made up their minds. They may not get listed in the contest programs, which have already gone to the printers—and if they are shown, they may be scheduled during the least desirable exhibition times. And of course, *late* entries are usually sent back unopened.

• SEND PUBLICITY AND INFORMATION MATERIALS—Send supporting materials unless positively prohibited. (Definitely send them when they are requested.) Every little bit helps: biographical, technical, and project background information; publicity and press materials; still photos, production philosophy, synopsis, translation, transcription (and advertising materials if appropriate). The judges may occasionally use some of these in making their final decisions, and the events may use the publicity in their programs, flyers, and press rooms. Remember to send along any special technical instructions or return shipping requests you feel are needed.

• USE PROPER SHIPPING—First a word about the U.S. and international mail systems (as opposed to international Air Freight; some foreign contests even prohibit the use of air freight, as the entries may become held up in customs). Provided your entries are properly packaged, sealed, marked, stamped, and insured, and have correctly filled-out customs stickers (information about all of this is available through the U.S. Post Office), they should be able to travel almost anywhere in the world with relative safety. (This is based on personal experience. *West Texas* was mailed to a large number of film festivals all over the world, and I never lost a print or received one back damaged in transit.)

Remember always to ship by air to overseas competitions (as boat mail may take as long as three months from the U.S. to Australia, for example). On domestic U.S. shipments, you can mail at various rates lower than First Class, if you take into account the time for possible delays. (Again, contact the post office for information about mailing costs and times.)

Of course, if you have a heavy international shipment (a large print portfolio for example), you may be over the postal weight limitations, and have to ship by Air Freight. In this case, it may be best to contact a customs house broker/international freight forwarder about services and charges.

Short overseas messages will travel very rapidly by international telegram. And always remember to enclose sufficient return postage and a correctly sized self-addressed stamped return envelope (SASE) when requested. Finally, if your entry arrives with "Postage Due," it could be a negative factor in the contest staff preselection process.

A WORD ABOUT GRANTS

It would take an entire volume to discuss all the "ins" and "outs" of grant solicitation. However, we can touch on a few of the more important aspects.

• FIND OUT AS MUCH AS POSSIBLE about a potential grant source before investing the time in sending a proposal. Write to the granting organization for more information—and once you have this information, analyze it and focus your energies on the most likely prospects.

• WRITE AN INQUIRY LETTER—a brief letter of introduction, to see if they are interested in your project. Include a short description of the project and its unique aspects, background information about yourself and your sponsoring organization, the proposal budget, and ask them if they would be interested in further information. Keep your introductory letter brief, to the point, well written, easy to understand, and not exaggerated. If the foundation is interested, it will request what it needs, which may run anywhere from an expanded summary to a full-scale proposal and budget.

• GET AN ORGANIZATION TO SPONSOR YOU—Many foundations restrict their granting to only nonprofit, tax-exempt organizations, institutions, etc. However, this does not necessarily prohibit you from securing a grant from them. Simply get a nonprofit organization to sponsor you and your project, and have the organization apply for the grant in their name. Many organizations offer grant solicitations as one of their services, and this can have benefits for the sponsoring organizations: You give them credit and publicity through your finished project. They have a track-record as a successful fund raiser, which may help them in obtaining future grants. And they can even be paid through your budget for handling certain administrative and bookkeeping duties.

• GET SOME NAMES ON YOUR SIDE—well-known persons in the roles of advisors, technical consultants, etc. can help greatly toward building an impressive project package.

• TRY SPECIAL INTEREST GROUPS—If you have designed a project involving a special interest (a Medical Slide Show, for example), rather than only approaching sources that grant your medium (Photography), you might consider going to those grant sources that fund the special interest instead (i.e., Medical Grants). Or you may find similar money sources through special-interest organizations, associations, institutions, and businesses. The public library is a good place to start your search.

WHY ENTER CONTESTS

Finally, a word about the positive benefits of entering your work in contests, festivals, and competitions.

To start with, it is an extremely good way to test (and prove) the artistic and commercial value of your work before professional judges, critics, and the public. There is also the challenge of the competition—the excitement and glamour of knowing that your work is being seen in contests, festivals, salons, exhibitions, and publications around the world. Your entry competes with those of your peers —and if it reaches the finals and wins, there is the great personal satisfaction and certification of acceptance.

If you do win, you can win substantial cash prizes, trips, art items, equipment, services, exhibition, distribution, broadcast, publication, sales, trophies, and other

awards. There can be useful free publicity for both you and your work, through (1) press information and literature released by the event, (2) the writings and reviews of others about your work, and (3) your own promotional materials designed around your winnings.

All of this can bring valuable international exposure through the print and broadcast media, and the resulting recognition and prestige can certainly help to sell both your award-winning work and yourself as an award-winning photographer.

The end benefits can be sales, valuable contacts, jobs, contracts, increased fees, and the financing of other projects.

How does this translate into real terms . . . The 48 international film awards won by *West Texas* resulted directly in: (1) a large number of valuable art objects, trophies, and awards; (2) enough cash winnings to cover all the film festival entry fees, shipping, promotion, and other costs; (3) an enormous amount of free personal publicity; (4) the eventual sale and distribution of the film; (5) the writing and directing of a subsequent feature-length theatrical, *Moonchild;* (6) several paid speaking engagements; (7) a TV script assignment; (8) a stint as a film magazine contributing editor; and (9) eventually to writing this series of books on contests and grants . . . So, the entering of contests and the winning of awards in many ways can be quite profitable.

THE CHANGING NATURE OF COLOR PHOTOGRAPHY CONTESTS

In the three years since my previous book was published, there has been significant growth in the number and types of color photography contests and grants offered throughout the world. Many of these changes (reflected in the updated and revised listings in this book) were no doubt motivated by recent advances in the overall field of color photography (the advent of inexpensive and easy-to-use cameras, better film and processing, more sophisticated photographic equipment, and so on). With so many people now owning cameras and taking pictures, several of these changes should be noted:

First, there has been a distinct increase in the number of general photography contests sponsored by art galleries, photo fairs, and other sales-exhibition outlets (many of which have definite commercial ramifications—the acquiring of high-quality photography for possible commissioned sales). This can certainly be of great benefit to the photographers involved; they not only win a cash prize, but may have their work sold as well.

The second expansion has been in specialized color photography, slide show, and photojournalism contests, especially in the Advertising, Design, Graphics, Business, Industrial, and Underwater fields. Apparently more and more of these special-interest groups and organizations are finding that sponsoring a photo competition is an excellent way to keep up with the latest photographic and audiovisual materials available in their respective fields.

The third, and possibly most important increase has come in the number of photographic grants, scholarships, fellowships, internships, and residence grants currently available (aided in part by the leadership in government grant funding over the past few years). Let us hope that these grant outlets will continue through aid from private and business sources.

A FEW CLOSING THOUGHTS — While I have found the vast majority of events to be highly reputable and continually striving to improve their quality, there are still a few bad exceptions (lost entries, withheld awards, judging problems, etc.).

However, the interesting thing is that just as numbers and types of events change from year to year, so do most of these questionable conditions. Just when you hear someone complain about an unfair judging process, the next year the judges change, and that same person may come out a winner. Or the rules and administration change, and what was once a suspect practice disappears.

With this in mind, there has been no attempt on our part to editorialize about the occasional bad occurrences we hear of. This is strictly a reference guide (not a critical work). We list all those events which qualify, from the largest to the smallest, the oldest to the youngest, the well-known and the not so well-known. And we have tried to print enough information about each event to give you a firm basis upon which to decide whether or not to write for further information. (See HOW TO ANALYZE AN EVENT.)

It should also be stated that we do not endorse (or accept any responsibility for the conduct of) the events listed in this book.

Finally, no book of this type can ever be all-inclusive. That would be virtually impossible. Each year hundreds of new events start up, old ones lapse or go out of business, only to be replaced by similar events in a new form. As I have mentioned, there is constant growth and progression based on general changes in the art and media fields. However, considering the many individual events we have listed, each as thoroughly as possible within the edited format, and each updated and verified to the best of our knowledge based on entry materials and questionnaires provided us, we feel that we have brought you quite a comprehensive reference guide.

A special thank you to the American Library Association (the Reference and Adult Services Division, Reference Committee) for awarding the previous contest book an "OUTSTANDING REFERENCE SOURCE OF THE YEAR" . . . and to the many readers and reviewers of that book for their favorable response. These honors have been extremely gratifying.

And an additional thanks and grateful appreciation to the many events, sponsors, contributors, and correspondents who have so graciously provided us with the information included in this directory.

As a final reminder, please remember that to ensure you have the latest information, complete regulations, and proper entry forms, ALWAYS WRITE TO AN EVENT BEFORE ENTERING YOUR WORK

And please advise us of any new Contests and Grants you may know of, so that we may include them in our future editions.

Alan Gadney
Festival Publications
P.O. Box 10180
Glendale, California 91209 U.S.A.

COLOR PHOTOGRAPHY

ADVERTISING, DESIGN, GRAPHICS

Prints, Slides, and Filmstrips, including ADVERTISING, BUSINESS, CALENDAR, COMMISSIONED, GRAPHICS, POSTER, PROMOTION, PHOTOJOURNALISM, PHOTOGRAPHIC and PUBLICATION DESIGN. (Also see BUSINESS-INDUSTRIAL.)

Art Annual Photography and Illustration Exhibition

Communication Arts Magazine
Jean A. Coyne, Executive Editor
P.O. Box 10300
410 Sherman Avenue
Palo Alto, California 94303 U.S.A.
Tel: (415) 326-6040

September

International; entry open to all; annual; established 1976. Purpose: to recognize photographers, art directors, illustrators, commissioning clients. Sponsored and supported by *Communication Arts (CA) Magazine.* Average statistics (all sections): 3000 entries. Also sponsor CA Design and Advertising Exhibition.

PRINT CONTEST: **Commissioned Color,** produced or published March previous to March current year; unmounted; limit 5 per entrant. Require 25-word explanation of work's function. No original art. Divisions: Single, Campaign-Series. Categories: Advertising, Book, Editorial, Institutional, Self-Promotion, Unpublished. Competition includes monochrome prints, color slides, drawings, paintings, collage, other commissioned media arts including 3D.

SLIDE CONTEST: **Commissioned Color,** 35mm, paper-mounted or unmounted transparencies. No glass. Other requirements, restrictions, categories same as for Prints.

AWARDS: Excellence Certificates to artist, art director, commissioning agent. Publication in July-August *Art Annual* edition of *CA Magazine* (50,000 circulation; color winners reproduced in color; indexed with artists' addresses).

JUDGING: By 4 professional photographers, illustrators, art directors plus *CA Magazine* editor-designer. Unpublished work judged separately. Based on quality, originality, appropriateness. Sponsor may publish, exhibit entries. Not responsible for loss or damage.

ENTRY FEE: $6 single, $12 series. Return fee, $6 first piece, $2 each additional. No acceptance or hanging fees.

DEADLINES: Entry, March. Judging, April. Notification, May. Awards, September.

2

Art Directors Club Annual Exhibition
488 Madison Avenue
New York, New York 10022 U.S.A.

May

International; **entry open to U.S., Canada;** annual; established 1922. Purpose: to search for new expressions, techniques, breakthroughs, talents, directions. Sponsored by New York Art Directors Club. Publish *Art Directors Club Annual.* Have traveling exhibits (U.S., Europe, Asia).

PHOTO CONTEST: **Advertising, Promotion, Editorial Color,** first produced in U.S. or Canada in current calendar year. Submit proofs, tearsheets or photographs (8x10 prints or 35mm slides of large, bulky entries). Campaign is 1 entry of 2 pages or more (3-5 components from same series-strategy). No original art or foreign market publications. Categories: Advertising, Promotion, Editorial, Packaging or Packaging Preparation, Books and Book Jackets, Section-Insert-Supplement (submit as campaign). Competition includes monochrome prints. Also have Newspaper-Magazine Advertising-Editorial, Promotion-Graphic Design, Poster, Book and Jacket Design, Art-Illustration, Television categories.

AWARDS: Gold, Silver Medals (1 per entry), Distinctive Merit Awards, each category. Merit Award and publication in *Annual* each accepted for exhibition.

JUDGING: May withhold awards. No entries returned. Not responsible for loss or damage.

ENTRY FEE: $12 single, $25 campaign. $55 (single), $85 (campaign) hanging fee for accepted entries.

DEADLINES: Entry, November. Notification, March. Awards, event, May.

3

Chicago
Communications Collaborative
410 South Michigan Avenue
Suite 433
Chicago, Illinois 60605 U.S.A.
Tel: (312) 633-9566

Summer

International; entry open to all; annual; established 1978. Purpose: to recognize finest communications nationally and internationally through Chicago shows. Sponsored by Communications Collaborative, an organization of Chicago communication associations. Recognized by Art Directors Club and Artists Guild of Chicago, American Society of Magazine Photographers, Graphic Arts Council. Held at various Chicago area locations for 1 month. Publish *Chicago Annual* (Yearbook of Winners). Have traveling exhibitions.

PHOTO CONTEST: **Advertising, Business, Journalism Color,** created after March previous year. Poster: 30x40 inches maximum; submit transparency if larger. Categories: Advertising (Single, Campaign), Editorial (Single, Campaign), Picture Story Campaign, Poster, Slide-Filmstrip, Annual Report, Art Direction, Public Service, Unproduced, other. Also have print, writing, visual-audio media sections.

FILMSTRIP CONTEST: **Educational, Institutional Color,** 35mm, created after March previous year. Categories: Corporate (Internal, External), Educational, Public Service, Unproduced. Also have print, writing, visual-audio media sections.

AWARDS: Best of Category, Best of Show at judges' discretion. Winners exhibited for 1 month and published in catalog for pubic sale.

JUDGING: By 3 photography experts. Based on 5-point scale. No entries returned. Not responsible for loss or damage.

ENTRY FEE: $15 single, $35 campaign. $7 not-for-profit public service, $17 campaign. Acceptance: $50 single, $150 campaign. $25 not-for-profit public service single, $75 campaign. Entrant pays postage.

DEADLINES: Entry, August. Exhibition, Summer.

4

Creativity Awards Show
Art Direction Magazine
Ray Morrison, Director
10 East 39th Street, 6th Floor
New York, New York 10016 U.S.A.
Tel: (212) 889-6500

September

International; **entry open to professionals;** annual; established 1969. Purpose: to record trends in advertising design, art, illustration, photography, TV commercials; reward, publicize talented art directors. Sponsored by *Art Direction Magazine.* Average statistics (all sections): 15,000 entries, 800 awards, 15,000 attendance. Held in New York, other major cities. Publish *Advertising Techniques Magazine* (annual), *Graphic Arts Buyer, Creativity Annual* (international yearbook of show).

PHOTO CONTEST: Advertising Color, produced in previous year; prints or 35mm slides, unmounted. No originals. Categories: Consumer Full Page (Single Unit, Campaign), Fractional (Single, Campaign): Trade Full Page (Single, Campaign), Fractional (Single, Campaign); Posters; Annual Reports; Brochures-Catalogs; Covers (Magazines, Book, Record Album); Package Design; Calendars; Editorial Design (Single, Multiple Unit); Trademarks and Logotypes; Letterhead-envelope; Letterhead Set (up to 5 pieces); Promotional Pieces, Collateral and Miscellaneous Materials; Public Service (Single, Campaign); Political (Single, Campaign); Television Graphics; Special Creative Achievement. Competition includes film, videotape, audiotape, commercial art and design, and monochrome photography.

AWARDS: Creative Certificates of Distinction. All accepted entries reproduced in *Creativity Annual.*

JUDGING: By committee. Based on concept and design. Sponsor retains entries.

ENTRY FEE: $5 single sheet-spread, campaign; $10 3 or more pieces. Winners pay hanging fees.

DEADLINES: Entry, May. Judging, awards, July. Event, September.

5

Decorating With Photography Design Competition
Professional Photographers of America (PPofA)
Carolyn Wojak
1090 Executive Way
Des Plaines, Illinois 60018 U.S.A.
Tel: (312) 299-8161, ext. 26

May

International; **entry open to U.S., Canadian professional photographers, interior designers, architects;** annual; established 1978. Formerly called PHOTOGRAPHIC ART FOR WALL DESIGN to 1980. Purpose: to identify best installations and recognize photographers, designers, archi-

tects, who created them. Sponsored by PPofA and Eastman Kodak Company. Also sponsor Exhibition of Professional Photography, Industrial Photographic Department of the Year Award, Exhibits of Industrial and Technical Photography Accomplishments.

PRINT CONTEST: **Photographic Design Installation Color,** original; 5x7 inches minimum; mounted on 16x20-inch display board (1 per board), illustrating actual installations where prints (reproduced on photographic paper only) or tranparencies have been used as principal design element; any subject. Individual or team entries. Request 500-word statement on problem-solution or description of entries (typed, single-spaced on plain paper). Categories: Residential, Business. Competition includes monochrome photographic design installations.

AWARDS: $1000 First, $300 Second, $200 Third Place, each category. 5 $100 Awards of Excellence, each category.

JUDGING: By professional photographer, interior designer, photo lab executive, art authority, industry photo buyer panels. Based on total concept (effectiveness of design installation), not on merits of individual photographs. May withhold awards. Not responsible for loss or damage.

ENTRY FEE: $10 handling and return shipping fee each 4 entries.

DEADLINES: Entry, April. Judging, event, May. Materials returned, August.

6

DESI Awards Competition
Graphic Design: USA Magazine
Louis J. Boasi, Director
32 Gansvoort Street
New York, New York 10014 U.S.A.
Tel: (212) 675-5867

Spring

National; **entry open to U.S.;** annual; established 1977. Purpose: to showcase designers, illustrators, photographers from worlds of design, advertising promotion, public relations, publishing, television, universities, institutions where superior graphics is important goal. Sponsored by *Graphics Design: USA Magazine.* Held in New York City for 2 weeks. Second contact: Valerie Stewart, Graphic Design: USA, 120 East 56th street, New York, New York 10022.

PHOTO CONTEST: **Commercial Graphics Color,** produced in previous year. Categories: Corporate Identity, Logotypes, Trademarks, Signage, Corporate Literature, Annual Reports, Posters, Advertising, Sales Literature, Direct Mail, Packaging, Point of Purchase Display, Sales Premiums, Book (Design, Cover), Publication (Design, Cover), Paper in Design, Envelope in Design, Calendars-Invitations, P.R. (Institution, Civic), Self-Promotion, Graphics (AV, TV, Film), Typography in Design, Editorial Design, Illustration, Photography in Design, Exhibits-Display, Stationery, Catalogs, Record Jackets, Sales-Educational Kits. Competition includes monochrome photography, graphics design, film, video.

AWARDS: DESI Certificates, winners. Exhibition at Graphics Design Show.

JUDGING: By 4 graphic design spe-

cialists. Not responsible for loss or damage.

ENTRY FEE: $8, single piece or slide; $20, campaign series. Winners pay hanging fee. Entrant pays return postage.

DEADLINES: Entry, January. Judging, February-March. Event, awards, Spring.

7

National Retail Merchants Association (NRMA) Newspaper and Direct Mail Competition
John A. Murphy, Vice President
100 West 31 Street
New York, New York 10001 U.S.A.
Tel: (212) 244-8780

May

International; **entry open to professionals, members of retail stores and agencies;** established 1944. Purpose: to recognize retail promotional creativity. Sponsored by NRMA, TUB, RAB, NAB. Average statistics (all sections): 800 entries, 50 countries, 100 awards, 500 attendance. Have sales promotion-marketing conference, advertising, visual merchandising, seminars.

PHOTO CONTEST: **Advertising Color.** Submit mounted tearsheets or direct mail pieces. Require explanation of campaign, results. Categories: Newspaper, Direct Mail. Competition includes monochrome photography. Also have TV and radio sections.

AWARDS: First, Second, Honorable Mention each category.

JUDGING: By 5 judges. Based on saleable use of copy, art and photography. Sponsor retains entries; not responsible for loss or damage.

ENTRY FEE: $5.

DEADLINES: Entry, judging, January. Event, May.

Society of Publication Designers Competition
Liz Wilbur
Room 501
3 West 51st Street
New York, New York 10019 U.S.A.
Tel: (212) 582-4077

Spring

International; entry open to all; annual; established 1966. Purpose: to evaluate and recognize designer, photographer, art director, illustrator, creative efforts. Sponsored by Society of Publication Designers, founded 1964. Have exhibitions.

PHOTO CONTEST: **Newspaper-Magazine Design Color,** published during previous calendar year; unmounted proofs and tearsheets; text attached to each entry. No catalogs, advertising, promotional publicity materials. Divisions: 1 or 2 colors, 3 or more colors, each category. Categories: Cover, Single Page, Story Presentation (2 or more pages). Classes: Consumer Publications (General Interest, Women's, Men's, News-Business, Shelter, Food, Beauty-Fashion, Travel-Entertainment-Art, Sports, Outdoors, Technical, Educational), Trade-Professional, Institutional Publications Without Advertising (Institution-Company, Museum, Annual Reports, School, Newsletters-Journals), Newsprint Publications (Daily, Weekly, Magazine Supplement), New Publications. Competition includes monochrome prints. Also have Newspaper-Magazine design categories.

AWARDS: Merit Award, inclusion in exhibition and book, each finalist. Excellence Gold Award, Distinctive Merit Silver Award to art director at

judges' discretion. Jerome Snyder Award for Exceptional Art Direction, Best of Show, at judges' discretion.

JUDGING: Judged against like publications. Based on aesthetics, relationship of aesthetics to editorial requirements. Consider illustrative material only in relation to editorial text. May withhold awards. No entries returned.

ENTRY FEE: $10 (members), $15 (nonmembers), each entry. $45 (members), $60 (nonmembers) hanging fee and mounted entry required from finalists.

DEADLINES: Entry, February. Finalists notified, April. Event, Spring.

Kodak International Color Photography Calendar Contest
Kodak Aktiengesellschaft Public Relations
Josef Pokorny
Postfach 369
7 Stuttgart 60, WEST GERMANY
(FRG) Tel: (07 11) 4011-1

January-February

International; entry open to all; annual; established 1970. Sponsored by Stuttgart Graphics Club, Landesgewerbeamt Baden-Wuerttemberg and Kodak Corporation. Held at annual Stuttgart Graphics Club Calendar Show (established 1951) for 3-1/2 weeks. Second contact: Landesgewerbeamt Baden-Wuerttemberg, Kanzleistrasse 19, Postfach 831, 7 Stuttgart 1, West Germany.

PHOTO CALENDAR CONTEST: General Color, unlimited entry. Submit 3 copies each and information sheet. Categories: Business; Industry and Advertising.

AWARDS: Certificates to best calendars. Top Certificates to Exemplary and Laudable calendars. Kodak Certificates for excellent color photography.

JUDGING: By 9 judges. Based on theme, form, printing technique, bookbinding, quality.

ENTRY FEE: None.

DEADLINES: Entry, December. Event, January-February.

AMATEUR
Prints, Instant Prints, Slides, Slide Shows, including GENERAL, NATURE, PHOTOJOURNALISM, and TRAVEL PHOTOGRAPHY. AMATEUR usually defined as photography produced entirely for fun and pleasure, with no commercial purpose or profit in mind, by persons not engaged in photography as their main source of income at the time of production; and which has not been sold, commissioned, sponsored, or subsidized. However, these definitions may vary. (Also see other PRINT and SLIDE CATEGORIES.)

10

Great American Photo Contest
R. M. J. Enterprises
P. O. Box 120050
Nashville, Tennessee 37212 U.S.A.
Tel: (615) 244-3748

July-August

International; **entry open to amateurs;** annual; established 1980. Sponsored by R. M. J. Enterprises. Average statistics (all sections): 6000 entries, 6 countries.

PRINT CONTEST: Amateur General, Nature-Travel, People Color 11x14 inches maximum; limit 3 per entrant (6 if entering early). Categories: General, Nature-Travel, People. Grand Prize competition includes monochrome prints, color slides.

INSTANT PRINT CONTEST: Amateur General Color. Requirements same as for Prints. Competition includes monochrome instant prints.

SLIDE-TRANSPARENCY CONTEST: Amateur General, Nature-Travel, People Color, any size; limit 3 per entrant (6 if entering early). Categories: General, Nature-Travel, People.

ELIGIBILITY: Amateur earns less than 25% of income from use or sale of photos. No pictures published for payment.

AWARDS: $10,000 Grand Prize (includes monochrome and color prints, color slides). Print-slide: $500 First, $250 Second, $125 Third, 4 $50 Fourth Prizes, 50 Honorable Mentions, each category. Instant print: $1000 Grand, $250 First, $125 Second, $75 Third, 4 $25 Fourth Prizes, 100 Honorable Mentions.

JUDGING: By group of judges. Based on originality, creativity, composition, appeal. Entrant assumes liability for copyright infringement, retains all rights; sponsors may use winners only in contest promotion.

ENTRY FEE: $9 1 photo, $12 2 photos, $15 3 photos (instant: $3, $5, $7) plus return postage. Early entry, double number of entry for same price.

DEADLINES: Early entry, February. Entry, March. Judging, awards, event, July-August.

11

Great American Slide Competition
Unicolor
Peter Ewen, Manager, Consumer Education
7200 West Huron River Drive
Dexter, Michigan 48130 U.S.A.
Tel: (313) 426-4646, ext. 53

June

International; **entry open to amateurs;** annual; established 1981. Purpose: to promote home color slide processing. Theme: American Life. Sponsored and supported by Unicolor, Ricoh. Publish *FACTS* magazine (quarterly).

SLIDE CONTEST: Amateur American Color, 35mm; limit 4 per entrant. Home-processed with Unicolor E6 chemistry. Submit box top from E6 chemistry kit. No published, prize winning commercially-processed entries. Categories: American People, Land, Towns, and Cities; General.

AWARDS: Camera, Best of Show. Cameras, First, Second, Third Prize, each category. 10 Honorable Mention camera pouches.

JUDGING: Entry review by National Unicolor Darkroom Schools' instructors. Awards judging by panel of independent professionals. Sponsor claims advertising, public relations, exhibition rights for 1 year. Not responsible for loss or damage.

ENTRY FEE: None.

DEADLINES: Entry, March. Notification, June.

12
Home Magazine Photography Contest
Los Angeles Times
P. O. Box 2291
Los Angeles, California 90053 U.S.A.

June

International; **entry open to amateurs;** annual; established 1974. Purpose: to encourage amateur photographers to explore photographic medium and develop their skills. Sponsored by *Home Magazine* of *Los Angeles Times.* Held in Los Angeles for 6 days.

SLIDE CONTEST: **Amateur General Color,** 35mm; limit 2 per entrant. Submit signed releases. Competition for some awards includes monochrome prints.

ELIGIBILITY: Open to amateurs. No persons affiliated with *Los Angeles Times* or Times Mirror Company.

AWARDS: 8-day Hawaiian Holiday Grand Prize for two, Best of Show (includes monochrome prints). $250 First, $200 Second, $150 Third Prizes. Honorable Mentions.

JUDGING: By panel of judges. Sponsor owns entries; may reproduce entries for exclusive promotional purposes for 1 year.

ENTRY FEE: None.

DEADLINES: Entry, April. Judging, notification, May. Event, June.

13
Kodak International Newspaper Snapshot Awards
Eastman Kodak Company
Betty D. Wolcott, Corporate
Communications
343 State Street
Rochester, New York 14650 U.S.A.
Tel: (716) 724-4727

January-March

International; **entry open to U.S., Canadian, Mexican amateur photographers;** annual; established 1936. Sponsored by Eastman Kodak Company. Average statistics (all sections): 300,000 entries to 98 newspapers, 698 finalists, 247 awards. Held at Kodak Photo Gallery, New York for 2 months (entry review judging held at local newspapers). Also sponsor Scholastic Kodak Photo Awards for junior and senior high school students.

PRINT CONTEST: **Amateur General Color,** any size, taken since July of preceding year. Competition includes monochrome prints, color slides.

SLIDE CONTEST: **Amateur General Color,** any size, taken after July of preceding year. Submit original transparency, subject release.

AWARDS: Grand Prize of $10,000 cash or all-expense-paid trip around the world for two people for 30 days plus $1000 spending money. $55,000 cash and travel awards.

JUDGING: By 5 judges. Entry review by local newspapers. Awards judging by Eastman Kodak Company in Rochester.

ENTRY FEE: None.

DEADLINES: Entry during summer (dates vary with newspaper). Event, January-March.

14
Marin County Fair Photography Competition
Yolanda F. Sullivan, Manager
Marin Center Fairgrounds
San Rafael, California 94903 U.S.A.
Tel: (415) 499-6400

June-July

Regional; **entry open to Northern California amateurs;** annual; established 1945. Sponsored by and held at Marin County Fair & Exposition for 5 days. Average statistics (all sections): 650 entries, 225 entrants, 16 awards. Also sponsor fine arts, crafts, films, music contests.

PRINT CONTEST: **Amateur General, Creative Color,** 16x20 inches maximum including mount; limit 4 per category. No frames (narrow-shallow framing accepted for Creative), glass, commercially processed prints. Categories: General, Creative. Competition includes monochrome prints.

SLIDE CONTEST: **Amateur General Color,** 2x2 inches, mounted; limit 4 per entrant. No glass over ready mounts.

AWARDS: $100 and ribbon, Best of Show, prints and slides. Prints: $70, best each category; $50 Merit Award, each category. Honorable Mention ribbons. Additional $25-$50 awards, various.

JUDGING: By 3 (prints), 2 (slides) photographers. Not responsible for loss or damage.

ENTRY FEE: $3 per category (plus return postage).

DEADLINES: Entry, May. Judging, notification, June. Event, June-July.

15

New River Mixed Media Gathering
Appalachian State University (ASU)
Joseph R. Murphy, Associate
Professor
P.O. Box 5000
Boone, North Carolina 28608 U.S.A.
Tel: (704) 262-2243

October

International; **entry open to amateurs;** annual; established 1978. Purpose: to encourage photography by amateurs and provide audience for their work. Sponsored by ASU, North Carolina Arts Council, North Carolina Independent Film and Video Association. Supported by NEA. Recognized by Coalition of Southern Media Organizations. Held at ASU, North Carolina for 3 days. Tickets: $10 ($5 students).

PRINT CONTEST: **Amateur General Color,** 8x10 to 16x20 inches including mount (matting optional); unlimited entry. Categories: General, Experimental. Experimental includes monochrome prints. Also have film, video sections.

AWARDS: Purchase prize award, Certificates of Merit, each category.

JUDGING: By panel. Sponsor purchases winning entries.

ENTRY FEE: $5.

DEADLINES: Entry, judging, event, October.

16

Portsmouth Photography Show and Exhibition
Portsmouth Parks and Recreation Department
Deborah Avant, Cultural Planner
801 Crawford Parkway
Portsmouth, Virginia 23704 U.S.A.
Tel: (804) 393-8481

February

International; **entry open to amateurs (exhibit open only to professionals);** annual; established 1975. Purpose: to give amateur photographers opportunity to show, sell, compete. Sponsored by Harris Camera Company, Portsmouth Parks and Recreation Department. Average statistics

(all sections): 350 entries, 85 entrants, 30 awards, 10,000 attendance. Held in Portsmouth, Virginia, for 3 days. Also sponsor Seawall Art Show. Second contact: Harris Company, Mr. Harris, 4201 Portsmouth Boulevard, Portsmouth, Virginia 23704; tel: (804) 465-0505.

PRINT CONTEST: Amateur General Color, 5x5 to 16x20 inches, mounted on 16x20-inch board; unlimited entry. Works to be hand-delivered; may be commercially processed. Categories: Informal Portrait, Animal, Children, Scenic, Still-Life, Open. Competition for some awards includes monochrome prints.

AWARDS: Percentage of entry fees and ribbons, First, each category. Percentage of entry fees and plaque, Best of Show (includes monochrome). Second, Third Place ribbons, each category. Special ribbons, most popular, most humorous (includes monochrome).

JUDGING: By 3 photography and art educators. Based on composition, interest, relation to category, technical quality.

ENTRY FEE: $1 each plus return postage.

DEADLINES: Entry, event, judging, February.

San Mateo County Fair Photography Competitions
San Mateo County Fair Arts Committee
Lois Kelley, Administrator
171 Flying Cloud Isle
Foster City, California 94404 U.S.A.
Tel: (415) 349-2787

August-September

International; entry open to all; annual; established 1947. Purpose: to showcase emerging trends in the arts. Sponsored and supported by San Mateo County Fair Association (founded 1935). Held at San Mateo County Fairgrounds Fine Arts Room and Fiesta Hall for 13 days, 200,000 attendance. Have photo day, demonstrations, video theater with continuous presentations. Second contact: San Mateo County Fair Association, P. O. Box 1027, San Mateo, California 94403.

PHOTO CONTEST: Amateur Color, 17x21 inches maximum including mat and frame, ready for hanging. No trade-processed prints. Competition includes monochrome prints. Also have film, video, fiction, art, crafts, performing arts sections.

SLIDE CONTEST: Amateur Color, 2x2 inches, mounted (set of 3 per entry); unlimited entry. No glass. May be combination of prints and slides.

PHOTO CONTEST: Fine Arts Color, any size, ready for hanging; unlimited entry. Competition includes monochrome prints.

AWARDS: (Amateur, prints and slides): $100 Brooks merchandise certificate Grand Photo of the Year Award (including monochrome prints); $25 merchandise certificate First Place prints and slides. Merit awards-ribbons. Fine Arts: $100 First Place plus $100 merchandise certificate and weekend for 2 to Disneyland, solo exhibitions. $50, $25 merchandise certificates to Second, Third Place. Special Subjects (Amateur and Professional Prints): $50 First Place and 2 Gold passes to Marine World Africa; individual passes Second, Third for best interpretation of any attraction in Marine World compound. $100 and Trophy First, $50 Second, $25 Third, ribbons by California Jockey Club at Bay Meadows for best interpretation

of thoroughbred race horse. $100 First, $35 merchandise certificate Second, $25 Third for best interpretation of a floral work. $100 First, $50 Second, $25 Third, ribbons San Mateo Times Award for best News Photo of the Year. 5 $1760 scholarships to Academy of Art College, San Francisco; 2 $625 scholarships to Institute Allende de San Miguel, Guanajato, Mexico (to high school graduate for 2 semesters each). (Scholarships and Special Subject awards include all visual arts media.) Selected slides will be projected continuously during fair.

JUDGING: By 6 judges. Based on merit in all areas. May withhold awards, reproduce entries. Not responsible for loss or damage.

ENTRY FEE: $6 each print. $6 each 3 slides. $3 handling for crated entries. Entrant pays return postage.

DEADLINES: Entry, July. Event, August-September.

18

Senior Olympics International Photography Contest
Senior Sports International
Warren Blaney
5670 Wilshire Blvd., Suite 360
Los Angeles, California 90036 U.S.A.

January-October

International; **Entry open to amateurs age 20 or over;** annual; established 1969. Purpose: to foster positive thinking and positive action. Motto: "Youth eternal; creating the new adult image." Sponsored by Senior Sports International (nonprofit). Supported by membership, contestants. Also have various sports, art, music, dance, talent categories. Second contact: John Cates, Western Photographer, Box 80906, San Diego, California.

PRINT CONTEST: Amateur Gen-

eral Color, 8x10 inches, unmounted; limit 4 per category. Categories: Human Interest, Action, Senior Olympic Activity, General. Competition divided by sex and 16 age groups (in 5-year spans from 20-24). Also have monochrome print section.

SLIDE CONTEST: Amateur General Color, 2x2 inches, plastic or cardboard mounts; limit 4 per category. Categories, age and sex groups same as for Print.

AWARDS: Gold, Silver, Bronze Medals each category, sex and age group. Participation patches.

JUDGING: Based on general appeal, originality, quality. Sponsor may retain entries for noncommercial promotion; entrant retains rights. Not responsible for loss or damage.

ENTRY FEE: $6 first category, $3 each additional category, plus $1 per section. Entrant pays return postage.

DEADLINES: Entry, September. Event, January-October.

19

Iris-Aartrijke International Color Slide Exhibition
Victor Demeulemeester, Secretary
Steenstraat 42
B-8260 Aartrijke, BELGIUM
Tel: 050-20-05-92

January

International; **entry open to amateurs;** annual; established 1970. Sponsored by Iris-Aartrijke. Recognized by PSA, FIAP, FBCP. Held in Jonkhove Youth Center, Aartrijksestraat in Aartrijke, Belgium for 10 days.

SLIDE CONTEST: Amateur General, Nature, Journalism Color, 5x5cm, Glass-mounted; limit 4 per category. Categories: General, Nature, Photojournalism.

AWARDS: General: PSA Gold Medal, Best of Show. Iris Gold Medal, best contemporary. Basseghem Caben Cup, best club entry. FIAP Gold, Silver, Bronze Medals. 2 Diplomas. Honorable Mentions. Nature: PSA Silver Medals, best nature, best wildlife. Iris-Aartrijke Cup, best club entry. 2 FIAP Diplomas. Honorable Mentions. 5 Medals. 8 Diplomas. Photojournalism: PSA Gold Medal, Best of Show. Zedelgen-Aartrijke Municipality Cup, best club entry. 2 FIAP diplomas. Honorable Mentions. 8 Medals. 8 Diplomas.

JUDGING: By 5 judges, each category. Best club entry (3 entrants maximum) determined by adding points of best 10 slides of club. Not responsible for loss or damage.

ENTRY FEE: $3.50 (90Bf) per category. $1 (30Bf) for airmail return.

DEADLINES: Entry, judging, December. Event, January. Materials returned, February.

20

Liege International Festival of Picture and Sound

Francois Oury, Chair
62-106 Voie de l'Ardenne
B-4920 Embourg, BELGIUM
Tel: (041) 65-93-19

November

International; **entry open to amateurs;** biennial (odd years); established 1977. Slide competition established 1981. Formerly called LIEGE AUDIO-VISUAL FESTIVAL to 1979. Purpose: to promote nonprofessional works. Sponsored by University of Liege. Supported by Province and City of Liege. Recognized by FBCP, FIAP, PSA, UNICA. Average statistics (all sections): 2500 entries, 2000 entrants, 10 countries, 112 finalists, 35 awards. Held at Palais des Congres

(Esplande de l'Europe, Liege) for 5 days. Have hotel accommodations, projection equipment, workshops. Second contact: Fernard Hick, rue de Berneau, 23, B-4540 Vise, Belgium; tel: (041) 79-37-22.

SLIDE CONTEST: **Amateur General Color,** 2x2 inches, glass mounts; limit 4 per entrant. Also have film, video sections.

SLIDE SHOW WITH SOUND: **Amateur General Color,** 24x36cm for 2 projectors; sound mono-stereo, 2- or 4-track tape or cassette. Maximum length, 10 minutes.

AWARDS: FIAP Gold, Silver, Bronze Medals. Honorable Mentions.

JUDGING: By 3-5 judges. Entries viewed once in entry review, twice in awards judging. Sponsor reserves right to reproduce entries. Not responsible for loss or damage.

ENTRY FEE: Slides: $3 (80 Belgian francs). Slide show with sound: $7.50 (200 Bf) each. Checks, add 50¢.

DEADLINES: Entry, September (slide show), October (slides). Judging, notification, October. Event, November.

21

World Dialogue International Slide Exhibition

Retina Kuurne Camera Club (RKCC)
Marcel D. Holvoet
Hoevedreef 3
B-8720 Kuurne, BELGIUM Tel: (056) 712865

October

International; **entry open to amateurs;** biennial (odd years); established 1981. Sponsored by RKCC. Recognized by PSA, FIAP, WVFD, BFFK. Average statistics: 4580 entries, 750 entrants, 44 countries. Held in

Kuurne for 9 days.

SLIDE CONTEST: Amateur General, Nature, Journalism, Travel Color, 2x2 inches (5x5cm), glass mounts; limit 4 per category. Categories: General, Nature, Photojournalism, Travel.

AWARDS: General: FIAP Gold, Silver, Bronze Medals. RKCC Gold, Silver, Bronze Medals. 3 special medals. John Himpe Trophy, best model photography; Cup, best club. Nature: BFFK Silver Medal. RKCC Gold, Silver, Bronze Medals. Special medals, best wildlife, botany, zoology. Marcel Holvoet Trophy, best club. Photojournalism: BFFK Gold Medal. RKCC Gold, Silver, Bronze Medals. 3 special medals. Travel: RKCC Gold, Silver, Bronze Medals. 3 special medals. Additional medals, each category.

JUDGING: By 5 judges each category (3 for nature). Sponsor may reproduce accepted works. Not responsible for loss or damage.

ENTRY FEE: $3 each category; Benelux countries, 90Bf. Additional for return airmail.

DEADLINES: Entry, September. Judging, event, October. Materials returned, November.

| 22 |

Photo Life Magazine Photo Contest
Guenter Ott, Editor
Box 7200
Don Mills, Ontario M3L 2T9 CANADA
Tel: (416) 445-7740
May

National; **open to Canadian amateurs;** continuous; established 1981. Purpose: to give amateur photographers chance to have work published. Sponsored by *Photo Life Magazine,*

Harlequin Magazine, Skylark Holidays. Average statistics (all sections): 3000 entries, 800 entrants, 50 semifinalists, 4 finalists, 4 awards. Held in Toronto, Canada.

PRINT CONTEST: Amateur Theme Color, 8x10 inches maximum, completed in previous year; unmounted, unframed; limit 4 per entrant. No prize-winning entries previously entered in a North American contest. Competition includes monochrome prints and color slides.

SLIDE CONTEST: Amateur Theme Color, 35mm, 2-1/4 inches; completed in previous year; mounted in plastic slide sheets; limit 4 per entrant.

AWARDS: 2 trips for two to Hawaii. 2 autofocussing cameras. Copies *Alpine Canada,* monthly. Advertising and promotion in *Photo Life Magazine.*

JUDGING: By editor, assistant editor, art director of *Photo Life Magazine.* Not responsible for loss or damage.

ENTRY FEE: Prints and slides, $2.

DEADLINES: Entry, continuous. Notification, 3 months later. Event, May.

BUSINESS, INDUSTRIAL

Prints, Slides, Slide Shows and Audiovisual, including AUDIOVISUAL DEPARTMENT, ECONOMICS-TRAINING, INDUSTRIAL-BUSINESS PROBLEM SOLVING, PROFESSIONAL, WEDDING. (Also see SCIENTIFIC-TECHNICAL.)

23

Audio Visual Department of the Year Awards Competition
Information Film Producers of
America (IFPA)
Wayne Weiss
750 East Colorado Blvd., Suite 6
Pasadena, California 91101 U.S.A.
Tel: (213) 795-7866

Fall

National; **entry open to U.S. audiovisual departments;** annual; established 1980. Purpose: to recognize total accomplishments of audiovisual departments. Sponsored by 3M, IFPA (founded 1957, nation's largest nonprofit association of documentary, educational, industrial, business filmmakers, dedicated to professional advancement, recognition of those who create film, video, audiovisual for communications as opposed to entertainment). Average statistics (all sections): 75-100 entries, 15 winners. Location varies. Publish *The Communicator* (bimonthly newsletter). Also sponsor Cindy Competition for film and video, IFPA Film and Video Communicators Scholarship, IFPA National Conference and Trade Show, seminars.

AUDIOVISUAL CONTEST: Audiovisual Department Production Color; entries must represent audiovisual department from business, industry, education, government (including Department of Defense agencies); single product or multimedia, including prints, slides, filmstrips, slide shows with sound, films, videotapes. Competition includes monochrome photography.

AWARDS: Gold, Silver, Bronze Awards, each category. Audiovisual Department of the Year Grand Award (in memory of D. David Bash, past

IFPA president), chosen from 6 gold winners.

JUDGING: By panel of experienced audiovisual managers selected by IFPA. Not responsible for loss or damage.

ENTRY FEE: Not specified.

DEADLINES: Entry, April. Event, Fall.

24

Industrial Photography Annual Contest
Industrial Photography Magazine
(IPM)
David Silverman, Editor
475 Park Avenue South
New York, New York 10016 U.S.A.
Tel: (212) 725-2300

April

International; **entry open to industrial photographers;** annual; established 1974. Sponsored by IPM (founded 1952). Average statistics (all sections): 2000 entries, 83 awards.

PRINT CONTEST: Industrial Color, 11x14 inches maximum, mounted; taken in year prior to contest year; limit 5 per category. Categories: Portrait, The Invisible, Architecture-Engineering Problem, Glamorizing Industry. Competition includes monochrome prints, color slides.

SLIDE CONTEST: Industrial Color, 35mm, 2x2 inches; any format. Others cardboard mounts, 5x7 inches minimum; limit 5 per category. Categories same as for Prints.

AWARDS: Publication in *Industrial Photography Annual.* Certificates to entries chosen.

JUDGING: By 6 judges experienced in art-technique of industrial photography. Based on visual effectiveness,

technical merit. Not responsible for loss or damage.

ENTRY FEE: None. Entrant pays return postage.

DEADLINES: Entry, December. Winners published, April.

| 25 |

Professional Photographers of America (PPofA) Exhibition of Professional Photography
Valerie Bluemel, Secretary
1090 Executive Way
Des Plaines, Illinois 60018 U.S.A.
Tel: (312) 299-8161

May

International; **entry open to professional photographers, photographic artists, retouchers;** annual; established 1891. Sponsored by PPofA, founded 1880. Recognized by American Photographic Artisans Guild. Average statistics (all sections): 5000 entries, 1200 entrants, 200 accepted, 600 awards. Held at PPofA annual trade show and convention for 5 days. Have exhibitions. Publish *The Professional Photographer, PPofA Today Newsletter.* Also sponsor Industrial Photographic Department of the Year Award, Decorating With Photography Design Competition, exhibits of Industrial and Technical Photography Accomplishments.

PRINT CONTEST: Professional General Color, 16x20 inches; taken in previous 2 years; permanently cardboard mounted (3/16-inch combined print and mount thickness), limit 4 per entrant (includes all sections). No excessive artwork. Categories: Portrait, Commercial, Industrial, Unclassified (including Pictorial), Social Function Candid. Competition includes monochrome prints.

TRANSPARENCY CONTEST:

Professional General Color, 4x5 inches minimum, masked and mounted under 12x12-inch black mat (cut-out), limit 4 per entrant (includes all sections). Accepted transparencies will not be displayed. Categories same as for Prints. Competition includes monochrome prints, artwork, retouching sections.

MASTER PRINT CONTEST: Professional General Color (open to *Master of Photography* degree holders), 24x30 inches maximum (100 square inches minimum); taken in previous 2 years; cardboard mounted; limit 4 per entrant (includes all sections). No excessive artwork. Categories same as for Prints. Competition includes monochrome master prints.

PHOTO SPECIALIST COMPETITION: Artist, Negative Retoucher Color, taken in previous 2 years; 16x20 or 20x16-inch mats or mounts, limit 4 per entrant (includes all sections). For artist, require 8x10-inch dry-mounted identical guide print with each entry except Light or Brush Oil, Direct Color (may be smaller). Artist categories: Light or Brush Oil (11x14 inches, furnished by PPofA), Direct Color (11x14 inches, furnished by PPofA); Freestyle, Color Enhancement (16x20 inches, furnished by entrant). Retoucher category: Color retouching (on 2 negatives, furnished by PPofA). Competition includes monochrome artwork, retouching.

ELIGIBILITY: Entrant may enter 1 PPofA Competition per year. No entries made under supervision of instructor.

AWARDS: (General and Master sections): Exhibition Merit Certificate, each accepted for Exhibit. Second Merit, each selected for Loan Collection. 2 American Society of Photographers (ASP) Fellowship Points, each selected for Traveling Exhibit (Master

only). Limit 7 Merits and Points per entrant per year. (Specialist): Specialists Degree Merit, each accepted in Specialist Exhibit (limit 4 merits per entrant per year). Merits, Points count toward PPofA degrees.

JUDGING: By 5-member Master of Photography panels. Based on point system. Sponsor may retain accepted entries for publication, reproduction, and sales for educational purposes. Not responsible for loss or damage. Judges' critiques available on cassette tapes.

ENTRY FEE: $12 each ($36 minimum), nonmembers; $25 members. $25 for artwork, retouching materials. Fee for judges' Critique. Entrant pays return postage for unaccepted entries.

DEADLINES: Entry, April. Entry, March (retouchers). Judging, exhibition, May.

26

Professional Photographers of America (PPofA) Industrial Photographic Department of the Year Award
Jane Shaffer
Industrial Division
1090 Executive Way
Des Plaines, Illinois 60018 U.S.A.

July-August

National; **entry open to U.S. photographic departments;** annual; established 1976. Purpose: to measure, reward, publicize business-oriented achievements of industrial photographic departments; communicate these successes to company management. Sponsored by PPofA Industrial Division, Eastman Kodak Company. Held at PPofA annual convention in Des Plaines. Also sponsor Exhibition of Professional Photography, Photographic Art for Wall Design New Ideas Contest.

PHOTO CONTEST: **Industrial and Business Problem-Solving Project Color,** 8x10 inches, produced in previous year. Submit information on problem, complications, solution, results, impact; end product of project (photos, film, videotape, other audiovisual material). No entries accepted from governmental, educational, nonprofit institutions. Categories: Sales-Advertising, Engineering, Research-Development, Manufacturing, Personnel-Training, Public Relations, Accounting-Finance. Competition includes monochrome photography, film, videotape.

AWARDS: Outstanding Industrial Photographic Department of the Year Award, best each category.

JUDGING: By experienced panel of managers. May withhold awards. Not responsible for loss or damage.

ENTRY FEE: $20 each project.

DEADLINES: Entry, June. Judging, event, July-August.

27

World of Wedding Photography Blue Garter Grand Awards
Wedding Photographers International
1312 Lincoln Boulevard
P. O. Box 2003
Santa Monica, California 90406
U.S.A. Tel: (213) 451-0090

April

International; entry open to all; annual. Sponsored by Wedding Photographers International (WPI). Held at The World of Wedding Photography Trade Show and Convention at Sheraton Washington, Washington, D.C. for 4 days. Also sponsor IWPA awards competition.

PRINT CONTEST: **Wedding Color,** 16x20 inches, mounted; limit 4

per entrant. Categories: Bride and Groom Alone, Together, With Family; Bridal Party, Candid, Special Effects.

AWARDS: Blue Garter Award, each category.

JUDGING: By members of WPI Advisory Board. Based on photographic artistry, craftsmanship. Reproduction rights reserved by WPI and *The Rangefinder* magazine. Not responsible for loss or damage during mailing.

ENTRY FEE: $15 ($11 WPI members), plus return postage.

DEADLINES: Entry, February. Judging, notification, event, April.

International Festival of Economics and Training Films
Cercle Solvay
Didier Cloos, President
Avenue Franklin Roosevelt 48
B-1050 Brussels, BELGIUM
Tel: 02-6490030, ext. 2528

November

International; entry open to all; triennial; established 1978. Purpose: to acquaint public with film, video, and slides as teaching aids. Sponsored by Cercle Solvay. Supported by Union of Commercial Engineers, Free University of Brussels. Recognized by King Baudouin. Average statistics: 2500 entries, 400 entrants, 25 countries, 6 awards. Held at the University of Brussels for 1 week. Tickets: 400-4000 Belgian francs. Have exhibition of office equipment. Also sponsor conferences, seminars.

SLIDE SHOW WITH SOUND: Economics, Training Color, completed in last 10 years, rotary tray of slides, 80 maximum; French (preferred), English, or Dutch; sound

track, incorporated or separate, reacting to 1000hz impulses. Competition includes film, video sections.

AWARDS: Grand Prize, best production. University Teaching Prize, best teaching production. Section prizes.

JUDGING: Entry review by university professors, business specialists. Awards judging by Grand Jury. Based on technical realization and educational aspects. Sponsor insures during festival.

ENTRY FEE: None. Entrant pays return postage.

DEADLINES: Entry, May. Judging, event, November. Materials returned, December.

GRANTS (General)
Primarily for RESEARCH, PRODUCTION, DEVELOPMENT, and AID, including PHOTOGRAPHY, AUDIOVISUAL EXHIBITION, CAREER ADVANCEMENT, TRAVEL, and EMERGENCY ASSISTANCE. (Also see RESIDENCE GRANTS, SCHOLARSHIPS, FELLOWSHIPS.)

29

Change Inc. Emergency Assistance Grants
Susan Lewis, Secretary
Box 705, Cooper Station
New York, New York 10276 U.S.A.
Tel: (212)473-3742

Continuous

National; **entry open to U.S. professionals;** continuous; established 1970. Purpose: to award emergency grants to professional artists in all

fields. Sponsored by Change Inc., P.O. Box 480027, Los Angeles, California 90048.

PHOTOGRAPHY GRANTS: Emergency Assistance. $100-$500 to professional photographers in need of emergency assistance resulting from utility turn-off, eviction, unpaid medical bills, fire, illness. Submit detailed letter describing situation, proof of professional status, 2 recommendation letters from people in applicant's field, outstanding bills substantiating amount needed. Competition includes color and monochrome photography.

JUDGING: By Board of Directors.

DEADLINES: Continuous.

30

Eben Demarest Trust Fund Grant
Anne Shiras, Secretary
4609 Bayard Street, Apt. 81
Pittsburgh, Pennsylvania 15213
U.S.A.

January

International; **entry open to all (nomination by organization)**; annual. Created by Elizabeth Demarest, history of civilization teacher at Carnegie Institute. Purpose: to free artist from livelihood dependence upon sale, approval of work. Sponsored and supported by Eben Demarest Fund.

PHOTOGRAPHY GRANTS: Artistic Work. 1 or more grants up to $7000 total to gifted artist who has produced work of recognized worth, has no other income equal to grant; nominated by organizations, institutions, or by Demarest Advisory Council member. No applications from individuals. Competition includes color and monochrome photography, fine and performing arts, archeology.

JUDGING: By 5-member council.

DEADLINES: Application, May. Notification, Summer. Grant, January.

31

Film Fund Media Grants Program
The Film Fund
Terry Lawler, Director
80 East 11th Street, Suite 647
New York, New York 10003 U.S.A.
Tel: (212) 475-3720

September

National; **entry open to U.S. independents;** annual; established 1976. Purpose: to encourage, support films and slide shows that take hard look at pressing social issues by providing resources for organizing social change, assisting in production and distribution of social issue media. Sponsored by The Film Fund, tax-exempt public foundation. Supported by foundations, individuals, government grants. Average statistics: 440 entries, 24 awards, $104,501 total grants. Publish *News from The Film Fund* (quarterly newsletter). Second contact: The Film Fund, 309 Santa Monica Blvd., Santa Monica, California 90401; tel: (213) 394-6275.

PHOTOGRAPHY GRANTS: Social Issue-Change Slide Show Production and Distribution. $1000-$10,000 to individuals, organizations for preproduction and research, production, completion of noncommercial artistic, educational, charitable slide shows on social issues, social change. Require sample work (semifinalists), personal interview (finalists). Submit project summary and description, table of contents, personnel list, budget, verification of tax-exempt status.

JUDGING: Initial review by Film Fund staff. Second review by 9-mem-

ber screening panel of film and video-makers, distributors, exhibitors, community activists. Final by Board of Directors based on importance, social relevance, maker ability, production aspects, potential audience, distribution. DEADLINES: Application, March. Notification, September (may vary).

32
Friends of Photography Ferguson Grant
James Alinder, Director
P. O. Box 500
Carmel, California 93921 U.S.A.
Tel: (408) 624-6330
Spring

International; entry open to all; annual; established 1972. Purpose: to assist in professional and artistic growth of recipient. Sponsored by Friends of Photography (founded 1967), international, nonprofit organization devoted to support, advancement of photography as creative art. Average statistics: 300 applicants, 1 grant. Have workshops, lectures, exhibitions. Publish photographic journal.

PHOTOGRAPHY GRANT: Photographic-Artistic Career Advancement. $2000 cash grant to creative photographer demonstrating excellence, commitment. Require 10 examples of prints (20x24 inches maximum), slides (if medium to be utilized), three-dimensional or photomedia work; resume. Competition includes color and monochrome photography.

JUDGING: Juror changes yearly so that award may be given to artists representing broad spectrum of photographic ideas. Limited insurance while in sponsor's possession; not responsible for loss or damage.

ENTRY FEE: None. Entrant pays return postage.

DEADLINES: Application, Winter. Judging, notification, Spring.

33
Information Film Producers of America (IFPA) Communicators Scholarship
Wayne Weiss
750 East Colorado Blvd., Suite 6
Pasadena, California 91101 U.S.A.
Tel: (213) 795-7866
Fall

National; entry open to U.S. photography students; annual. Purpose: to educate audio-visual career students. Sponsored by IFPA (founded 1957), nation's largest (17 chapters) nonprofit association of documentary, educational, industrial, business filmmakers, dedicated to professional advancement, recognition of creators of film, video, audio-visual for communications as opposed to entertainment. Held at IFPA National Conference and Trade Show. Publish *The Communicator* (bimonthly newsletter). Also sponsor Cindy Competition for film and video, Audio Visual Department of Year Awards Competition, seminars, other scholarships and grants.

AUDIO-VISUAL GRANT: Student Informational Slide Show. 1 $1500 cash and 1 year material-equipment-service grant to high school or college photography student, age 18-30, 3.0 grade point average minimum (based on 4.0 scale) for multimedia slide project (10 minutes maximum). Submit project proposal, budget, schedule, purpose, grade transcripts, goal statement, biography, 4 recommendation letters. Require 30-45-minute project report, screening, accounting of production expenses at

IFPA Conference at end of grant term (travel expenses to conference paid by sponsor). Competition includes color and monochrome photography, film, video.

JUDGING: By committee. May suspend or withdraw grants. IFPA scholarship fund retains profits from project.

ENTRY FEE: $5.

DEADLINES: Application, June. Grants, October.

34

Ludwig Vogelstein Foundation Grants
Douglas Turnbaugh, Treasurer
Box 537
New York, New York 10013 U.S.A.

Various

International; entry open to all; semiannual; established 1940. Purpose: to support original projects by individuals in arts and humanities. Average statistics (all sections): 35 awards per year, $3000 each. Also sponsor writing, art, music, drama grants.

PHOTOGRAPHY GRANTS: Original Project. $100-$5000 to individuals to support original project. Submit evidence of achievement in field, importance of project to field, financial need. Competition includes color and monochrome photography.

DEADLINES: Various

35

Massachusetts Bay Transportation Authority (MBTA) Arts on the Line Program
Cambridge Arts Council (CAC)
Pallas Lombardi, Administrator
City Hall Annex
57 Inman Street
Cambridge, Massachusetts 02139
U.S.A. Tel: (617) 846-5150
Continuous

International; entry open to all; continuous; established 1978. Purpose: to support artists, enhance public environments (subway stations), encourage collaboration between artists-architects by making artwork an integral part of station structure. Sponsored and supported by Urban Mass Transportation Administration, CAC, MBTA, NEA. Recognized by U.S. Department of Tranportation. Held in Cambridge, Somerville, Boston, Massachusetts. Have temporary art projects, exhibitions. Second contact: MBTA, Charlie Steward, 50 High Street, Boston, Massachusetts 02110.

PHOTOGRAPHY GRANT: Commissioned for Mass Transit System. $10,000-$100,000 each, to artists for incorporating art into subway systems in Massachusetts. Submit 20 slides maximum in 8-1/2x11-inch clear acetate slide sheet, resume of involvement with this project, 2-page future objectives. Require contract between artist and MBTA. Categories: Open Competition (from unsolicited, unpaid proposals, 1 proposal is commissioned), Limited Competition (from paid proposals, 1 proposal is commissioned), Invitation (solicited and paid proposals, 1 paid commission), Direct Purchase (installation of already completed works). Competition includes color and monochrome photography.

JUDGING: By 3 art professionals advised by 5 representatives (architectural, demographic, historical, sociological). Based on information obtained from artist and slides. Panel selects artists by viewing slides and given information. Sponsor retains entries for future use. Not responsible for loss or damage.

DEADLINES: Continuous.

36

National Endowment for the Arts (NEA) Photography Fellowships and Grants
2401 E Street N.W.
Washington, DC 20506 U.S.A.
Tel: (202) 634-6044

Various

National; **entry open to U.S. citizens, residents, and nonprofit, tax-exempt organizations;** annual; established 1965. Sponsored by NEA (independent agency of federal government) to encourage and assist U.S. Cultural resources, make arts widely available, strengthen cultural organizations, preserve cultural heritage, develop creative talent. Supported by annual appropriations from U.S. Congress, private donations. Address inquiries to program *italicized* in parentheses.

PHOTO FELLOWSHIP GRANTS: **Career Development** *(Visual Arts Program)* $12,500 fellowships (some limited $4000 fellowships) to visual artists (including photographers) of demonstrated talent, for materials, time to pursue work. Require 10 slides of recent work, 2 catalogs of recent exhibitions, 3 reviews. Application once in only 1 medium. No students; project funds. Application, February. Original works, May. Notification, January.

Contemporary Visual Arts Criticism *(Visual Arts Program)* $10,000 fellowships to critics for projects investigating, evaluating, analyzing contemporary visual arts; travel expanding critic's knowledge of art (limited $3000 travel fellowships also available). Require copies (on 8-1/2x11-inch paper) of 3 recent articles-essays, maximum 5000 words each. Not for primarily art-historical

research. Application, December. Notification, July.

PHOTO GRANTS: **American Culture Photo Documentation** *(Visual Arts Program)* up to $15,000 on matching basis to nonprofit organizations for commissioning photographers, projects investigating, documenting contemporary American culture, activity, region; or collections of historical significance. Require minimum 10 (contemporary), 20 (historical) prints or slides for entry review. Not for major equipment, facility construction, administrative-research costs, exhibits-publication. Application, December. Notification, September.

Art in Public Places *(Visual Arts Program)* up to $5000 on nonmatching basis to individuals; and up to $50,000 (for commercial works), $25,000 (purchases), $10,000 (public site planning-design) on matching basis to state-local governments, nonprofit organizations, for making contemporary art accessible in public places. Require 10 slides of recent work (individual); 8x10-inch monochrome prints, 35mm slides and-or drawings of proposed site, resumes, plans to obtain community support (organizations). Have planning-design grants for artists' fees. No exhibitions, museum acquisitions, historical-commemorative projects. Application, May (individual), December (organizations). Notification, January (individual), July (organizations).

Folk Arts Preservation Presentation *(Folk Arts Program)* up to $50,000 on matching basis to nonprofit organizations for media exhibits, distribution projects, to document folk art work methods, repertoires, performance styles. Require resumes, up to 10 photos demonstrating technical competency, sensitivity to needs of folklore documentation. Application, January, April, October. Notification,

6 months later.

Services to the Field *(Visual Arts Program)* up to $15,000 on nonmatching basis to individuals, and on matching basis to nonprofit organizations, for projects with direct, immediate effect on professional lives of visual artists, for financial-legal-technical assistance, information-resource-advisory services, publications. No students, amateurs, newsletters, major equipment, conferences, symposia, restricted programs. Application, June (artists' organizations, spaces), October (other). Notification, July.

Special Arts Projects *(Inter-Arts Program)* up to $50,000 to artists' colonies and interdisciplinary arts projects, up to $40,000 to art services organizations for programs involving 2 or more arts that are ineligible for funding under other NEA programs.

PHOTO EXCHANGE FELLOW-SHIP: **Artist Exchange Between U.S. and England-Japan** *(International Activities Program)* 6-9-month stipend and round-trip transportation to American mid-career artists for exchange with British or Japanese artists. Priority to those with specific purpose who have not recently resided in chosen country.

ELIGIBILITY: Require (from individuals) project description, career summary, 35mm slide work samples; (organizations) project description, dissemination plans, detailed budget, secured sources of matching grants, IRS certification of tax-exempt status, supplementary documentation. Application usually limited to 1 per year. Final reports required after project-program completion.

JUDGING: Application review by Program Panel. Recommendation by National Council on the Arts. Final by NEA Chair. Review criteria vary by program but generally include demonstrated quality of previous work, merit of and ability to realize proposed project, potential contribution to national and NEA program goals, budget feasibility.

DEADLINES: Vary by Program. Application 6-12 months before notification.

37

National Endowment for the Arts (NEA) Photography Exhibition and Education Grants
2401 E Street N.W.
Washington, DC 20506 U.S.A.
Tel: (202) 634-6044

Various

National; **entry open to U.S. citizens, residents, and nonprofit tax-exempt organizations;** annual; established 1965. Sponsored by NEA (independent agency of federal government) to encourage and assist U.S. cultural resources, make arts widely available, strengthen cultural organizations, preserve cultural heritage, develop creative talent. Supported by annual appropriations from U.S. Congress, private donations. Address inquiries to program *italicized* in parentheses.

PHOTO GRANT: **Artists' Spaces** *(Visual Arts Program)* up to $20,000 on matching basis to organizations providing structure, atmosphere conducive to artistic dialog, experimentation, for exhibitions, access to working facilities-equipment, visiting artists' series (up to $10,000 on nonmatching basis for artists' honoraria). No amateurs, students, real estate, construction, maintenance, major equipment, creation of new organizations. Application, June. Notification, April.

Arts Development *(Challenge Arts Grants)* $30,000-$1,500,000 on matching basis to media arts centers,

cultural groups, consortia, for fundraising, other activities contributing to organization's long-term financial stability. Application, June. Notification, February.

Contemporary Photo Exhibition *(Visual Arts Program)* up to $20,000 on matching basis to nonprofit organizations for exhibitions of living photographers, accompanying catalogs, educational activities increasing public awareness of photography. Require slides, other materials for entry review. Not for commissioning works, major equipment purchase, facilities construction, extensive research, awards, juried exhibitions, receptions. Application, July. Notification, January.

Design Communication *(Design Arts Program)* up to $50,000 on matching basis to organizations for exhibits informing about value, practice, impact of design and relationship to physical environment, human activity. Application, December, May. Notification, June, December.

Media Arts Education *(Expansion Arts Program)* $5000-$30,000 on matching basis to nonprofit community-based arts organizations for regional arts education programs, festivals. Includes instruction-training, community cultural centers, arts exposure programs, summer projects, regional touring events, services to neighborhood arts organizations. Application, November. Notification, June.

Museum Development *(Museum Program)* $5000-$100,000 on matching basis to museums for special exhibitions, permanent collections catalogs, contemporary arts purchases, visiting specialists, collection development-maintenance, internships. Deadlines vary by program.

Photography Publication *(Visual Arts Program)* up to $20,000 on matching basis to nonprofit organizations for publication of contemporary or historically significant photography, photo research-criticism. Require 10-20 slides or copy prints of photos to be reproduced. Not for periodicals, technical investigations, exhibition catalogs. Application, December. Notification, July.

Visual Arts Education *(Visual Arts Program)* up to $5000 on matching basis to nonprofit organizations for visiting artists' lectures, seminars, short-term workshops, artist-in-residence programs. Require 5 slides of artist's work, biographies, other documentation. Not for faculty positions, equipment purchase, regular educational curricula, administrative salaries, exhibition, receptions. Application, February. Notification, September.

ELIGIBILITY: Require (from individuals) project description, career summary, 35mm slide work samples; (organizations) project description, dissemination plans, detailed budget, secured sources of matching grants, IRS certification of tax-exempt status, supplementary documentation. Application usually limited to 1 per year. Final reports required after project-program completion.

JUDGING: Application review by Program Panel. Recommendation by National Council on the Arts. Final By NEA Chair. Review criteria vary by program but generally include demonstrated quality of previous work, merit of and ability to realize proposed project, potential contribution to national and NEA program goals, budget feasibility.

DEADLINES: Vary by program. Application 6-12 months before notification.

38

Polaroid Corporation Collection Program

Clarence Kennedy Gallery
Sherry Lassiter, Director
770 Main Street
Cambridge, Massachusetts 02139
U.S.A. Tel: (617) 577-5177

June, January

International; entry open to all; annual; established 1968. Gallery named after Clarence Kennedy, photographer-art historian. Purpose: to encourage and assist artists in Polaroid medium. Supported by Polaroid Corporation. Average statistics (all sections): 4000 entries, 400 entrants, 5 countries, 40 grants, 8 exhibitions. Also sponsor Spring Workshop.

PHOTOGRAPHY MATERIALS GRANTS: **Polaroid film.** 40 grants to photographers for generating work for Polaroid collection. Sponsor collects new work twice a year in exchange for film. Submit maximum 10 overmatted prints of work, resume. Competition includes color and monochrome photography.

PRINT PURCHASE: **Polaroid.** Purchase awards to photographers for generating work for Polaroid collection. Submit maximum 10 overmatted prints of work, resume.

JUDGING: By 25 Polaroid Corporation volunteer judges. Sponsor retains right to exhibit at Clarence Kennedy Gallery and traveling show; reproduce for publicity, art-education purposes. Accepts liability at Gallery only.

ENTRY FEE: $7 shipping fee.

DEADLINES: Entry, November. Judging, notification, January. Grants, purchases, June, January.

39

Rockefeller Foundation Humanities Fellowships

1133 Avenue of the Americas
New York, New York 10036 U.S.A.
Tel: (212) 869-8500, ext. 392

March

International; entry open to all; annual; established 1975. Purpose: to support humanistic scholarship intended to illuminate and assess contemporary social, cultural issues. Sponsored and supported by Rockefeller Foundation. Average statistics (all sections): 1000 entrants, 140 semifinalists, 35 awards. Also sponsor Rockefeller Foundation Research Fellowship Program for Minority-Group Scholars; 5-6 Rockefeller Foundation Human Rights Research Fellowships.

PHOTOGRAPHY GRANTS: **Contemporary Issues Scholarly Project** (including fully developed text). Approximately 40 1-year fellowships up to $20,000 (usually $10-$15,000) to scholars (or through tax-exempt institutions with which they are affiliated) in traditional humanistic disciplines and social sciences with clear humanistic implications, or artists undertaking scholarly projects, for salary, benefits, travel, secretarial-research support, materials for projects analyzing-evaluating contemporary issues. Submit (in English) 3 copies each 500-1000-word project description typed double-spaced, applicant vita and publications bibliography, 3 references. Upon sponsor request submit 7 copies each of vita, developed proposal. Competition includes all media, eligible disciplines.

JUDGING: By panel of scholars.

DEADLINES: Application, September. Proposal request, December. Notification, March.

GRANTS (Regional-State)

*Limited to specific Region, State.
Primarily for RESEARCH,
PRODUCTION and DEVELOPMENT.
Includes MASSACHUSETTS
MINNESOTA, NEW YORK, OHIO,
SOUTHEAST, SOUTHWEST,
CANADA. (Also see RESIDENCE
GRANTS, SCHOLARSHIPS,
FELLOWSHIPS.)*

40

Artists Foundation Artists Fellowship Program
Dale Stewart, Manager
100 Boylston Street
Boston, Massachusetts 02116 U.S.A.
Tel: (617) 482-8100

October

State; **entry open to Massachusetts independents, professionals;** annual; established 1975. Purpose: to recognize outstanding creative artists in Massachusetts; support future work of high merit. Sponsored and supported by Massachusetts Council on the Arts and Humanities. Average statistics (all sections): 4000 entries, 3500 entrants, 160 finalists, 75 awards. Have workshops.

PHOTOGRAPHY FELLOWSHIP GRANTS: Photographic Work. $3500 grants to Massachusetts residents over 18. Submit 10 prints or slides. Competition includes color and monochrome photography. Also have film, dance, writing, music, craft sections.

JUDGING: By practicing, anonymous out-of-state artists. Not responsible for loss or damage.

DEADLINES: Application, October.

41

Bush Foundation Fellowships for Artists
E-900 First National Bank Building
St. Paul, Minnesota 55101 U.S.A.
Tel: (612) 227-0891

March

State; **entry open to Minnesota;** annual; established 1975. Purpose: to assist artists to work full-time. Sponsored by Bush Foundation.

PHOTOGRAPHY GRANTS: Still Photographic Work. Up to 10 stipends ($15,000 for 12-18 months, $1250 per month for 6-12 months, $3000 in program and travel expenses) for career, goal advancement. Require evidence of professional accomplishment through publication, exhibition (35mm slides, photos). Competition includes color and monochrome photography; arts, writing, film-video sections.

ELIGIBILITY: Minimum 25-year-old Minnesota resident for 1 year prior to application. No students.

JUDGING: Entry review by panel. Awards judging by interdisciplinary panel. Based on demonstrated artistic quality, fellowship importance to creative growth.

DEADLINES: Application, October. Entry review, January. Notification, March.

42

Catskill Center for Photography (CCP) Photographer's Fund
Colleen Kenyon
59A Tinker Street
Woodstock, New York 12498 U.S.A.
Tel: (914) 679-9957

July

State; **entry open to New York;** annual; established 1980. Purpose: to honor and aid New York photographers in production of work. Sponsored by CCP. Supported by CCP membership, NYSCA, NEA. Have gallery, exhibitions, lectures, library, workshops, darkroom, auctions. Publish *Center Quarterly*. Also sponsor Juried Photography Exhibitions, Woodstock Photography Workshops.

PHOTOGRAPHY GRANT: New Work or Project Completion. Unspecified number of small grants to photographers residing in New York counties (Ulster, Dutchess, Greene, Columbia, Rennsalaer, Albany, Schoharie, Sullivan, Orange, Delaware) for production of new work or completing ongoing project. Submit resume, project description, 10 maximum unframed photographs (include return postage). Required to give lecture, demonstration, or print donation at end of grant term.

JUDGING: By 3 noted photographers.

DEADLINES: Application, June. Notification, July.

43

Creative Artists Public Service (CAPS) Program Fellowship Grants
Creative Artists Program Service
250 West 57th Street
New York, New York 10019 U.S.A.
Tel: (212) 247-6303

March

State; **entry open to New York;** annual; established 1970. Purpose: to aid individual creative artists in creating new work, completing work in progress. Sponsored by CAPS, non-profit arts service organization. Supported by NEA, NYSCA. Average statistics (all sections): 200 awards. Have community service program, visual arts and playwrights referral services. Also sponsor other media fellowship grants.

PHOTOGRAPHY FELLOWSHIP GRANTS: Artistic Work. $3500-$5000 for 12 months to create new work or complete work in progress. Submit maximum 15 prints, mounted or in album or portfolio. Competition includes color and monochrome photography. Also have art, writing, film, choreography, music sections.

MULTIMEDIA FELLOWSHIP GRANTS: Artistic Work. $3500-$6500 for 12 months to create new work or complete work in progress. Submit videotape (advisable) or request visit-audit (3 weeks' notice).

ELIGIBILITY: New York residents willing to perform community-related service. No matriculated graduate, undergraduate students. No proposals to travel, study, teach, publish or produce already completed work or purchase equipment.

JUDGING: By professional photographers. Work belongs to artists; CAPS requires 1 copy. Not responsible for loss or damage. Entrant pays return postage.

DEADLINES: Application, May. Audits, September-January. Materials (on request), November. Notification, March.

44

Dallas Museum of Fine Arts (DMFA) Awards to Artists
Sue Graze, Curator Of Contemporary Art
P.O. Box 26250
Dallas, Texas 75226 U.S.A.
Tel: (214) 421-4187

March

Regional; **entry open to Southwest U.S. under age 36;** annual; established 1980. Purpose: to recognize talent and promise in young visual artists. Sponsored by DMFA. Supported by Clare Hart DeGolyer, Anne Giles Kimbrough Memorial Funds. Average statistics (all sections): 500 entries, 100 entrants, 2 awards. Publish *DMFA Bulletin* (quarterly), *DMFA President's Newsletter* (annual).

PHOTOGRAPHY GRANTS: **Travel, Independent Study, Special Project.** 2 awards ($1000 maximum *Clare Hart DeGolyer Award;* $3000 maximum *Anne Giles Kimbrough Award)* to artists with reasonable promise; to be utilized during the same calendar year, but not for tuition. Submit 5-10 35mm slides or videotape of work; current curriculum vitae, residency information, 2 recommendation letters, project statement, budget proposal. Competition includes color and monochrome photography, fine arts.

ELIGIBILITY: Clare Hart DeGolyer Award: age 15-25, residing in Texas, Oklahoma, New Mexico, Arizona or Colorado. Anne Giles Kimbrough Award: age 35 and under, having resided in Texas for past 3 years.

JUDGING: By committee appointed by Board of Trustees. Based on consideration of abilities, intelligence, talents, convictions, continuing endeavors. Applicant's need considered but is not determining factor. May withhold awards.

DEADLINES: Application, January. Notification, March.

45

Film in the Cities Photography Fellowships
Karon Sherarts
2388 University Avenue
St. Paul, Minnesota 55114 U.S.A.
Tel: (612) 646-6104

May

State; **entry open to Minnesota residents;** annual; established 1982. Purpose: to assist Minnesota photographers whose work demonstrates excellence. Sponsored by Film in the Cities. Supported by McKnight Foundation Arts Funding Plan. Average 4-8 fellows, $40,000 annual total.

PHOTOGRAPHY GRANTS: **Individual Work.** $5000 to $10,000 grants (amount requested by applicant) to photographers who have been Minnesota residents for 1 continuous year for securing time to work; materials, travel expenses (must be used within 1 year). Submit resume, 12 work samples (35mm slides or portfolio) and return postage. Require participation in McKnight Fellowship exhibition at Film in the Cities Gallery with completed project at end of fellowship term. No framed or glassed work, organizations or full-time students. Competition includes color and monochrome photography.

JUDGING: By 3 judges. Based on quality of previous work. Not responsible for loss or damage.

DEADLINES: Application, December. Notification, January. Grants available, May.

46

Ohio Arts Council Aid to Individual Artists
Denny Griffith, Coordinator
727 East Main Street

Columbus, Ohio 43206 U.S.A.
Tel: (614) 466-2613

June

State; **entry open to Ohio residents;** annual; established 1978. Purpose: to provide direct, nonmatching grants to photographers for creation of new work. Sponsored by Ohio Arts Council. Average statistics (all sections): 590 entries, 110 grants. Second contact: 50 West Broad Street, Columbus, Ohio 43215; tel: (614) 466-2613.

PHOTOGRAPHY GRANTS: New Work Creation, Completion, Presentation. $500 to $6000 to Ohio residents for planning, supplies, facilities-services, rental, research, presentation, reproduction, documentation, publication expenses for creating new work. Submit 10 maximum slides of work or portfolio of 10 maximum photographs (16x20 inches maximum including mat). Artists encouraged to indicate direction, focus, concepts they will employ and showcase through exhibitions, publications. No students. Competition includes color and monochrome photography, art, performing arts, crafts, creative Writing, music.

MULTIMEDIA GRANTS: Multidisciplinary Work. $500 to $6000 to Ohio residents for planning, supplies, facilities-services, rental, research, presentation, reproduction, documentation, publication expenses for creating noncollaborative work of 2 media maximum. Submit letter justifying basis of work and disciplines work encompasses. Artists are encouraged to indicate direction, focus, concepts they will employ and showcase through exhibitions, publications. No students. Competition includes color and monochrome photography, art, performing arts, crafts, creative writing, music.

JUDGING: Based on creative, technical excellence of work. Preference given to work advancing art.

DEADLINES: Application, January. Notification, June.

47

Southeastern Center for Contemporary Art (SECCA) Grants
Vicki Kopf, Curator
750 Marguerite Drive
Winston-Salem, North Carolina
27106 U.S.A. Tel: (919) 725-1904

January

Regional; **entry open to U.S. professionals residing in Southeastern states;** annual; established 1976. Purpose: to enable Southeastern artists to advance their careers. Sponsored by SECCA. Supported by SECCA, NEA. Average statistics: 6000 entries, 1000 entrants. Have exhibitions, travel show, children's summer programs, art sales, rental gallery.

PHOTOGRAPHY GRANTS: Career Advancement. 7 $2000 grants to Southeastern artists to set aside time and-or purchase materials and advance their careers. Submit 6 maximum 35mm slides for entry review. Competition includes color and monochrome photography, fine arts.

ELIGIBILITY: Open to U.S. citizens and professional photographers over age of 18 residing in Alabama, Florida, Georgia, Kentucky, Louisiana, Mississippi, North Carolina, South Carolina, Tennessee, Virginia, West Virginia or Washington D.C.

JUDGING: By 4 distinguished national judges. Not responsible for loss or damage.

DEADLINES: Application, Octo-

ber. Notification, January. Materials returned, March.

48

Canada Council Grants
Robert Kennedy, Head, Arts Awards Service
P. O. Box 1047
255 Albert Street
Ottawa, Ontario K1P 5V8 CANADA
Tel: (613) 237-3400

September, March

National; **entry open to Canada;** semiannual; established 1957. Sponsored by Canada Council, founded 1957 by Act of Parliament to foster and promote study, enjoyment, production of art in Canada. Have architecture, arts criticism, dance, film, music, theater, writing, multidisciplinary and performance art sections. Also sponsor Aid to Arts Organizations.

PHOTOGRAPHY GRANTS: General, *(Under Aid to Artists Branch)* to Canadian citizens, landed immigrants with 5 years residence. Submit 30 work samples. Categories: **Arts Grants A:** up to $19,000 for living expenses, project, travel costs for 4-12 months to senior artists with record of significant contributions. **Arts Grants B:** up to $11,000 for living expenses, project costs (possible added travel allowance) for 4-12 months to professional artists. **Short-Term Grants:** $800 per month and travel allowance (up to $800 possible project allowance) for 3 months to artists for specific project. **Project Cost Grants:** up to $2700 for goods, services, travel (no living) for completion of project. **Travel Grants:** for travel (up to $100 possible living expenses). Competition includes film, video, art, dance, music, theater, writing, performing arts, color and monochrome photography sections.
Photography Work. Submit 30 work samples.

JUDGING: Entry review by outside juries. Based on artistic merit, potential significance, project value, artistic quality, relevance. First awards judging by 28-member Advisory Arts Panel. Final awards judging by 31-member Canada Council.

DEADLINES: Application, April, October. Notification, September, March.

49

National Film Board of Canada Exhibition Purchase Program
Still Photography Division
Martha Langford, Executive Producer
Tunney's Pasture
Ottawa, Ontario K1A 0N1 CANADA
Tel: (613) 992-7494

Continuous

National; **entry open to Canada;** continuous. Sponsored by National Film Board of Canada, Still Photography Division. Have 100 traveling exhibitions (20-250 prints each) exploring broad definition of photographic art, available free to institutions, organizations.

PRINT PURCHASE PROGRAM: **General Color,** including non-silver processes, unmounted, processed as much as possible for archival permanence. Submit negatives on request only. No work prints, contact sheets. Competition includes monochrome prints.

SLIDE SHOW PURCHASE PROGRAM: **Audiovisual Color.** Require soundtrack, detailed outline for adaptation to National Film Board's technical facilities, evidence of preliminary editing and thematic direction. Competition includes monochrome slide shows. May purchase single slides.

AWARDS: Purchase right to reproduce and-or exhibit in announcement, catalog, brochure, advertisement for promotion of traveling exhibition (with credit to maker). Retain original transparencies for slide productions and provide photographer with duplicate set of entire show. 5 print, 4 slide shows produced yearly. Purchase awards higher for prints in proper condition, ready for exhibition.

JUDGING: Subject matter secondary to viewpoints, impressions of Canadian photographers. Prints based on representation of range of submissions received. Not responsible for breach of contract between entrants and private galleries that may represent them.

ENTRY FEE: None.

DEADLINES: Vary by exhibition. Judging time, up to 3 months.

NATURE, ANIMAL, WILDLIFE

Includes DOG, DESERT, ENTOMOLOGY, WILDLIFE, ZOOLOGY. NATURE usually defined as observations of natural history facts or phenomena, in honest presentation, with identifiable subjects (normally excluding artificial-produced hybrid plants-animals, still-life studies, set flower arrangements, mounted specimens, museum habitats-groups, photographic manipulations). Human elements should be unobtrusive, enhancing natural story. WILDLIFE usually defined as organisms living free and unrestrained in natural or adopted habitat. However, these definitions may vary. (Also see other PRINT and SLIDE CATEGORIES.)

50

Animal Care and Education Center Animal Photo Contest
Ivan Golakoff, Director of Education
P.O. Box 64
Rancho Santa Fe, California 92067
U.S.A. Tel: (714) 756-3791,
452-9230

August

National; **entry open to U.S. amateurs;** annual; established 1980. Purpose: to promote respect for animals; demonstrate human-animal kinship. Sponsored by Animal Care and Education Center (founded 1972 as nonprofit corporation dedicated to improving human-animal relationships through public education). Average statistics (all sections): 600 entries, 54 awards. Held at Animal Care and Education Center in Rancho Santa Fe. Publish *2&2* (journal), animal information pamphlets. Also sponsor animal health, locator, training services, workshops; Therapeutic Horsemanship Program for handicapped persons.

PRINT CONTEST: Animal Color, 5x7 to 8x10 inches, optional mounting not to exceed print size; limit 3 per category. No frames, matting. Divisions: Age 15 and Under, 16-60, 61 and Over. Categories: People and Animals, Domestic Animals, North American Wild Animals-Sea Creatures. competition includes monochrome prints.

SLIDE CONTEST: Animal Color, 35mm, originals or good-quality duplicates; limit 3 per category. Divisions, categories same as for Prints.

AWARDS: $100 Sweepstakes Award, $75 Kinship of People and Animals Award (all sections). Camera and accessory bag to best each category, each division. First, Second,

Third Ribbons-Certificates, each category, each division. Special, Honorable Mention awards at judges' discretion.

JUDGING: Entry review, secret ballot awards judging by 4 professional photographers, animal experts. May withhold or add awards. Sponsor owns entries for educational, promotional purposes; may also use names and likenesses of entrants.

ENTRY FEE: Request $2 tax-deductible donation per entry.

DEADLINES: Entry, judging, awards, August. Displayed, September.

51

California Fish & Game Commission Photography Award Program
Harold C. Cribbs, Executive Secretary
1416 Ninth Street
Sacramento, California 95814 U.S.A.
Tel: (916) 445-5708

December

International; entry open to all; annual; established 1975. Purpose: to foster appreciation for California's varied fish, wildlife, habitat resources. Sponsored by California Fish & Game Commission. Average statistics (all sections): 180 entries.

PRINT CONTEST: **California Nature-Wildlife Color;** 5x7 to 16x20 inches; taken within California; mounted; limit 4 per category. Submit date, time, place of photograph. Categories: Fish, Invertebrate, Bird, Mammal, Reptile-Amphibian, Natural Environment, special yearly categories. Competition includes monochrome print section.

AWARDS: Picture of the Year

Award, Trophy replica, photograph displayed on perpetual trophy in State Capitol, right to accompany Department of Fish & Game employee into field to take photographs. Excellence Certificates, Honorable Mentions, each category.

JUDGING: By wildlife-related photography experts, selected by Commission. Sponsor keeps entries for publication, display; credits photographer. Entrant retains negatives, rights.

ENTRY FEE: None.

DEADLINES: Entry, September. Notification, December.

52

Desert Botanical Garden Photography Exhibition
Dorothy O'Rourke, Co-Chair
P.O. Box 5415
Phoenix, Arizona 85010 U.S.A.
Tel: (602) 941-1217

January-February

International; **entry open to North America;** annual; established 1978. Part of annual cactus show 1948-1978. Purpose: to increase knowledge and love of desert landscapes and plant life. Theme: Deserts of the World. Sponsored by Desert Botanical Garden. Average statistics (all sections): 350 entries, 80 entrants, 9 finalists, 4 awards. Held in Papago Park, Phoenix, for 10 days. Tickets: $2. Second contact: 1509 North 46th Street, C-60, Phoenix, Arizona 85008; tel: (602) 273-1953.

PRINT CONTEST: **Desert Color,** 5x7 to 16x20 inches mounted size; unframed, titled; limit 2 per category. May be commercially processed. Categories: Desert Plant Portraits, Desert Landscapes. Also have monochrome print section.

SLIDE CONTEST: Desert Color, 2x2 or 2-3/4x2-3/4 inches, glass or cardboard mounts; unframed, titled; limit 2 per category. May be commercially processed. Categories same as for Prints.

AWARDS: Trophies to best print, best photo (including monochrome) taken in Desert Botanical Garden. First, Second, Third Place and Honorable Mention ribbons, each category (prints and slides).

JUDGING: By 3 PSA Associates and Fellows. Sponsor may reproduce entries without payment unless otherwise specified. Not responsible for loss or damage.

SALES TERMS: Entries may be for sale. Sponsor charges 15% commission.

ENTRY FEE: $3 prints; $2.50 slides.

DEADLINES: Entry, judging, January. Event, January-February.

53

Dog Writers' Association of America Photo Competition
Kathryn Braund, Secretary-Treasurer
1616 13th Avenue S.W.
Great Falls, Montana 59404 U.S.A.
Tel: (406) 761-1871

February

International; entry open to all; annual; established in 1940s. Purpose: to promote, honor excellence in photography of dogs. Sponsored and supported by Dog Writers' Association of America (founded 1935). Held at annual banquet in New York. Also sponsor grants to college students with background in dog activities; Public Service Awards, writing and film competitions. Second contact: Susan J. Jeffries, Contest Chair, 1828 Shady Lane, Louisville, Kentucky 40205; tel: (502) 454-7018, 582-4444.

PHOTO CONTEST: Dog Color, published in any medium during previous year. Competition includes monochrome prints.

AWARDS: Certificates, Best of Show. Merit Certificates, Honorable Mentions.

JUDGING: May withhold awards. Not responsible for loss or damage.

ENTRY FEE: $5 each plus postage.

DEADLINES: Entry, October. Notification, January. Awards, event, February.

54

Humane Society of the United States Photo Contest
Lisa Zurlo
2100 L Street N.W.
Washington, DC 20097 U.S.A.
Tel: (202) 452-1100

Spring

National; entry open to all; annual; established 1980. Sponsored by Humane Society of the United States. Supported by Diane and Allan Manning. Average statistics (all sections): 1000 entries, 49 awards. Publish *Report Newsletter.*

PRINT CONTEST: Animal Color, 5x7 inches to 8x10 inches; unlimited entry. No entries retouched, mass produced for sale, published in media with circulation exceeding 10,000. Categories: Pets, Non-Pets (including livestock, wild animals). Competition includes monochrome prints, color slide sections.

SLIDE CONTEST: Animal Color, unlimited entry. Categories, restrictions same as for Prints.

AWARDS: $150 Grand Prize, Best of Show (includes monochrome prints, color slides). $50 First, $25 Sec-

ond Prizes. 10 Honorable Mentions and Photo Book.

JUDGING: By 3 judges. Sponsor keeps all entries, may publish or permit publication to others (photographer gets credit).

ENTRY FEE: None.

DEADLINES: Entry, December. Judging, January. Notification, event, awards, Spring.

55

Kentucky International Exhibition of Nature Photography
Kentucky Society of Natural History (KSNH)
Lester L. Duncan, General Chair
213 Maevi Drive
New Albany, Indiana 47150 U.S.A.
Tel: (812) 945-7690

September-October

International; entry open to all; annual; established 1942. Purpose: to promote study and interest, encourage research, conduct educational programs in fields of natural history and related science. Sponsored by KSNH. Recognized by PSA. Held at University of Louisville for 3 weeks. Publish *The Kentucky Naturalist Magazine* and monthly newsletter. Second contact: Kentucky Society of Natural History, P. O. Box 7882, Louisville, Kentucky 40207.

PRINT CONTEST: Nature Color, 16x20 inches maximum including mount, (foreign unmounted); no trade-processed prints. Require 2 to 10 prints in order for sequences telling story; 400-word (maximum) commentary. Divisions: Single, Sequence. Categories: Wildlife, Botany, Zoology, General. Competition includes monochrome prints section.

SLIDE CONTEST: Nature Color, 2x2 inches, maximum 1/8-inch thick, mounted. Require 2 to 10 slides in order for sequences telling story; 400-word (maximum) commentary. Divisions: Single, Sequence. Categories: Wildlife, Botany, Zoology, General.

AWARDS: PSA Silver Medals each division, Best of Show, best wildlife. KSNH Bronze medals, highest each category, each division. Honorable Mention ribbons.

JUDGING: By 3 judges, each division. Entries may be published in catalog. Not responsible for loss or damage.

ENTRY FEE: $3.50, 4 prints or 2 sequences. $2.75, 4 slides or 2 sequences.

DEADLINES: Entry, judging, September. Event, September-October.

56

National Insect (Entomologic) Photographic Salon
Elroy Limmer, Director
221 East Frye Avenue
Peoria, Illinois 61603 U.S.A.

November-December

International; entry open to all; annual; established 1957. Sponsored by Entomological Society of America (ESA). Recognized by PSA, Central Illinois Camera Club Association (CICCA).

SLIDE CONTEST: Entomology Color (insects, spiders, related arthropods); 2x2 inches; limit 4 (individual), 2 (sequences of up to 10 slides) per entrant. Submit 400-word typed commentary with sequence.

AWARDS: PSA Silver Medal, Best of Show. CICCA medal, most unusual slide. Peoria Color Camera Club Award, best story-telling slide. Awards of Excellence best slide by

ESA member, nonmember. Honorable Mention ribbons.

JUDGING: By 3 professionals. Based on scientific value and sound entomological reporting. Not responsible for loss or damage.

ENTRY FEE: $2.50. Foreign (except Canada) add 50¢.

DEADLINES: Entry, judging, November. Event, November-December. Materials returned, January.

57

National Wildlife Photo Contest
National Wildlife Federation
Margaret N. Silber, Editorial Assistant
225 East Michigan Street
Milwaukee, Wisconsin 53202 U.S.A.
Tel: (414) 273-2486

June

International; entry open to all; annual; established 1970. Sponsored by National Wildlife Federation. Theme: Nature Around the World. Average statistics (all sections): 30,000 entries, 5000 entrants. Publish *National Wildlife Magazine and International Wildlife Magazine* (bimonthlies).

PRINT CONTEST: **Nature-Wildlife Color,** 8x10 inches maximum; limit 5 per entrant. Submit information on how, when, where taken; camera, lens, film type. Categories: Nature Scenes, Wildlife, People Enjoying Nature.

SLIDE CONTEST: **Nature-Wildlife Color,** dimensions not specified (35mm Kodachrome preferred), limit 5 per entrant. Other requirements, categories same as for Prints.

AWARDS: Winners share $2000, prints or slides showcased in December *National Wildlife.*

JUDGING: Entry review and awards judging by *National Wildlife* editorial staff. Based on execution, originality, subject matter. Not responsible for loss or damage.

ENTRY FEE: None. Entrant pays return postage.

DEADLINES: Entry, awards, June. Materials returned, September.

58

Natural Science Photography Competition
Northeast Natural Science League
Raymond J. Stein
P.O. Box 427
Peapack, New Jersey 07977 U.S.A.

June

International; **entry open to photos taken in Northeastern U.S.;** annual; established 1979. Purpose: to promote interest in preservation of wildlife and natural resources in Boston to Washington, D.C., area. Sponsored by Northeast Natural Science League. Average statistics (all sections): 500 entries, 200 entrants, 30 awards. Held at Princeton University, Princeton, New Jersey. Publish *Megafocus* (membership bulletin). Also sponsor traveling environmental-nature photography exhibition based on this event. Second contact: William Sharp, 9 Lee Avenue, Madison, New Jersey 07940.

PRINT CONTEST: **Northeastern Nature Color,** 5x7 to 11x14 inches; taken in Northeast U.S. 13-state area; unpublished; limit 5 (including monochrome prints, slides) per entrant. No photographs of tamed, caged, domesticated animals, cultivated garden plants. Categories: Fauna, Flora, Environment, Atmosphere and Space. Competition includes monochrome print section.

SLIDE CONTEST: **Northeastern Nature Color,** 2x2 inches, mounted (no glass mounts). Other requirements, restrictions, categories same as for Prints.

AWARDS: All sections: Engraved Plaque, best each category. First, Second, Third Place Certificates, each category. Honorable Mentions, special certificates at judges' discretion. Some winners selected for traveling exhibit to museums, environmental education centers, other Northeast U.S. institutions.

JUDGING: By 3 judges. Sponsor keeps winners for traveling exhibit, publication, then returns to entrant. Not responsible for loss or damage.

ENTRY FEE: $3 donation requested. Entrant pays return postage.

DEADLINES: Entry, judging, event, June.

59

North Central Insect Photographic Salon
Maxine R. Vinson
1604 E. Oakland Avenue
Bloomington, Illinois 61701 U.S.A.

March

International; entry open to all; annual; established 1961. Sponsored by North Central Branch, Entomological Society of America (ESA). Recognized by PSA. Held during ESA annual meeting at various locations in U.S. for 2 days.

SLIDE CONTEST: **Entomology Color** (insects, spiders related arthropods), 2x2 inches, mounted; limit 4 per entrant. No glass over cardboard or cellophane mounting.

AWARDS: PSA Silver Medal, Best of Show. Donald T. Ries Memorial Award, highest total 4-slide score.

Mary D. Ries Memorial Award, best insect portrait. ESA Excellence Certificates, best by member, nonmember. Honorable Mention ribbons.

JUDGING: By 3 professional judges. Not responsible for loss or damage.

ENTRY FEE: $2.50.

DEADLINES: Entry, February. Judging, event, March. Materials returned, April.

60

Saguaro Nature Exhibition
Eva M. Latham, Chair
520 North 53rd Street
Phoenix, Arizona 85008 U.S.A.
Tel: (602) 275-8350

April

International; entry open to all; annual; established 1958. Purpose: to promote honest, recognizable photographic presentations of natural history. Sponsored by Saguaro Camera Club. Recognized by PSA. Held in Phoenix area. Second contact: Marjorie M. Cushing, 5019 East Florian Mesa, Arizona 85026.

SLIDE CONTEST: **Nature Color,** 2x2 inches; limit 4 per entrant. No obviously artificially arranged photographs.

AWARDS: PSA Silver Medals, best wildlife, other. Saguaro Gold Medal, best action. Paul Kimse Award, most outstanding contribution to nature photography. Bob Cushing Award, best cactus or succulent. Howard Lindly Award, best insect. Lee Spencer Award, best desert landscape. Gold Medal, alternate judge's choice. Honorable Mention ribbons. Awards of Merit, Loyalty.

JUDGING: By 4 judges. Not responsible for loss or damage.

ENTRY FEE: U.S., Canada, $2.75, $3.50, Foreign.

DEADLINES: Entry, March. Judging, event, April. Materials returned, May.

61

Entomological Society of Canada Insect Photo Salon

Dr. William B. Preston
Manitoba Museum of Man and Nature
190 Rupert Avenue
Winnipeg, Manitoba R3B 0N2
CANADA Tel: (204) 956-2830, ext. 154

October

International; entry open to all; annual; established 1970. Sponsored by Entomological Society of Canada. Recognized by PSA. Average statistics (all sections): 300 entries, 100 entrants, 7 countries, 6 awards. Held in Canada at various locations for 5 days in conjunction with Society's annual meeting.

PRINT CONTEST: Entomology Color (insects, related arthropods, insect damage, nests, tracks), 16x20 inches maximum, mounted on cards; limit 4 per entrant. No trade-processed prints. Competition includes monochrome prints.

SLIDE CONTEST: Entomology Color (insects, related arthropods, insect damage, nests, tracks), mounted; limit 4 per entrant.

AWARDS: $25 First, $15 Second, $10 Third Prize, each section. Certificates, ribbons.

JUDGING: By 3 professional photographers, entomologists. Not responsible for loss or damage.

ENTRY FEE: $4 (prints), $3 (slides).

DEADLINES: Entry, August. Judging, September. Event, October.

62

Adventure of Nature International Photographic Competition

Grasduinen Magazine
Frans J. A. Van de Hulsbeek, Administrator
P. O. Box 51333
1007 EH Amsterdam,
NETHERLANDS Tel: 020-944628

August

International; entry open to nature photographers; annual; established 1981. Sponsored by *Grasduinen* Dutch Nature History magazine (monthly). Held in Amsterdam, Holland.

PRINT CONTEST: Nature Color, 13x18cm to 30x40cm, unmounted; limit 3 per category (including slides). No composite or trick photography. Divisions: National (Belgium, Holland Amateur), International. Categories: Macro-Micro, Flora, Birds, General Animals, Landscapes, Man and Environment, Sequences.

SLIDE CONTEST: Nature Color, limit 3 per category (includes prints). No composite or trick photography. Divisions, categories same as for prints.

AWARDS: $2500, Diploma of Excellency, best nature photography. Each category: First Place $500, Grand Diploma. Second, Third Diplomas. Award Winners, runners-up published in *Grasduinen.*

JUDGING: By international jury of 3 professional nature photographers. Sponsor reserves right to publish and exhibit photos within framework of competition. No entries returned.

ENTRY FEE: None.

DEADLINES: Entry, April. Awards, August. Publication, September.

PHOTOGRAPHY

General Photography, including PHOTO FAIRS. (Also see PRINT and SLIDE CATEGORIES.)

63

American Annual at Newport Exhibition

Art Association of Newport (AAN)
Stephanie Shoemaker, Administrative Assistant
76 Bellevue Avenue
Newport, Rhode Island 02840 U.S.A.
Tel: (401) 847-0179

September-October

National; **entry open to U.S.;** annual; established 1911. Sponsored by AAN. Average statistics (all sections): 500 entries, 177 entrants, 100 finalists, 12 winners. Held at AAN, Newport, Rhode Island for 1 month. Have 4 galleries in historic Victorian building.

PHOTO CONTEST: General Color, completed in previous 2 years, framed for hanging, 72x72 inches maximum including frame. Submit slides for entry review. Competition includes monochrome photography. Also have arts sections.

AWARDS: Cash prizes totalling $2500 (all sections).

JUDGING: By 1 professional. Not responsible for loss or damage.

SALES TERMS: Sponsor charges 25% (nonmembers), 15% (members) commission on sales.

ENTRY FEE: $15 plus return postage (include SASE).

DEADLINES: Entry, July. Notification, August. Accepted works due, judging, September. Event, September-October.

64

Art Association of Newport (AAN) American Exhibition

Stephanie Shoemaker
76 Bellevue Avenue
Newport, Rhode Island 02840 U.S.A.
Tel: (401) 847-0179

June

National; **entry open to U.S.;** annual; established 1911. Purpose: to show contemporary U.S. art. Sponsored by AAN. Held in Newport for 1 month. Have monthly exhibits.

PHOTO CONTEST: General Color, produced in previous 2 years; framed and ready to hang; 72 inches maximum any side. Submit slides for entry review. Competition includes monochrome photography, art, mixed media.

AWARDS: Includes all media: $200 AAN Prize. 2 $150 John Elliott Prizes.

JUDGING: By 3-member jury.

SALES TERMS: Sponsor charges 25% commission on sales. Entrant insures work.

ENTRY FEE: $17.

DEADLINES: Entry, April (slides), June (prints). Event, awards, June.

65

Art on the Green Arts and Crafts Festival

Citizens Council for the Arts
Sue S. Flammia
P. O. Box 901

Coeur d'Alene, Idaho 83814 U.S.A.
Tel: (208) 667-3561

August

International; entry open to all; annual; established 1968. Purpose: to celebrate arts through displays, demonstrations, performances. Sponsored and supported by Citizens Council for the Arts (nonprofit). Held at North Idaho College, Coeur d'Alene, for 3 days. Have arts and crafts booths; Clothesline Sale (of small matted or unframed paintings); Mini-Booths (for high school students or younger); Children's Art Corner; theatrical, music, dance performances; food booths.

PHOTO CONTEST: **General Color,** 48x48 inches maximum; executed in previous 2 years; framed, ready for hanging; limit 2 per entrant. No copies, fragile materials. Competition includes monochrome photography, paintings.

AWARDS: 7 $100 cash awards (including paintings). $250 North Idaho College President's Purchase Award; $250 Community Purchase Award; $175 Ralph E. Holmberg Memorial Award (includes crafts). Also have $200 Best-Decorated Booth Award.

JUDGING: Awards judging by 3-member jury of artists, teachers. May reject, remove questionable entries. Not responsible for loss or damage.

SALES TERMS: Work must be for sale. Items judged overpriced not accepted. Sponsor charges 20% commission; artist must pay 3% sales tax, use sponsor's salesbook.

ENTRY FEE: $3 each. $15 for 10x10-foot booth (optional). Entrant pays return postage.

DEADLINES: Entry review, April. Event, awards, August.

66

Beverly Art Center Art Fair and Festival
Pat McGrail, Manager
Beverly Art Center and Vanderpoel Art Association
2153 West 111th Street
Chicago, Illinois 60643 U.S.A.
Tel: (312) 445-3838

June

International; entry open to all; annual; established 1975. Purpose: to bring art to people and people to art. Sponsored and supported by Beverly Art Center and Vanderpoel Art Association. Average statistics (all sections): 130 entries. Held at Beverly Art Center for 2 days. Have 2-story gallery, 460-seat theater. Also sponsor workshops.

PHOTO CONTEST: **General Color.** Submit 5 2x2-inch 35mm slides for entry review. Competition includes monochrome photography, arts, crafts.

AWARDS: $400 Best of Show. 8 $200 Excellence Awards.

JUDGING: By panel of art educators, administrators, artists, critics. Not responsible for loss or damage.

ENTRY FEE: $15 entrance fee, $7.50 jury fee plus return postage. No commission charged on sales.

DEADLINES: Entry, April. Notification, May. Judging, event, awards, June.

67

Brownsville Art League International Art Show
Ted Sloss, Chair
P. O. Box 3404
Brownsville, Texas 78520 U.S.A.
Tel: (512) 546-1356, 542-0941

March

International; entry open to all; annual. Sponsored by Brownsville Art League. Held at Friendship Garden, Fort Brown, Brownsville, Texas for 5 days. Second contact: 230 Neale Drive, Brownsville, Texas 78520.

PHOTO CONTEST: General Color, completed in previous 2 years; maximum 6 feet wide, including required frame or mat; suitable for hanging. No pornography, supervised work. Competition includes monochrome photography. Also have arts, crafts sections; Junior division arts sections.

AWARDS: $500 Best of Show. $100 First, $50 Second Place. Third Place, Honorable Mentions, ribbons, purchase awards. Winners displayed at League Fine Arts Museum.

JUDGING: By 1 artist. Purchase awards by League Selection Committee and bank representatives. Not responsible for loss or damage.

ENTRY FEE: 1 entry, $5; $3 each additional plus return postage. Sponsor charges 30% commission on sales.

DEADLINES: Entry, materials, February. Event, March.

68

Chautauqua National Exhibition of American Art
Chautauqua Art Association Galleries
Millie Gilles, Director
Box 1365
Chautauqua, New York 14722
U.S.A. Tel: (716) 357-2771

June-July

National; **entry open to U.S. residents 18 years and older;** annual; established 1957 (slides 1978, prints 1982). Formerly called THE NA-TIONAL JURY SHOW to 1979. Purpose: to present two-dimensional artwork to summer audiences of Chautauqua Institute. Sponsored by Chautauqua Art Association, Gallery Association of New York State. Average statistics (all sections): 2535 entries, 1268 entrants, 76 finalists, 19 awards, 20,000 attendance. Held at Chautauqua Institution (founded 1874) for 3 weeks. Have 4 galleries, arts lectures, film series. Also sponsor National Exhibition of American Art Sculpture Invitational. Second contact: P.O. Box 12916, N.T. Station, Denton, Texas 76203.

PHOTO CONTEST: General Color, produced in previous 2 years; limit 2 per entrant. Submit 2 35mm, 2x2-inch slides (cardboard or thin plastic mount) for entry review. Competition includes monochrome photography, arts, crafts.

AWARDS: Over $4000 in cash and purchase awards.

JUDGING: By 2 professionals. Sponsor may reproduce entries for publicity purposes. Not responsible for loss or damage.

SALES TERMS: Sales encouraged. Sponsor charges 25% commission.

ENTRY FEE: $6, 1 entry; $10, 2 entries plus postage.

DEADLINES: Entry, event, June-July.

69

Coca-Cola Bottling Company (CCBC) of Elizabethtown Art Show
Jan Schmidt, Chair
1201 North Dixie Highway
P.O. Box 647
Elizabethtown, Kentucky 42701
U.S.A. Tel: (502) 737-4000, ext. 222

May

National; **entry open to U.S.;** annual; established 1972. Purpose: to encourage, promote visual arts; educate and entertain. Sponsored and supported by Elizabethtown CCBC Art Show. Average statistics (all sections): 600 entries (200 accepted), 500 entrants, 17 awards, 7000 attendance, $9000 sales. Held in Elizabethtown, Kentucky, for 3 weeks. Have children's workshops-tours, demonstrations, special 3-week traveling exhibit to Louisville, Kentucky.

PHOTO CONTEST: General Color, completed in previous 3 years, suitably matted and framed, ready to hang; limit 2 (Adult), 1 (Young People) per entrant. No photomechanically reproduced prints. Divisions: Adult, Young People (High School, Junior High, Elementary and Under). Competition includes monochrome photography, fine art, crafts (multimedia).

AWARDS: All media: First, Second, Third Place Juror Awards; Purchase Awards ($3000 worth at artists' price); Special Merit Awards (approximately 25 for special exhibit); First, Second, Third Place Public Vote Awards; Exhibitions. Ribbons to Purchase, Special Merit Awards. Young People: First, Second, Third Place. Honorable Mentions, each division.

JUDGING: Adult: viewed in entirety by different renowned juror each year. Young People's: by special judge.

SALES TERMS: Sales encouraged. Sponsor charges 20% commission (except on Purchase Awards).

ENTRY FEE: $7 each ($3 young people) plus $4 handling fee and return postage.

DEADLINES: Entry, exhibition, awards, May.

70

Dogwood Festival International Art Show
Atlanta Playhouse Theatre Ltd.
Sloan Borochoff
3450 Old Plantation Road N.W.
Atlanta, Georgia 30327 U.S.A.

March-April

International; entry open to all; annual; established 1973. Purpose: to show artists' works from U.S.A. and other countries. Sponsored by Atlanta Womens Chamber of Commerce. Held at Georgia Tech Student Center Art Gallery for 3 weeks. Second contact: Becky Kirkland, 4724 Dudley Lane NW, Atlanta, Georgia 30327.

PHOTO CONTEST: General Color, Submit 3 slides for entry review. Competition includes monochrome photography, arts and textiles sections.

AWARDS: Merit Awards, First, Second, Third Place. Purchase Prize for Georgia Tech Art Gallery.

JUDGING: By 1 judge. Sponsor insures while on exhibit only.

ENTRY FEE: $10.50. No commission charged on sales.

DEADLINES: Entry, February. Event, notification, March-April. Awards, April.

71

Fairfield Art Show Oak Room Photography Exhibition
Fairfield Chamber of Commerce
Harold B. Harris, Executive Director
1597 Post Road
Fairfield, Connecticut 06430 U.S.A.
Tel: (203) 255-1011

June

International; entry open to all; an-

nual; established 1970. Sponsored by Fairfield Chamber of Commerce. Held at Fairfield University for 4 days. Also sponsor Sidewalk Arts and Crafts Show and Sale.

PHOTO CONTEST: General Color, 50x50 inches maximum, framed, ready for hanging (clear glass preferred); limit 4 per entrant. Also have monochrome photography, fine arts sections.

AWARDS: $100 First Place and medallion. $3000 total in cash prizes and purchase awards (includes all sections).

JUDGING: By 3 jurors. Not responsible for loss or damage.

SALES TERMS: All entries must be for sale. Sponsor charges 25% commission (no commission charged for Sidewalk Show).

ENTRY FEE: $10 first, $7.50 each additional entry. (Sidewalk Show, $20 for 2-day space fee.)

DEADLINES: Entry, awards, event, June.

72

Felician College Art Festival
Iris G. Klein, Director
P.O. Box 546105
Surfside, Florida 33154 U.S.A.
Tel: (305) 868-6870

July

International; **entry open to professionals;** annual; established 1972. Purpose: to raise money for Felician College from donations at art fair. Sponsored by patrons and sisters of Felician College. Average statistics (all sections): 112 entrants, 10,000 attendance. Held at 3800 W. Peterson Avenue, Chicago, Illinois for 1 day.

PHOTO CONTEST: General

Color. Submit slides or prints for entry review. Competition includes monochrome photography, arts, crafts, mixed-media.

AWARDS: $250 purchase awards.

JUDGING: Entry review by art fair director. Awards judging by panel. Not responsible for loss or damage.

ENTRY FEE: Not specified. Entrant pays return postage.

DEADLINES: Entry, January. Acceptance, June. Judging, event, July.

73

Fort Smith Art Center (FSAC) Photography Competition and Exhibition
Britt Crews, Assistant Director
423 North 6th Street
Fort Smith, Arkansas 72901 U.S.A.
Tel: (501) 782-6371

November

National; **entry open to U.S.;** annual; established 1977. Regional contest to 1980. Sponsored by FSAC, Photographic Alliance. Average statistics (all sections): 100 entries. Held at FSAC for 3 weeks. Publish *FSAC Bulletin, Photographic Alliance Newsletter.*

PHOTO CONTEST: General Color, 8x10-20x24 inches, framed or mounted, ready for hanging; limit 2 per entrant. Divisions: Professional, Amateur. Also have monochrome photography section.

AWARDS: (Including monochrome): $100 Best of Show; People's Choice plaque. Each division: $50 First, $25 Second Prize; 3 Honorable Mentions.

JUDGING: By 2 professional Southwestern photographers. Entry review, awards judging. Sponsor re-

serves right to reproduce entries for publicity.

ENTRY FEE: $5 plus return postage.

DEADLINES: Entry, judging, October. Event, November.

74

Galerie Triangle National Exhibition
Averille and Charles Jacobs, Directors
1206 Carrollburg Place S.W.
Washington, DC 20024 U.S.A.
Tel: (202) 554-7700

September

National; **entry open to U.S.;** annual; established 1980. Purpose: to display high-quality, marketable works from artists of all races. Sponsored by and held at Galerie Triangle, Washington. D.C. for 1 month. Average statistics (both sections): 50 entries, 40 entrants, 13 finalists, 4 awards, 100 attendance. Also sponsor east coast regional exhibition and monthly contest. Second contact: P.O. Box 8232, SW Station, Washington, D.C. 20024.

PHOTO CONTEST: General Color, prints and slides, 40x40 inches maximum, framed, ready for hanging; limit 4 per entrant. No glass slides. Entries to be for sale. Sponsor charges 30% commission. Competition includes monochrome prints, fine art.

AWARDS: $100 First, $50 Second, $25 Third Place.

JUDGING: Entry review by directors. Awards judging by 2 judges.

ENTRY FEE: None ($30 if chosen) plus return postage.

DEADLINES: Entry, July. Judging, notification, August. Event, September.

75

Hill Country Arts Foundation Photograph-Graphics Exhibition
Jeanne Bowman, Art Director
P. O. Box 176
Ingram, Texas 78025 U.S.A.
Tel: (512) 367-5121

May

National; **entry open to U.S.;** biennial; established 1958. Alternates with Biennial Craft Exhibition. Purpose: educational. Sponsored by and held at Hill Country Arts Foundation for 3 weeks. Average statistics (all sections): 150 entries, 100 entrants, 5 awards. Have summer photography and arts seminars, drama productions.

PHOTO CONTEST: General Color, framed for hanging; limit 3 per entrant. Categories: Portrait-Pictorial, Scenic-Wildlife, Unclassified. Competition includes monochrome photography, graphics.

AWARDS: Up to $1000 in cash.

JUDGING: By 1 judge. Not responsible for loss or damage.

ENTRY FEE: $5 plus return postage. Sponsor charges 20% commission on sales.

DEADLINES: Entry, event, May.

76

La Junta Fine Arts League National Fine Art Show
P.O. Box 55
La Junta, Colorado 81050 U.S.A.
Tel: (303) 384-7035

May

International; entry open to all; annual; established 1968. Formerly called FINE ARTS LEAGUE NATIONAL SPRING SHOW. Purpose: to afford artists opportunity to com-

pete; encourage self-evaluation; promote public's appreciation of fine arts. Sponsored and supported by La Junta Fine Arts League (founded 1967). Recognized by Colorado Artist Association. Average statistics (all sections): 346 entries, 173 entrants, 2 countries, 73 awards, $6850 total sales, $214 average sales per entrant. Held at Koshare Kiva, La Junta, Colorado, for 1 week. Have annual member show, one-person shows, workshops. Second contact: Koshare Kiva, 115 West 18th, La Junta, Colorado 81051; tel: (303) 384-2768, 384-9696.

PHOTO CONTEST: General Color, 36x48 inches maximum, original; ready for hanging, limit 2 per entrant. Require resume of art career for publicity, files. No trade-processed prints. Divisions: Professional, Nonprofessional. Competition includes monochrome photography, fine arts.

AWARDS: $100, Best of Show. $50, best professional. $25, best nonprofessional. $25, jurors' choice. Purchase awards. Ribbons.

JUDGING: By 2 professionals. Not responsible for loss or damage.

SALES TERMS: All work must be for sale. Sponsor charges 15% commission.

ENTRY FEE: $6, nonmembers; $4, members plus $1 handling fee and postage.

DEADLINES: Entry, April. Event, May.

Marietta College Crafts National Exhibition
Arthur Howard Winer, Director
Marietta College Art Department
Marietta, Ohio 45750 U.S.A.
Tel: (614) 373-4643, ext. 275

November

National; **entry open to U.S. amateurs, students;** annual; established 1972. Formerly called MARIETTA COLLEGE CRAFTS REGIONAL EXHIBITION (1972-73), MAINSTREAMS (1974-77). Purpose: to display and reward creative efforts of finest artists throughout U.S. Sponsored and supported by Marietta College. Average statistics (all sections): 2848 entries, 1102 entrants, $5500 in awards. Displayed at Marietta College, Ohio, for 1 month. Also sponsor Marietta national painting and sculpture exhibition.

PHOTO CONTEST: General Color, prepared for hanging on masonary or concrete; limit 3 per entrant (set counts as 1 entry). Submit 35mm slides for entry review. No teacheraided entries. Competition includes monochrome prints, sculpture, crafts sections.

AWARDS: $2500 Judges' Award. $1000 Judges' Craftmanship Award. $1500 in Puchase Awards. The Hand and The Spirit Crafts Gallery Award.

JUDGING: By 3 nationally known judges. Based on merit. Purchase prizes selected by Marietta College Art Department. Sponsor insures entries during exhibition; not responsible for loss or damage during transit.

SALES TERMS: Sponsor charges 25% commission (including purchase prizes).

ENTRY FEE: $15 plus return postage.

DEADLINES: Entry, judging, September. Notification, October. Event, awards, November. Materials returned, January.

78

**Middletown Fine Arts Center
American Art Exhibition**
Edith Kohler, President
130 North Verity Parkway
Middletown, Ohio 45042 U.S.A.
Tel: (513) 424-2416

September-October

National; **entry open to U.S.;** annual; established 1975. Formerly area art show covering 50-mile radius. Became national 1981. Sponsored by Middletown Fine Arts Center. Average statistics (all sections): 300 entries, 200 entrants, 1500 attendance, $200 average sales per entrant. Held in Middletown for 4 weeks. Also sponsor Mario Cooper Watercolor Workshop (October).

PHOTO CONTEST: General Color, 60x72 inches maximum, including frame, ready for hanging. Submit 35mm mounted slides representative of work for entry review. Competition includes monochrome photography. Also have arts, crafts sections.

AWARDS: $1000, Best of Show (includes all media). $100 First Place.

JUDGING: Entry review by 5-member committee. Awards judging by 2 art professionals.

SALES TERMS: Sponsor charges 33-1/3% commission.

ENTRY FEE: $7 plus prepaid-return postage.

DEADLINES: Entry, notification, August. Materials, event, judging, awards, September-October.

79

**New York University Small Works
Competition**
Robert J. Coad, Assistant Director
80 Washington Square East Galleries
New York, New York 10003 U.S.A.
Tel: (212) 598-3369

January-February

International; entry open to all; annual; established 1977. Purpose: to provide exposure to artists. Sponsored by and held at New York University, 80 Washington Square East Galleries for 4 weeks. Average statistics (all sections): 4000 entries, 2200 entrants, 1 award, $4000 total sales.

PHOTO CONTEST: General Color, 12 inches per side maximum; limit 3 per entrant. Competition includes monochrome photography, small works in any medium.

AWARDS: $350 First Prize.

JUDGING: By 1 prominent curator.

SALES TERMS: Sales encouraged. Sponsor charges 20% commission.

ENTRY FEE: $5 each.

DEADLINES: Entry, event, January-February.

80

**Palm Beach International Art
Competition**
Palm Beach Art Galleries
Holly Daly Herman, Director
240 Worth Avenue
Palm Beach, Florida 33480 U.S.A.
Tel: (305) 655-9364

November

International; entry open to all; annual; established 1979. Purpose: to seek out talented artists. Sponsored by Palm Beach Art Galleries. Average

statistics (all sections): 400 entries, 200 entrants, 6 countries, 50 semifinalists, 25 finalists, 14 awards, 1000 attendance. Held in Palm Beach for 4 days. Have monthly lectures, seminars.

PHOTO CONTEST: General Color, 3x3 feet maximum; limit 2 per entrant. Require resume, brochure. Competition includes monochrome photography, arts sections.

AWARDS: $500 First and 1-week, 1-person show. Second, Third, Fourth Place, group shows. Honorable mentions.

JUDGING: By 1 art professional. Based on creativity, subject matter.

SALES TERMS: Sponsor charges 40% commission on sales.

ENTRY FEE: $25 plus return postage.

DEADLINES: Entry, August. Event, judging, awards, November.

81

Paula Insel Art Exhibition
Galerie Paula Insel
987 Third Avenue
New York, New York 10022 U.S.A.
Tel: (212) 355-5740

September

International; entry open to all; annual; established 1955. Sponsored by Galerie Paula Insel, United Mutual Banks. Average statistics (all sections): up to 100 entrants. Held in New York and various cities for two weeks. Also sponsor Paula Insel Puerto Rican Art Exhibition (March), bank shows.

PHOTO CONTEST: General Color, 20x24 inches including frame (larger accepted), ready for hanging. Competition includes monochrome photography. Also have arts, crafts sections.

AWARDS: Ribbons, merchandise.

JUDGING: By critics. Not responsible for loss or damage.

SALES TERMS: Entry must be for sale. Sponsor charges 40% commission.

ENTRY FEE: $8 (additional for oversized entries) plus prepaid return postage.

DEADLINES: Entry, June. Materials, August. Notification, event, September. Materials returned, October.

82

Paula Insel Puerto Rican Art Exhibition
Galerie Paula Insel
39 Los Meros
Box 7271
Playa Ponce, Puerto Rico 00731
U.S.A. Tel: (809) 844-8478

March

International; entry open to all; annual; established 1975. Sponsored by Galerie Paula Insel. Average statistics (all sections): 40 entries, 10 entrants. Held at airports for 2 weeks. Also sponsor Paula Insel Art Exhibition (September), bank shows.

PHOTO CONTEST: General Color, 20x24 inches including frame (larger accepted), ready for hanging. Require releases. Competition includes monochrome photography. Also have arts, crafts sections.

AWARDS: Various merchandise prizes.

JUDGING: Not responsible for loss or damage.

SALES TERMS: Entry must be for sale. Sponsor charges 40% commission.

ENTRY FEE: $8 (additional for

oversized entries) plus prepaid return postage.

DEADLINES: Entry, December. Materials, February. Event, March. Materials returned, April.

83

Sister Kenny Institute (SKI) International Art Show by Disabled Artists

Mary Ellefson, Assistant Coordinator
Room 2728
800 East 28th Street at Chicago Avenue
Minneapolis, Minnesota 55407
U.S.A. Tel: (612) 874-4577, 874-4482

April-May

International; **entry open to disabled artists;** annual; established 1964. Purpose: to increase public awareness of abilities of disabled artists; give disabled artists chance to gain recognition, sell art. Sponsored and supported by SKI, Abbott-Northwestern Sister Kenny Auxiliary. Average statistics (all sections): 450 entries, 150 entrants, 15 countries, 18 awards, 2000 attendance, $15,000 total sales. Held at SKI, Minneapolis for 2 weeks.

PHOTO CONTEST: General Color, limit 4 per entrant. Submit biography (2 paragraphs, 75 words), current portrait photograph. No glass mounting through mail. Competition includes monochrome photography. Also have arts sections.

AWARDS: Over $1000 in awards (includes all sections). First, Second, Third Place ribbons, Honorable Mentions, purchase prizes. Sponsor may purchase entries.

JUDGING: By 4-6 local professional art critics.

ENTRY FEE: None. Entrant pays return postage. Sponsor charges 20% commission on sales.

DEADLINES: Entry, January. Event, April-May.

84

Springville Museum of Art National April Salon

Vern G. Swanson, Director
126 East 400 South
P. O. Box 258
Springville, Utah 84663 U.S.A.
Tel: (801) 489-9434

April

National; **entry open to U.S.;** annual; established 1937. Sponsor has 600 permanent-collection pieces. Purpose: to allow art to build character, improve people's lives. Motto: "As the sun colours flowers, so art colours life" (Sir Laurence Alma-Tadema). Sponsored by City of Springville and Springville Museum Association. Supported by state, private donations. Average statistics (all sections): 420 entries, 200 entrants, 35,000 attendance, $8000 total sales. Held at Springville Museum of Art for 2 weeks. Also sponsor art classes, lectures, workshops, concerts, docent and intern training programs.

PHOTO CONTEST: General Color, completed in previous 3 years; framed for hanging (prefer plexiglass); limit 3 per entrant. Request slides for entry review. No abstract, nonobjective entries. Competition includes monochrome photography, arts.

AWARDS: 5-10 Gold, 10-20 Silver Medals. Purchase awards.

JUDGING: By artists, professors, collectors, critics, dealers. Sponsor insures for duration at museum. Not responsible for glass breakage.

ENTRY FEE: $4 each entry.

DEADLINES: Entry review, February. Judging, March. Event, March-May.

Tahoe Ehrman Mansion Art Show and Crafts Fair
North Tahoe Fine Arts Council
Eileen Janowitz-Ward, Coordinator
P. O. Box 249
Tahoe Vista, California 95732 U.S.A.
Tel: (916) 546-5562

August

International; entry open to all; annual; established 1967. Purpose: to provide high-quality fine arts show. Sponsored by North Tahoe Fine Arts Council, Lake Tahoe State Parks Advisory Committee. Average statistics (all sections): $5000 total sales. Held at Ehrman Mansion (west shore of Lake Tahoe, Sugar Pine Point Park) for 1 week. Have reception, music. Publish *Arti-facts* (semimonthly). Also sponsor Outdoor Arts and Crafts Fair ($15 handling fee, $75 for 10x15-foot space for 1 week, no commission charged).

PHOTO CONTEST: General Color, framed, ready for hanging; limit 2 (General), 1 (Children-High School) per entrant. Divisions: General, Children-High School (includes all media). Competition includes monochrome photography. Also have arts, crafts sections.

AWARDS: Not specified.

JUDGING: By 3 art professionals.

SALES TERMS: Sales optional. Sponsor charges 20% commission.

ENTRY FEE: $6 each entry, General. Free, Children-High School.

DEADLINES: Entry, judging, event, August.

Texas Fine Arts Association National Exhibition
Beverly Petty, Assistant to Director
3809 West 35th Street
P.O. Box 5023
Austin, Texas 78763 U.S.A.
Tel: (512) 453-5312

April-May

National; **entry open to U.S.;** annual. Purpose: to honor excellent work by visual artists throughout U.S. Sponsored by Texas Fine Arts Association (TFAA, founded 1911). Held at Laguna Gloria Art Museum, Austin, Texas for 1 month, followed by statewide touring exhibition of selected works.

PHOTO CONTEST: General Color, framed, 50x50 inches maximum, under plexiglass, ready for hanging. Submit 35mm slides of works for entry review; no glass or thicker than standard cardboard mounts. Competition includes monochrome photography and fine arts.

AWARDS: $500, Best of Show. Additional $1000 in cash prizes. Purchase awards. Approximately 50 works selected for statewide tour.

JUDGING: By 1 professional judge. Sponsor reserves right to reproduce entries for exhibition catalog, promotional purposes.

ENTRY FEE: $5 TFAA members; $10 nonmembers; plus return postage. Sponsor charges 30% commission on sales.

DEADLINES: Entry, January. Notification, accepted works due, March. Event, April-May.

PHOTOJOURNALISM

Usually defined as story-telling pictures or sequences as seen in news media-periodicals (including documentary, contemporary life, illustrative, spot news, human interest). However, these definitions may vary. Includes NEWSPAPER, MAGAZINE, WIRE SERVICE, BROTHERHOOD, CHILDREN ISSUE, DISADVANTAGED, HEALTH, HOUSE JOURNAL, INTERNATIONAL, PENAL, PUBLIC INTEREST, MARITIME, and STUDENT PHOTOJOURNALISM. (Also see PRINT and SLIDE CATEGORIES.)

87

American Penal Press Contest
Southern Illinois University
W. Manion Rice, Director
School of Journalism
Carbondale, Illinois 62901 U.S.A.

December

National; **entry open to U.S. penal institution newspapers, magazines, and their inmate staffs;** annual; established 1965. Sponsored by School of Journalism, Southern Illinois University at Carbondale. Also sponsor short story, poetry, article, art, cartoon contests and periodic Charles C. Clayton Award for outstanding contribution to prison journalism (not open to entry).

PRINT CONTEST: Penal Newspaper-Magazine Journalism Color, published October previous to October contest year in U.S. penal institution publications; limit 3 per entrant. Single pictures with captions affixed to 8 1/2x11-inch paper. Sweepstakes categories: Printed Newspaper, Printed Magazine, Mimeographed-Dittoed Publications. Competition includes monochrome prints.

AWARDS: Sweepstakes Trophy, newspaper, magazine; Sweepstakes Certificate, mimeograph. First, Second, Third Place Certificates, Honorable Mentions.

JUDGING: Based on general excellence, appropriateness to prison media.

ENTRY FEE: None.

DEADLINES: Entry, October. Notification, December.

88

Captain Donald T. Wright Maritime Journalism Awards
Southern Illinois University at Edwardsville (SIUE)
John A. Regnell, Chair
Department of Mass Communications, Box 73
Edwardsville, Illinois 62026 U.S.A.
Tel: (618) 692-2230

Winter

International; entry open to all; annual; established 1970. Named after Captain Donald T. Wright, riverboat pilot and publisher of *Waterways Journal.* Purpose: to recognize outstanding achievement in maritime journalism contributing to better understanding of U.S. inland and intracoastal waterways. Sponsored by SIUE Foundation, SIUE Department of Mass Communications. Supported by Mrs. Donald T. Wright. Average statistics (all sections): 20 entries, 2 awards. Held at various River Association meetings.

PHOTO CONTEST: U.S. Maritime Journalism Color, published photo essay about inland or intracoastal waterways. Submit tearsheets. Competition includes monochrome photography, film, writing, all

mass media.

AWARDS: Bronze Plaques (showing river transportation).

JUDGING: By SIUE Department of Mass Communications faculty. Not responsible for loss or damage.

ENTRY FEE: None.

DEADLINES: Entry, September. Awards, February-March. Event, Winter.

89

Deadline Club Journalism Awards Competition

Steven Osborne, President
P. O. Box 2503, Grand Central Station
New York, New York 10017 U.S.A.
Tel: (212) 644-2151

April

City; **entry open to New York City journalists;** annual. Sponsored by and held at Deadline Club, New York City Chapter of Sigma Delta Chi Society of Professional Journalists. Also sponsor $250 scholarships to New York City journalism schools.

PRINT CONTEST: Newspaper, **Magazine, Wire Serivce, Syndicate Journalism Color,** published in previous calendar year; mounted with captions; tearsheets; unlimited entry. Competition includes monochrome photography.

AWARDS: Deadliner Statuette. 2 Special Achievement Plaques.

JUDGING: Not specified. No entries returned.

ENTRY FEE: $10 each section.

DEADLINES: Entry, March. Awards, April.

90

George Polk Awards in Journalism

Long Island University (LIU)
Sidney Offit, Curator
The Brooklyn Center
Universtiy Plaza
Brooklyn, New York 11201 U.S.A.
Tel: (212) 834-6170

March

International; entry open to all; annual; established 1949. Formerly called GEORGE POLK MEMORIAL AWARDS. Purpose: to recognize distinguished reporting, writing, editing, photography, production in newspaper, magazine, book, radio and TV local, national, foreign coverage, community service, criticism. Sponsored by LIU Department of Journalism. Average statistics (all sections): 200 entrants, 20 awards.

PHOTO CONTEST: Newspaper-Magazine Journalism Color, enlarged, mounted, with letter explaining, justifying entry. Competition includes monochrome photography. Also have print and broadcast journalism, book sections.

AWARDS: George Polk Awards for Outstanding Achievement in Journalism.

JUDGING: By LIU journalism faculty. Based on initiative, coverage, perception, style, courage, resourcefulness, skill. No entries returned.

ENTRY FEE: None.

DEADLINES: Entry, January. Winners announced, February. Awards, March.

91

Harold Ferman Photojournalism Achievement Award
Journalism Foundation of
Metropolitan St. Louis
Marilee Martin, Coordinator
CASA, Saint Louis Conservatory &
School for the Arts
560 Trinity Avenue
St. Louis, Missouri 63130 U.S.A.
Tel: (314) 622-7565

May

Regional; **entry open to St. Louis college students;** annual; established 1969. Named after freelance photographer with St. Louis *Star-Times.* Sponsored by Journalism Foundation of Metropolitan St. Louis. Supported by Society of Professional Journalists (Sigma Delta Chi), Women In Communications, International Association of Business Communicators, Association of Black Journalists, Newspaper Guild. Average statistics (all sections): 90 entries, 12 awards, 440 attendance. Held at annual banquet in St. Louis. Tickets: $15. Also sponsor journalism scholarships. Second contact: Ronald D. Willnow, Chair, St. Louis Post Dispatch, 900 North Tucker Blvd, St. Louis, Missouri 63101.

PRINT CONTEST: **Student Journalism Color,** 8x10-inches; 10 per entrant (clippings, tearsheets, or prints). Submit biographical information. Competition includes monochrome prints.

ELIGIBILITY: College journalism students enrolled in at least 1 journalism course and resident in metropolitan St. Louis (city of St. Louis, Franklin, Jefferson, St. Charles, St. Louis counties in Missouri; Madison, Monroe, St. Clair counties in Illinois).

AWARDS: $200 Harold Ferman

Photojournalism Achievement Award.

JUDGING: By 6 judges. Based on human interest, news appeal, technical skill.

ENTRY FEE: None.

DEADLINES: Entry, March. Judging, April. Event, notification, May.

92

Health Journalism Awards
American Chiropractic Association
(ACA)
Joann Ozimek, Thomas E. Blackett,
Public Affairs
2200 Grand Avenue
Des Moines, Iowa 50312 U.S.A.
Tel: (515) 243-1121

Summer

International; **entry open to journalists;** annual; established 1976. Purpose: to recognize journalists who promote health, suggest problem solutions, motivate public health care, contribute to responsible reporting. Sponsored by ACA. Average statistics (all sections): 161 entries. Held at annual ACA conference.

PHOTO CONTEST: **Health Journalism Color,** published in previous calendar year; public-oriented. Submit tearsheets. No chiropractic professionals, associations, employees. Categories: Newspaper Picture Story, Consumer Magazine Picture Story. Competition includes monochrome photography, news and feature articles, columns.

FILMSTRIP, AUDIOVISUAL CONTEST: **Health Journalism Color.** Submit full text, typed or printed; copy of final production. Restriction same as for Photo.

AWARDS: $200 and Distinguished Journalism Gold Award. Bronze Med-

allions to runners-up each photo category. Special Recognition Plaques.

JUDGING: By media professionals. Sponsor may withhold awards, display entries.

ENTRY FEE: None.

DEADLINES: Entry, March. Event, Summer.

93

Heywood Broun Journalism Award
The Newspaper Guild
Yette Riesel, Research & Information Associate
1125 Fifteenth Street N.W., Suite 835
Washington, DC 20005 U.S.A.
Tel: (202) 296-2990

January

International; **entry open to U.S., Canadian, Puerto Rican journalists;** annual; established 1941. Named after Heywood Broun, crusading journalist and founder of The Newspaper Guild. Purpose: to encourage, recognize individual journalistic achievement, particularly in correcting injustice. Sponsored and supported by The Newspaper Guild. Average statistics (all sections): 100 entries.

PHOTO CONTEST: Public Interest Journalism Color, published, submitted in scrapbook form with letter describing circumstances and results of work. Competition includes monochrome photography.

ELIGIBILITY: Work done or completed in previous year by newspaper, news magazine, news service employees in U.S., Canada, Puerto Rico Guild jurisdiction.

AWARDS: $1000 and Guild Citation for outstanding journalistic achievement in spirit of Heywood

Broun (devotion to public interest, concern for underdog). Citations, Honorable Mentions.

JUDGING: By 3 prominent journalists. Entries returned only on request (sponsor owns all others). Not responsible for loss or damage.

ENTRY FEE: None.

DEADLINES: Entry, judging, winners announced, January.

94

Mission San Jose (MSJ) International Exhibition of Photojournalism
Mater Dei Press
Sister Michael Marie
P. O. Box 3508
Mission San Jose, California 94538
U.S.A.

March

International; entry open to all; annual; established 1966. Sponsored by MSJ. Recognized by PSA. Held in San Jose, California for 15 days.

PRINT CONTEST: Journalism Color, large prints 16x20 inches maximum, mounted; small prints 8x10 inches maximum, unframed, may be sequences of 2 or more on single mount or separate prints; limit 4 per entrant. Trade-processing of small prints acceptable. Competition for some awards includes monochrome prints, color prints and slides.

SLIDE CONTEST: Journalism Color, may be sequences of 2-4; limit 4 per entrant.

AWARDS: Prints and slides: MSJ Awards, separate sequence, 3 local photographers (includes monochrome, color prints and slides). Prints (large and small) and slides: PSA Medal. 3 MSJ Awards. Yerba Buena

Chapter Medals. Honorable Mention ribbons.

JUDGING: By 3 judges. Sponsor may reproduce entries for publicity. Not responsible for loss or damage.

ENTRY FEE: $3.50 (large prints), $2.50 (small Prints and slides).

DEADLINES: Entry, judging, notification, February. Event, March.

95

National Mass Media Brotherhood Awards

National Conference of Christians and Jews
Harry A. Robinson, Vice President
43 West 57th Street
New York, New York 10019 U.S.A.
Tel: (212) 688-7530

Various

National; **entry open to U.S.;** various throughout year. Purpose: to foster brotherhood and better understanding among people; pay tribute to outstanding creative work on behalf of brotherhood in mass communications. Sponsored by National Conference of Christians and Jews. Second contact: Robert M. Jones, Executive Director, 3460 Wilshire Blvd., Suite 1012, Los Angeles, California 90010.

PHOTO CONTEST: **Brotherhood Journalism Color,** in newspaper or magazine, captioned; pertaining to or published in previous calendar year. Competition includes monochrome photography. Also have film, TV, audiotape, writing, journalism sections.

AWARDS: Gold Medallion and Recognition Certificates.

JUDGING: Entry review by executive director (Los Angeles). Awards judging committee (New York). Based on mass impact, originality, creativity, integrity.

ENTRY FEE: None.

DEADLINES: Open.

96

National Press Photographers Association (NPPA) Pictures of the Year Competition

University of Missouri School of Journalism
Angus McDougall, Director
100 Neff Hall
P. O. Box 838
Columbia, Missouri 65202 U.S.A.

Spring

International; **entry open to photojournalists, picture editors;** annual; established 1944. Oldest, largest news photo contest in world. Purpose: to recognize photojournalists for skill, creativity in visual communication; encourage better use of photos in print journalism by recognizing picture editors. Sponsored and supported by University of Missouri, NPPA, Nikon, Inc. Average statistics (all sections): 9627 entries, 827 entrants. Held at University of Missouri School of Journalism and as traveling exhibit. Also sponsor annual Television News Photography Competition, membership photo contests. Second contact: Charles H. Cooper, Executive Director, P. O. Box 1146, Durham, North Carolina 27702.

PRINT CONTEST: **Photojournalism Color,** taken or published during previous calendar year, mounted on 11x14-inch boards (1 print per board), captioned; limit 25 per entrant. Color tearsheets acceptable. Newspaper Categories: Spot News, General News, Feature Picture, Sports Action, Sports Feature, Portrait Personality, Pictorial, Food Illustration, Fashion Illustration, Editorial Illustration. Magazine Categories: News-Documentary Picture, Feature Picture, Sport Picture, Portrait

Personality, Pictorial, Science-Natural History. Competition includes monochrome prints.

PRINT PORTFOLIO CONTEST: Photojournalism Color, taken or published during previous calendar year, revealing story line or point of view; limit 20 prints per entrant; mounted on 6 11x14-inch boards maximum per newspaper entry (magazine entries unlimited), captioned. Submit mounted tearsheets for published entries. Newspaper Categories: News Picture Story (PS), Feature PS, Sports PS, Published Self-Produced PS. Magazine Categories: Self-Edited PS, Published PS. Competition includes monochrome portfolios.

Newspaper and Magazine Photographers of the Year Color, taken or published during previous calendar year; limit 20 photos or picture stories per entrant; mounted on 11x14-inch boards, captioned. Must include 2 picture stories, news picture (spot, general, or documentary), 3 other competition categories minimum. Competition includes monochrome portfolios.

World Understanding Photojournalism Color, established 1972, to recognize and honor living photographer whose work best portrays common purposes of mankind. Mounted on 11x14-inch boards; limit 10 minimum per entrant. Submit portfolios on single theme, explanatory statement (1 double-spaced, typed page).

PHOTO EDITING CONTEST: Newspaper, Magazine Color. Best use of photographs: Submit 3 issues from one week (daily), or 3 consecutive issues (weekly or semiweekly newspapers, magazines). Picture editor: submit 3 stories (magazine), or 10 tearsheets from 30-day period (daily newspaper), or 10 consecutive tearsheets (weekly or semiweekly newspaper). Tearsheets mounted on lightweight cardboard. Categories: Best Use of Photographs (Newspaper, Magazine), Picture Editor Award (Newspaper, Newspaper-Magazine, Magazine). Competition includes monochrome photography.

AWARDS: Camera, $1000, and Bronze "Unity of Man" Sculpture, best World Understanding. Camera, $1000, and trophy, Newspaper Photographer of the Year, Magazine Photographer of the Year. Plaques and $500, Second; Plaques and $250 Third (Best Photographers of the Year). Newspaper Picture Editor Award. Newspaper-Magazine Picture Editor Award. Magazine Picture Editor Award. Plaques and $100 to best; Plaques to Second, Third, each category.

JUDGING: Prints entered in wrong category will not be reclassified. Portfolios judged on subject matter, originality, technical excellence, versatility. Pictures are judged in other categories after portfolio judging. World Understanding Portfolios judged on international interest, importance and are kept intact and not judged in other categories. Picture Editor Award judged on skill in selection, cropping, sizing, layout.

ENTRY FEE: $10 (NPPA and KAM members free) plus return postage.

DEADLINES: Entry, January. Judging, event, Spring.

97

Odyssey Institute Media Awards Competition
Jean S. Elahi, Vice President Development
656 Avenue of the Americas
New York, New York 10010 U.S.A.
Tel: (212) 691-8510

December

International: **entry open to U.S.,**

Australia, New Zealand; annual; established 1977. Purpose: to recognize, encourage media productions in children's issues-programming. Theme: Concerns of Children. Sponsored by Odyssey Institute. Average statistics (all sections): 520 entries, 260 entrants, 3 countries, 70 finalists, 36 awards, 250 attendance. Held in New York City for 1 day. Have multimedia library. Publish *Odyssey Journal.* Also sponsor internships for fieldwork experience.

PHOTO CONTEST: Children's Issue Journalism Color, original, published in magazine or newspaper within previous year. Competition includes monochrome photography, writing, video.

AWARDS: Awards each section. Special mentions. Entries referenced in publications; appearances, legislative consultations prepared by sponsor.

JUDGING: By panel of 15 from media schools, Congress, public relations firms and foundations. No entries returned.

ENTRY FEE: $20.

DEADLINES: Entry, October. Judging, November. Event, December.

98

Overseas Press Club of America (OPCA) Awards
Norman A. Schorr, Chair
52 East 41st Street
New York, New York 10017 U.S.A.
Tel: (212) 679-9650

April

International; entry open to all; annual; established 1941. Purpose: to recognize outstanding journalism by newspeople reporting overseas developments to American audiences.

Sponsored by OPCA. Held at awards reception in New York City.

PHOTO CONTEST: International Journalism Color, published in previous calendar year. Clippings may be in scrapbook. Submit 3 copies of 200-word biography, 3 entrant photos. Categories: Photographic Reporting-Interpretation from Abroad Requiring Exceptional Courage or Enterprise, Photographic Reporting from Abroad, International Reporting Demonstrating Concern for Humanity (includes all media). Competition includes monochrome photography. Also have book, cartoon, print journalism, radio, TV sections.

AWARDS: Robert Capa Gold Medal for photographic reporting requiring courage or enterprise. $400 Madeline Dane Ross Award for international reporting demonstrating concern for humanity (includes all media). Illuminated scrolls to best photographic reporting from abroad, other award winners.

JUDGING: By panel of newspeople.

ENTRY FEE: $20 each entry.

DEADLINES: Entry, February. Event, awards, April.

99

Page One Awards in Journalism
Newspaper Guild of New York
Bea Eastman
133 West 44th Street
New York, New York 10036 U.S.A.
Tel: (212) 582-0530

September

Regional; **entry open to New York, New Jersey, and Connecticut journalists;** annual. Sponsored by Newspaper Guild of New York (founded 1934). Held in New York City.

PRINT CONTEST: Newspaper-Magazine Journalism Color, 11x14 inches to 16x20 inches; published during previous calendar year in New York, New Jersey, Connecticut newspapers or magazines; mounted on 16x20-inch board, titled; limit 3 per category. Series, wire services acceptable. No scrapbooks or portfolios. Categories: Magazine (News, Feature), Newspaper-Magazine Photo Essay (News, Feature). Also have monochrome prints, cartoon, graphics, print journalism sections.

AWARDS: Page One Award Certificates.

JUDGING: By panel of journalists.

ENTRY FEE: Not specified.

DEADLINES: Entry, August. Winners announced, September.

100

Pulitzer Prizes in Journalism
Columbia University
Robert C. Christopher, Secretary
Graduate School of Journalism
702 Journalism Building
New York, New York 10027 U.S.A.
Tel: (212) 280-3841(2)

Spring

International; entry open to all; annual; established 1917 by the first Joseph Pulitzer. Sponsored by Columbia University. Also sponsor Pulitzer Prizes in Music, Drama, and Letters; $3000 Fellowships to Columbia University journalism graduates for foreign study, travel.

PRINT CONTEST: Newspaper Journalism Color, 8x10 inches suggested; published in daily, Sunday or weekly U.S. newspaper during previous calendar year; glossy, in scrapbook; limit 20 per entrant. Submit publication proof, summary, biogra-

phy, nominee photo. Clippings, sequences, albums accepted. Categories: Spot News, Feature, Public Service by Newspaper. Competition includes monochrome prints. Also have print journalism, cartoon sections.

AWARDS: Gold Medal, best Public Service (includes cartoons, editorials, reporting). $1000 Pulitzer Prize to best feature, spot news.

JUDGING: Preliminary by juries of newspaper people. Final by Pulitzer Board. Sponsor keeps all entries; may withhold awards. Not responsible for loss or damage.

ENTRY FEE: None.

DEADLINES: Entry, January. Awards, Spring.

101

Quill and Scroll National Writing-Photography Contest
Quill and Scroll Society
Richard P. Johns, Executive Secretary
University of Iowa
School of Journalism
Iowa City, Iowa 52242 U.S.A.
Tel: (319) 353-4475

April-May

National; entry open to U.S. junior-senior high school students (selected by local schools); annual. Purpose: to provide exposure and critique for entrant; determine eligibility for journalism scholarship. Sponsored by Quill and Scroll Society (International Honorary Society for High School Journalists), American Newspaper Publishers Association (ANPA). Supported by Quill and Scroll Foundation. Average statistics (all sections): 3839 entries, 228 finalists. Publish *Quill and Scroll* (quarterly). Also sponsor 10 $500 Edward J. Nell Memorial Scholarships in Journalism

(open to senior class Writing, Photography, Current Events Quiz contest winners); George H. Gallup Award Newsmedia Evaluation (for member high school news publications); Current Events Quiz (open to U.S. junior-senior high school students); Graduate Student Journalism Research Grants.

PRINT CONTEST: High School Journalism Color, by 1 student; published in high school or professional newspaper September previous to February of contest year; limit 2 entries per school. No yearbook work. Competition includes monochrome prints. Also have writing, advertising, cartoon sections.

AWARDS: Quill and Scroll National Award Gold Key to national winner. Senior winners may apply for $500 Edward J. Nell Journalism Scholarships.

JUDGING: By professional and scholastic journalists. All entries automatically eligible for ANPA Journalism Awards. No entries returned.

ENTRY FEE: None.

DEADLINES: Entry, February. Winners announced in April-May issue of *Quill and Scroll.*

102

Robert F. Kennedy Journalism Awards
Coates Redmon, Executive Director
4014 49th Street N.W.
Washington, DC 20016 U.S.A.
Tel: (202) 362-0515

June

National; **entry open to U.S.;** annual; established 1968. Largest single program to honor outstanding reporting on problems of disadvantaged in U.S. by journalists covering Robert F. Kennedy's presidential campaign.

Purpose: to encourage more such reporting. Sponsored by RFK Journalism Awards Committee. Average statistics (all sections): 600 entries. Also sponsor Robert F. Kennedy Book Awards.

PRINT CONTEST: Disadvantaged Journalism Color, 11x14 inches maximum mounted, published in previous year; photo essays in scrapbook, portfolio, or on boards 14x17 inches maximum. Submit tearsheets. Divisions: Professional, Student. Competition includes monochrome prints; for some awards includes print and broadcast journalism.

AWARDS: Professional: $2000 to most outstanding entry (includes monochrome prints, print and broadcast journalism). $1000 to most outstanding entry (includes monochrome prints). Honorable Mentions, Citation Certificates. Student: 3-month internship in Washington D.C. to most outstanding entry (includes monochrome prints, print and broadcast journalism). Honorable Mentions, Citation Certificates.

JUDGING: By 20 or more journalists representing all media. No entries returned.

ENTRY FEE: None.

DEADLINES: Entry, February. Awards, June.

103

Sigma Delta Chi Distinguished Service in Journalism Awards
Society of Professional Journalists
Kathy Lieberman, Information Director
35 East Wacker Drive, Suite 3108
Chicago, Illinois 60601 U.S.A.
Tel: (312) 236-6577

April-May

International; entry open to all; annual; established 1932. Purpose: to foster high ethics; safeguard flow of information; attract young people to journalism; raise prestige of journalists. Sponsored by Society of Professional Journalists (Sigma Delta Chi), international nonprofit voluntary professional journalist societies with 154 campuses, 130 professional chapters; founded 1909 as fraternity at Depauw University, Greencastle, Indiana. Average statistics (all sections): 1200 entries, 16 winners, 1000 attendance. Publish *The Quill* (monthly magazine).

PHOTO CONTEST: Newspaper Journalism Color, single or series of news event by staff or freelance photographer; published during year; limit 6 per entrant. Competition includes monochrome photography.

AWARDS: Bronze Medallions, Plaques for Distinguished Service in Journalism.

JUDGING: By journalist jury. Based on excellence, interest, enterprise, resourcefulness of photographer. May withhold awards. Sponsor keeps all entries.

ENTRY FEE: $10.

DEADLINES: Entry, January. Judging, February-March. Winners announced, April. Event, April-May.

| 104 |

William Allen White Foundation National Award for Journalistic Merit
William Allen White School of Journalism
Del Brinkman, Director
University of Kansas
Lawrence, Kansas 66045 U.S.A.

February

National; **entry open to U.S.;** annual. Sponsored by William Allen White Foundation. Also accept broadcast and print journalism.

PHOTO CONTEST: Journalism Color. Require recommendation letter. Other requirements, restrictions not specified. Competition includes monochrome photography.

AWARDS: National Award for Journalistic Merit.

JUDGING: By 100 Foundation trustees.

ENTRY FEE: None.

DEADLINES: Awards, February.

| 105 |

British Association of Industrial Editors (BAIE) House Journal Competition
K. B. Bartlett, Secretary General
3 Locks Yard, High Street
Sevenoaks, Kent TN13 1LT,
ENGLAND Tel: (0732) 59331

Spring

International; entry open to all; annual; established 1958. Sponsored by BAIE. Have assessment and consultancy service to analyze content, writing, appearance of journals for improving effectiveness.

PHOTO CONTEST: House Journal Newspaper-Magazine Color, published in previous calendar year, in English. Submit 3 consecutive issues (2 consecutive for quarterly or less). Classes: Internal Newspapers, Magazines; External Newspapers, Magazines (circulation up to 10,000, 10-20,000, over 20,000). Categories: Color, Overall Standard-Use in Single Issue (including monochrome). Also have monochrome photography section.

AWARDS: Certificates and awards, trophies, cups, each class. Excellence and Merit Certificates at judges' discretion. Trophies held for 1 year.

JUDGING: By experts, based on effectiveness. Entrants receive judges' appraisal forms.

ENTRY FEE: Members, £12-£19, nonmembers, £14-£22 per class, category.

DEADLINES: Entry, January. Judging, April. Awards, Spring.

106

World Press Photo Contest
World Press Photo Holland
Foundation
Frans J. A. van de Hulsbeek,
Executive Director
Weesperzijde 86
P.O. Box 51333
1007 EH Amsterdam, THE
NETHERLANDS Tel: 020-944847

January-February

International; **entry open to professional photojournalists;** annual; established 1956. Purpose: to promote interest in press photography as means of furthering international understanding. Sponsored by World Press Photo Holland Foundation. Supported by the Netherlands Government, City of Amsterdam. Recognized by H. R. H. Prince Bernhard of the Netherlands. Average statistics (all sections): 4500 entries, 850 entrants, 50 countries, 50 awards. Held at Tropenmuseum in Amsterdam. Have seminars, traveling exhibition of contest winners.

PRINT CONTEST: Journalism Color, 16x20 inches (40x50cm) to 20x24 inches (50x60cm), series may be 12x16 inches (30x40cm); produced in previous year, intended for publication; unmounted; unlimited entry

(limit 8 per series). Require 2 8x10-inch prints for yearbook. No composite photos. Categories: Spot News, News Features, People in the News, Sports, Arts and Sciences, Happy News, Nature, Living. Competition includes monochrome prints, color slides.

SLIDE CONTEST: Journalism Color. Categories same as for Prints.

AWARDS: 5000 Dutch guilders Premier Award, Diploma of Excellency, round-trip flight to awards ceremony of Press Photo of the Year. 10,-000 Dutch guilders Oskar Barnack Award to series best expressing relationship of man to his environment. 1000 Dutch guilders, Golden Eye Trophies, Grand Diplomas to First Place, each category. Foundation's Gold Medals, Diplomas, Second, Third Places, each category. Recognition certificates.

JUDGING: By 9 international judges. Sponsor retains prints for yearbook, exhibition, publicity (slides returned). Not responsible for loss or damage.

ENTRY FEE: None.

DEADLINES: Entry, January. Judging, awards, February.

PRINTS (General in U.S.)

Includes PHOTO FAIRS. Colored tints are usually classified as Color. However, this definition may vary. (Also see other PRINT CATEGORIES.)

107
Alaska State Fair Photography Contest
Sara Jansen, Assistant Manager
Mile 40 Glenn Highway
P. O. Box 1128
Palmer, Alaska 99645 U.S.A.
Tel: (907) 745-4827
August-September

International; entry open to all; annual; established 1936. Formerly called MATANUSKA VALLEY FAIR ASSOCIATION to 1959. Purpose: to promote agriculture and home arts, provide family entertainment setting for Alaskans. Recognized by IAFE, WFA, IFA. Average statistics (all sections): 7000 entries, 1 country, 3500 awards, 250,000 attendance. Held at Alaska State Fairgrounds in Palmer for 11 days. Tickets: $4 (children free).

PRINT CONTEST: General Color, 8x10 inches to 4 feet wide including framing or matting, mounted, ready to hang; limit 1 per category (3 entries maximum). Divisions: Junior, Adult. Junior categories: Ages 6-8, 9-11, 12-14, 15-17, 18-20. Adult categories: Animal, Portrait, Scenery, Still Life, Action, Experimental, Other. Junior competition includes monochrome prints. Also have arts, craft sections.

AWARDS: Purple Rosette, junior (includes monochrome), adult. Junior Division (includes monochrome): $5 and Blue Ribbon, First; $3 and Red Ribbon, Second; $2 and White Ribbon, Third Prize. Adult Divisions: $10 and Blue Ribbon, First; $6 and Red Ribbon, Second; $4 and White Ribbon, Third Prize.

JUDGING: By 4 judges. May withhold awards. Not responsible for loss or damage.

ENTRY FEE: None.

DEADLINES: Entry and judging, August. Event, August-September.

108
Central Pennsylvania Festival of the Arts (CPFA) Juried Photography Exhibition
P. O. Box 1023
State College, Pennsylvania 19801 U.S.A.
July

International; **entry open to U.S., Canada, Mexico;** annual; established 1966. Sponsored by CPFA. Held at Pennsylvania State University for 2 weeks. Also sponsor CPFA Juried Color Slide Salon and Exhibition. Second contact: Ken Graves, School of Visual Arts, 102 Visual Arts Building, Pennsylvania State University, University Park, Pennsylvania 16802.

PRINT CONTEST: General Color, 8x10 to 20x24 inches, matted (unframed); limit 3 per entrant. Competition includes monochrome photography.

AWARDS: 5 $300 Prizes. 5 $100 Honorable Mentions.

JUDGING: By professional photographer-instructor. Entrant insures work; sponsor not responsible for loss or damage.

ENTRY FEE: $10 each plus return postage. No commission charged.

DEADLINES: Entry, June. Judging, event, July.

109
Central Washington International Photographic Exhibit
Central Washington State Fair
P.O. Box 1381
Yakima, Washington 98907 U.S.A.
September-October

International; entry open to all; annual; established 1954. Sponsored by Central Washington State Fair. Recognized by PSA. Also sponsor Yakima Valley Photography Show. Average statistics (all sections): 300 entries. Held at Washington State Fairgrounds in Yakima for 8 days.

PRINT CONTEST: General Color, 16x20 inches maximum, mounted (overseas entries any size, unmounted); limit 4 per entrant. No trade-processed prints. Competition includes monochrome prints.

AWARDS: Best of Show Award. Special Awards, scenic, portrait, experimental, children, human interest, animal. Honorable Mentions.

JUDGING: By 3 judges. Not responsible for loss or damage.

ENTRY FEE: $3.50.

DEADLINES: Entry, judging, notification, September. Event, September-October.

110

Coos Art Museum Juried Photographic Exhibit
Maggie Karl, Director
515 Market Avenue
Coos Bay, Oregon 97420 U.S.A.
Tel: (503) 267-3901

April

National; entry open to U.S.; annual; established 1974. Purpose: to show direction of contemporary U.S. photography. Sponsored by Coos Art Museum (nonprofit organization). Recognized by Oregon Art Commission. Average statistics (all sections): 200-300 entries, 200 entrants, 15 winners, 5000 attendance, $500 total sales. Also sponsor annual juried art exhibitions, art students' exhibitions; annual Crafts Now exhibition; arts, crafts,

dance classes, workshops.

PRINT CONTEST: General Color, 5x5 inches minimum; produced within previous year; matted or mounted; limit 3 per entrant. Require statement of insurance value, sales price. No frames, glass, multiphotographs on same mat. Competition includes monochrome prints.

AWARDS: Works selected for exhibition hang in Coos Art Museum during April. 15 winners exhibit 10 prints each in January invitational exhibit. Possible purchase for permanent collection. Merit Award. Honorable Mentions.

JUDGING: By professional photographer. Based on standards of focus, print quality, composition, subject, meaning, impact. Sponsor insures entries selected for exhibition for 1/2 sale price. Not responsible for loss or damage.

SALES TERMS: Sales optional. Sponsor charges 25% commission.

ENTRY FEE: $10 for 1-3 photographs plus return postage.

DEADLINES: Entry, February. Judging, March. Event, awards, April. Materials returned, May.

111

Date Festival Photographic Salon
Wind and Sun Council of Camera Clubs (WSCCC)
Lew and Peg Heaston, Chairs
5338 Nancy Way
Riverside, California 92503 U.S.A.
Tel: (714) 689-5675

February

National; entry open to U.S.; annual; established 1957. Purpose: to increase interest in photographic print endeavors. Sponsored and supported by WSCCC. Average statistics (all

sections): 275 entries, 96 entrants, 9 awards. Held at Riverside County National Date Festival in Indio, California for 10 days. Second contact: WSCCC, P.O. Box 385, San Bernardino, California 92402.

PRINT CONTEST: General Color, mounted on maximum 16x20-inch mounts; hand-colored acceptable, any process; limit 4 per division. No commercially processed prints. Divisions: General, Student (12th grade, age 18 maximum). Student competition includes monochrome prints. Also have monochrome print general division.

AWARDS: WSCCC Gold Medals, each division, best nature, best creative, Judges' Choice. 3 Trophies, each division. Honorable Mention ribbons.

JUDGING: By 3 experienced photographic exhibitors. Based on interest, technique, composition. Not responsible for loss or damage.

ENTRY FEE: None. Entrant pays postage.

DEADLINES: Entry, January. Judging, event, February.

112

Electrum Juried Photography Show
Helena Arts Council
P. O. Box 1231
Helena, Montana 59624 U.S.A.
Tel: (406) 442-6400

October

International; **entry open to U.S., Canada;** annual; established 1972. Sponsored by Helena Arts Council. Average statistics (all sections): 400 entries, 250 entrants, 2 countries, 175 finalists, 45 awards, 5000 attendance. Held at Helena Civic Center as part of 3-day art festival for the community. Have "Marketplace" for display of

work ($40 for 8-foot space). Second contact: Sally Starnes, Electrum, 814 Gilbert, Helena, Montana 59601; tel: (406) 442-9666.

PRINT CONTEST: General Color, matted or mounted on board, ready for hanging, unframed; limit 3 per entrant. Competition includes color prints. Also have art, craft sections.

AWARDS: Cash, and Electrum Medallion, Best of Show. Cash Awards to First, Second, Third. Merit Awards.

JUDGING: By 9 judges. All entries viewed in entirety. Sponsor may reproduce works for publicity and publications; divide awards in case of tie. Not responsible for loss or damage.

SALES TERMS: Sales encouraged. Sponsor charges 20% commission on gallery sales; no commission on "Marketplace" sales.

ENTRY FEE: $4.

DEADLINES: Entry, September. Event, awards, October.

113

F-8 Camera Club Annual Photography Contest
Walt Kinsey, Jr., President
430 East Congress Street
Sturgis, Michigan 49091 U.S.A.
Tel: (616) 651-9919, (219) 875-5166

November

International; entry open to all; annual; established 1968. Purpose: to provide forum of expression to photographers; give opportunity to compete and be recognized. Sponsored and supported by F-8 Camera Club. Recognized by PSA. Average statistics (all sections): 200 entries, 30 entrants, 2 countries, 21 awards. Held in Sturgis. Also sponsor color slide competitions. Second contact: Richard Zehr, 25578 Wasepi Road, Center-

ville, Michigan 49032; tel: (616) 467-6089.

PRINT CONTEST: General Color, 70 square inches, mounted or matted, unframed, ready for hanging. Competition for some awards includes monochrome prints.

AWARDS: $50 Best of Show (includes monochrome). $25 First, $10 Second, $5 Third Place. Honor Award ribbons. Winning entries go on touring exhibition.

JUDGING: Entry review by F-8 Club members. First awards judging by F-8 members. Second awards judging by 3 judges (photographer, artist, public). Sponsor retains winning entries for 120-day touring exhibition. Not responsible for loss or damage.

ENTRY FEE: $2 each ($1 members) plus return postage.

DEADLINES: Entry, September. Judging, notification, event, November. Awards, traveling exhibit, December-January. Materials returned, February.

114

Finished Print Juried Photography Show
Cindy MacKay
Art Guild
Church Street
Farmington, Connecticut 06032
U.S.A. Tel: (203) 677-6205

June

National; **entry open to U.S.;** annual; established 1978. Sponsored by The Art Guild. Supported by Heublein, Somerset Importers, Tilcon Tomasso. Average statistics (all sections): 600 entries, 150 entrants, 41 accepted, 5 awards, 400 attendance. Held at The Art Guild, Farmington, Connecticut for 2 weeks. Have 6 exhi-

bitions (annually). Tickets: $10 (workshop-critique), $3 (lecture-slide presentation). Also sponsor fine arts and crafts workshops, Christmas arts and crafts exhibit-sale.

PRINT CONTEST: General Color, 20x24 inches maximum; any process; mounted or matted on white board, unframed, ready for hanging; limit 5 (adults), 3 (students) per entrant. Divisions: Adult, Student (grade 12 and under). Competition includes monochrome prints.

AWARDS: Unspecified cash prizes per division. Selected photographs in exhibition catalog.

JUDGING: By 2 judges of national status. All entries exhibited under glass. Not responsible for loss or damage.

ENTRY FEE: $12 per adult, $2 per student entry. Entrant pays return postage. Sponsor charges 25% commission on sales.

DEADLINES: Entry, May (only). Event, June.

115

Greater Birmingham Arts Alliance (GBAA) Juried Photography Exhibition
J. R. Horlacher, Executive Director
2114 First Avenue North
P. O. Box 2152
Birmingham, Alabama 35201 U.S.A.
Tel: (205) 251-1228

December

International; entry open to all; annual; established 1977. Sponsored by GBAA. Supported by Alabama State Council on the Arts and Humanities, NEA. Held at GBAA in Alabama for 3 weeks.

PRINT CONTEST: General Color,

any process, unframed, unglassed, matted or mounted on board; completed in previous 2 years; limit 3 per category. Categories: Conventional, Nonstandard (hand coloring, sequences, collage, photo silkscreen, etching, lithography, photosculpture, as long as primary medium is photography). Nonstandard competition includes monochrome print section.

AWARDS: $300 GBAA Purchase Award, Best of Show. $100 First, $75 Second, $50 Third Place, each category.

JUDGING: By nationally renowned theatrical photographer, teacher, juror, published author. Not responsible for loss or damage, hand-delivered entries left after January.

SALES TERMS: Entries must be priced and offered for sale. Sponsor charges 25% commission.

ENTRY FEE: $5 each print.

DEADLINES: Entry, November. Awards, event, December.

116
Greater Hazleton Creative Arts Festival
Arts Council of Greater Hazleton
Alice Laputka, President
Mezzanine, Northeastern Building
Hazleton, Pennsylvania 18201 U.S.A.
Tel: (717) 459-2975

May

National; **entry open to U.S.;** annual; established 1966. Sponsored and supported by Arts Council of Greater Hazleton. Supported by Pennsylvania Council on the Arts. Average statistics (all sections): 14 awards, 20,000 attendance. Held at Highacres, Hazleton Campus of Pennsylvania State University for 3 days. Have simultaneous nonjuried indoor Open Art Show; workshops, demonstrations, performances.

PRINT CONTEST: General Color, 5x7 inches minimum; completed in previous 18 months; mounted on single or double weight mat or photomount board (preferably white); limit 5 per entrant. Competition includes monochrome prints. Also have arts, crafts sections.

PHOTO FAIR: General Color. Entrants provide and attend sales displays. Also have monochrome photography, arts, crafts sections.

AWARDS: $50 First, $25 Second Prizes (contest). Ribbons (photo fair).

JUDGING: By 2 judges from Philadelphia Arts College. Not responsible for loss or damage.

SALES TERMS: Photo Fair sales encouraged. Sponsor charges 10% commission.

ENTRY FEE: Print contest: $3 each plus return postage. Photo Fair: $5 for 10-foot space for a day ($9 for 2 days).

DEADLINES: Entry, April. Judging, notification, event, May.

117
Inland Center Mall Photo Show and Contest
Kits Cameras
Don and Kathy Kaufman
418 Inland Center Mall
San Bernardino, California 92408
U.S.A. Tel: (714) 888-2929

May

International; entry open to all; annual; established 1981. Purpose: to give amateurs chance to display their work and receive recognition. Sponsored by Inland Center Mall and Kits Cameras. Held at Inland Center Mall for 4 days.

PRINT CONTEST: General Color, 5x7 inches to 11x14 inches; mounted on board to measure 8x10 to 16x20 inches, unframed; may be commercially made; limit 6 per entrant. Divisions: High School, College, Open. Categories: Architectural, Portrait, Scenic, Sports, Journalism, Animal-Wildlife, Open-Manipulative (includes 3D). Competition includes monochrome prints.

AWARDS: Ribbons to Grand, First, Second, Third Place each division. Gift certificates: $100 Grand, $75 First, $50 Second, $25 Third Prize.

JUDGING: By public ballot. Not responsible for loss or damage.

ENTRY FEE: 50¢ each print.

DEADLINES: Entry, April. Event, judging, May.

118

LaGrange National Competition
Chattahoochee Valley Art Association (CVAA)
William B. Gay, Director
112 Hines Street
P. O. Box 921
LaGrange, Georgia 30241 U.S.A.
Tel: (404) 882-3267

March-April

National; **entry open to U.S.;** annual; established 1975. Formerly called CALLAWAY GARDENS ART FESTIVAL, 1962 to 1975. Purpose: to provide showplace for established and new artists in all media. Sponsored by CVAA, LaGrange College. Supported by Callaway Foundation, local businesses. Average statistics (all sections): 3000 entries, 900 entrants, 100 accepted, $9000 in awards, 10,000 attendance. Held at CVAA Gallery for 1 month. Publish *CVAA Newsletter* (monthly). Also sponsor Affair on the Square (May sidewalk art show), Har-

vest Heyday Arts and Crafts Show (October). Second contact: John Lawrence, LaGrange College, LaGrange, Georgia 30240.

PRINT CONTEST: General Color, recent work only; matted or mounted with firm backing; limit 3 per entrant. Require 3 35mm slides for entry review. No frames, glass, plexiglass. Competition for some awards includes monochrome prints, arts.

AWARDS: 5 $150 photography awards. 10 Merit Awards. $5000 in purchase awards (all media).

JUDGING: Entry review, final selection by 1 judge. Sponsor keeps slides for catalog, publicity; insures accepted works during exhibition (not responsible for loss or damage in transit).

SALES TERMS: Sale optional. Sponsor charges 20% commission (excluding purchase awards).

ENTRY FEE: $9 plus return postage.

DEADLINES: Entry, December. Judging, February. Notification, March. Event, March-April.

119

Magic Silver Show
Murray State University Art Department
Michael Johnson, Director
Murray, Kentucky 42071 U.S.A.

January-February

International; entry open to all; annual; established 1976. Purpose: to encourage and reward those involved in photographic media. Sponsored by Murray State University. Average statistics (all sections): 1800 entries, 450 entrants, 4 countries, 220 accepted. Held at Clara M. Eagle Gallery, Murray State University for approximately 4 weeks.

PRINT CONTEST: General Color, any light-sensitive material; any size, process, combination; mounted or matted on rigid cardboard; limit 5 per entrant. No previously published or purchased entries. Competition includes monochrome prints.

AWARDS: $2000 in cash awards.

JUDGING: By nationally prominent, published photographer. Sponsor insures during show only.

ENTRY FEE: $5 plus return postage.

DEADLINES: Entry, October. Event, January-February.

120

New York International Salon of Color Photography

Chan Hung, Chair
C-O Chan's Studio
20 East Broadway, 2nd Floor
New York, New York 10002 U.S.A.

April

International; entry open to all; annual; established 1972. Recognized by PSA. Sponsored by and held for 1 week at Photographic Society of New York (PSNY). Second contact: PSNY, 200 Center Street, New York, New York 10013; tel: (212) 966-3891.

PRINT CONTEST: General Color, 16x20 inches (40x50cm) maximum, mounted (foreign unmounted); limit 4 per entrant. No trade-processed prints.

AWARDS: PSA Gold Medal, Best of Show. PSNY Trophy, 5 Awards. Henry and Sylvia Mass Award.

JUDGING: By jury. Not responsible for loss or damage.

ENTRY FEE: $3.50.

DEADLINES: Entry, judging, notification, March. Event, April. Materials returned, May.

121

New York State Fair Photography Competition

George Dygert, Photography Superintendent
202 Lynhurst Avenue
North Syracuse, New York 13212
U.S.A. Tel: (315) 458-1402

August-September

International; entry open to all; annual; established 1978. Sponsored and supported by New York State Fair. Average statistics (all sections): 350 entries, 175 entrants, 14 awards. Held at New York State Fairgrounds for 10 days. Second contact: Elizabeth Crowley, Director, Art and Home Center, New York State Fair, Syracuse, New York 13209.

PRINT CONTEST: General Color, mounted on 16x20 inches maximum cardboard, unframed; limit 2 per entrant. Also have monochrome print section.

AWARDS: $150, 3 $75, 2 $50, $25 Awards. Award-winning entries displayed during Fair week.

JUDGING: By 3 judges. May withhold awards. Not responsible for loss or damage.

ENTRY FEE: $5 plus return postage.

DEADLINES: Entry, July. Event, August-September.

122

Oregon State Fair International Exhibition of Photography

Lee Jacobson, Superintendent
State Fairgrounds
2330 17th Street N.E.
Salem, Oregon 97310 U.S.A.
Tel: (503) 378-3247

August-September

International; entry open to all; annual. Sponsored and supported by Oregon State Fair. Recognized by PSA. Held at Oregon State Fairgrounds, Salem, Oregon for 11 days. Tickets: $3. Also sponsor Salon of Oregon Photography.

PRINT CONTEST: General Color, 16x20 inch maximum including mounts (foreign unmounted); limit 4 per entrant. No trade-processed prints, or entrants in Salon of Oregon Photography. Competition for some awards includes monochrome prints. Also have arts, crafts sections.

AWARDS: PSA Gold Medal, Best of Show. Director's Gold Medal, most original. Oregon State Fair Silver, Bronze Medals, Honorable Mention ribbons. Roy Atkeson Award, best landscape or seascape (includes monochrome prints).

JUDGING: Entry review, awards judging by 3 judges. Sponsor may purchase entries. Not responsible for loss or damage.

ENTRY FEE: $3.

DEADLINES: Entry, judging, notification, August. Event August-September. Materials returned, September.

123

Parkersburg Art Center (PAC) Juried Photography Exhibit
Exhibits Coordinator
220 Eighth Street
P. O. Box 131
Parkersburg, West Virginia 26101
U.S.A. Tel: (304) 485-3859

March

International; entry open to all; annual; established 1980. Purpose: to provide opportunities for sales, a public forum for young photographers. Sponsored by PAC, West Virginia Arts and Humanities Commission. Held at PAC, West Virginia, for 4 weeks. Publish newsletter (monthly). Also sponsor art exhibition, film festival.

PRINT CONTEST: General Color, 5x5 inches minimum; completed in previous 3 years; matted, unframed; limit 2 per entrant. Divisions: Professional, Amateur. Also have monochrome print section.

AWARDS: Professional: $100 First, $50 Second, $25 Third Place. Amateur: $50 First, $25 Second, $10 Third Place.

JUDGING: Entry review, awards judging, by 3 judges. Sponsor not responsible for loss or damage; insures during event.

SALES TERMS: Sponsor charges 30% commission.

ENTRY FEE: $5 plus return postage.

DEADLINES: Entry, judging, February. Notification, event, March. Materials returned, April.

124

Print Club International Competition
Ofelia Garcia, Director
1614 Latimer Street
Philadelphia, Pennsylvania 19103
U.S.A. Tel: (215) 735-6090

November

International; **entry open to Print Club members (may join with entry);** annual; established 1925. Sponsored by Print Club, nonprofit, educational organization supporting printmaking (founded 1915). Average statistics (all sections): 1600 entries, 800 entrants, 10 countries, 130 finalists, 27

awards, 1000 attendance. Held at Print Club for 1 month. Have in-house, traveling exhibition. Publish *Newsprint* (monthly), *Counterproof* (biannual). Also sponsor lectures, demonstrations.

PRINT CONTEST: General Color, made in previous 2 years; backed, matted, acetated; limit 2 per entrant. Hand-colored entries acceptable. Competition includes monochrome prints and arts.

AWARDS: Purchase prizes, cash prizes, professional prizes, patron awards, special awards, totaling $8000.

JUDGING: By 3 artists and curators. Sponsor may reproduce entries for catalog and publicity purposes. Sponsor insures entries on premises.

SALES TERMS: Work must be for sale. Sponsor charges 50% commission (except on purchase prizes).

ENTRY FEE: None. Membership $25, $15 (student, foreign, nonlocal artist), $20 (local artist).

DEADLINES: Entry, judging, notification, October. Event, November.

125

Rogue Gallery Northwest Exposure Juried Photographic Exhibition
Susan Lindley, Gallery Director
40 South Bartlett
P. O. Box 763
Medford, Oregon 97501 U.S.A.
Tel: (503) 772-8118

July

National; **entry open to continental U.S.;** annual; established 1979. Purpose: to give exposure to photographers in Medford; raise community consciousness about photo art, raise money for Rogue Valley Art Associa-

tion. Sponsored by Rogue Valley Art Association, Northwest Exposure. Recognized by Oregon Arts Commission. Average statistics (all sections): 300 entries, 100 entrants, 30 finalists, 3 awards, 1000 attendance. Held in Rogue Gallery, Medford for 3 weeks. Have lecture hall, tours.

PRINT CONTEST: General Color, including non-silver process; 5x7 inches minimum, mounted on matte board, unframed; limit 5 per entrant. Competition includes monochrome prints.

AWARDS: Recognition awards to 5 entrants, 3 of whom are invited to participate in a 3-person exhibition.

JUDGING: By nationally recognized professional photographer. Not responsible for loss or damage in transit.

SALES TERMS: Sponsor charges 30% commission.

ENTRY FEE: $3 each plus return postage.

DEADLINES: Entry, June. Judging, event, July.

126

Second Street Gallery National Juried Exhibition
116 N. E. Second Street
Charlottesville, Virginia 22901 U.S.A.

April-May

National; **entry open to U.S. residents or U.S. agents of foreign residents;** annual; established 1973. Purpose: to promote new and innovative artistic works. Sponsored by and held at Second Street Gallery for 5 weeks.

PRINT CONTEST: General Color, produced in previous 2 years; unframed, mounted on 16x20-inch white mat, covered with acetate; limit

2 per entrant. Competition includes monochrome prints. Also have arts section.

AWARDS: $400 Purchase Award, Best of Show (includes monochrome prints). 2 $250 Purchase Awards and Honorable Mentions.

JUDGING: By photography professor. Sponsor retains winning entries; insures during exhibition.

ENTRY FEE: $10 plus return postage. Sponsor charges 30% commission on sales.

DEADLINES: Entry, judging, March. Event, April-May. Materials returned, June.

127

Shenandoah International Print Exhibition Circuit

Charles A. Keaton, Manager
2401 Beekay Court
Vienna, Virginia 22180 U.S.A.
Tel: (703) 938-3295

March-July

International; entry open to all; annual; established 1982. Purpose: to promote photography as art form. Sponsored by Shenandoah Circuit. Recognized by PSA. Traveling exhibition held in Washington, D.C.; Staunton, Virginia; Charleston, West Virginia; Richmond, Virginia for about 1 week each location.

PRINT CONTEST: General Color, 16x20 inches maximum including mount (overseas unmounted); limit 4 per entrant. May be hand-colored. No trade-processed prints. Also have monochrome print section.

AWARDS: Place medals, Honorable Mention ribbons.

JUDGING: By 4 photographers,

each exhibition. Not responsible for loss or damage.

ENTRY FEE: $8 ($4, multiple entries) entire circuit.

DEADLINES: Entry, March. Event, March-July.

PRINTS (General Foreign)

Includes Print Series. (Also see other PRINT CATEGORIES.)

128

Liege Cite Ardente International Exhibition

Maurice Noiret
Rue Doumier, 85
B-4300 Ans, BELGIUM

March-April

International; entry open to all; biennial (even years); established 1976. Sponsored by Photo-Club Berleur. Recognized by PSA, FIAP, FBCP. Held at Palais des Congres in Liege for 9 days.

PRINT CONTEST: General Color, 16x20 inches (40x50cm) maximum, unmounted; limit 4 per entrant. No trade-processed prints. Also have monochrome print section.

AWARDS: FIAP Gold, Silver, Bronze Medals. Liege Trophy, Gold, Silver, Bronze Medals. Other medals, prizes, diplomas.

JUDGING: By 3 judges. Not responsible for loss or damage.

ENTRY FEE: $3.

DEADLINES: Entry, February.

Judging, notification, March. Event, March-April.

129

Zwevegem International Photo Salon

Fotoclub Sobeka
Leon Leroy
Beekstraat 5
8591 Moen-Zwevegem, BELGIUM
Tel: 056-755972

September

International; entry open to all; biennial (odd years); established 1965. Sponsored by Fotoclub Sobeka, Bekaert. Recognized by PSA, FIAP. Average statistics (all sections): 2200 entries, 600 entrants, 30 countries, 200 finalists, 30 awards. Held in Zwevegem for 2 weeks. Second contact: Leon Vanneste, Twee Moenstraat 16, 8550 Zwevegem, Belgium.

PRINT CONTEST: General Color, 12-20 inches (28-50cm) each side, unmounted; limit 4 per entrant. No rolled, hand-colored prints. Also have monochrome prints section.

AWARDS: Gold, Silver, Bronze plates, especially in Experimental, Humor, Landscape, Portrait.

JUDGING: By 5-member jury. Not responsible for loss or damage.

ENTRY FEE: $5. Free to entrants from countries with currency control.

DEADLINES: Entry, judging, June. Notification, July. Event, material returned, September.

130

Jauense Salon of Photographic Art

Foto Clube do Jau
Caixa Postal No. 151
17200 Jau (SP), BRAZIL

August

Inernational; entry open to all; annual; established 1965. Sponsored by Foto Clube do Jau. Held for 15 days.

PRINT CONTEST: General Color, 12x16 inches (30x40cm), unmounted; any process. No hand-colored prints. Competition includes monochrome prints.

AWARDS: Awards, best entries.

JUDGING: By jury.

ENTRY FEE: None. Entrant pays return postage.

DEADLINES: Entry, June. Event, August. Materials returned, October.

131

Calgary Stampede International Salon of Pictorial Photography

James H. Peacock, Chair
Box 1060
Calgary, Alberta T2P 2K8 CANADA

July

International; entry open to all; annual; established 1942. Purpose: to expose work of worldwide photographers to people of Western Canada. Sponsored by PSA. Supported by Calgary Exhibition and Stampede Board. Average statistics (all sections): 1362 entries (350 accepted), 400 entrants, 35 countries, 6 awards, 900,000 attendance. Held at Calgary Exhibition and Stampede for 10 days. Tickets: $3. Second contact: 2836 49th Street S.W., Calgary, Alberta, Canada T3E 3Y2.

PRINT CONTEST: General Color, 16x20 inches (40x50cm) maximum, mounted (foreign unmounted); any process; limit 4 per entrant. No trade-processed prints. Competition includes monochrome prints.

AWARDS: PSA Gold Medal, Best

of Show. 6 Commemorative Stampede Pins.

JUDGING: By 3 professional photographer-artist judges. Exhibited under glass. Not responsible for loss or damage.

ENTRY FEE: $2.

DEADLINES: Entry, May. Judging, notification, June. Event, July.

| 132 |

Essex International Salon of Photography
Southend-on-Sea Borough Council, Amenities Department
Betty Frost, Salon Organizer
P. O. Box 6, Civic Centre, Victoria Avenue
Southend-on-Sea, Essex SS2 6ER, ENGLAND Tel: 0702-49451, ext. 280

July-August

International; entry open to all; annual; established 1959. Formerly called ESSEX SALON OF PHOTOGRAPHY to 1970. Purpose: to help promote amateur and professional photography. Sponsored by ACCESS (Joint Credit Card Company). Supported by Southend Borough Council. Recognized by PSA. Average statistics (all sections): 1000 entries, 160 entrants, 12 countries, 50 awards, 15,000 attendance. Held in Central Library for 3 weeks.

PRINT CONTEST: General Color, 8x10 inches (20x25cm) to 20x24 inches (50x60cm), mounted (overseas unmounted); may be trade-processed; limit 10 per entrant (4 per student). Categories: Portraiture, Photojournalism, Landscape or Seascape, Record, Scientific, Technical, Architectural, Natural History (includes domestic animals), Any Subject, By Photography Student. Competition includes monochrome prints.

AWARDS: Trophies to best print, best by student, by Essex resident. First, Second, Third Place Merit Certificates each category.

JUDGING: By panel. May reclassify entries. Not responsible for loss or damage.

ENTRY FEE: 1-3 prints, £1; 4-7, £2; 8-10, £3. Students free. Entrant pays return postage.

DEADLINES: Entry, May. Event, July-August.

| 133 |

Fos-sur-Mer International Color Print Salon
ASLPS-Photo
Jean-Jacques Peres
9 Place Cisampe
13118 Entressen, FRANCE

May

International; entry open to all; biennial (even years); established 1982. Sponsored by local union in Province of Cote d'Azur 13. Supported by ASLPS, Municipal Cultural Committee, Tourism Office-Chamber of Commerce of Fos-sur-Mer. Held at Cultural Center in Fos-sur-Mer, France for 2 weeks. Second contact: ASLPS-Photo, P. O. Box 47, 13771 Fos-sur-Mer, France.

PRINT CONTEST: General Color, 30x40cm; any subject, unmounted preferred; limit 4 per entrant.

AWARDS: FIAP Gold, Silver, Bronze Medals, best prints. Diplomas.

JUDGING: By 3 judges. Accepted entries exhibited under glass. Not responsible for loss or damage.

ENTRY FEE: $3 (15Ff) per entrant plus $1 for airmail return postage.

DEADLINES: Entry, judging, notification, April. Event, May.

| 134 |

French Museum of Photography Photo Fair
Jean Fage, President
78 rue de Paris
F-91570 Bievres, FRANCE Tel: (1) 322-11-72

June

International; entry open to all; annual; established 1963. Sponsored by French Museum of Photography, Phot'Argus. Held in Versailles and Evry Agora in France. Also sponsor International Marketplace of Photographic Antiques. Second contact: Phot'Argus, 116 Boulevard Nalesherbes, 75017 Paris, France.

PRINT CONTEST: General Color, 10x12 inches (24x30cm) minimum, recent work; limit 10 to 20 per entrant. Selections mounted under glass at exhibitions. Competition includes monochrome prints.

AWARDS: Photographer of the Year Award and prize, Best of Show.

JUDGING: Entry review by selection committee. Sponsor may reproduce entries without royalty payments. Not responsible for loss or damage.

ENTRY FEE: None. Entrant pays return postage.

DEADLINES: Entry, January. Event, June.

| 135 |

Macon International Salon of Photographic Art
Photoclub de la Maison des Jeunes et de la Culture
24 ter, rue de L'Heritan
71000 Macon, FRANCE

November

International; entry open to all; annual; established 1970. Sponsored by and held at Maison des Jeunes et de la Culture, Macon for 2 weeks. Recognized by FIAP, FNSPF.

PRINT CONTEST: General Color, 12x16 inches (30x40cm); limit 4 per entrant. Also have monochrome print section.

AWARDS: Medals and diplomas.

JUDGING: By jury of photographers. Not responsible for loss or damage.

ENTRY FEE: None.

DEADLINES: Entry, September. Judging, October. Event, November. Materials returned, December.

| 136 |

Royan International Salon of Photographic Research
Royan General Board of Animation
C. Fricaud-Chagnaud, Commissioner
Palais des Congres
B.P. 102
17201 Royan Cedex, FRANCE
Tel: (46) 38-65-11

July

International; entry open to all; annual; established 1972. Sponsored by Royan General Board of Animation. Recognized by FIAP, FNSPF. Held during Royan International Festival of Contemporary Art at the Palais des Congres for 15 days.

PRINT SERIES CONTEST: General Color, 8 to 12 prints or photopanels (with any number of prints) constitutes a print series. 40x50cm maximum for prints or photo-panels, cardboard-mounted; entries unlimited. Series to be unified theme. No

published or previously exhibited entries. Competition includes monochrome print series.

AWARDS: 10,000F Grand Prize.

JUDGING: By jury. Sponsor reserves reproduction rights. Not responsible for loss or damage.

ENTRY FEE: None. Entrant pays return postage.

DEADLINES: Entry, judging, notification, May. Event, July.

137
E. A. International Salon of Photography
Photographic Salon Exhibitors Association
Dr. Kenneth Ching, Secretary
G.P.O. Box 5099
HONG KONG
May-June

International; entry open to all; annual; established 1968. Sponsored by Photogaphic Salon Exhibitors Association Limited. Recognized by PSA. Held in Hong Kong City Hall for 1 week.

PRINT CONTEST: General Color, 16x20 inches (40x50cm) maximum, mounted or unmounted; limit 4 per entrant. No trade-processed prints. Also have monochrome print section.

AWARDS: PSA Gold Medal, Best of Show. 1 Gold, 2 Silver, 3 Bronze Trophies. 12 Bronze Plaques.

JUDGING: By 7 judges.

ENTRY FEE: $3.50 plus return postage.

DEADLINES: Entry, judging, notification, April. Event, May-June.

138
Dum Dum Photo Salon
Photographic Association of Dum Dum
Tushar Rakshit, Salon Chair
467-40 Jessore Road
Calcutta 700074, INDIA
October

International; entry open to all; annual; established 1957. Purpose: to provide opportunity for Indian photographers to observe modern worldwide pictorial photography. Sponsored by Photographic Association of Dum Dum. Recognized by FIAP. Average statistics (all sections): 1200 entries, 269 entrants. Held at Dum Dum, Calcutta, India for 2 weeks. Have conference, 8 seminars, 2 workshops. Publish *Image* (annual and special editions). Also sponsor 2 courses in photography. Second contact: Biswatosh Sen Gupta, 35A, Motijheel Avenue, Calcutta 700074, India.

PRINT CONTEST: General Color, 4x7 to 16x20 inches, any process, unmounted; limit 4 per entrant. Competition includes monochrome prints.

AWARDS: Plaques and Merit Certificates.

JUDGING: By 5 judges. Sponsor may reproduce entries. Not responsible for loss or damage.

ENTRY FEE: None. Entrant pays return postage.

DEADLINES: Entry, August. Event, October.

139
Manila International Exhibition of Color Photography
Multi-Color Exhibitors Association (MCE)
P. O. Box 2748
Manila, PHILIPPINES

September-October

International; entry open to all; biennial (even years); established 1974. Formerly called MCE INTERNATIONAL COLOR SLIDE EXHIBITION to 1980. Purpose: to promote international goodwill and mutual understanding. Sponsored by MCE. Recognized by PSA, FIAP. Held in Manila for 10 days.

PRINT CONTEST: General Color, 16x20 inches (40x50cm) maximum, mounted (overseas unmounted).

AWARDS: Photographic Society of New York Award, Best of Show. FIAP Gold, Silver, Bronze Medals, first, second, third best sets of four entries. PAI Medal, highest-scoring PAI-affiliated club member. Photo Pictorial Gold Medal, best from Asia. Henry & Sylvia Mass Hands Across the Sea Plaque, best local entry. Wellington Lee Award, best human figure study. Dr. G. C. Tansiongkun Award, best creative. James H. Turnbull Award, best portrait. Kok Noun Ho Award, best landscape. 7 MCE Awards. 6 Honorable Mentions.

JUDGING: By 5 judges. May publish entries in exhibition catalog. Not responsible for loss or damage.

ENTRY FEE: US$4 (P20, local).

DEADLINES: Entry, judging, August. Notification, September. Event, September-October.

140

Edinburgh International Exhibition of Pictorial Photography
Edinburgh Photographic Society
Grace L. Alison
40A Inverleith Place
Edinburgh EH3 5QB, SCOTLAND
U.K. Tel: 031-552-3415

August-September

International; entry open to all; annual; established 1862. One of the oldest international photography exhibitions. Purpose: to exhibit best pictorial photographs available from worldwide field. Sponsored by Edinburgh Photographic Society. Recognized by PSA, FIAP, RPS, PAGB, SPF, FIP. Average statistics (all sections): 2500 entries, 600-700 entrants, 45-50 countries, 200 finalists, 10,000 attendance. Held during Edinburgh International Festival of Music and Drama (St. Cuthbert's Hall, King's Stables Road, Edinburgh) for 3 weeks. Tickets: 50 pence (including catalog).

PRINT CONTEST: General Color, 24 inches maximum per side, mounted (overseas unmounted); self-processed (mounting excepted); limit 4 per entrant. No hand-colored prints. Also have monochrome print section.

AWARDS: Acceptance labels.

JUDGING: By 3 international judges. Sponsor may reproduce entries for exhibition catalog, promotional purposes. Not responsible for loss or damage.

ENTRY FEE: $5 plus return postage.

DEADLINES: Entry, judging, winners announced, July. Event, August-September.

141

Malmo International Exhibition of Photography
Malmo Fotoklubb
Bo Prumell, Chair
Box 19091
S-200 73 Malmo, SWEDEN

October

International; entry open to all; annual; established 1978. Sponsored by Malmo Fotoklubb. Recognized by PSA, FIAP, RSF.

PRINT CONTEST: General Color, 12x16 inches (30x40cm) maximum, unmounted; limit 4 per entrant. No trade-processed prints. Competition for some awards includes monochrome prints.

AWARDS: FIAP Gold, Silver, Bronze Medals. PSA Gold Medal, Best of Show. Plaques, best set of entries, portrait, landscape, action. Including monochrome: Bronze Plaques, best Swedish entry, Fotoklubb entry, jury choice. Merit Certificates.

JUDGING: By 5 judges, each section. Sponsor may reproduce entries for puclicity, catalog. Not responsible for loss or damage.

ENTRY FEE: $3 ($2.50 group of 5 minimum). Checks, add $1.50.

DEADLINES: Entry, judging, notification, September. Event, awards, October. Materials returned, November.

| 142 |

Triennial International Exhibition of Photography
Museum of Art and History
227 rue Pierre-Aeby
CH-1700 Fribourg, SWITZERLAND

June-October

International; entry open to all; triennial. Purpose: to bring best international photographers together in competition; honor recognized artists; discover new talents. Sponsored by Canton and City of Fribourg. Held in Museum of Art and History in Fribourg for 65 days. Exhibit tours internationally.

PRINT CONTEST: General Color, 7-1/2x9-1/2 inches (18x24cm) to 35-1/2x50-1/2 inches (91x128cm) unmounted; limit 3-5 individual or 2 maximum portfolios or sequences of total 12 prints per entrant. Competition includes monochrome prints.

AWARDS: 20,000 Swiss francs and Golden Diaphragm, Grand Prize (includes monochrome). 7500 Swiss francs and Silver Diaphragm, First; 5000 Swiss francs and Bronze Diaphragm, Second Prize. 10,000 Swiss francs and Bronze Diaphragm Prizes for research photographs (includes monochrome). Selected photographers reimbursed for enlargement costs.

JUDGING: By international judges. Sponsor may withhold Grand Prize; may reproduce entries for promotional purposes. Accepted entries remain property of exhibit. Not responsible for loss or damage.

SALES TERMS: Sponsor charges 20% commission on sales of exhibited prints.

ENTRY FEE: None.

DEADLINES: Entry, September. Event, June-October.

PRINTS (General, Nature, Journalism, Experimental)
Includes AGRICULTURE, THEME.

| 143 |

California Exposition and State Fair Photography Contest
Peter Scott, Chief of Exhibits
Building 7 Exposition Center
1600 Exposition Blvd., P.O. Box 15649
Sacramento, California 95813 U.S.A.
Tel: (916) 924-2015

August-September

State; **entry open to California photographers;** annual; established 1854. Originally agricultural fair; now includes industry, culture, science, and arts. Theme: agriculture emphasis. Sponsored by California State Fair, California State General Fund. Average statistics (all sections): 2000 entries, 1200 entrants, $15,000 in awards, 755,000 attendance. Held at California State Fairgrounds. Sacramento for 18 days. Tickets: $4.

PRINT CONTEST: General, Non-Silver, California Agriculture Color; 8x10, 11x14, 13-1/4x15, 14x18, 16x20, 20x24, 24x30 inches only mat size, unframed; limit 2 per category (4 for California Agriculture). No glass-covered entries. Categories: General, Non-Silver Process, California Agriculture. Competition includes monochrome prints (except General category). Also have arts, crafts sections.

AWARDS: $2,000 in cash awards; $100 and wine goblet, Best of Show (includes monochrome prints). Each Category: $100 and State Fair Plaque, First: $125 and ribbon, Second; $75 and ribbon, Third; $50 and ribbon, Fourth; $25 and ribbon, Fifth. Up to 15 Honorable Mention ribbons each category.

JUDGING: By 3 photographer-lecturers. May withhold awards. Not responsible for loss or damage.

ENTRY FEE: $2 each category (nonrefundable). No commission charged.

DEADLINES: Entry, judging, June. Notification, July. Event, August-September.

| 144 |

Lighthouse Gallery International Photo Salon
Douglas S. Smith, Chair
P. O. Box 3814

Tequesta, Florida 33458 U.S.A.
Tel: (305) 746-3101

April

International; entry open to all; annual; established 1981. Purpose: to display photographic prints. Sponsored by Lighthouse Gallery, Inc. Recognized by PSA. Average statistics (all sections): 1500 entries, 442 entrants, 28 countries, 9 awards. Held for one month.

PRINT CONTEST: General, Nature Color, 8x10 to 16x20 inches, mounted; limit 4 per entrant. Categories: General, Nature. Nature competition includes monochrome prints. Also have monochrome print general category.

AWARDS: Gold Medals, First Place; Cash Awards, Second, Third Place, each category.

JUDGING: By 3 judges. All entries viewed in entirety. Not responsible for loss or damage.

ENTRY FEE: $2 each category, plus return postage.

DEADLINES: Entry, judging, March. Event, notification, April. Materials returned, May.

| 145 |

VIGEX International Photographic Exhibition
James Abrahams
P. O. Box 952
Geelong Victoria 3220, AUSTRALIA
Tel: 052-97225

January-February

International; entry open to all; biennial; established 1979. Acronym for Victoria Geelong Exhibition. Purpose: to promote art of photography in Victoria and Geelong. Sponsored by Alcoa (Australia). Supported by Al-

coa, Geelong municipalities. Recognized by PSA, FIAP. Average statistics (all sections): 2000 entries, 32 countries, 300 finalists, 15 awards. Held in Geelong, Victoria for 9 days. Second contact: Timonthy Bracher, Publicity Officer, 1 McDonald Drive, Winchelsia 3241, Australia.

PRINT CONTEST: General, Nature, Journalism Color, 8x10 inches (20x25cm) to 16x20 inches (40x50cm), unmounted; limit 4 per category. No trade-processed prints. Categories: Color, Nature, Photojournalism. Competition for some awards, categories includes monochrome prints.

AWARDS: PSA Gold Medal, best print. Gold, Silver, Bronze Medals, each category. Malcolm Jay Gottesman's "Hands Across the Sea" Award, best North American entry; *Geelong Advertiser* Trophy, best print (includes monochrome). FIAP and Vigex Medals. Merit Certificates.

JUDGING: By 10 judges. Not responsible for loss or damage.

ENTRY FEE: $3.50 or $3 Aust. per category.

DEADLINES: Entry, judging, December. Awards, January. Event, January-February.

| 146 |

Delta World Salon of Photography
J. Maitrejean, General Chair
Rue A. Renard 354-62
B-4100 Seraing, BELGIUM

March-April

International; entry open to all; biennial (odd years). Sponsored by ABC 73 Seraing, Iris Flemalle, Photo-Club Saint-Nicolas. Recognized by PSA, FBCP, FIAP. Held for 10 days. Second contact: Pierre Gurne, 148 rue

S. Donnay, B 4111 Flemalle, Belgium.

PRINT CONTEST: General, Journalism Color, 16x20 inches (40x50cm) maximum, unmounted; limit 4 per entrant. No trade-processed prints. Categories: General, Photojournalism. Also have monochrome prints section.

AWARDS: PSA Gold Medal, Best of Show. FBCP and FIAP Medals.

JUDGING: By 5 judges (general), 3 judges (photojournalism). Not responsible for loss or damage.

ENTRY FEE: $3 plus return postage.

DEADLINES: Entry, judging, February. Notification, March. Event, March-April.

| 147 |

World Reflection of Photography
Photo-Club Artec
Marcel Delusinne, Secretary
14, rue de l'Hospice
B-7770 Herseaux, BELGIUM

March-April

International; entry open to all; biennial; established 1969. Sponsored by Photo-Club Artec. Recognized by PSA, FIAP, FBCP. Average statistics (all sections): 2240 entries, 530 entrants, 30 countries. Held at Maison de la Culture for 2 weeks. Second contact: 186 rue de Roubaix, B-7770 Mouscron, Belgium.

PRINT CONTEST: General, Experimental Color, 28x36cm to 40x50cm, unmounted; limit 4 per category. Categories: General, Experimental. Competition includes monochrome prints.

AWARDS: Medals, diplomas, prizes.

JUDGING: By 5 judges. Sponsor

may reproduce entries. Not responsible for loss or damage.

ENTRY FEE: 150 Belgian francs plus return postage.

DEADLINES: Entry, judging, notification, February. Event, March-April.

| 148 |

Credit Lyonnais Photo Group National Salon of Photographic Art
19, Boulevard des Italiens
B.P. 12
75060 Paris Cedex 02, FRANCE

June

International; entry open to all; annual; established 1972. Sponsored by Credit Lyonnais Photo Group. Supported and recognized by FNSPF, Northeastern Ile de France Photographic Art Union. Held in Paris for 12 days.

PRINT CONTEST: **General, Theme Color,** 12x16 inches (30x40cm), mounted on light cardboard; limit 4 per entrant. Categories: General, Theme (varies). Competition includes monochrome prints.

AWARDS: Art Books. Cups, best club entries. Memorial Certificate.

JUDGING: By jury. Not responsible for loss or damage.

ENTRY FEE: $2 (10F).

DEADLINES: Entry, March. Judging, April. Event, June.

| 149 |

Toro Association International Photographic Trophy
Toro Photographic Group
Alberto Marsaglia
Via Arcivescovado 16

Casella Postale 471
10100 Torino Centro, ITALY
Tel: 011-57331

October-November

International; entry open to all; biennial; established 1969. Purpose: cultural, promotional. Sponsored by Toro Photogaphic group. Recognized by PSA, FIAP, FIAF. Average statistics (all sections): 4000 entries, 1000 entrants, 39 countries, 39 awards. Held in 2 Italian cities for 1 week each.

PRINT CONTEST: **General, Experimental Color,** any size (30x40cm suggested) unframed; limit 4 per category. No hand-colored, commercially processed prints. Categories: General, Experimental-Vanguard. Competition for some awards includes color prints.

AWARDS: Toro Association Silver Trophy (statuette), Best of Show. PSA Gold Medal, best print group. 2 Gold, 4 Silver, 6 Bronze FIAP Medals; 2 Gold, 4 Silver FIAF Medals, city awards.

JUDGING: By 2 Italians, 3 others.-Entrant may withhold reproduction permission. Not responsible for loss or damage.

ENTRY FEE: $4 (L4000), each category.

DEADLINES: Entry, judging, September. Notification, October. Event, awards, October-November.

PRINTS, SLIDES (General in U.S.)

Includes PRINT PORTFOLIOS. Colored tints are usually classified as Color. CONTEMPORARY usually defined as creative, experimental, imaginative, and-or departure from

realistic representation. However, these definitions may vary. (Also see other PRINT and SLIDE CATEGORIES.)

150

American Vision Juried Photography Exhibition
National Artists' Alliance (NAA)
Eugene Healy, Director
P. O. Box 1498
New Haven, Connecticut 06506
U.S.A. Tel: (203) 773-0076

October-November

National; **entry open to U.S.;** annual; established 1978. Sponsored by NAA. Held at New York University's 80 Washington Square East Galleries, New York for 3-1/2 weeks.

PRINT CONTEST: General Color, 16x20 inches maximum, unframed, may be unmatted and unmounted; unlimited entry (minimum 2) per entrant. Competition includes monochrome prints.

SLIDE CONTEST: General Color, 35mm; unlimited entry (minimum 2).

AWARDS: $2000 NAA Award. $3000 cash prizes.

JUDGING: By 10 photographers, curators, editors, critics. Not responsible for loss or damage.

ENTRY FEE: $20 for initial 2 entries ($5 each additional) plus return postage. No commission charged on sales.

DEADLINES: Entry, judging, notification, June. Event, October-November.

151

Arizona State Fair International Exhibition of Photography
Frank J. Rigo, Superintendent
Department "S" Photography
P.O. Box 6715
Phoenix, Arizona 85005 U.S.A.
Tel: (602) 252-6711, ext. 211

October-November

International; entry open to all; annual; established 1950. Sponsored by Arizona Camera Club Council (ACCC). Recognized by PSA. Held at Arizona State Fair, Phoenix.

PRINT CONTEST: General Color, 16x20 inches maximum, mounted (U.S., Canada, Mexico; overseas not specified), unframed; limit 4 per entrant. No trade-processed or hand-colored prints. Also have monochrome print section.

SLIDE CONTEST: General Color, 2x2 inches; limit 4 per entrant. No slides mounted in glass over ready-mounts.

AWARDS: Each section: PSA Gold Medal, Best of Show. Sweepstakes Award Plaques. ACCC Medal, best by Arizona resident. 4 Award Plaques. Honorable Mention ribbons.

JUDGING: By 3 judges. Not responsible for loss or damage.

ENTRY FEE: $3 prints, $2 slides (nonrefundable).

DEADLINES: Entry, September. Judging, awards, October. Exhibition, October-November.

152

Baltimore International Exhibition of Photography
Baltimore Camera Club (BCC)
Lester B. Shockey, Jr.
436 Gatewood Court

Glen Burnie, Maryland 21061 U.S.A.

February

International; entry open to all; annual. Sponsored by BCC, founded 1884. Recognized by PSA. Held at various locations in Baltimore for 15 days. Second contact: Frank Mugno, President, 509 York Road, Towson, Maryland.

PRINT CONTEST: General Color, 16x20 inches (36x43cm foreign) maximum including mount; limit 4 per entrant. No trade-processed prints. Also have monochrome print section.

SLIDE CONTEST: General Color, 2x2 inches; limit 4 per entrant. No cardboard in glass mounts.

AWARDS: PSA Gold Medals, best print, color and contemporary slides. Edward L. Bafford Medal for best color in a print. BCC Gold, 2 Silver, 2 Bronze Medals each section. Honorable Mention ribbons.

JUDGING: By 3 judges each section. Not responsible for loss or damage.

ENTRY FEE: $3.50 prints, $3 slides.

DEADLINES: Entry, judging, January. Event, February.

| 153 |

Boston International Exhibition of Photography
Boston Camera Club (BCC)
David F. Rodd, Chair
P.O. Box 1482
Boston, Massachusetts 02104 U.S.A.

October

International; entry open to all; annual; established 1939. Sponsored by BCC. Recognized by PSA. Print contest held for 12 days, slide contest for 2 days, in Brookline, Massachusetts

Second contact: P.O. Box 982, Boston, Massachusetts 02103. Third contact: Evelyn M. Charbonnet, Secretary, 91 Mayfair Drive, Westwood, Massachusetts 02090.

PRINT CONTEST: General Color, 16x20 inches maximum, mounted (overseas unmounted); limit 4 per entrant. Hand-colored prints acceptable. No trade-processed prints. Also have monochrome print section.

SLIDE CONTEST: General Color, 2x2 inches, glass mounts preferred; limit 4 per entrant. No glass over cardboard mounts.

AWARDS: Prints and slides: Frank Roy Fraprie Memorial Medal, Best of Show. BCC Centennial medals, best portrait, contemporary, nature, landscape-seascape, photojournalism, best by BCC member. BCC Centennial Medal, best 3 entries by single entrant. New England Camera Club Council Award, best by New England entrant. Honorable Mention ribbons. Slides: BCC Centennial Medal, best phototravel.

JUDGING: By 3 judges. Sponsor may reproduce entries. Not responsible for loss or damage.

ENTRY FEE: Prints, $2. Slides, $3 (overseas $3.50).

DEADLINES: Entry, judging, notification, September. Event, October.

| 154 |

Camera Portfolio Photo Contest
Camera Portfolio Magazine
Martin Wolin, Jr., Editor
P. O. Box 265
Redlands, California 92373 U.S.A.
Tel: (714) 793-6395

November-April

International; entry open to all; semiannual; established 1981. For-

merly called *Portfolio Magazine.* Purpose: to collect published photographic images. Sponsored by *Camera Portfolio Magazine.*

PRINT CONTEST: General Color, any subject. Submit technical information. Divisions: Professional, Amateur-Student. Competition includes monochrome prints and color slides.

SLIDE CONTEST: General Color, any subject. Divisions and requirements same as for prints.

AWARDS: Cash awards to winning photos. Winners published in *Camera Portfolio Magazine,* receive camera.

JUDGING: By 2 judges. All entries viewed in entirety. Sponsor claims one-time publishing rights.

ENTRY FEE: $10, 2 entries and 1 issue of *Camera Portfolio Magazine;* $20, 2 entries and 4 issues; $3 each additional entry, plus return postage.

DEADLINES: Entry, November. Event, November-April.

| 155 |

CavOILcade International Exhibition of Photography
Neeley N. Johnson, Secretary
3932 Gulfway Drive
Port Arthur, Texas 77640 U.S.A.

October

International; entry open to all; annual; established 1954. Sponsored by Port Arthur Camera Club and Gulf Oil Corporation. Recognized by PSA. Held at Port Arthur, Texas for 2 weeks. Second contact: Leonora De-Grasse, 3433 East 11th Street, Port Arthur, Texas 77640.

PRINT CONTEST: General Color, 16x20 inches maximum, mounted (overseas unmounted); limit 4 per entrant. No trade-processed prints.

Competition for some awards includes monochrome prints, color prints and slides.

SLIDE CONTEST: General Color, 2x2 inches; limit 4 per entrant. No entries too thick for projection.

AWARDS: Color Prints, slides: CavOILcade Gold Medal, contemporary; Honorable Mention ribbons (include monochrome). Prints: PSA Gold Medal, Best of Show. 2 CavOILcade Gold Medals, best pictorial. 2 Gulf Oil Corporation Gold Medals, best oil themes. Slides: PSA Gold Medal, Best of Show. 3 CavOILcade Gold Medals, pictorial. CavOILcade Gold Medals, nature, seascape. 3 Gulf Oil Gold Medals, best oil themes.

JUDGING: By 3 judges. Sponsor may use entries for publicity. Not responsible for loss or damage.

ENTRY FEE: Prints, $3.25; slides, $2.50.

DEADLINES: Entry, judging, notification, September. Event, October. Materials returned, November.

| 156 |

Chinese New Year International Exhibition of Photography
Chinatown Photographic Society
Wing C. Toy, General Chair
132 Waverly Place
San Francisco, California 94108 U.S.A.

January

International; entry open to all; annual; established 1976. Sponsored by Chinatown Photographic Society. Recognized by PSA. Held in San Francisco for 8 days. Second contact: Wing C. Toy, Chong Lee Photo Lab, 1642 Bush Street, San Francisco, California 94108.

PRINT CONTEST: General Color,

16x20 inches maximum, mounted, unframed; limit 4 per entrant. No trade-processed prints. Also have monochrome print section.

SLIDE CONTEST: General Color, 2x2-inch mounts; limit 4 per entrant.

AWARDS: Prints: PSA Gold Medal, Best of Show. Yerba Buena Chapter Medal, best set of show. Each section: Gold, Silver, Bronze Trophies. Honorable Mention ribbons.

JUDGING: By 3 judges each section. Not responsible for loss or damage.

ENTRY FEE: Prints $3.50. Slides $3. $3.50 foreign, both sections.

DEADLINES: Entry, judging, notification, December. Event, January. Materials returned, February.

157

Idaho International Photographic Exhibition
Boise Camera Club
David B. Smith, Secretary
11073 Highlander Road
Boise, Idaho 83709 U.S.A.

May

International; entry open to all; annual; established 1961. Sponsored by Boise Camera Club. Recognized by PSA. Held in Boise, Idaho for 10 days. Second contact: Dan Heidel, 3720 Rugby, Boise, Idaho 83704.

PRINT CONTEST: General Color, 16x20 inches maximum, mounted (overseas may be unmounted); limit 4 per entrant. No trade-processed prints. Competition includes monochrome prints, color slides.

SLIDE CONTEST: General Color, 2x2 inches, glass mounts preferred; limit 4 per entrant. No slides too thick for projection.

AWARDS: Prints and slides: PSA Medal, Best of Show. 2 Idaho Plaques, judges' choice. Honorable Mention ribbons. Bronze Medal, Silver Medal, judges' choice print, slides (2).

JUDGING: By 3 judges each section.

ENTRY FEE: $3.50 prints, $2.50 slides.

DEADLINES: Entry, judging, notification, April. Event, May.

158

Jackson International Salon of Photography
Anne Comfort, General Chair
839 South State Street
Jackson, Mississippi 39201 U.S.A.

August

International; entry open to all; annual; established 1957. Sponsored by Jackson Photographic Society (JPS), Mississippi Power and Light Company. Recognized by PSA. Held in Jackson, Mississippi for 16 days.

PRINT CONTEST: General Color, mounted (foreign mounted or unmounted); unlimited entry. Competition for some awards includes monochrome prints.

SLIDE CONTEST: General Color, 2x2 inches, mounted; unlimited entry. No glass over ready mounts.

AWARDS: Prints: PSA Gold Medal, Best of Show. 3 JPS Medals. Honor ribbons. Slides: PSA Gold Medal, Best of Show. 3 JPS Medals. Caldwell Still Life Award, pictorial (includes monochrome prints).

JUDGING: By 2 judges. Sponsor may reproduce entries for publicity. Not responsible for loss or damage.

ENTRY FEE: $3 each 4 entries. Foreign check, add 75¢.

DEADLINES: Entry, judging, event, August.

159
Northwest International Exhibition of Photography
Western Washington Fair
Floramae D. Raught, Photo Salon Superintendent
P.O. Box 430
Puyallup, Washington 98371 U.S.A.

September

International; entry open to all; annual; established 1937. Sponsored by Western Washington Fair. Recognized by PSA. Held at Western Washington Fair in Puyallup for 2 weeks.

PRINT CONTEST: General Color, 16x20 inches maximum including mount (foreign unmounted); limit 4 per entrant. No trade-processed prints. Competition for some awards includes monochrome prints.

SLIDE CONTEST: General Color, 2x2 inches maximum, glass or cardboard mounted; limit 4 per entrant. No slides too thick for projection.

AWARDS: PSA Medal, Best Print of Show. Medals, most original treatment, 1 each to prints (includes monochrome) and slides. 20 Judges' Choice Citations to prints (includes monochrome). Honorable Mentions. Special Western Washington Fair awards.

JUDGING: By 3 judges each section. Not responsible for loss or damage.

ENTRY FEE: $3 each section.

DEADLINES: Entry, judging, August. Event, September.

160
Petersen's Photographic Magazine Gallery Monthly Photo Contest
8490 Sunset Boulevard
Los Angeles, California 90069 U.S.A.
Tel: (213) 657-5100, ext. 314

Monthly

International; entry open to all; monthly. Sponsored by *Petersen's Photographic Magazine.* Held in Los Angeles, California.

PRINT CONTEST: General Color, 3-1/2x4-1/2 inches minimum, glossy paper, unmounted; unlimited entry. Require subject releases for any recognizable persons; equipment, exposure information. No textured-finished, machine-finished prints. Competition includes monochrome prints.

SLIDE CONTEST: General Color, mounted; limit 5 per entrant. Requirements same as for Prints.

AWARDS: $25, each picture published.

JUDGING: By *Petersen's Photographic Magazine* staff. Photos published once and returned.

ENTRY FEE: None.

DEADLINES: Monthly.

161
San Antonio International Exhibition of PHotography
San Antonio International Salon Association
Beth Hurley, General Chair
P. O. Box 13035
San Antonio, Texas 78213 U.S.A.

June

International; entry open to all; annual; established 1967. Sponsored by

San Antonio International Salon Association. Recognized by PSA. Held in San Antonio, Texas for 2 weeks.

PRINT CONTEST: General Color, 16x20 inches maximum, mounted (overseas unmounted); limit 4 per entrant. No trade-processed prints. Also have monochrome print section.

SLIDE CONTEST: General Color, 2x2 inches, mounted; limit 4 per entrant. No slides too thick for projection.

AWARDS: Prints: PSA Gold Medal, Best of Show. San Antonio Medals, best adult portrait, child, humorous, landscape, small print (14 inches maximum per side), best from GSCCC area. Honorable Mention ribbons. Slides: PSA Gold Medal, Best of Show. San Antonio Medals, best architecture, butterfly, contemporary, close-up, glassware, humorous, landscape, mission, mountain scene, mushroom(s), nature, night scene, old house, pottery, travel, wild bird in flight, seascape, best from GSCC area, chairman's choice. Honorable Mention ribbons.

JUDGING: By 3 judges, each section. Not responsible for loss or damage.

ENTRY FEE: Prints, $3.50. Slides, $2.50 (overseas $3).

DEADLINES: Entry, May. Judging, event, June.

| 162 |

Seattle International Exhibition of Photography
Seattle Photographic Society (SPS)
Roy L. Richards, Chair
P. O. Box 9804, Queen Anne Station
Seattle, Washington 98109 U.S.A.

Fall

International; entry open to all; annual; established 1942. Added slide category 1954; print portfolio categories 1974. Purpose: to promote photography as art form. Sponsored and supported by SPS. Recognized by PSA. Held in Seattle.

PRINT CONTEST: General Color, 16x20 inches maximum, mounted (foreign unmounted); limit 4 per entrant. No trade-processed prints. Competition for some awards includes monochrome prints.

PRINT PORTFOLIO CONTEST: General Color, any dimensions; 8-12 prints per portfolio, including monochrome; mounted; may portray sequences related by subject matter, point of view, processing technique. No commercially made prints. Competition includes monochrome, mixed portfolios.

SLIDE CONTEST: General Color, 2-3/4x2-3/4 inches maximum, mounted on glass or cardboard.

AWARDS: Color prints: PSA Gold Medal, Best of Show. 2 SPS Gold Medals. Honorable Mention ribbons. Prints (including monochrome): 1 Sturdevant Memorial Medal. Chao-Chen Yang Memorial Medal, best contemporary print taken within previous 18 months. Portfolios (including monochrome): $50 to best; all accepted exhibited in Seattle Public Library. Slides: PSA Gold Medal, Best of Show. Nan Justice Award, best contemporary. 1 Sturdevant Memorial Medal. 4 SPS Gold Medals (3 traditional, 1 contemporary). Howard and Sadie Wilder Medal, best slide depicting frost. Honorable Mention ribbons.

JUDGING: By 3-member jury. Contemporary based on creativity, experimentation, imagination, departure from realism. Portfolio based on merit as set expressing entrant's indi-

viduality, vision, skill. Not responsible for loss or damage.

ENTRY FEE: $3.50, prints; $5 plus return postage, portfolio; $3, slides.

DEADLINES: Entry, October. Event, Fall.

163

Wilmington International Exhibition of Photography
Margaret G. Bramble, Chair
108 Pierce Road
Deerhurst
Wilmington, Delaware 19803 U.S.A.

February-March

International; entry open to all; annual; established 1934. Sponsored by Delaware Camera Club (DCC) founded 1931. Recognized by PSA. Held at University of Delaware, Newark.

PRINT CONTEST: General Color, 16x20 inches maximum mounted (foreign unmounted); limit 4 per entrant. No trade-processed prints. Competition includes monochrome prints, color slides.

SLIDE CONTEST: General Color, 2x2 inches, standard mounts; limit 4 per entrant. No glass over readymounts.

AWARDS: Prints and slides: PSA Gold Medal, Best of Show. Margaret Hartig Memorial Gold Medal (includes monochrome). DCC Gold, Silver, Bronze Medals (includes monochrome prints). Honorable Mention ribbons.

JUDGING: By 3 judges. May withhold awards. Not responsible for loss or damage.

ENTRY FEE: $4 prints, $3 slides.

DEADLINES: Entry, January. Judging, notification, February. Event, February-March.

PRINTS, SLIDES (General Foreign)
See PRINTS & SLIDES (in U.S.) for definition of Contemporary. (Also see other PRINT and SLIDE CATEGORIES.)

164

Santo Andre International Exhibition of Photography
Cromos Photographic Group
Claudio H. Feliciano, Salon Chair
Caixa Postal 11531
05049 Sao Paulo, BRAZIL

April

International; entry open to all; annual; established 1978. Sponsored by City of Santo Andre and Cromos Photographic Group. Recognized by PSA, PAI. Held in Sao Paulo, Brazil for 13 days.

PRINT CONTEST: General Color, 40x50cm maximum, mounted (overseas unmounted); limit 4 per entrant. No trade-processed prints. Competition for some awards includes monochrome, color prints and slides.

SLIDE CONTEST: General Color, 35mm, mounted; limit 4 per entrant.

AWARDS: Prints and slides: PSA Gold Medal, Best of Show. 1 Gold, 2 Silver, 3 Bronze Medals. Honorable Mention ribbons. Prints or slides: Santo Andre City Trophy; Hands Across the Sea Award; PAI Medal, best total score from PAI member (includes monochrome prints).

JUDGING: By 10 judges. Not responsible for loss or damage.

ENTRY FEE: $3 prints, $2 slides.

DEADLINES: Entry, February. Judging, March. Event, April.

165

Red River Exhibition Association International Photo Salon
Stanley F. Lewis, Director
Room 9, Winnipeg Arena
1430 Maroons Road
Winnipeg, Manitoba R3G 0L5
CANADA Tel: (204) 772-9464

June-July

International; entry open to all; annual; established 1952, became international 1981. Named after Winnipeg's Red River Valley. Purpose: to promote photography in Manitoba, opportunity to view international-calibre work. Sponsored by Red River Exhibition Association. Recognized by PSA. Held in Winnipeg Arena, Manitoba, Canada for 9 days. Tickets: $2.75 Can. Average statistics (all sections): 2800 entries, 700 entrants, 34 countries, 300,000 attendance. Have art, craft exhibits, outdoor and indoor entertainment.

PRINT CONTEST: General Color, 16x20 inches maximum; limit 4 per entrant. No trade-processed prints. Also have monochrome print section.

SLIDE CONTEST: General Color, 2x2 inches (5x5cm); limit 4 per entrant. May be trade-processed.

AWARDS: Each section: $150 and Trophy, First; $100 and Trophy, Second; $50 and Trophy, Third Prize. 10 $25 Honorable Mentions.

JUDGING: By 3 judges each section. Sponsor reserves right to reproduce entries. Not responsible for loss or damage.

ENTRY FEE: $5 plus return postage.

DEADLINES: Entry, January. Notification, judging, May. Event, June-July.

166

Southampton International Exhibition of Photography
Southampton Camera Club
Nicholas J. Scott, Secretary
74 Stannington Crescent
Totton, Hampshire SO4 3QD
ENGLAND Tel: 867582

March

International; entry open to all; annual; established 1896. Purpose: to promote photography. Sponsored by Southampton Camera Club. Recognized by PSA. Average statistics (all sections): 4000 entries, 550 entrants, 42 countries, 6 awards. Held at Civic Centre Art Gallery, Southampton.

PRINT CONTEST: General Color, 16x20 inches (40x50cm) unmounted, larger prints mounted; limit 4 per entrant (club entries accepted). Competition for one award includes monochrome prints.

SLIDE CONTEST: General Color, 2x2 inches (5x5cm) mounted; limit 4 per entrant.

AWARDS: PSA Gold Medals, best color print, best color slide, best contemporary slide. City of Southampton Trophy, best UK print (includes monochrome).

JUDGING: By 3 photography professionals each section. Not responsible for loss or damage.

ENTRY FEE: $3, UK 60p (12F or 7DM). Entrant prepays return postage.

DEADLINES: Entry, judging awards, February (prints), March

(slides). Event, March. Materials returned, April.

167

Bordeaux International Salon of Photographic Art

Andre Leonard, President
Residence Godard A/4.9e
33110 Le Bouscat, FRANCE

October

International; entry open to all; biennial (even years); established 1948. Considered largest photo salon in Europe. Sponsored by Photo-Club de Bordeaux. Recognized by PSA, FIAP, RPS, FNSPF. Average statistics (all sections): 2400 entries, 60 countries. Held at Galerie des Beaux-Arts, Bordeaux for 24 days.

PRINT CONTEST: General Color, 9-1/2x9-1/2 inches, unmounted, unframed; limit 4 per entrant. No trade-processed prints. Also have monochrome print section.

SLIDE CONTEST: General Color, 2x2-inch glass mounts; limit 4 per entrant.

AWARDS: Each section: FIAP Gold, Silver, Bronze Medal. Bordeaux la Noble Ville Bronze Plaque, best portrait, nude, landscape-seascape, typical scene, contemporary print. 6 Silver, 12 Bronze Ville de Bordeaux Medals.

JUDGING: By 3 judges. Entry review, awards judging based on technical execution, artistic value. Not responsible for loss or damage.

ENTRY FEE: $3 (15 French francs) each section; group entries $2 (10 French francs) each section.

DEADLINES: Entry, judging, September. Event, October. Materials returned, November.

168

Hong Kong Camera Club (HKCC) International Salon of Pictorial Photography

Wu Hee-Chi, Chair
P. O. Box 10657
General Post Office, HONG KONG

April

International; entry open to all; annual; established 1971. Sponsored by HKCC. Supported by Urban Council of Hong Kong. Recognized by PSA. Held at Exhibition Gallery, Hong Kong City Hall for 1 week.

PRINT CONTEST: General Color, 16x20 inches maximum, mounted (overseas unmounted); Limit 4 per entrant. No trade-processed prints. Competition for some awards includes monochrome prints and color slides.

SLIDE CONTEST: General Color, 2x2 inches, glass or cardboard mount; limit 4 per entrant.

AWARDS: Prints and slides, each: PSA Gold Medal; 1 Gold, 2 Silver, 3 Bronze Trophies; 12 Bronze Medals. Special Subjects Awards, best pictorial, action, portrait, nature prints or slides (includes monochrome prints). Photo-Art Cup to best set local prints. Wellington Lee Cup to best set local slides. Certificates of Merit, Honorary Exhibitor of HKCC to entrants with minimum 3 (including monochrome prints, slides) accepted for 3 consecutive years in the same section.

JUDGING: By 5 judges each section. Not responsible for loss or damage.

ENTRY FEE: $3.50 (HK$15) each section.

DEADLINES: Entry, February. Judging, notification, March. Event, April. Material returned, May.

169
Hong Kong International Salon of Photography
Photographic Society of Hong Kong
Chain Sui-Kwun, Chair
G. P. O. Box 3815
HONG KONG

December

International; entry open to all; annual; established 1946. Sponsored by Photographic Society of Hong Kong (founded in 1937). Recognized by PSA. Held in Hong Kong for 10 days.

PRINT CONTEST: General Color, 16x20 inches maximum, mounted (foreign unmounted); limit 4 per entrant. No trade-processed prints. Also have monochrome print section.

SLIDE CONTEST: General Color, 2x2 inches, mounted; limit 4 per entrant.

AWARDS: Governor's Trophy, best set by single entrant, prints and slides. Prints: PSA Gold Medal, Best of Show. 1 Gold, 1 Silver, 3 Bronze Trophies. 6 Bronze Medals. 2 Bronze Trophies. Slides: PSA Gold Medals, general, contemporary. 1 Gold, 3 Silver, 4 Bronze Trophies. 10 Bronze Medals.

JUDGING: By 5 judges each section. Sponsor may reproduce entries for publicity. Not responsible for loss or damage.

ENTRY FEE: $3.50 prints, slides.

DEADLINES: Entry, November. Event, December.

170
Photographic Society of India Photography Exhibition
R. A. Achavya
195, Dr. Dadabhoy Naoroji Road
Above Central Camera
Bombay 400 001, INDIA

February

International; entry open to all; biennial (even years); established 1960. Purpose: to promote the art of photography. Sponsored by Photographic Society of India. Average statistics (all sections): 1000 entries, 260 entrants, 14 countries. Held at Jehangir Art Gallery, Bombay, India for 1 week. Also sponsor All India Annual Photographic Exhibition.

PRINT CONTEST: General Color, 16x20 inches maximum (or long side 10 inches minimum); limit 4 per entrant. Competition includes monochrome prints.

SLIDE CONTEST: General Color, 2x2-inch mount; limit 4 per entrant.

AWARDS: President's Award, best entry. Medals, Merit Certificates. Merit Certificate to entrants who submit 4 entries accepted in 1 section.

JUDGING: By 3 photographers. Sponsor may reproduce entries. Not responsible for loss or damage.

ENTRY FEE: $3 (8 rupees) each section. Group entries (5 or more), 25% discount on total entry fee.

DEADLINES: Entry, November. Judging, December. Exhibition, February. Materials returned, March.

171
Irish Salon of Photography
Peadar Slattery, Secretary
74 Bettyglen
Raheny
Dublin 5, IRELAND

July

International; entry open to all; biennial (even years); established

1926. Sponsored by Photographic Society of Ireland (PSI), founded 1854. Recognized by PSA. Held at Bank of Ireland Centre for 12 days. Second contact: J. G. McCusker, Flat #9, Sunnybank Mews, Dundrum, Dublin 14, Ireland.

PRINT CONTEST: General Color, 16x20 inches (40x50cm) maximum, overseas unmounted (Ireland and U.K. may be mounted); limit 4 per entrant. No trade-processed prints. Also have monochrome print section.

SLIDE CONTEST: General Color, 2x2 inches (5x5cm), mounted between glass; limit 4 per entrant. No card-mounted slides.

AWARDS: PSA Gold Medals, best color and contemporary slides. PSI Gold Medals, best print and slide by Ireland resident. PSI Silver, Bronze Medals each section.

JUDGING: By 3 judges each section. Not responsible for loss or damage.

ENTRY FEE: $3.50 (£1.75) each section.

DEADLINES: Entry, judging, June. Event, July.

172

La Ciucchina International Trophy of Photographic Art
Saronno Amateur Photo Group (GFAS)
Giampaolo Cordini, President
Via Giuditto Pasta 29
21047 Saronno, ITALY

November

International; entry open to all; biennial (odd years); established 1979. GFAS founded 1969, launched Photographic Trophy to exchange and compare experiences in photographic art. Sponsored by local manufacturers and traders. Recognized by FIAP, FIAF, PSA. Average statistics (all sections): 3332 entries, 889 entrants, 42 countries, 230 finalists, 39 awards.

PRINT CONTEST: General Color, 12x16 inches maximum, unmounted; limit 4 per entrant. No trade-processed prints. Also have monochrome print sections.

SLIDE CONTEST: General Color, 2x2 inches, glass-mounted; limit 4 per entrant.

AWARDS: Each section: La Ciucchina Trophy. FIAP Gold, Silver, Bronze Medals. FIAF Gold Medal. 5 GFAS La Ciucchina Silver Medals.

JUDGING: By 6 judges. Not responsible for loss or damage.

ENTRY FEE: $5, 1 section; $6, 2 sections.

DEADLINES: Entry, judging, notification, October. Exhibition, November. Materials returned, December.

173

Macau International Salon of Photography
Photographic Society of Macau
Lee Kung-Kim, Chair
Rua Almirante Costa Cabral
No. 36, R-C, Bloco C, MACAU
(ASIA) Tel: 72770

June-July

International; entry open to all; biennial (odd years); established 1981. Purpose: to promote photographic activities and techniques in Macau, friendship and cultural exchange. Sponsored by Photographic Society of Macau (founded 1958), Department of Education and Culture. Recognized by PSA. Average statistics (all sections): 4290 entries, 1153 entrants, 38 countries, 1042 finalists, 57 winners. Held in Macau for 1 week. Second

contact: Photographic Society of Macau, P. O. Box 876, Macau, Asia.

PRINT CONTEST: General Color, 16x20 inches (40x50cm) maximum, mounted, limit 4 per entrant. No trade-processed prints. Competition includes monochrome prints and color slides.

SLIDE CONTEST: General Color, 2x2 inches (5x5cm) maximum, 1/8-inch (3mm) maximum thickness, mounted; limit 4 per entrant.

AWARDS: Each section: 1 Gold, 2 Silver, 3 Bronze statuettes. 5 Silver, 3 Bronze Medals. Governor of Macau Trophy, highest total marks for 4 entries.

JUDGING: By 5 judges each section. Based on content, artistic value. Sponsor reserves right to reproduce for exhibition catalog, promotional purposes. Not responsible for loss or damage.

ENTRY FEE: $3 (local and Hong Kong entries HK$7) plus return postage.

DEADLINES: Entry, May (prints), June (slides). Judging, notification, June. Event, July.

| 174 |

Barreiro International Salon of Photographic Art
Grupo Desportivo da Quimigal
Francisco Marques, Salon Secretary
2830 Barreiro, PORTUGAL

December

International; entry open to all; biennial (odd years); established 1951. Sponsored by Grupo Desportivo da Quimigal (formerly Grupo Desportivo da Cuf, founded 1937 to encourage sports, cultural activities). Supported by Casa da Cultura dos Trabalhadores da Quimigal. Recognized by FIAP.

Average statistics (all sections): 3800 entries, 1000 entrants, 40 countries. Held in Barreiro and Lisbon for 3 weeks.

PRINT CONTEST: General Color, 16x20 inches (40x50cm) maximum, mounted; limit 4 per entrant or group (3 artists minimum). No trade-processed prints. Also have monochrome print section.

SLIDE CONTEST: General Color, 2x2 inches (5x5cm) maximum, mounted, 1/8-inch (3mm) thick maximum; limit 4 per entrant.

AWARDS: Prints: Gold Medal, best set of 4. 1 Silver, 2 Bronze Medals. 4 Honorable Mentions. Bronze Medal, best group entry. Cup, best exhibitor from Portuguese-speaking country. Slides: Gold Medal, best set of 4. 3 Silver, 6 Bronze Medals. 4 Honorable Mentions. Bronze Medal, best group entry. Cup, best exhibitor from Portuguese-speaking country.

JUDGING: By 3 judges. Not responsible for loss or damage.

ENTRY FEE: Prints: $3.50 individual, $3 group. Slides: $3 individual, $2.50 group.

DEADLINES: Entry, judging, October. Notification, event, awards, December. Materials returned, January.

| 175 |

Photo-Art International Exhibition
Photo-Art Association of Singapore (PAS)
Tham Chong Ho, Chair
P.O. Box 77, Bras Basah
Singapore 9118, SINGAPORE

June

International; entry open to all; biennial (even years); established 1970. Sponsored by PAS. Recognized by PSA. Held at National Library, Sin-

gapore for 1 week. Second contact; Lim Kwong Ling, President, No. 22, St. Michael's Road, Singapore 1232; tel: 2943035, 887480.

PRINT CONTEST: General Color, 16x20 inches (40x50cm) maximum, mounted (foreign unmounted); limit 4 per entrant. Also have Monochrome prints section.

SLIDE CONTEST: General Color, 5x5cm, glass or cardboard mounts; limit 4 per entrant. No glass over cardboard entries.

AWARDS: Prints and slides: PSA Gold Medal, Best of Show. 10 PAS Medals. Rajaratnam Gold Medal, best local. FAPA Medal, best Asian.

JUDGING: By 3 judges. Not responsible for loss or damage.

ENTRY FEE: $3.50 prints, $3 slides. Foreign checks, add 50¢. Singapore entrants S$6.

DEADLINES: Entry, judging, notification, April. Event, June.

176

Singapore Color Photographic Society International Salon of Color Photography
Goh Wee Seng, Salon Secretary
P. O. Box 61, Macpherson Road
Post Office
Singapore 9134, SINGAPORE
Tel: 2966987

November

International; entry open to all; annual; established 1974. Purpose: to promote art of color photography. Sponsored by Singapore Color Photographic Society. Recognized by PSA. Average statistics: 2250 entries, 600 entrants, 40 countries, 40 awards. Held at Singapore Cultural Exhibition Hall for 5 days. Have running commentary and background music for

slide show. Second contact: Yeo Thiamhuat, Salon Chair, 285 Jalan Besar, Singapore 0820, Singapore.

PRINT CONTEST: General Color, 10x12 inches (25x30cm) to 16x20 inches (40x50cm), unmounted (Malaysia and Singapore mounted); limit 4 per entrant. No commercially made prints.

SLIDE CONTEST: General Color, 2x2 inches (5x5cm) maximum, glass or cardboard mounted; limit 4 per entrant. No glass over cardboard mounts.

AWARDS: Per section: PSA Gold Medal, Best of Show. 8 Gold, 10 Silver Medals. Special Award, best local.

JUDGING: By 5 judges each section. Sponsor may reproduce entries for catalogs, publicity. Not responsible for loss or damage.

ENTRY FEE: $3.50 per section (foreign checks, add 50¢). $5 local photographers (members free).

DEADLINES: Entry, judging, October. Event, November.

177

Singapore International Salon of Photography
Photographic Society of Singapore
Robert Tan Tee-Yoke, Chair
4 Cashin Street
Singapore 0718, SINGAPORE
Tel: 3373978

November

International; entry open to all; annual; established 1950. Purpose: to promote photography as art. Sponsored by Photographic Society of Singapore. Recognized by PSA, FIAP. Average statistics (all sections): 4300 entries, 1200 entrants, 42 countries, 34 awards, 80,000 attendance, $4000 total sales. Held at Chinese Chamber of

Commerce for 5 days. Have slide shows, photographic equipment displays. Publish bimonthly journal.

PRINT CONTEST: General Color, 40x50cm, overseas unmounted; limit 4 per entrant. Also have monochrome print, color slide sections.

SLIDE CONTEST: General Color, 5x5cm; limit 4 per entrant.

AWARDS: PSA Gold Medals, best print, general and contemporary slides. FIAP Gold Medal, best print. Pewter Medals, to best 4 prints, best 10 slides.

JUDGING: By 5 judges each section. Sponsor reserves right to reproduce for publicity-catalog. Not responsible for loss or damage.

ENTRY FEE: Prints, $3; slides, $2.50 (PSS members $1.50 each section). Foreign checks, add 50¢.

DEADLINES: Entry, not specified. Exhibition, November.

178

Thai International Salon of Photography
Photographic Society of Thailand (PST)
Rungson Sirichoo
P. O. Box 1258
Bangkok 12, THAILAND

November-December

International; entry open to all; annual; established 1972. Sponsored by PST. Recognized by PSA, FIAP, PAGB. Held at locations in Bangkok for 11 days.

PRINT CONTEST: General Color, mounted on 16x20-inch maximum boards, foreign unmounted; limit 4 per entrant. Also have monochrome print section.

SLIDE CONTEST: General Color, 2x2 inches, glass or ready mounted; limit 4 per entrant. No glass over ready mounts.

AWARDS: PSA Gold Medals, best print, best traditional and contemporary slides. Photo Art Association of Singapore Gold Medal, each section. 3 Silver, 5 Bronze PST Medals, each section.

JUDGING: By 5 judges, each section. Not responsible for loss or damage.

ENTRY FEE: $3 prints, $2.50 slides ($2 PST members). Foreign checks, add 50¢.

DEADLINES: Entry, judging, notification, October. Event, November-December.

PRINTS, SLIDES (General, Nature)

Includes PICTORIAL. See PRINTS & SLIDES (In U.S.) for definition of Contemporary. (Also see other PRINT and SLIDE CATEGORIES.)

179

Circle of Confusion International Exhibition of Photography
Robert and Bernice Schneller
1446 Alrosa Road
La Habra, California 90631 U.S.A.

February

International; entry open to all; annual; established 1938 Sponsored by Orange County and Laguna Hills Camera Clubs. Recognized by PSA. Held in Whittier, Laguna Hills, Seal Beach, California for 1 month. Second contact: Clyde and Mary Lou Manzer,

7364 Forest Avenue, Whittier, California 90602.

PRINT CONTEST: General Color, 16x20 inches, mounted (foreign unmounted); limit 4 per entrant. No trade-processed prints. Competition for some awards includes monochrome prints.

SLIDE CONTEST: General, Nature Color, 2x2-inch mounts; limit 4 per entrant. Categories: General, Nature.

AWARDS: Prints: PSA Gold Medal, Best of Show. 2 Circle of Confusion Silver Medals. Al Gordon Memorial Special Circle Silver Medal, best portrait (includes monochrome prints). Slides: PSA Gold Medal, Best of Show. 10 Circle of Confusion Silver Medals. Nature slides: PSA Silver Medal, Best of Show, Best authenticated wildlife. 8 Circle of Confusion Silver Medals. Honorable Mention ribbons (all sections).

JUDGING: By 5 judges each section. Not responsible for loss or damage.

ENTRY FEE: Prints, $3.50. Slides, $3 (Foreign $3.50). $3.50).

DEADLINES: Entry, judging, notification, January. Event, February. Materials returned, March.

180

Fresno International Salon of Photography
Robert Normart
5091 North Fresno Street, Suite 110
Fresno, California 93710 U.S.A.

October

International; entry open to all; annual; established 1956. Sponsored by Fresno Camera Club. Recognized by PSA. Held at Fresno District Fair for 12 days. Publish catalog of winners.

PRINT CONTEST: General Color, unmounted or mounted on 16x20-inch board; limit 4 per entrant. Also have monochrome print section.

SLIDE CONTEST: Pictorial, Nature Color, 2x2-inch mounts (no glass mounts); limit 4 per entrant. Categories: Pictorial, Nature.

AWARDS: Prints: PSA Gold Medal, Best of Show. Fresno Camera Club Bronze Medallion. Elmer Lew Trophy, best portrait. 10 honor ribbons. Pictorial slides: PSA Gold Medals, Best of Show, best contemporary slide. 3 Fresno Camera Club Bronze Medallions. 30 honor ribbons. Nature slides: PSA Silver Medal, best nature, wildlife slide. 2 Fresno Camera Club Bronze Medallions. 20 honor ribbons. Dr. Lloyd G. Ingles Trophy, best mammal. Alden H. Miller Memorial Award, best bird.

JUDGING: By 3 judges each section. Not responsible for loss or damage.

ENTRY FEE: Prints, $2.50. Slides, $2 each category.

DEADLINES: Entry, judging, September. Event, October.

181

Minneapolis-St. Paul International Exhibition of Photography
William A. Stewart, General Chair
1525 East Magnolia
St. Paul, Minnesota 55106 U.S.A.

February-March

International; entry open to all; annual; established 1949. Sponsored by Twin Cities Area Council of Camera Clubs (TCACCC). Recognized by PSA. Held for 1 month in Minneapolis-St. Paul, Minnesota.

PRINT CONTEST: General Color, 16x20 inches maximum, mounted

(overseas unmounted); limit 4 per section. No trade-processed prints. Also have monochrome prints section.

SLIDE CONTEST: Pictorial, Nature Color, 2x2 inches, glass mounts preferred; limit 4 per category. No mounts too thick for projection. Categories: Pictorial, Nature (General, Botany, Zoology).

AWARDS: Prints: PSA Gold Medal, Best of Show. 2 PSA Medals, best nature. 2 TCACCC Medals. Honorable Mention ribbons. Slides: PSA Gold Medal, Best of Show. TCACCC Medals, Pictorial (14), nature (9). 2 PSA Silver Medals, nature slides. Bakke Medal, best unaltered picture of child. Honorable Mention ribbons.

JUDGING: By 3 judges each category. Sponsor may reproduce entries for publicity. Not responsible for loss or damage.

ENTRY FEE: Prints, $3.25; slides, $2.50, each category.

DEADLINES: Entry, judging, notification, January. Event, February-March.

| 182 |

National Orange Show (NOS) International Exhibition of Photography
Dorothy and Joseph Reis, Chairs
689 South "E" Street
San Bernardino, California 92408
U.S.A.

April-May

International; entry open to all; annual; established 1915. Sponsored by NOS, and Wind and Sun Council of Camera Clubs (WSC). Recognized by PSA. Held in San Bernardino for 10 days. Second contact: Dorothy and Joseph Reis, Chairs, 1222 West Lynwood Drive, San Bernardino, California 92405

PRINT CONTEST: General Color, 16x20 inches maximum (overseas, 14x17 inches unmounted maximum) any color process; limit 4 per entrant. No trade-processed prints.

SLIDE CONTEST: Nature Color, 2x2 inches, glass or cardboard mounts; limit 4 per category. No glass over ready-mounts. Categories: General, Botany, Zoology.

AWARDS: Slides: PSA Silver Medal, best nature, authentic wildlife. NOS Gold Medal, General, Botany, Zoology. WSC Silver Medallions, General, Botany, Zoology. Prints: PSA Gold Medal, Best of Show. NOS Gold Medal. WSC Silver Medallion. Honorable Mention ribbons.

JUDGING: By 3 judges. Not responsible for loss or damage.

ENTRY FEE: $3.50 prints, $2.75 slides (foreign $3.25).

DEADLINES: Entry, judging, April. Event, April-May.

| 183 |

Santa Clara Valley International Exhibition
Central Coast Counties Camera Club Council
W. B. Heidt, Chair
124 Blossom Glen Way
Los Gatos, California 95030 U.S.A.
Tel: (408) 356-5854

May

International; entry open to all; biennial (even years); established 1955. Formerly called LIGHT AND SHADOW INTERNATIONAL EXHIBITION. Purpose: to provide photographers means to compete with each other. Sponsored by Central Coast Counties Camera Club Council. Recognized by PSA. Average statistics (all sections): 1357 entrants, 38 countries. Held at various venues. Also

sponsor biennial Mission San Jose Photojournalism Photographic Exhibition (odd years). Second contact: Joe Shrock, 2040 Middlefield Road, Mountain View, California 94040.

PRINT CONTEST: General, Nature Color, 16x20 inches maximum, unframed, mounted (foreign unmounted); limit 4 per category. May be hand-colored. No trade-processed prints. Categories: General, Nature. Competition includes monochrome prints.

SLIDE CONTEST: General, Nature Color, 2x2 inches, mounted; limit 4 per category. Categories: General, Nature.

AWARDS: Color prints: PSA Medal, Best of Show; Yerba Buena Chapter Medal; 4 Santa Clara Valley Medals. Nature prints (includes monochrome): PSA Medals, Best of Show, best authenticated wildlife; Yerba Buena Chapter Medal; 3 Santa Clara Valley Medals. Nature slides: PSA Medals, Best of Show, best authenticated wildlife; Yerba Buena Chapter Medal; 7 Santa Clara Valley Medals. Color slides: PSA Medals, Best of Show, best contemporary, Yerba Buena Chapter Medal; 8 Santa Clara Valley Medals. Eleanor Irish Memorial Medal, outstanding exhibitor (must have entered 3 divisions). Special award medal, best local entry, each division. Honorable Mention ribbons.

JUDGING: By 3 experienced judges in each category, active as exhibitors, lecturers, judges. Entrant may withhold reproduction permission. Not responsible for loss or damage.

ENTRY FEE: Prints: $3.50 each category. Slides: $3 each category.

DEADLINES: Entry, judging, event, May. Materials returned, June.

184

INTERPHOT International Exhibition of Photography
Adelaide Festival of Arts
Margaret Speechley, Secretary
46 Edgecumbe Terrace
Rosslyn Park, South Australia 5072, AUSTRALIA

March

International; entry open to all; biennial (even years); established 1968. Purpose: to foster worldwide photography. Sponsored by South Australian Photographic Federation (SAPF). Recognized by PSA, FIAP, APS. Average statistics (all sections): 3500 entries, 750 entrants, 40 countries, 40 awards. Held during Adelaide Festival of Arts in Adelaide, South Australia for 9 days.

PRINT CONTEST: General, Nature Color, 11x14 inches (28x36cm) minimum, 16x20 inches (40x50cm) maximum; prefer unmounted; limit 4 per entrant. Trade processing permitted. Categories: General, Nature. Competition for some awards includes monochrome prints.

SLIDE CONTEST: General, Nature Color, 2x2 inches (5x5cm) maximum; prefer glass mounts (no glass over cardboard); limit 4 per entrant. Trade processing permitted. Categories: General, Nature, Contemporary.

AWARDS: *Prints-* APS Silver Medal. SAPF Silver, Bronze Medals. Kodak Silver Trophy. Agfa-Gevaert Gold Medal, best portrait. (Include monochrome): Contemporary: APS, SAPF Bronze Medals. Kodak Silver Trophy. Nature, Wildlife: PSA Silver Medal each category. APS Bronze Medal. SAPF Silver, Bronze Medals. Kodak Silver Medals, Bronze Trophy. *Slides-* Pictorial: PSA Gold Medal. FIAP Silver, Bronze Medals. SAPF Sil-

ver, Bronze Medals. Kodak Silver Medals, Bronze Trophy. Contemporary: SAPF Bronze Medal. Agfa-Gevaert Gold, Silver, Bronze Medals. Nature, Wildlife: PSA Silver Medal each category. APS Bronze Medal. SAPF Silver, Bronze Medals. Agfa-Gevaert Gold, Silver, Bronze Medals.

JUDGING: Entry review by 6-member selection panel. Awards judging by 6-member jury. Entrant may withhold reproduction permission. Not responsible for loss or damage.

ENTRY FEE: $3.50 (U.S. or Aust.). Checks, add 50 cents.

DEADLINES: Entry, judging, February. Event, March.

185

Maitland International Salon of Photography
Joy Kelly, Secretary
P. O. Box 144
Maitland 2320
New South Wales, AUSTRALIA

February

International; entry open to all; annual; established 1935. Became national 1945, international 1953. Purpose: to exhibit overseas work; promote knowledge of different techniques. Sponsored and supported by Hunter River Agricultural and Horticultural Association. Supported by Tomago Aluminium, Maitland City Council, Kodak, Shortland County Council. Recognized by PSA, APS, FIAP. Average statistics (all sections): 430 entries, 42 countries. Held at Maitland Fine Arts Pavilion for 5 days in conjunction with annual Maitland Show. Second contact: James Walsh, 176 Columbus Avenue, Apt. 721, Pittsfield, Massachusetts 01201.

PRINT CONTEST: General, Na-

ture Color, 16x20 inches maximum, mounted or unmounted; limit 4 per category. No commercially made prints. Categories: General, Nature. Nature competition includes monochrome prints.

SLIDE CONTEST: General, Nature Color, 2x2 inches (5x5cm); limit 4 per category. Categories: Pictorial (including contemporary), Nature.

AWARDS: Prints: PSA Gold Medal best each category, best wildlife; Maitland City Council Gold Plaque, each category; Silver, Bronze Plaques, Certificates of Merit. Slides: PSA Medals, best pictorial, best wildlife; APS-FIAP Gold Medal, 4 best pictorial; Kodak Plaque, outstanding entry. Maitland City Council Gold Plaque, exceptional entry. Silver, Bronze Plaques. Certificates of Merit.

JUDGING: By 3 judges each section. Not responsible for loss or damage.

ENTRY FEE: $3.50A (bank draft) each section.

DEADLINES: Entry, judging, January. Event, February.

186

British Columbia International Exhibition of Photography
Emily Tindale, Secretary
3230 West 5th Avenue
Vancouver, British Columbia V6K 1V4 CANADA

March

International; entry open to all; annual; established 1975. Sponsored by British Columbia International Exhibition of Photography Society (IEPS). Recognized by PSA, NAPA. Held in Vancouver, B.C. for 5 days.

PRINT CONTEST: General Color, 16x20 inches maximum including

mount (foreign unmounted); limit 4 per entrant. No trade-processed prints. Competition for some awards includes monochrome prints.

SLIDE CONTEST: General, Nature Color, 2x2 inches, cardboard or glass mounts; limit 4 per entrant. Categories: Pictorial, Nature.

AWARDS: Prints: PSA Gold Medals, Best of Show, best print. IEPS Trophy, best print by B.C. resident. Slides: PSA Silver Medals, Best of Show, best wildlife. IEPS Trophy, best portrait, contemporary, wildflower. Each section: NAPA Gold Medal, highest aggregate score. Pentax camera, highest aggregate score by Canadian. Honorable Mention ribbons.

JUDGING: By 4 judges each section, category. Not responsible for loss or damage.

ENTRY FEE: Prints, $2; slides, $4 plus return postage.

DEADLINES: Entry, January. Judging, notification, February. Event, March. Materials returned, April.

| 187 |

Toronto International Salon of PHotography
Toronto Camera Club
Eric Godfrey, General Chair
16 Roxaline Street
Weston, Ontario M9P 2Y7 CANADA
Tel: (416) 241-1477

November

International; entry open to all; annual; established 1891. Oldest continuous photo salon in Americas. Sponsored by Toronto Camera Club (founded 1888). Recognized by NAPA, PSA. Held at various Ontario locations. Second contact: Toronto Camera Club, 587 Mount Pleasant Road, Toronto, Ontario M4S 2M5 Canada.

PRINT CONTEST: General Color, 16x20 inches maximum mounted size; limit 4 per entrant. No trade-processed prints. Competition for some awards includes monochrome prints.

SLIDE CONTEST: Pictorial, Nature Color, 2x2 inches (40x50cm), glass mounts preferred (no glass over cardboard); limit 4 per category. Categories: Pictorial, Nature (Wildlife, Botany, Zoology, General).

AWARDS: TCC and PSA Gold Medals, Best of Show in Prints, Nature Slides, Pictorial Slides (PSA Gold Medal includes monochrome prints). NAPA Gold Medals, best contemporary color print, contemporary pictorial slide, habitat nature slide. W. Aubrey Crich Gold Medals, best portrait slide (pictorial), insect in action (nature). TCC Sterling Silver Medals, best nature botany, zoology, general slides. PSA Sterling Silver Medals, best nature slide, wildlife slide. Honorable Mention ribbons.

JUDGING: By 4 photography professionals per category. Sponsor may keep entries for publicity purposes. Not responsible for loss or damage.

ENTRY FEE: Prints, $3.50. Slides, $2.50 each category.

DEADLINES: Entry, judging, October. Event, November.

| 188 |

Bristol Salon of Photography
Bristol Photographic Society
P. J. McCloskey
3 Cranside Avenue
Redland, Bristol BS6 7RA,
ENGLAND Tel: 0272-41424

May

International; entry open to all; annual. Sponsored by Bristol Salon of Photography. Recognized by PSA, RPS, PAGB, FIAP. Held in City Mu-

seum, Bristol; and Devises, Newport, Swindon, Taunton. Second contact: L. R. Hollingsworth, 37 Alandene Avenue, Watnall, Nottingham N616 1HH, England.

PRINT CONTEST: General Color, 16x20 inches (40x50cm) maximum, unmounted; limit 4 per entrant. No commercially made prints. Also have monochrome print section.

SLIDE CONTEST: General, Nature Color, 2x2 inches (5x5cm); limit 4 per category. Categories: General, Natural History (including Wildlife).

AWARDS: PSA Gold Medal, best print. PSA Silver Medals, best slide each category, best wildlife. FIAP Gold, Silver, Bronze Medals. Bristol Silver Medals.

JUDGING: By 3 judges. Prints shown under glass. Not responsible for loss or damage.

ENTRY FEE: $2 prints, $3 slides, plus return postage.

DEADLINES: Entry, March (prints), April (slides). Judging, notification, April. Event, May.

189

Midland Salon of Photography
Midland Counties Photographic Federation
Alan G. Millward, Chair
3 Beausale Croft, Mount Nod
Coventry CV5 7HL, ENGLAND
Tel: 0203-461417

November

International; entry open to all; annual. Supported by Midland Counties Photographic Federation, The West Midlands Arts. Recognized by PSA, FIAP, RPS, PAGB. Average statistics (all sections): 4000 entries, 1000 entrants, 42 countries, 8 awards. Held in Dudley, West Midlands. Tickets:

print exhibit free; slide show, 50p.

PRINT CONTEST: General, Nature Color, dimensions not restricted; mounted or unmounted; limit 4 per entrant. Categories: General, Nature. Competition for some awards includes monochrome prints.

SLIDE CONTEST: General, Nature Color, 2x2 inches (5x5cm); prefer glass mounts; limit 4 per entrant. Categories: General, Nature, Contemporary.

AWARDS: Prints: PSA Gold Medal. (Include monochrome): PSA Silver Medal, best nature, wildlife. FIAP Gold Medal. Slides: PSA Gold Medal. PSA Silver Medals, best nature, wildlife. FIAP Silver Medal. FIAP Bronze Medal, best contemporary.

JUDGING: By 3 judges per section. Not responsible for loss or damage.

ENTRY FEE: Prints $6-$7, slides $3.50 (U.K.: £1.50 prints and slides) plus return postage (foreign checks add $1).

DEADLINES: Entry, judging, awards, October. Exhibition, November.

190

Smethwick Color International Exhibition
Smethwick Photographic Society
Anthony Wharton, Chair
2 Ashfield Grove
Halesowen
West Midlands B63 4LH, ENGLAND

January

International; entry open to all; annual; established 1976. Sponsored by Smethwick Photographic Society. Recognized by PSA, FIAP. Held at Club Headquarters in Smethwick, Warley, West Midlands for 10 days.

Second contact: R. Dallow, 25 Wentworth Park Avenue, Harborne, Birmingham B17 9QU, England.

PRINT CONTEST: General Color, 11x14 inches (28x36cm) to 16x20 inches (40x50cm), mounted overseas unmounted); limit 4 per entrant. No trade-processed prints.

SLIDE CONTEST: Pictorial, Nature Color, 2x2 inches (5x5cm), mounted (glass preferred); limit 4 per entrant. Categories: Pictorial, Nature.

AWARDS: PSA Gold Medal, best pictorial slide, best traditional print. FIAP Gold Medal, best nature slide; Silver Medal, best contemporary slide; Bronze Medal, best contemporary print. Smethwick Medals (3 each), best print, pictorial slide, color slide. Honorable mentions.

JUDGING: By 3 judges per category. Not responsible for loss or damage.

ENTRY FEE: Prints: $2 plus return postage. Slides: $3.50 per category. Overseas checks, add $1.

DEADLINES: Entry, November. Judging, November-December. Notification, December. Event, January.

191

Foto Arte Group (FAG) Niharika International Photographic Salon
O. P. Sharma
Modern School
New Delhi 110001, INDIA
Tel: 383460

Winter

International; entry open to all; biennial; established 1964 (FAG New Delhi), 1938 (Niharika Ahmedabad). Purpose: to pursue cause of photographic art and present to viewers. Sponsored by FAG New Delhi and Niharika Ahmedabad. Recognized by

PSA, FIAP. Average statistics (all sections): 4400 entries, 1000 entrants, 55 countries. Held in New Delhi and Niharika Ahmedabad art galleries for 1 week each. Have national workshops, seminars. Second contact: S. R. Patel, 1633 Kadwapole, Ahmedabad, 38001, India; tel: 24587.

PRINT CONTEST: Pictorial, Nature Color, 10x12 inches minimum, unmounted; limit 4 per category. Categories: Pictorial, Nature. Competition for some awards includes monochrome prints.

SLIDE CONTEST: Pictorial Color, 2-1/4x2-1/4 inches standard, mounted, limit 4 per entrant.

AWARDS: 3 best pictorial prints (includes portrait and nude). 3 best nature (includes monochrome prints). 5 best pictorial slides. 4 Merit Certificates, pictorial prints. 3 Merit Certificates, nature (includes monochrome prints). 4 Merit Certificates, pictorial slides.

JUDGING: By 3-5 judges. All entries viewed in entirety. Not responsible for loss or damage.

ENTRY FEE: $3 each entrant. Sponsor pays return postage.

DEADLINES: Entry not specified. Event, Winter.

192

Border International Salon of Photography
F. Peter Filmer, Director
P. O. Box 147
East London 5200, SOUTH AFRICA

August

International; entry open to all; annual; established 1962. Sponsored by East London Photographic Society. Recognized by PSA, PSSA. Held in East London for 6 days.

PRINT CONTEST: General Color, 40x50cm maximum, including mounts (overseas unmounted); limit 4 per entrant. No trade-processed prints. Also have monochrome print section.

SLIDE CONTEST: Pictorial, Nature Color, 5x5cm; limit 4 per entrant. Categories: Pictorial (including contemporary), Nature.

AWARDS: PSA Gold Medals, best print, pictorial slide. PSA Silver Medals, best authenticated wildlife, nature slide. PSSA Gold Medals, nature slide, pictorial slide. Border Salon Bronze Medals awarded at judge's discretion. Honorable Mentions.

JUDGING: By 3-5 judges each section, category. Not responsible for loss or damage.

ENTRY FEE: Prints $3.50 (3 rand); Slides $2.50 (2 rand). Foreign checks add 60¢.

DEADLINES: Entry, judging, notification, July. Event, August.

193

Cape of Good Hope International Salon of Photography
Cape Town Photographic Society (CTPS)
David Fisher and Eric Vertue, Chairs
P. O. Box 2431
Cape Town 8000, SOUTH AFRICA

April-May

International; entry open to all; biennial (even years). Sponsored by PSSA, CTPS. Recognized by PSA. Held in Cape Town, South Africa for 10 days. Second contact: 28 Jarvis Street, Cape Town, South Africa.

PRINT CONTEST: General, Nature Color, 16x20 inches (40x50cm) maximum, foreign entries unmounted; limit 4 per category (Nature Sequence limit 2). Categories: General, Nature, Nature Sequence (2-10 prints each, with optional 400-word maximum commentary). Competition includes monochrome prints, color slides.

SLIDE CONTEST: General, Nature Color, 2-3/4x2-3/4 inches (7x7cm) maximum, glass mounts; limit 4 per category (Nature Sequence limit 2). Categories same as for Prints.

AWARDS: PSA Gold Medal, best general print, general and contemporary slides. Medals, contemporary slide, nature sequence (includes all sections). Prints and Slides (includes monochrome prints): PSA Silver Medals, best nature and wildlife. Cape of Good Hope Plaques and Medals, general, nature. Medals, wildlife. PSSA Gold Medals, highest scoring 4 entries. Honorable Mention ribbons.

ENTRY FEE: $3 prints, $2 slides, foreign checks, add 60¢.

DEADLINES: Entry, judging, March. Notification, April. Event, April-May.

194

Durban International Exhibition of Photography
Durban Camera Club
Dave Hoyer, Exhibition Director
P. O. Box 37160
Overport 4067, SOUTH AFRICA

July

International; entry open to all; biennial (even years); established 1974. Sponsored by Durban Camera Club. Recognized by PSA, PSSA. Average statistics (all sections): 5000 entries, 1400 entrants, 50 countries, 800 finalists, 35 awards, 500 attendance. Held at Lonsdale Hotel, Durban, South Africa for 1 week. Publish *Pan Magazine.*

PRINT CONTEST: **General, Nature Color,** 16x20 inches maximum, foreign unmounted; limit 4 per category. No trade-processed prints. Categories: General, Nature. Nature competition includes monochrome prints. Also have general monochrome prints section.

SLIDE CONTEST: **General, Nature Color,** 2x2-inch mounts; limit 4 per category. Categories same as for Prints.

AWARDS: PSA Gold Medals, best print, slide. Silver Medals, best nature, wildlife prints and slides. 2 Silver, 3 Bronze Durban Camera Club Medals each category. Merit Certificates.

JUDGING: By 4 judges each category. Sponsor may reproduce for publicity. Not responsible for loss or damage.

ENTRY FEE: Prints, $3.50 (3 Rand). Slides, $3 (2.50 Rand). Foreign checks, add 60¢. Entrant pays return postage if over 2 kilograms.

DEADLINES: Entry, judging, June. Event, July. Materials returned, August.

195
Eastcape International Salon of Photography
Port Elizabeth Camera Club
G. Garth Robertson, Director
P. O. Box 1322
Port Elizabeth 6000, SOUTH AFRICA

March

International; entry open to all; annual; established 1965. Sponsored by Port Elizabeth Camera Club. Recognized by PSA, PSSA. Held in Port Elizabeth, South Africa for 11 days.

PRINT CONTEST: **General, Nature Color,** 16x20 inches (40x50cm) maximum, mounted (overseas un-

mounted); limit 4 per category. Categories: General, Nature. Competition includes monochrome prints.

SLIDE CONTEST: **General, Nature Color,** 2x2 inches (5x5cm) or 2-3/4x2-3/4 inches (7x7cm), 3mm thick maximum, glass mounted; limit 4 per category. Categories: General, Nature.

AWARDS: Prints, slides (nature prints include monochrome): PSA Gold Medal, Best of Show. PSA Silver Medals, best nature, authenticated wildlife. PSSA Gold Medals. Gold, Silver, Bronze Eastcape International Salon Medals, best nature. Honorable Mentions. Special Awards for Port Elizabeth Camera Club members.

JUDGING: By 3 judges each category. Not responsible for loss or damage.

ENTRY FEE: Prints, $3 (R2 South African); slides, $2 (R1.50 South African), each category.

DEADLINES: Entry, judging, February. Event, March.

196
Pretoria International Exhibition of Photography
J. P. Russell, Secretary
P.O. Box 20048
Alkantrant, Pretoria 0005, SOUTH AFRICA

May

International; entry open to all; biennial (odd years); established 1971. Sponsored by Photographic Clubs of Pretoria. Recognized by PSA, Photographic Society of South Africa (PSSA). Held at Pretoria Boys' High School Hall, Brooklyn, Pretoria for 1 week.

PRINT CONTEST: **General, Nature Color,** 16x20 inches (40x50cm) maximum including mount, foreign

unmounted; limit 4 per category. No trade-processed prints. Categories: General, Nature. Nature competition includes monochrome prints.

SLIDE CONTEST: General, Nature Color, 2-3/4x2-3/4 inches (7x7cm) maximum, mounted between glass; limit 4 per category. No cardboard covered with glass. Categories same as for Prints.

AWARDS: PSA Gold Medals, best general print, general and contemporary slides; Silver Medals, best nature and wildlife prints and slides. PIEP Silver and Bronze Plaques (1 each) to general and nature prints and nature slides, 2 each to general slides. PSSA Gold Medals to most successful exhibitors, prints (includes monochrome), general and nature slides. Kruger Gold Medal, best action-wildlife slide. Memorial Plaque to best by South African.

JUDGING: By 3 judges each category. Not responsible for loss or damage.

ENTRY FEE: $3 or 2 rand (prints), $2.50 or 1.50 rand (slides), per category. U.S. checks, add 50¢.

DEADLINES: Entry, judging, April. Event, May.

197

Republic of China International Salon of Photography
Photographic Society of China
Li Chuan, Secretary
P. O. Box 1188
Taipei, TAIWAN, REPUBLIC OF CHINA

April

International; entry open to all; annual; established 1963. Sponsored by Photographic Society of China. Supported by Natural Museum of History. Recognized by PSA, FIAP. Average statistics: (prints) 2400 entries, 700 entrants, 550 accepted; (slides) 2900 entries, 700 entrants, 600 accepted; 40 countries (all sections). Held at National Art Gallery, Taipei for 14 days.

PRINT CONTEST: General, Nature Color, 16x20 inches maximum; limit 4 per category. No trade-processed prints. Categories: General, Nature. Competition for some awards includes monochrome prints, slides.

SLIDE CONTEST: General, Nature Color, 2x2 inches, mounted on glass or cardboard; limit 4 per category. Restrictions, categories same as for Prints.

AWARDS: Prints: PSA Gold Medals, best general. PSA Medals, best nature, wildlife (includes monochrome prints). 1 Gold, 3 Silver, 6 Bronze Medals, general. 1 Gold, 2 Silver, 3 Bronze Medals, nature (includes monochrome). Merit Certificates. FIAP and FAPA Medals at jury's discretion (includes monochrome prints, color slides). Slides: PSA Gold Medals, general, pictorial. PSA Medals, best nature, wildlife. 1 Gold, 3 Silver, 6 Bronze Medals, general. 1 Gold, 2 Silver, 3 Bronze Medals, nature. Certificates of Merit. FIAP and FAPA Medals at jury's discretion (includes monochrome and color prints).

JUDGING: By jury. Sponsor may reproduce entries for publicity purposes. Not responsible for loss or damage.

ENTRY FEE: $3.50 prints, $3 slides (each category). Entrant pays return airmail postage.

DEADLINES: Entry, notification, March. Event, April. Materials returned, May.

PRINTS, SLIDES (General, Nature, Journalism)

Includes PICTORIAL. See PRINTS & SLIDES (in U.S.) for definitions of Contemporary. (Also see other PRINT and SLIDE CATEGORIES.)

198

CACCA International Exhibition of Photography
Chicago Area Camera Clubs Association
Edward A. Trusk, General Chair
2701 West 59th Street
Chicago, Illinois 60629 U.S.A.

July

International; entry open to all; annual; established 1976. Sponsored by CACCA. Recognized by PSA. Average statistics (all sections): 1319 entries, 299 monochrome, 93 color, 35 countries, 70 awards. Held in Chicago, for 9 days.

PRINT CONTEST: Pictorial, Nature, Journalism Color, 16x20 inches (Photojournalism Class B, 8x10 inches) maximum, mounted (overseas unmounted); limit 4 per entrant. May be hand-colored. Categories: Pictorial, Nature, Photojournalism (Class A, Class B). Competition for some awards includes monochrome prints.

SLIDE CONTEST: Pictorial, Nature, Journalism Color, 2x2 inches; limit 4 per entrant. Categories: Pictorial, Nature, Photojournalism.

AWARDS: Prints and slides: PSA Gold Medal, pictorial, photojournalism (Classes A and B include monochrome prints); Silver Medal, nature, authenticated wildlife. CACCA Gold Medal, pictorial (human portrait, fig-ure study, landscape, marine, still life, animal, architectural, contemporary), photojournalism (man in action, spot news, human interest, sports, humor; Class A and B includes monochrome prints), nature (bird, animal, zoo, insect, plant, fungi, general). Honorbale Mention ribbons.

JUDGING: By 3 judges each category. Sponsor may reproduce entries. Not responsible for loss or damage.

ENTRY FEE: $3.50 each category (photojournalism Class B, nature, $2.-50). Slides: $2.50 each category. Entrant pays return postage.

DEADLINES: Entry, judging, June. Event, July.

199

Louisiana State Fair International Exhibition of Photography
Jim Caldwell, General Chair
P. O. Box 5844
Bossier City, Louisiana 71111 U.S.A.

October-November

International; entry open to all; annual; established 1960. Sponsored by Shreveport Photographic Society, Louisiana State Fair. Recognized by PSA. Held at Louisiana State Fair for 9 days.

PRINT CONTEST: General, Journalism Color, Class A: 16x20 inches maximum including mount; no trade-processed prints. Class B: 8x10 inches maximum, unmounted; home or trade-processed. Limit 4 per category. Categories: General, Photojournalism (Class A, Class B). Competition for some awards includes monochrome prints and color slides.

SLIDE CONTEST: General, Journalism Color, 2x2 inches, no glass mounts; limit 4 per entrant. Categories same as for Prints.

AWARDS: Each section: PSA Gold Medal, Best of Show. Louisiana Gold, Silver, Bronze Medals. Prints: Medals, best glamor, nature. Slides: Medals, best portrait, nature, contemporary, child. (Includes all sections): PSA Medals, best Class A and B photojournalism. Class A Medal, best sports human interest. *Shreveport Journal* Medal (Class B), best spot news.

JUDGING: By 3 judges each section. Not responsible for loss or damage.

ENTRY FEE: $3.50, Class A; $3, slides, Class B.

DEADLINES: Entry, September. Judging, notification, October. Event, October-November.

200

Oklahoma International Exhibition of Photography
Oklahoma Camera Club
Ethel Mears, Salon Secretary
6718 N.W. 11th Street
Oklahoma City, Oklahoma 73127
U.S.A.

September-October

International; entry open to all; annual; established 1962. Sponsored by State Fair of Oklahoma, Oklahoma Camera Club. Recognized by PSA. Held at Oklahoma State Fair, Oklahoma City, for 10 days. Second contact: Gilbert and Louise Hill, Chairs, 4716 Mayfair Drive, Oklahoma City, Oklahoma 73112.

PRINT CONTEST: General, Nature, Journalism Color, 16x20 inches (36x43cm foreign) maximum, mounted (foreign unmounted); may be hand-colored; limit 4 per category. Photojournalism Class A: 16x20-inch (36x43cm foreign) mounts, containing 1 or more prints (monochrome, color or mixed), limit 4 mounts. Photojour-

nalism Class B: 8x10 inches (20x25cm) maximum, unmounted, home or trade-processed; limit 4 per entrant. May enter Photojournalism Class A or B, not both. No trade-processed prints (except Photojournalism Class B). Categories: General, Nature, Photojournalism (Class A, Class B). Nature and photojournalism competition includes monochrome prints.

SLIDE CONTEST: General, Nature, Journalism Color, 2x2 inches, cardboard or glass mounted; limit 4 per category. No glass over ready mounts. Categories: General, Nature, Photojournalism.

AWARDS: PSA Gold Medals, best general and photojournalism slides; Silver Medals, best photojournalism prints (Class A, Class B), best nature and wildlife prints and slides. OCC Gold, Silver, Bronze Medals, general and photojounalism slides and prints (all classes); Silver and Bronze Medals, nature slides and prints. Okie Trophies, most original-unusual general slide and print and overall entry, best slide and print showing balance of nature.

JUDGING: By 3 judges each category. Domestic prints judged separately. Not responsible for loss or damage.

ENTRY FEE: Photojournalism Class B, $3 ($3.50 non-North America). Others $3.50 per category. Slides $2.50 North America, $3.50 foreign per category.

DEADLINES: Entry, August. Judging, notification, September. Event, September-October.

201

**Buenos Aires Photo Club (FCBA)
International Salon of
Photographic Art**
Ismael E. Rusconi, Chair
Casilla de Correo 5377
1000 Buenos Aires, ARGENTINA
Tel: 38-7890
July

International; entry open to all; annual; established 1946. Sponsored by FCBA. Recognized by PSA, FIAP, PAI, Fondo Nacional de las Artes. Held in Buenos Aires for 2 weeks. Second contact: FCBA, Avenida de Mayo 1370, Buenos Aires, Argentina.

PRINT CONTEST: **General, Journalism Color,** 16x20 inches (40x50cm) maximum, unmounted; limit 4 per entrant. No trade-processed prints. Categories: General, Photojournalism. Competition for some awards includes monochrome prints.

SLIDE CONTEST: **General, Nature, Journalism Color,** 2x2 inches (Nature, 2x2 inches maximum), glass mounted; limit 4 per category. Categories: Pictorial-Contemporary, Nature, Photojournalism.

AWARDS: PSA Gold Medal and FIAP Gold, Silver, Bronze Medals, each category. 2 PSA Silver Medals (includes monochrome prints). FCBA Gold Pyramids, Gold Medallions, Silver-Plated Medallions. FCBA Plaques, best camera club entry each category, and 4 best Argentine pictures (includes monochrome). FCBA medals, best by FCBA member. Honorable Mentions. Honorary membership and medal to entrants accepted in 5 consecutive or 8 alternate years. PAI Medal, best slide by PAI member.

JUDGING: By 5 judges per category. Not responsible for loss or damage.

ENTRY FEE: $3 per category. Photo clubs or societies sponsoring an international salon, $3 for any number of entries.

DEADLINES: Entry, judging, June. Event, July. Materials returned, August.

202

**Omni-Candid World Festival of
Photographic Arts**
Frans Noben, Chair
Processiestraat 24
B-3751 Bilzen, BELGIUM
Tel: 0032-11-411492
December

International; entry open to all; biennial (odd years); established 1971. Sponsored by Fotoclub Candid Munsterbilzen. Recognized by PSA, FIAP, BFFK. Average statistics (all sections): 4000 entries, 1000 entrants, 42 countries, 50 awards. Second contact: Desire Geurts, Merelstraat 2, 3751 Munsterbilzen, Belgium.

PRINT CONTEST: **Pictorial Color,** 16x20 inches (40x50cm) maximum, unmounted (Benelux entries mounted); limit 4 per entrant. No commercially-made prints. Competition for some awards includes monochrome prints and color slides.

SLIDE CONTEST: **General, Nature, Journalism Color,** 2x2 inches (5x5cm), glass mounts; limit 4 per entrant. Categories: General, Nature, Journalism.

AWARDS: PSA Gold Medals, best color print and slide. PSA Silver Medals, best nature, wildlife slides. PSA Medal, best journalism slide. (Include monochrome): FIAP Gold, Silver, Bronze Medals. BFFK Gold Medal.

VLF Medals. Candid Medals. Honorable Mentions. Jury prizes.

JUDGING: By 5 judges, print and slide; 3 each, journalism and nature slides. Not responsible for loss or damage.

ENTRY FEE: 100 Belgian francs or $3.50.

DEADLINES: Entry, judging, November. Exhibition, December. Materials returned, January.

| 203 |

South African International Salon of Photography
Johannesburg Photographic Society (JPS)
Eddie B. L. Lightbody, Director
P. O. Box 65019
Benmore, Transvaal 2010, SOUTH AFRICA Tel: (011) 976-2136

September

International; entry open to all; biennial (even years); established 1935. First international salon organized in South Africa. Purpose: to promote international photography in South Africa. Sponsored by JPS (founded 1899). Recognized by PSA, Photographic Society of South Africa (PSSA). Average statistics (all sections): 6000 entries, 1500 entrants, 35 countries, 400 finalists, 80 awards, 1000 attendance, 8 public viewings. Held in Johannesburg for 4 days. Tickets: $2.10 (2 rands). Second contact: Colin Mead, P.O. Box 68914, Bryanston 2021, Transvaal, South Africa.

PRINT CONTEST: **General, Nature, Journalism Color,** 16x20 inches (40x50cm) maximum, overseas unmounted (General, Nature); 16x20-inch mounts (Class A Photojournalism); 8x10 inches (20x25cm) maximum, mounted or unmounted (Class B Photojournalism); limit 4 per category. No commercially processed prints (except Class B Photojournalism). Categories: General, Nature, Photojournalism (yearly theme). Competition for most awards includes monochrome prints.

SLIDE CONTEST: **General, Nature, Journalism Color,** 2-3/4x2-3/4 inches (7x7cm) maximum (Pictorial, Contemporary, Nature), 2x2 inches (5x5cm) maximum (Photojournalism), glass-mounted; limit 4 per category. Categories: General (Pictorial, Contemporary), Nature, Photojournalism (yearly theme).

AWARDS: PSA Gold Medals, best color pictorial print, best photojournalism print (Class A or B, include monochrome); best pictorial and contemporary slides. PSA Silver Medals, best nature and wildlife slides; nature and wildlife prints (include monochrome). PSSA Gold Medals, best photojournalism slide and best 4 slides. JPS Gold, Silver, Bronze Plaques, best contemporary and action-wildlife prints (include monochrome); best portrait-landscape and action-wildlife slides. Merit Certificates, most successful South African print and slide exhibitors.

JUDGING: By 3 judges, each category. Entrant may withhold reproduction permission. Not responsible for loss or damage.

ENTRY FEE: Prints, $3 each category. Slides, $2 each category. Foreign checks, add 50¢. Additional for airmail return postage.

DEADLINES: Entry, August. Judging, event, awards, September. Materials returned, October.

PRINTS, SLIDES (General, Nature, Journalism, Travel)

Includes PICTORIAL, THEME. See PRINTS & SLIDES (in U.S.) for definition of Contemporary. (Also see other PRINT and SLIDE CATEGORIES.)

204

Mississippi Valley International Salon of Photography

St. Louis Camera Club
Winifred Brenner, Secretary
9237 Glen Garden Drive
St. Louis, Missouri 63136 U.S.A.

November

International; entry open to all; annual; established 1945. Sponsored by St. Louis Camera Club (founded 1914). Recognized by PSA, Arts and Education Council of Greater St. Louis. Held in St. Louis for 3 weeks. Second contact: Eugene E. Brucker, Chair, 517 Selma Avenue, Webster Groves, Missouri 63119.

PRINT CONTEST: General Color, 16x20 inches maximum, domestic mounted; limit 4 per entrant. No trade-processed prints. Also have monochrome print section.

SLIDE CONTEST: General, Nature, Travel Color, 2x2 inches; glass mounts preferred; limit 4 per category. Categories: General, Nature (including Wildlife), Travel.

AWARDS: Prints: PSA Gold Medal, best pictorial. 1 MVS Medal. Honorable Mention ribbons. Slides: PSA Gold Medals, Best of Show, best travel. PSA Silver Medals, best nature, best wildlife. MVS Medals, general

(7), nature (4), travel (2). Honorable Mention ribbons.

JUDGING: By 3 lecturers, exhibitors. Sponsor retains right to reproduce entries. Not responsible for loss or damage.

ENTRY FEE: $3.50 ($4 foreign). Slides: $2.50 ($3.50 foreign) plus return postage.

DEADLINES: Entry, judging, notification, October. Event, November.

205

North American International Exhibition of Photography

Vivian Pfleiderer, General Chair
P.O. Box 161326
Sacramento, California 95816 U.S.A.

August

International; entry open to all; annual; established 1971. Sponsored by California State Fair and Sierra Camera Club (SCC) of Sacramento. Held at Sacramento locations for 3 days (slides), 1 week (prints).

PRINT CONTEST: General, Nature Color, 16x20 inches (40x50cm) maximum including mount (foreign unmounted); may be hand-colored; limit 4 per category. No trade-processed prints. Categories: General, Nature (Botany, Zoology, General, Wildlife). Nature competition includes monochrome prints.

SLIDE CONTEST: General, Nature, Journalism, Travel Color, 2x2 inches; limit 4 per category. No slides too thick for projection. Categories: General, Nature (Botany, Zoology, General, Wildlife), Photojournalism, Travel.

AWARDS: PSA Gold Medals, best color print and best general, photojournalism, and travel slides; Silver Medals, best nature and wildlife

prints and slides. SCC Medals: 4 general, 2 nature prints; 6 general, 4 nature, 4 travel, 4 photojournalism slides; 1 to best each category by SCC member. Memorial Awards, best contemporary print (includes monochrome) and slide and to general, nature, and travel slides. Special award to exhibitor with highest total 4-slide score. Honorable Mention ribbons.

JUDGING: By 3 judges each category. Not responsible for loss or damage.

ENTRY FEE: $3.50 prints, $3 slides ($3.50 foreign).

DEADLINES: Entry, judging, July. Event, August.

| 206 |

Teaneck International Exhibition of Photography
Teaneck Camera Club (TCC)
Henry Forrest, Chair
Town House
Teaneck, New Jersey 07666 U.S.A.

March-April

International; entry open to all; annual; established 1978. Sponsored by TCC. Recognized by PSA. Held in locations in New Jersey and New York for 27 days.

PRINT CONTEST: General Color, 18x20 inches maximum, mounted (foreign mounted or unmounted); limit 4 per entrant. No trade-processed prints. Competition includes monochrome prints.

SLIDE CONTEST: Pictorial, Journalism, Travel Color, 2x2 inches, mounted; limit 4 per category. Trade processing permitted. No glass over ready mounts. Categories: Pictorial, Photojournalism, Travel.

AWARDS: Prints and slides: PSA Gold Medal, Best of Show. Teaneck Medals, Honorable Mention ribbons. Prints: New Jersey Federation of Camera Clubs Medal, best pictorial (includes monochrome). Richard Bruggeman Medal, best pictorial (includes monochrome). 4 TCC Medals. Slides: PSA Gold Medals, best man at work, travel themes. 3 Wohltmans Awards, best story-telling, travel, journalism. Morris Photo Color Club Medals, best pictorial, travel. TCC Medals, travel (4), photojournalism (4), pictorial (10). Ridgewood Camera Club Medal, nature. Medals, best pictorial humor, action, still life, female portrait, landscape.

JUDGING: By 3 judges, lecturers, exhibitors, each category.

ENTRY FEE: Prints, $3; slides, $2.-75.

DEADLINES: Entry, judging, March. Event, March-April. Materials returned, May.

| 207 |

Rosario International Photographic Salon
Pena Fotografica Rosarina (PFR)
Dr. Leo J. Lencioni, Chair
Casilla De Correo 621
2000 Rosario, ARGENTINA

September

International; entry open to all; annual; established 1951. Sponsored by PFR. Recognized by PSA, FIAP. Held in Rosario, Argentina for 23 days.

PRINT CONTEST: General Color; limit 4 per entrant. No trade-processed prints. Competition includes monochrome prints, color slides.

SLIDE CONTEST: General, Nature, Journalism, Travel Color, 2x2-inch glass or cardboard mounts; limit 4 per category. Categories: General, Nature, Photojournalism, Travel.

AWARDS: 5 Silver-plated Medals, best; Silver-plated Medal, best Argentine entry (all sections). Prints: PSA Gold Medal, Best of Show. City of Rosario Medal, family of man (includes monochrome prints). Slides: 2 PSA Gold Medals, photojournalism, travel. 2 PSA Silver Medals, nature, authenticated wildlife. City of Rosario Medals, nature (flora, birds, insects, harmony with environment), photojournalism (sports, human interest, human solidarity, work), travel (Argentine landscape, seascape, world folklore). Prints and slides: PSA Gold Medal, Best of Show. FIAP Gold, Silver, Bronze Medals. City of Rosario Medals, general (landscape, seascape, human figure, originality, most unusual technique). 5 Silver-plated Medals, best by Argentine artist (include monochrome prints).

JUDGING: By 5 judges (General category), 3 judges (Nature, Travel, Photojournalism categories). Not responsible for loss or damage.

ENTRY FEE: Prints, $3.50; slides, $3.

DEADLINES: Entry, judging, notification, August. Event, September. Materials returned, October.

208

Euro-Picamera Intercontinental Photographic Exhibition
Etienne Vandenweghe
Wulvestraat 27
8902 Ieper, BELGIUM

September

International; entry open to all; annual; established 1971. Motto: "Five continents in one world." Sponsored by Euro-Picamera. Recognized by PSA, FIAP, FBCP. Average statistics (all sections): 2950 color, over 2000 theme entries from 62 countries. Held in Ieper, Belgium in conjunction with World Salon of Photographic Art Prints.

PRINT CONTEST: General, Theme Color, 30x40cm; limit 4 per entrant. No trade-processed prints. Categories: General, Theme (varies yearly). Competition for some awards includes color slides.

SLIDE CONTEST: General, Theme Color, 5x5cm; limit 4 per entrant. Categories same as for Print.

AWARDS: PSA Gold Medals, best print, slide. 6 FIAP Medals. Trophies, Medals, best club entries. PAI Medal, highest-scoring club member. Honorable Mentions.

JUDGING: By 5 judges. Not responsible for loss or damage.

ENTRY FEE: $3 each section. Checks, add $1.

DEADLINES: Entry, July. Judging, notification, August. Exhibition, September.

PRINTS, SLIDES, STEREO SLIDES, SLIDE SHOWS
Includes GENERAL, NATURE, PHOTOJOURANLISM, TRAVEL, PICTORIAL, and PHOTO ESSAY. (Also see other PRINT, SLIDE, and STEREO CATEGORIES.)

209

Alameda County Fair Exhibition of Photography
Alameda County Agricultural Fair Association
Lee R. Hall, Secretary-Manager
4501 Pleasanton Avenue

P. O. Box 579
Pleasanton, California 94566 U.S.A.
Tel: (415) 846-2881

June-July

International; entry open to all; annual; established 1912. Purpose: to promote spirit of exhibiting in public shows; encourage aspiring artists. Motto: "Family fun for everyone." Sponsored by Alameda County Agricultural Fair Association. Recognized by California Fairs & Expositions. Average statistics (all sections): 400 entrants, 400,000 attendance. Held in Alameda, Contra Costa counties for 15 days. Tickets: free (fairgrounds admission, $2.50).

PRINT CONTEST: General Color, produced in previous 3 years, mounted on 8x10-inch or 16x20-inch standard board, unframed; limit 6 per entrant (amateur 3 per category, professional 4 per category). Divisions: Amateur, Professional. Categories: (amateur) General (8x10, 16x20), Nature (16x20), Portrait (16x20); (Professional) General-Weddings, Portrait-Brides (8x10, 16x20). Also have monochrome print section.

SLIDE CONTEST: General Color, 2x2 inches, produced in previous 3 years; standard projector thickness; limit 6 per entrant (3 per category). Division: Amateur. Categories: General, Nature, Portrait, Transportation.

STEREO SLIDES CONTEST: General, Nature Color, 1-5/8x4 inches, produced in previous 3 years, glass-mounted (sponsor may remount). Division: Amateur. Categories: General, Nature.

AWARDS: $50 First, $35 Second, $15 Third Place, each division and category. Amateur 8x10 prints: $25 First, $17.50 Second, $15 Third Place. Honorable Mention ribbons, each category.

JUDGING: By jury. May reclassify, disqualify entries, withhold awards. Limit 1 cash award per entrant. Fair display at judges' discretion, based on space availability; may remove from display if not in sponsor's best interests. Sponsor retains right to reproduce. Entrant insures entries; sponsor not responsible for loss or damage.

SALES TERMS: Work may be for sale. Sponsor charges 10% commission.

ENTRY FEE: $2 each entry plus return postage.

DEADLINES: Entry, judging, June. Event, June-July.

210

Detroit International Salon of Photography
Otis W. Sprow, Chair
26872 Rochelle
Dearborn Heights, Michigan 48127
U.S.A.

August-September

International; entry open to all; annual; established 1934. Sponsored by Greater Detroit Camera Club Council. Recognized by PSA. Held in Detroit for 2 weeks.

PRINT CONTEST: General, Nature Color, 16x20 inches maximum, mounted (foreign unmounted); limit 4 per category. No trade-processed prints. Categories: General, Nature. Also have monochrome print section.

SLIDE CONTEST: General, Nature Color, 2x2-inch mounts (glass preferred); limit 4 per category. Categories: General, Nature.

STEREO SLIDE CONTEST: Gen-

eral Color, 1-5/8x4 inches, glass-covered, projection mounts not exceeding 1/8-inch thickness; limit 4 per entrant.

AWARDS: Prints and slides: PSA Medal, Best of Show, nature, authentic wildlife. Spirit of Detroit Medal, Judges' Choice (nature). Honorable Mention ribbons. Prints: Detroit Medal, judges' choice (pictorial). Medals, best landscape-seascape. Slides: Detroit Medal, judges' choice (traditional, contemporary). Medals, best landscape, seascape, portrait, human interest, humor, still life-tabletop, nature (botanical, zoological). Stereo slides: PSA Medal, Best of Show. Detroit Medal, judges' choice. Special Awards, fishing with bait. Julius Wolfe Award, best land scenic.

JUDGING: By 3 judges each category.

ENTRY FEE: Prints, $3.50; slides, $2.75 each category plus return postage.

DEADLINES: Entry, judging, August. Event, August-September.

211
Los Angeles County Fair (LACF) International Exhibition of Photography

Aileen M. Robinson, Coordinator
P. O. Box 2250
Pomona, California 91766 U.S.A.
Tel: (714) 623-3111

September-October

International; entry open to all; annual; established 1956. Sponsored and supported by LACF Association. Recognized by PSA, Stereo Club of Southern California, Southern California Council of Camera Clubs. Average statistics (all sections): 4929 entries, 1265 entrants, 35 countries, 1368 final works, 716 finalists, 294 awards.

Held at LACF, Pomona, California for 18 days. Tickets: $4. Also sponsor LACF Schools Exhibition of Photography.

PRINT CONTEST: General Color, North American mounted (16x20 inches maximum), foreign unmounted (any size), limit 4 (or 2 sequences of 2) per entrant. No commercially made prints, framed, or wood-mounted. Also have monochrome prints section.

SLIDE CONTEST: Pictorial, Nature Color, 2x2 inches, limit 4 (or 2 sequences of 2) per category. Categories: Pictorial, Nature (Botany, Zoology, General, Wildlife).

STEREO SLIDES CONTEST: General Color, 1/8-inch thick maximum, mounted in glass, limit 4 per entrant. Stereograms, 1-5/8x4 inches, 4-7 sprocket format.

AWARDS: PSA Medals, best print; wildlife, nature, stereo slides. PSA Medal, best contemporary, stereo slides. Stereo Club of Southern California Trophy, best stereo slide landscape. Yankee Photo Products Special Award, outstanding print (including monochrome). LACF Awards' C. B. Afflerbaugh Memorial Trophies, outstanding print, pictorial slide, nature slide, stereo slide. LACF Award, best picture taken at Fair (includes monochrome, color prints and slides). County Fair Gold, Silver, Bronze Medals, Honorable Mention ribbons, each section.

JUDGING: By 5 judges, prints and slides; 3, stereo. Not responsible for loss or damage.

ENTRY FEE: Prints, $3.50. Slides, $2.50. Stereo, $2.

DEADLINES: Entry, judging, notification, August. Event, September-October.

212
North Texas International Exhibition of Photography
Helen Radebaugh, Secretary
3047 Selma Lane
Farmers Branch, Texas 75234
U.S.A.

April

International; entry open to all; annual; established 1977. Sponsored by North Texas Chapter of PSA. Held at various Texas locations for 18 days. Second contact: Altie and Allen Gannaway, Chairs, 3263 Dothan Lane, Dallas, Texas 75229.

PRINT CONTEST: **General, Nature Color,** mounted on 16x20-inch boards (foreign unmounted); may be hand-colored; limit 4 per category. No trade-processed or similar prints. Categories: General, Nature. Nature competition includes monochrome prints.

SLIDE CONTEST: **Pictorial, Nature, Journalism Color,** 2x2 inches, glass or cardboard mounted (not both); limit 4 per entrant. Categories: Pictorial, Nature, Photojournalism.

STEREO SLIDE CONTEST: **General Color,** 1-5/8x4 inches, 5 or 7-inch sprocket widths; limit 4 per entrant.

AWARDS: PSA Gold Medals, best pictorial, photojournalism and stereo slides; Silver Medals, best nature and wildlife slides and prints. North Texas Medals, next 5 best pictorial, next 4 nature, next 3 photojournalism and stereo slides; Best of Show and next 3 best general, next 4 best nature prints. Honorable Mention ribbons.

JUDGING: By 3 judges per category. Not responsible for loss or damage.

ENTRY FEE: $3.50 each category, prints, $2.75 slides.

DEADLINES: Entry, judging, March. Event, April.

213
PSA International Convention Exhibition of Photography
Joseph B. Gill, Chair
3388 South 675 West
Bountiful, Utah 84010 U.S.A.

October

International; entry open to all; annual. Purpose: to promote photography throughout world. Sponsored by Photographic Society of America (PSA), international organization of amateur-professional photographers, camera clubs and photo dealers, founded 1933. Supported by PSA, PSA local chapters, individuals and companies. Average statistics (all sections): 7929 entries, 1983 entrants, 33 countries, 190 accepted for exhibition, 44 awards. Held at PSA Convention. Have membership contests-awards, conventions, workshops, seminars, training courses, traveling portfolios, libraries, display equipment available. Publish *PSA Journal.* Also sponsor PSA-MPD American International and Teenage Film Festivals, various international slide competitions throughout year, exhibitions, scholarships. Second contact: Walter H. Jensen, Director, 426 South Brentwood, Bountiful, Utah 84010. PSA National Headquarters: 2005 Walnut Street, Philadelphia, Pennsylvania 19103.

PRINT CONTEST: **Pictorial, Nature, Journalism Color,** 16x20 inches maximum, mounted (except foreign and Photojournalism Class B); any process (including hand-coloring), may be mixed (color-monochrome). Photojournalism Class A (large prints): limit 4 mounts per entrant. Photojournalism Class B (small prints): commercial processing accepted; limit 4 unmounted prints or 4

lightweight mounts, (8x10 inches maximum) per entrant, each mount containing 1 or more prints. May enter in only one class. Sequences accepted (1-4 prints maximum on single mount). No club entries, commercially made prints (except class B). Categories: Pictorial, Nature, Photojournalism "Man and Man's Environment" Class A (large prints), Class B (small prints). Competition includes monochrome prints.

SLIDE CONTEST: General, Nature, Journalism, Travel Color, 2x2 inches, glass or cardboard mounted (glass preferred); limit 4 per entrant. No club entries. Categories: General, Nature, Photojournalism, Travel.

STEREO SLIDES CONTEST: General Color, mounted in 1-5/8x4-inch mount, 5- or 7-inch sprocket width; limit 4 per entrant. Permission to do necessary remounting for proper projection is a condition of entry.

AWARDS: Steuben Glass Eagles (Kinsley Memorial Trophies), best 3 entries each section, each category. Pictorial Prints: 2 PSA Gold Medals; Kennedy-Maxwell Award, best color; Lee Award, best unusual use of color. (Kennedy-Maxwell and Lee Awards become property of PSA's permanent print collection.) Nature (prints): PSA Silver Medal-Plaques, best insect. PSA Silver Medals, Best of Show, best authenticated wildlife. Nature (slides): PSA Gold Medal, Best of Show; Silver, Bronze Medals, Second, Third Place. PSA Medals, best landscapes-seascapes, wildlife. PSA Silver Medal, best botanical subject. Photojournalism (prints and slides): PSA Gold Medal, Best of Show, each class. PSA Silver Medal, "Best Man in Action," each class. Slides (general): PSA Gold Medal, Best of Show. PSA Silver Medals, 4 runners-up. $100, best animal portrait. Van Gelder Award, to best photo-travel. 2 PSA Gold Med-

als, runners-up. Stereo Slides: PSA Gold Medal, Best of Show. PSA Silver Medal, best contemporary. Paul J. Wolfe Memorial Award, best portrait or figure study. Silver Tray, best landscape. Stergis Award, best flower.

JUDGING: All entries viewed by 3 different judges, each section. Kinsley Awards, judged on technical-photographic excellence demonstrating diverse capabilities of photographer. No slide receives more than 1 award (except Kinsley Award). Not responsible for loss or damage.

ENTRY FEE: $2.50 (slides, photojournalism Class B prints). $2 (pictorial, nature, photojournalism Class A prints).

DEADLINES: Entry, judging, notification, August. Exhibition, October.

214

Rochester International Salon of Photography
Joseph Derso
30 Thornwood Drive
Rochester, New York 14625 U.S.A.

March-April

International; entry open to all; annual; established 1929. Purpose: to encourage excellence in photography. Sponsored by Memorial Art Gallery. Recognized by PSA. Average statistics (all sections): 6000 entries, 1500 entrants, 30 countries. Held in Rochester, New York, for 3 weeks. Second contact: Phyllis Turner, Memorial Art Gallery, 490 University Avenue, Rochester, New York 14607; P.O. Box 25287, Rochester, New York 14625.

PRINT CONTEST: General, Nature Color, 16x20 inches maximum, mounted or unmounted; overseas 14x17 inches maximum, unmounted; limit 4 per category. No oil-colored or commercially made prints, club en-

tries. Categories: Pictorial, Nature. Nature competition includes monochrome prints.

SLIDE CONTEST: General, Nature, Journalism Color 2x2 inches maximum; limit 4 per category. No glass over cardboard mounts. Categories: General, Nature, Photojournalism (yearly theme).

STEREO SLIDE CONTEST: General Color, 1-5/8x4 inches commercial mount and glass over cardboard; limit 4 per entrant.

AWARDS: Prints: PSA Nature Medals, best botany, authenticated wildlife. PSA Medal, best portraiture. Rochester Medals, Best of Show each section, category. Slides: PSA Medals, best action, botany, authenticated wildlife. PSA Stereo Medals, best contemporary, stereo effect slides. PSA Photojournalism Medal, best sports slide. Special merit certificates. Awards for best journalism, human interest, humor slides. Honorable Mention certificates.

JUDGING: By 3 experts per section. Not responsible for loss or damage.

ENTRY FEE: Prints: $3.50 per category. Slides: $2.75 per category.

DEADLINES: Entry, judging, February. Event, March-April.

| 215 |

Southern California Council of Camera Clubs (S4C) International Exhibition of Photography
C. E. (Ed) Hickey, General Chair
11106 Hortense Street
North Hollywood, California 91602
U.S.A.

November-December

International; entry open to all; annual; established 1965. Sponsored by S4C. Recognized by PSA. Held in Los Angeles and vicinity for 1 month.

PRINT CONTEST: General Color, 16x20 inches maximum (including mount), foreign unmounted; limit 4 per entrant. No trade-processed prints. Also have monochrome print section.

SLIDE CONTEST: General, Nature, Journalism, Travel Color, 2x2-inch glass or cardboard mounts; limit 4 per category. Categories: General (including Contemporary), Nature, Photojournalism, Travel.

STEREO SLIDE CONTEST: General Color, 2x2-inch, glass or cardboard mounts; limit 4 per entrant.

AWARDS: Color Prints: PSA Gold Medal, Best of Show. S4C Silver, 2 Bronze Medals. Camera Club Medals, best fall color, highest individual score, best abstract. Color Slides: PSA Gold Medal, Best of Show. 2 S4C Gold, 4 Silver, 9 Bronze medals. 1 S4C special Gold Medal, most artistic contemporary. Camera Club Medals to best action, fall color. Nature Slide: PSA Silver Medals to Best of Show, authenticated wildlife. S4C Gold, 2 Silver, 5 Bronze Medals. Camera Club Medal, best animal action. Photojournalism Slides: PSA Gold Medal, Best of Show. S4C Gold, 2 Silver, 3 Bronze Medals. Long Beach Photo Journalists Award, best sports action. Camera Club Medal, human interest, Man in Action, Sports. Travel Slides: Gold Medal, Best of Show. S4C Gold, Silver, 3 Bronze Medals. Camera Club Medals, Judges' Choice, best California scenic taken in USA, accumulated individual score. Stereo Slides: PSA Silver Medal, Best of Show, contemporary. S4C Gold, Silver, 2 Bronze Medals. Camera Club Medals, most innovative, human interest.

JUDGING: By 4 recognized photog-

raphers. Not responsible for loss or damage.

ENTRY FEE: Slides, $3 per category or section ($3.50 outside North America). Prints, $3.50.

DEADLINES: Entry, judging, November. Event November- December.

216

Wichita International Exhibition of Photography
Wichita Photo Exhibitors Society
Eugene M. Sire, General Chair
518 Peterson Avenue
Wichita, Kansas 67212 U.S.A.
Tel: (316) 722-1855

April

International; entry open to all; annual; established 1957. Purpose: to foster interest in Wichita-area photography exhibitions. Sponsored by Wichita Photo Exhibitors Society. Recognized by PSA. Average statistics (all sections): 6500 entries, 1200 entrants, 48 awards. Held at Hillside Elementary School, Wichita, for 2 days.

PRINT CONTEST: **Pictorial, Journalism Color,** 16x20 inches maximum mounted size (North America), 14x17 inches (35x42.5cm) maximum unmounted (overseas); limit 4 per entrant. Hand-colored prints accepted. Categories: Pictorial, Photojournalism Class A (16x20 inches maximum, mounted), Class B (8x10 inches maximum, mounted). Sequences on 1 mount. Competition for Photojournalism includes monochrome prints. Also have monochrome pictorial print section.

SLIDE CONTEST: **Pictorial, Nature, Journalism Color,** 2x2-inch cardboard or glass mounts; limit 4 per category. Commercial processing acceptable. Categories: Pictorial, Nature, Photojournalism.

STEREO SLIDES CONTEST: **General Color,** 1-5/8x4-inch mounts; glass preferred; limit 4 per entrant. Commercial processing acceptable.

AWARDS: Pictorial prints: Grand Award Gold Medal, Best of Show. 1 Wichita Gold, 2 Wichita Silver Medals. Photojournalism prints: Grand Award Gold Medal, Best of Show. Wichita Gold Medal, each class (includes monochrome). Pictorial slides: Grand Award Gold Medal, Best of Show. 1 Wichita Gold, 2 Wichita Silver Medals. Nature slides: Grand Award Silver Medal, Best of Show; Gold Medal, best wildlife. 1 Wichita Gold, 2 Wichita Silver Medals. Photojournalism slides: Grand Award Gold Medal, Best of Show. 1 Wichita Gold, 2 Wichita Silver Medals. Stereo slides: Grand Award Silver Medal, Best of Show; Silver Medals, best contemporary, best photojournalism. Wichita Gold, Wichita Silver Medal. 5 Wichita Silver Medals, best by Kansas entrant for pictorial slide, nature slide, photojournalism Class A and Class B (includes monochrome prints), photojournalism slide, pictorial print. Honorable Mention ribbons.

JUDGING: By 3 photography professionals, each category, class. Sponsor may keep copies for exhibitors' catalog. Not responsible for loss or damage.

ENTRY FEE: $3-$4 each entry, depending on class, size.

DEADLINES: Entry, March. Judging, notification, awards, April. Materials returned, May.

217

Sydney International Exhibition of Photography
Ina Plumridge, Secretary
P. O. Box A144
Sydney South 2000, AUSTRALIA

March

International; entry open to all; annual; established 1959. Considered Australian exhibition of the year. Recognized by PSA, FIAP. Held at Australian Museum, Sydney.

PRINT CONTEST: General, Nature Color, 16x20 inches (40x50cm) maximum; any photographic medium; unmounted; limit 4 per entrant. Categories: General, Nature. Competition for some awards includes monochrome prints.
Photographic Essay Color, 12x16 inches (30x40cm) maximum; series of 4-6 developing complete theme-style; limit 2 series per entrant. Competition includes monochrome photographic essays.

SLIDE CONTEST: General, Nature Color, 2x2 inches (5x5cm), glass-mounted; any process; limit 4 per entrant. Categories: general, Nature.

STEREO SLIDE CONTEST: General Color, 1 5/8x4 inches, 7 sprocket holes; 1/8 inch thick maximum, mounted; limit 4 per entrant.

SLIDE SHOW WITH SOUND: General Color, 2x2 inches (5x5cm), glass-mounted slides in series-story sequences; with 10-minute maximum sound track, 1/4-inch reel audiotapes or cassette, monophonic or stereo; in English or with written English summary.

AWARDS: Sydney Silver Trophies, best each category. Plaques, Merit Certificates, each category. PSA Medals, best contemporary, action, nature-wildlife slides. Special awards, best experimental print, slide. Outstanding merit in photojournalism, portraiture, humor, landscape; documentary stereo slide. Youth awards (under age 25 at entry deadline), color slides.

JUDGING: By 3 judges per category. Photographic essay based on unified presentation, style. Not responsible for loss or damage.

ENTRY FEE: $3.50 each category.

DEADLINES: Entry, judging, notification, February. Event, March. Materials returned, April.

218

Royal Photographic Society International Exhibition of Photography

RPS National Center of Photography
The Octagon
Milsom Street
Bath BA1 1DN, ENGLAND
Tel: 0225-62841

September

International; entry open to all; annual. Sponsored by RPS (founded 1853; oldest photographic society in world). Have aerial photo, archaeological, education, historical, medical, motion picture, nature, pictorial, scientific-technical, visual journalism divisions; library; museum; gallery; lectures, demonstrations, meetings. Publish *Photographic Journal, Journal of Photographic Science.* Also sponsor Focus Convention, London Diaporama Festival (held at Piccadilly Hotel in December), International Slide Competition and Exhibition, other exhibitions.

PRINT CONTEST: General Color, maximum 30x40 inches (75x100cm) mounted size (British entries), overseas (unmounted); limit 6 per entrant. Accept group entries (limit 10 members); panel entries (4-6 prints, judged as whole). Entrants receiving production assistance (other than mounting) must describe nature of assistance. No entries duplicated in concurrent London exhibitions. Competition includes monochrome, mixed prints.

TRANSPARENCY CONTEST: General Color, over 2x2 inches; limit 4 per entrant. Other requirements, restrictions same as for Prints.

STEREO SLIDES CONTEST: General Color, limit 4 per entrant. Other requirements, restrictions same as for Prints.

AWARDS: Various.

JUDGING: By 3-5 judges. Sponsor may retain for touring exhibition; reproduce for journal, other publications. Not responsible for loss or damage.

ENTRY FEE: £2.50 (individuals), £12.50 (groups). Non-sterling payments, add £1. Entrant prepays return postage.

DEADLINES: Entry, May. Materials, May-June. Event, awards, September.

RESIDENCE GRANTS, FELLOWSHIPS

Primarily for RESIDENCE STUDY, RESEARCH, and PRODUCTION. Includes ASSISTANTSHIPS, SCHOLARSHIPS, WORK-STUDY PROGRAMS, CREATIVE and VISUAL ARTS. (Also see GRANTS, SCHOLARSHIPS, FELLOWSHIPS.)

219

**Apeiron Workshops
Artist-in-Residence Program**
Peter Schlessinger, Director
Silver Mountain Road
Box 551
Millerton, New York 12546 U.S.A.
Tel: (518) 789-4495

Continuous

International; entry open to all; continuous; established 1971. Purpose: to enable artists to work in supportive context without required teaching involvement or other demands. Sponsored by and held at Apeiron Workshops, Millerton, New York. Supported by Apeiron Workshops, NEA, NYSCA. Have darkrooms, class-exhibition space, library-archives, dormitory, traveling exhibitions, field trips, publication projects.

PHOTOGRAPHY RESIDENCE GRANTS: Creative Project. 5 1-6-month grants (includes room, board, darkroom facility, studio space, small monthly material stipend) to photographers for pursuing independent project of any style or format. Artist expected to work relentlessly toward goals; participate in discussions; share maintenance-operational tasks; leave portfolio or project results for archives. Submit letter of intention and financial need, skills. Competition includes monochrome and color photography.

JUDGING: By staff and Board of Directors. Based on financial need, useful professional skills (including carpentry).

DEADLINES: Open.

220

Arrowmont School of Arts and Crafts Spring and Summer Assistantships
Sandra J. Blain, Director
P.O. Box 567
Gatlinburg, Tennessee 37738 U.S.A.
Tel: (615) 436-5860

Spring, Summer

International; entry open to all; annual; established 1945. Purpose: to provide for artists to study, exchange ideas, perfect skills. Held at and spon-

sored by Arrowmont School of Arts and Crafts, located adjacent to Great Smoky Mountains National Park outside Gatlinburg for 2 to 5 weeks. Supported by Pi Beta Phi Fraternity, Tennessee Arts Commission, private and corporate donations. Recognized by University of Tennessee-Knoxville. Average statistics (all sections): 125 entrants; 10-15 assistantships (spring), 12 (summer). Have equipped studios, book-supply store, galleries, conferences, workshops, visiting artists, permanent collection.

PHOTOGRAPHY RESIDENCE ASSISTANTSHIPS: Workshop Sessions, 10-15 2-week (1 week class, 1 week work for school) in spring, 12 5-week (3 weeks class, 2 weeks work for school) summer tuition grants plus board and room to artists with 4 years completed course work or equivalent in experience. Submit 10-20 slides of recent work, 3 references. Graduate-undergraduate credit available through University of Tennessee-Knoxville, Assistants do work assignments related to general functions of school. Competition includes color and monochrome photography, arts and crafts.

JUDGING: By director and program coordinator. Based on application form, references, slide portfolio.

ENTRY FEE: $10 (nonrefundable).

DEADLINES: Application, January (spring), March (summer). Assistantships, March-April (spring), June-August (summer).

221

Artists for Environment Foundation Artist-in-Residence Program
Kenneth N. Salins, Director
Box 44

Walpack Center, New Jersey 07881
U.S.A. Tel: (201) 948-3630

Fall, Spring

National; **entry open to U.S. visual artists;** semiannual; established 1971. Purpose: to provide opportunity for professional artists to work unencumbered within national park setting; promote natural environment as source of inspiration. Sponsored by Department of Interior National Park Service, Union of Independent Colleges of Art. Supported by NEA, New Jersey State Council on the Arts. Average statistics (all sections): 80 entrants, 2 grants. Held at Delaware Water Gap National Recreation Area at Walpack Center, New Jersey, for 3 months. Have art gallery. Also sponsor 1-semester college landscape painting program for students from prominent U.S. art colleges and 8-week summer art program.

VISUAL ARTS RESIDENCE GRANTS: Photography. 2 grants of unspecified value, including house with paid utilities and studio space, to visual artists for opportunity to work without financial concerns for 3 months. Submit resume, samples of recent work, 6 35mm slides in 9x11-inch clear plastic sheet for review. Competition includes color and monochrome photography, fine arts.

JUDGING: By review committee. Sponsor retains slides of accepted applicants. Not responsible for loss or damage.

ENTRY FEE: None. Entrant pays return postage.

DEADLINES: Application, November. Notification, February. Residencies, Fall, Spring.

222

Cummington Community of the Arts Artist in Residence Scholarships

David Thomson, Director
Potash Hill Road
Cummington, Massachusetts 01026
U.S.A. Tel: (413) 634-2172

Continuous

International; **entry open to artists;** continuous; established 1923. Formerly called THE MUSIC BOX (1923-30), PLAYHOUSE IN THE HILLS (1930-53), CUMMINGTON SCHOOL OF THE ARTS (1953-68). Purpose: to stimulate artistic growth by providing living and studio space to artists, especially recently committed to the arts, or disadvantaged by race, sex, age, economic status. Sponsored and supported by Cummington Community of the Arts. Supported by NEA, Massachusetts Council on the Arts and Humanities. Average statistics (all sections): 75 artists. Held on 150-acre site in Cummington, Massachusetts (Berkshire Mountains). Have individual living accommodations, kitchen, dining hall, library, darkrooms, kiln, studios, concert shed, garden, workshops, readings, shows at local galleries, summer children's program (ages 5-14). Publish *Cummington Journal.*

PHOTOGRAPHY RESIDENCE SCHOLARSHIPS: **Artistic Development.** Several partial tuition abatements per month (1 month minimum, 7 months maximum), based on financial need. Submit samples of work, resume, work plan, complete financial statement (including past 2 years' income, tax forms, savings, holdings, projected income, expenses). Require interview. Competition includes color and monochrome photography, film, video, fine arts, performing arts.

JUDGING: By professional artists appointed by Board of Trustees. Based on work, interview. All entries viewed in entirety.

DEADLINES: Application, 2 months before desired residency (continuous).

223

Fine Arts Work Center in Provincetown Fellowships

Susan B. Slocum, Director
24 Pearl Street
P.O. Box 565
Provincetown, Massachusetts 02657
U.S.A. Tel: (617) 487-9960, 487-9351

October-April

International; entry open to all; annual; established 1968. Purpose: to encourage, support artists. Held at and sponsored by fine Arts Work Center in Provincetown (America's first art colony on Cape Cod). Supported by NEA, Massachusetts Council on the Arts and Humanities, CCLM. Average statistics (all sections): 800 entrants, 20 fellows. Have live-in studios, general equipment, exhibitions at Hudson D. Walker Gallery, readings, discussions, resident staff artists for consultations, visiting guest artists, darkroom. Publish *Shankpainter* (annual prose, poetry magazine). Also sponsor 10 writing fellowships.

VISUAL ARTS RESIDENCE GRANTS: **Photography,** 10 fellowships (including room and studio space) to artists in unspecified monthly stipends for 7-month residency to pursue own work in congenial, stimulating environment free from distraction. Applicant must provide any specialized equipment needed. Submit 10 slides maximum in 11x9-inch plastic slide sheet for entry review. No glass mounts. Competition

includes monochrome and color photography, fine arts.

JUDGING: All entries viewed by jury. Based on quality of work with preference given to young artists who have completed formal training and are working on their own. Not responsible for loss or damage.

ENTRY FEE: $15 plus return postage for material submitted.

DEADLINES: Application, January. Notification, May. Residence, October-April.

224

Fulbright-Hays Grants
Institute of International Education (IIE)
Theresa Granza, Manager
809 United Nations Plaza
New York, New York 10017 U.S.A.
Tel: (212) 883-8265

Spring

National; **entry open to U.S.**; annual; established 1946 by legislation authorizing use of foreign currencies accruing to U.S. abroad for educational exchanges. Named after Senator J. William Fulbright. Purpose: to increase mutual understanding between U.S. and other nationals through foreign study. Sponsored by IIE (founded to promote peace, understanding through educational, cultural exchanges in all academic fields), U.S. International Communication Agency (USICA). Supported by annual appropriations from U.S. Congress, other governments. Average 3000 entrants (all sections). Also sponsor grants to visiting scholars, American scholars-professionals, predoctoral fellowships, teacher exchanges, Hubert H. Humphrey North-South Fellowship Program (study-internships), Faculty Research Abroad Program, Doctoral Dissertation Research Abroad Program, Group Projects Abroad, Fulbright Awards for University Teaching and Advanced Research Abroad. Second contact: USICA, 1776 Pennsylvania Avenue N.W., Washington, D.C. 20547.

CREATIVE ARTS RESIDENCE GRANTS: Foreign Study, round-trip transportation, language and orientation course, tuition, books, health-accident insurance, single-person maintenance for 6-12 months' study in 1 foreign country (doctoral candidates may receive higher stipends). Competition includes all media.

ELIGIBILITY: U.S. citizens with majority of high school, college education in U.S., B.A. or equivalent (or 4 years professional experience-study in proposed creative art field). Require host-country language proficiency, certificate of good health, study plan, project proposal, reasons for choosing particular country, what contribution foreign experience will make to professional development, work samples, possible interview.

JUDGING: Professional juries and binational commissions in field of expertise prepare nominations to Fulbright agencies abroad, U.S. Board of Foreign Scholarship.

DEADLINES: Application, November. Judging, November-December. Preliminary notification, January. Awards, April-June.

225

Fulbright Awards for University Teaching and Advanced Research Abroad
Council for International Exchange of Scholars (CIES)
Suite 300
Eleven Dupont Circle
Washington, DC 20036 U.S.A.
Tel: (202) 833-4950

Academic Year

National; **entry open to U.S.;** annual; established 1946 by legislation authorizing use of foreign currencies accruing to U.S. abroad for educational exchanges. Named after Senator J. William Fulbright. Purpose: to increase mutual understanding between U.S. and other nationals through foreign study, teaching. Sponsored and administered by CIES and U.S. International Communication Agency (USICA). Supported by annual appropriations from U.S. Congress, other governments. Average statistics (all grants): 2500 entrants, 1000 semifinalists, 500 awards, 100 countries. Also sponsor Fulbright-Hays Grants, other grants for teacher-scholar exchanges, research abroad. Second contact: USICA, 1776 Pennsylvania Avenue N.W., Washington, D.C. 20547.

CREATIVE ARTS RESIDENCE GRANTS: University Teaching, Advanced Research. Stipend (in lieu of salary), round-trip transportation, other allowances for 1 academic year or less for university teaching and-or postdoctoral research abroad. Applicant must rank countries and openings of major interest from Fulbright list. Competition includes all media.

ELIGIBILITY: U.S. citizens, scholars, creative artists, professionals, institutions. Require demonstrated training-expertise in appropriate subject, language (academic degrees, university teaching, publications, etc.) doctorate, if specified by host country (for teaching); doctorate or recognized professional standing evidence by faculty rank, publications, exhibition record (for research); project presentation; other documentation.

JUDGING: 50 discipline-area committees and binational commissions assist CIES in preparing nominations to Fulbright agencies abroad and U.S. Board of Foreign Scholarship.

DEADLINES: Application, June (American Republics, Australia, New Zealand), July (Africa, Asia, Europe). Judging, September-December. Notification, January-April. Awards given 12-18 months following notification, usually for September-October to June-July academic terms of host institution.

226

Haystack Mountain Residence Grants

Haystack Mountain School of Crafts
Howard M. Evans, Director
Deer Isle, Maine 04627 U.S.A.

Summer

International; **entry open to 18 and over;** annual. Sponsored by and held at Haystack Mountain School of Crafts, Penobscot Bay, Deer Isle, Maine. Have courses and workshops in all forms of crafts. Undergraduate, graduate course credit available.

PHOTOGRAPHY RESIDENCE GRANTS: Summer Studio-Coursework. Free tuition ($100 per week for up to 6 weeks), room, and board to technical assistants. Require 1 year graduate specialization or equivalent. Competition includes color and monochrome photography, crafts sections.

ENTRY FEE: $15.

DEADLINES: Application, March. Residence for 6 weeks in summer.

227

Helene Wurlitzer Foundation of New Mexico Residencies

Henry A. Sauerwein, Jr., Executive Director
P.O. Box 545

Taos, New Mexico 87571 U.S.A.
Tel: (505) 758-2413

Continuous

International; entry open to all; continuous. Sponsored by Helene Wurlitzer Foundation. Have 12 studio-apartments.

PHOTOGRAPHY RESIDENCE GRANTS: Photographic Work. Furnished studio-apartment (including linen and utilities) in Taos for 3-12 months. Residents responsible for cleaning apartment. No families, transportation, material, or living expenses provided. Competition includes color and monochrome photography, fine arts, dance, allied fields.

ENTRY FEE: $150 refundable damage deposit.

DEADLINES: Continuous.

228

MacDowell Colony Residence Grants
680 Park Avenue
New York, New York 10021 U.S.A.

Continuous

International; entry open to all; continuous; established 1907 by American composer Edward MacDowell. Purpose: to help creative professional artists pursue work under optimal conditions. Sponsored by and held at MacDowell Colony, Peterborough, New Hampshire, nonprofit membership corporation. Supported by NEA, private donors. Average statistics: 190 residents, 39-day average stay. Have 30 isolated studios, 3 residence cottages, graphics workshops, library, main hall, on 450 acres of fields, woods. Also sponsor Edward MacDowell Medal (presented annually in August to major artist), MacDowell

Corporate Award (annually to individual in corporate life who exemplifies patronage of the arts). Second contact: MacDowell Colony, High Street, Peterborough, New Hampshire 03458.

VISUAL ARTS RESIDENCE GRANTS: Photography. Tuition waiver for working, living accommodations and solitude (no instuction). Submit work samples, recommendations. Competition includes color and monochrome photography, writing, film, music, art.

JUDGING: By professional photographers. Based on talent shown in submitted work samples and recommendations; number of accepted applicants; financial need for room, board, private studio.

DEADLINES: Entry, January (for June-August), April (September-November), July (December-February), October (March-May).

229

Montalvo Artist-in-Residence Program
Montalvo Center for the Arts
Harriet Leman, Publicity Director
P. O. Box 158
Saratoga, California 95070 U.S.A.
Tel: (408) 867-3586

Continuous

International; entry open to all; continuous; established 1948. Sponsored by Montalvo Association, private nonprofit corporation. Supported by Montalvo Center for the Arts AIR Committee, trust endowment investment income. Held at Montalvo 19-room Mediterranean style villa on 175-acre estate of late James D. Phelan, U.S. Senator and San Francisco mayor. 5 artists (all sections) accepted at any one time. Have exhibition gal-

lery; lectures, classes, workshops, readings, seminars, competitions, field trips, art sales, visiting artists, arboretum, indoor-outdoor theaters for plays; pavilion for recitals, concerts; library. Also sponsor Montalvo Summer Music Festival.

PHOTOGRAPHY RESIDENCE GRANTS: Creative Project. 4 1-3-month residencies at Montalvo villa, plus extension of 3 months (if needed and agreeable), including apartment, linens, laundry room, utilities except telephone to artists to work on new projects or complete projects already started. Limited funds available to assist artists unable to pay cost of residency ($75 per month for single; $90 for married couple). Submit work samples, resume, 1-page publicity summary, work proposal, 3 recommendation letters from professionals in field, personal photo. Applicant required to provide own equipment, food, materials. No children, pets, overnight guests. Competition includes color and monochrome photography, writing, music, art.

JUDGING: By Board of Trustees at first monthly meeting following receipt of application.

ENTRY FEE: $30 (cleaning-breakage deposit).

DEADLINES: Application, 6 months prior to desired residency.

230

Museum of Holography (MOH) Artist-in-Residence Program
Edward A. Bush, Laboratory Director
11 Mercer Street
New York, New York 10013 U.S.A.
Tel: (212) 925-0581

May-December

International; **entry open to practicing holographers;** annual; established 1980. Purpose: to promote excellence in holographic artistic displays by providing advanced facility for research, production of fine art holography. Sponsored by MOH. Supported by Rockefeller Foundation, NEA, NYSCA. Average statistics (all sections): 30 entrants, 8 grants. Held at MOH in New York City for 1 month. Have 2 light-tight rooms, 4x10-foot Newport Optical bench, Spectra Physics 125 helium neon laser (50mW output) with optional etalon, copy camera, library, optics and complete photographic processing equipment with work area. Publish *Holosphere* (monthly newsletter).

PHOTOGRAPHY RESIDENCE GRANTS: Holography. 8 grants of $25 per day (use of Museum's holography laboratory, film and chemicals, stipends for travel) to practicing holography artists for production of fine art holography. Require copy of finished work for permanent collection, daily lab notes; artist gives lecture at end of residency. Submit 1 hologram (prepared for hanging) and information sheet about work and artist for entry review. No commercial or commissioned work during residency, holographic stereograms, or larger works where hologram is only an element. Competition includes color and monochrome photography.

ELIGIBILITY: Must have been working actively in holography for minimum 1 year, assembled a body of own work, be well versed in design of holographic cameras, handling film and plates.

JUDGING: By panel of professional artists and gallery owners.

DEADLINES: Application, February. Notification, March. Residency, May-December.

231

Northwood Institute Creativity Fellowships

Alden B. Dow Creativity Center
Judith O'Dell, Director
3225 Cook Road
P. O. Box 1406
Midland, Michigan 48640 U.S.A.
Tel: (517) 631-1600, ext. 208

June-August

National; **entry open to U.S. mainland, English-speaking persons;** annual; established 1979. Named after Alden B. Dow, AIA. Purpose: to encourage creative thought; provide time, work facilities for creative persons to concentrate on ideas without financial worries; establish internationally recognized center for creative technology. Sponsored by Northwood Institute, Alden B. Dow. Average statistics (all sections): 6 fellows. Held at Northwood Institute, Midland, Michigan.

PHOTOGRAPHY RESIDENCE FELLOWSHIPS: **Creative project, all disciplines.** 3-month study at Northwood Institute (including room, board, travel expenses, professional council) for study, creation, innovation, appreciation. Submit description of proposed project, resume, budget projection. Require personal interview. College credit arranged upon request. Special certificates, recognition, recommendations upon successful completion. Competition includes color and monochrome photography, film, video, fine and performing arts.

JUDGING: By Board of Directors, Advisory Panel, Northwood Institute Alden B. Dow Creativity Center. All entries viewed in entirety. Ideas remain property of applicant. Not responsible for loss or damage.

DEADLINES: Application, December. Judging, December-March. Notification, April. Fellowships, June-August.

232

Rome Prize Fellowships

American Academy in Rome
Executive Secretary
41 East 65th Street
New York, New York 10021 U.S.A.
Tel: (212) 535-4250

April

National; **entry open to U.S.;** annual. Purpose: to promote study, practice, investigation of arts, archaeology, literature, history. Sponsored by and held at American Academy in Rome, (founded 1894) for 1 year. Supported by American Academy in Rome, NEA, Grahman Foundation, Steedman Fellowships, National Institute for Architectural Education.

PHOTOGRAPHY RESIDENCE FELLOWSHIPS: **Advanced, Independent work.** Approximately 22 $7200, 1-year residencies (including $450 monthly stipend, studio, room, board, $400 travel allowance, $400-$900 supply allowance) to U.S. citizen who has completed some graduate work in scholarly field, or is working on or has completed Ph.D. dissertation, or to advanced artist for study at American Academy in Rome in advanced, independent work in community of artists and scholars. Submit evidence of ability and achievement. Italian language ability advised. Housing allowance for married Fellows with children. Competition includes color and monochrome photography, architecture, fine art, music, humanities, art history, writing, archaeology.

JUDGING: Based on outstanding promise and achievement.

ENTRY FEE: $15.

DEADLINES: Application, November. Notification, April.

233
Truro Center for the Arts at Castle Hill Work-Study Program
Joyce Johnson, Director
Box 756
Castle Road
Truro, Massachusetts 02666 U.S.A.
Tel: (617) 349-3714

Summer

International; entry open to all; annual; established 1972. Purpose: to assist artists who are financially restricted to augment their experience, exposure. Sponsored by Truro Center for the Arts. Recognized by Massachusetts Council on the Arts and Humanities. Average 10 entrants (all sections). Held at Truro, Massachusetts for 10 weeks. Have studios, workshops, weekly concerts and lectures, films, classes, visiting artists.

PHOTOGRAPHY WORK-STUDY PROGRAM: **Summer Workshops.** 5-10 weeks of work-study to students, age 14 and over, who work at specific jobs (improving artistic skills) at center in exchange for tuition. Submit resume. Room and board not furnished. College credit may be arranged. Competition includes color and monochrome photography, fine arts, crafts, writing.

JUDGING: By director.

ENTRY FEE: $10.

DEADLINES: Application, June. Study Program, Summer.

234
United States and Japan Exchange Fellowship Program
Japan United States Friendship Commission
Francis B. Tenny, Executive Director
1875 Connecticut Avenue N.W.
Suite 709
Washington, DC 20009 U.S.A.
Tel: (202) 673-5295

April, October

National; **entry open to mid-career U.S. photographers;** semiannual; established 1975. Purpose: to aid education and culture at highest level; enhance reciprocal people-to-people understanding; support close friendship and mutuality of interests between U.S. and Japan. Sponsored by Japan-United States Friendship Commission; NEA (U.S.), Agency for Cultural Affairs (Japan). Also sponsor Book Translation Awards, American Performing Arts Tours in Japan, Japanese Cultural Performances in U.S. Second contact: Nippon Press Center Building, 2-1 Uchisaiwai-cho, 2 chome, Chiyoda-ku, Tokyo; tel: 508-2380.

PHOTOGRAPHY RESIDENCE GRANTS: **Work, Study in Japan.** 5 fellowships of $1600 monthly stipends, plus round-trip transportation, overseas travel fares for spouse and children to age 18, baggage allowance and additional expenses for language training, interpreter, etc. to creative and practicing artists well established in field, to observe Japanese traditional and contemporary artistic developments. Require completed training; not recent resident or working in Japan at time of application. Require written report at conclusion. No historians, scholars, art critics, students. Competition includes color and monochrome photography, journalism, literature, fine and commercial

arts, crafts, music composition, dance, theater.

JUDGING: Entry review by private citizen advisory panels who are experts in respective fields. American selection committee chooses semifinalists. Final awards judging by Japanese awards committee.

DEADLINES: Application, March, September. Fellowships, April, October.

| 235 |

Virginia Center for the Creative Arts (VCCA) Residence Fellowships
Sweet Briar College
William Smart, Director
Mt. San Angelo
Box VCCA
Sweet Briar, Virginia 24595 U.S.A.
Tel: (804) 946-7236

Continuous

International; **entry open to professionals;** continuous; established 1971. Purpose: to provide dedicated, talented professionals with uninterrupted time, adequate space to concentrate on their art. Sponsored by VCCA. Supported by NEA, Virginia Commission for the Arts, foundations. Average statistics (all sections): 100 entrants, 5 countries, 7 residencies. Have studios, pool, 450 acres of pasture and woodlands, library, recreation facilities, cultural events. Held at Mt. San Angelo Estate adjacent to Sweet Briar College for about 6 weeks. Residency costs: $10 per day. Also sponsor residencies for writers, composers.

VISUAL ARTS RESIDENCE GRANTS: **Photography,** up to $40 per day for 6 weeks' room, board, studio space. Have concerts, plays, films, dance recitals, art exhibits, lectures.

Submit slide samples, 2 professional recommendations, curriculum vitae, project description. Competition includes color and monochrome photography.

JUDGING: By 5 professional artists, professors. Based on talent, dedication, promise of professional achievement, financial need. Entrant pays return postage.

DEADLINES: Entry, continuous. Notification, within 6 weeks.

SCHOLARSHIPS, INTERNSHIPS
Primarily for STUDY and RESEARCH. Includes GRANTS, RESIDENCIES, and STUDY LOANS. (Also see GRANTS, RESIDENCE GRANTS.)

| 236 |

Art Institute of Fort Lauderdale (AIFL) Art Scholarships
3000 East Las Olas Boulevard
Fort Lauderdale, Florida 33316
U.S.A. Tel: (305) 463-3000

Fall

International; **entry open to high school seniors;** annual. Sponsored by AIFL (fully accredited by National Association of Trade and Technical Schools). Have housing, processing-printing equipment, live models, lectures, film-videotape workshops, supply store, library, photostat-typesetting facilities, gallery show, design conferences. Also sponsor Erlaine Pitts Scholarship (quarterly to in-school student), Summer Teen Program, The Design Schools Annual Art Contest, internship programs.

PHOTOGRAPHY SCHOLAR-SHIP: Art Institute Study. 1 $8720 scholastic (not monetary) scholarship to current year high school senior for 24-month study at AIFL (includes photo-lab techniques, coordination of design-color-composition, business principles, job experience, portfolio preparation, video production, special projects, filmstrips and multimedia presentations). Student receives Specialized Associate in Science degree. Require high school transcript, possession of 35mm camera with interchangeable lens. Submit 6 prints, 20x30 inches maximum including mounting or matting, comprised of minimum 1 each portrait, still life, landscape, action shot. No mounting under glass or slides. Competition includes color and monochrome photography. Also have Advertising, Interior Design; Fashion Illustration, Merchandising sections.

JUDGING: By committee of independent artists. Scholarship is void if enrollment is terminated. Sponsor uses student artwork for publicity. Entrant pays return postage. Not responsible for loss or damage.

DEADLINES: Application, February. Notification, April. Scholarship begins fall semester for 30 months (including 2 3-month summer vacations).

237

Dr. L. S. Hamory Memorial Scholarships
Miami Photography College (MPC)
June Hamory
20920 East Dixie Highway
North Miami Beach, Florida 33180
U.S.A. Tel: (305) 931-0211

Quarterly

International; **entry open to high school graduates;** quarterly; estab-

lished 1975. Named after MPC founder's father. Purpose: to further photography as art form; attract, develop, reward deserving career-bound amateurs. Sponsored by MPC. Have professional instruction in commercal photography, studios, labs. Also sponsor photo exhibitions.

PHOTOGRAPHY SCHOLAR-SHIPS: Career Education. $25,000 scholarship fund awarding 1 $4935 full scholarship to high school graduate, balance in $1000 individual awards, for 21-month study at MPC. Require 6 monochrome prints (5x7) or 6 color transparencies, statement of interest, 2 recommendations, school transcript, 2 character references, 2 photos of applicant. Competition includes color and monochrome photography.

DEADLINES: Not specified. Scholarships awarded, January, April, July, October.

238

George Eastman House Museum Intern Program
George Eastman House International Museum of Photography
Christine Hawrylak, Public Relations
900 East Avenue
Rochester, New York 14607 U.S.A.
Tel: (716) 271-3361

Fall

International; **entry open to Masters degree graduates;** annual; established 1972. Sponsored by George Eastman House International Museum of Photography. Supported by NEA.

MUSEUM INTERNSHIPS: Photography. 3 1-year internships of museum resources and $8000 each, to Masters degree graduates in art history, fine arts, science, history, litera-

ture, film for research project and normal departmental functions, following several weeks orientation in general museum operation. Research project should be one of: 19th- or 20th-century photography, film, conservation, equipment and apparatus, education, marketing services. Submit undergraduate and graduate transcripts, 3 recommendation letters, resume, personal statement of objectives.

DEADLINES: Application, February. Notification, April. Internships begin, Fall.

239

International Center of Photography (ICP) Internships
Phyllis Levine
1130 Fifth Avenue (at 94th Street)
New York, New York 10028 U.S.A.
Tel: (212) 860-1783

Continuous

International; entry open to all; continuous; established 1975. Purpose: to find and assist new talent. Sponsored by and held at ICP, considered New York City's only independent, nonprofit museum-center, devoted exclusively to appreciation, exhibition, instruction, preservation of photography. Supported by ICP, New York State Council on the Arts, NEA, Henry M. Blackmer Foundation, National Geographic Society, Mobile Foundation, Inc., Margot Keller Memorial Fund. Have permanent collections, resource library, film screening room, museum shop, lectures, workshops, seminars, courses-classes, visiting artists, darkroom facilities, galleries. Also sponsor bimonthly exhibitions of photography.

PHOTOGRAPHY INTERNSHIPS: **Professional Work.** Limited number of internships to individuals with

graduate degree or equivalent work experience to gain more work experience. College credit available. Categories: Exhibitions, Photographic Education, Documentary Photography, Museum Administration, Community Outreach. Competition includes monochrome and color photography.
Student In-Service Training. Scholarships available to college and high school students during the month of January and summer, for gaining work experience. College and high school credit available. Categories: Administration, Exhibition Production, Community Outreach, Photographic Education, Photography. Competition includes monochrome and color photography.

DEADLINES: Open

240

Leonard Shugar Memorial Workshop Scholarships
Silver Eye Photographic Workshop
Barbara Runnette, Director
631 Gettysburg Street
Pittsburgh, Pennsylvania 15206
U.S.A. Tel: (412) 441-1425

Summer

International; entry open to all; annual; established 1978 by The Darkroom, Inc. Sponsored by The Silver Eye. Supported by Pennsylvania Council for the Arts. Average statistics (all sections): 15 applicants maximum (each workshop), 3 workshops. Held at various locations in Pittsburgh, Pennsylvania for 2-1/2 days each. Have housing, facilities for lectures, slide presentations, film processing and printing, work and meeting areas; enlargers, equipment, and chemicals.

PHOTOGRAPHY SCHOLARSHIPS: **Weekend Workshops.** 2 $100 scholarships plus working stipend to

talented photographers in need of financial assistance to workshop of choice. Submit statement of need, work samples. Require portfolio of 15 photographs or slides for class critique upon acceptance. Competition includes color and monochrome photography.

JUDGING: By workshop directors.

ENTRY FEE: $10 (nonrefundable).

DEADLINES: Notification, prior to summer (not specified).

241
New York State Summer School of the Arts School of Film-Media Scholarships
New York State Education Department
Charles J. Trupia, Executive Director
Room 679 EBA
Albany, New York 12234 U.S.A.
Tel: (518) 474-8773

July-August

State; **entry open to New York high school students;** annual; established 1976 by New York State legislature. Purpose: to provide educational opportunities to most talented high school students. Sponsored by New York State Education Department (Humanities and Arts Division), NEA. Average 75 entrants accepted (all sections). Held at State University of New York in Buffalo for 6 weeks. Have 4-person dormitory rooms, meals, health care, recreational facilities, library; film-video screenings, lectures, instruction, field trips, workshops. Also sponsor New York State Youth Film-Media Shows and Workshops; Allstate Show; Schools of Visual Arts, Choral Studies, Dance, Theatre, Orchestral Studies.

PHOTOGRAPHY RESIDENCE SCHOLARSHIPS: Student Summer Program. Approximately 20 scholarships of $75 (applied to student expenses) to $750 (complete tuition, room, board, supplies, special events) to talented high school students who have participated in at least 1 New York State Youth Film-Media regional show, for study under direction of nationally known artists. Competition includes monochrome and color photography, film, creative sound, video, visual arts, dance, theater.

MIXED MEDIA RESIDENCE SCHOLARSHIPS: Student Summer Program. Conditions same as for Photography Residence Scholarships.

JUDGING: At Youth Film-Media Shows and Workshops (7 New York regional locations in January-March). Based on need, ability.

DEADLINES: Judging, February-March. Residence, July-August.

242
Peters Valley Craftsmen Internship Program
Sherrie Posternak, Director
Star Route
Layton, New Jersey 07851 U.S.A.
Tel: (210) 948-5200

Continuous

International; **entry open to age 18 and over;** continuous; established 1970. Purpose: to serve as alternative or supplemental program to traditional education. Sponsored by Peters Valley Craftsmen. Supported by NEA, New Jersey State Council on the Arts, Dodge Foundation. Have workshops, living accommodations, studios, kitchen facilities, sales, auctions, demonstrations, performances. Also sponsor summer studio assistantships, resident program.

PHOTOGRAPHY INTERNSHIPS: Studio Production. 10-13-week in-

ternships to qualified individuals for opportunity to learn through observation and participation with resident teachers. Submit resume, slides of work, recommendation letters, letter of intent. College credit may be arranged. Competition includes color and monochrome photography, crafts.

ENTRY FEE: $15 for annual membership.

DEADLINES: Open.

243

Photographic Art and Science Foundation (PASF) Scholarship and Loan Program
Frederick Quellmalz, Director
111 Stratford Road
Des Plaines, Illinois 60016 U.S.A.
Tel: (312) 824-6855

Academic Year

International; **entry open to U.S., Canadian students;** annual; established 1965. Sponsored by PASF. Average statistics: 80 applications. Also sponsor special grants to needy students (for last half of photographic education). Competition for all scholarships includes color, monochrome photography. Second contact: 1100 Executive Way, Oak Leaf Commons, Des Plaines, Illinois 60018; tel: (312) 299-8163.

PHOTOGRAPHY SCHOLARSHIP: Full-Course Study. 1 scholarship covering half of tuition for 28-month course to U.S. or Canadian freshman accepted at Brooks Institute of Photography (BIP), Santa Barbara, California. Submit application after BIP acceptance.

Freshman Year Study. 1 $750 tuition scholarship to U.S. or Canadian student accepted at Rochester Institute of Technology (RIT), Rochester, New York, for 1 year. Submit applica-

tion after RIT acceptance.

Summer Refresher Courses. Full-tuition (excludes room, board, supplies, transportation, other expenses) for study at Winona School of Professional Photography (WSPP), Winona Lake, Indiana (average course length, 1 week) to working U.S., Canadian photographers.

PHOTOGRAPHY SCHOLARSHIP LOANS: Portraiture Study. Unspecified number of loans, interest-free until 6 months after graduation (with option of 5-year repayment at 6% per annum interest), to U.S. and Canadian portraiture students in last 2 semesters of formal study; applicable to RIT, BIT, or Art Center College of Design in Los Angeles, California. Require unconditional recommendation of Dean of school, responsible co-signer, transcripts.

JUDGING: By Scholarship Committee of Foundation.

DEADLINES: Application, January. Notification, June. For academic year.

244

PSA-Rochester Institute of Technology (RIT) Tuition Scholarship
Photographic Society of America
Dr. Lydia G. Savedoff, Chair
PSA Education-Scholarship Committee
P. O. Box 1266
Reseda, California 91335 U.S.A.

Academic Year

International; **entry open to high school graduates;** annual. Sponsored and supported by PSA, RIT. Average statistics: 8 entrants, 3 finalists, 1 winner. RIT is accredited, endowed college, founded 1829, offering 4-year B.S., B.F.A. degrees in 5 photographic fields.

PHOTOGRAPHY SCHOLAR-SHIP: Freshman Year Study. $1500 and 1-year PSA membership to high school graduate or recent (within 2 years) graduate accepted to RIT. Require proof of acceptance; statement of aims and ambitions; 2 supporting letters; limit 6 color or monochrome prints (8x10 inches maximum, unmounted; monochrome printed and processed by applicant), or 20 transparencies, or 400 feet of film, or combination; 4x5-inch applicant photo. Competition includes color and monochrome photography.

JUDGING: By 3 judges. Winner's portfolio retained. Include SASE.

DEADLINES: Entry, February. Notification, March-April for academic year.

245

Society of Photographic Scientists and Engineers (SPSE) Raymond Davis Scholarship
Robert H. Wood, Executive Director
7003 Kilworth Lane
Springfield, Virginia 22151 U.S.A.
Tel: (703) 642-9090

Various

International; **entry open to candidates seeking degree in photographic science or engineering;** annual. Named after late Raymond Davis, first President of SPSE. Sponsored by SPSE.

PHOTOGRAPHY SCHOLAR-SHIP: Photographic Science-Engineering Study, 1 $1000 scholarship to student for academic study or research at accredited institution toward fulfillment of degree requirements. Submit information on schools previously attended or will attend, letters of recommendation. Competition includes color and monochrome photography.

ELIGIBILITY: Open to degree-seeking candidates in photographic science or engineering, graduate or undergraduate who will complete 2 years of college prior to scholarship term accepted by an institute for further study, full-time student.

JUDGING: By Committee of SPSE. Based on information provided by applicants, interviews. SPSE scholarship does not preclude acceptance of other scholarships. May withhold award.

DEADLINES: Not specified.

246

Virginia Museum Fellowships
Virginia Museum of Fine Arts
Boulevard & Grove Avenue
Richmond, Virginia 23221 U.S.A.

May

State; **entry open to Virginia;** annual; established 1978. Purpose: to provide financial aid for education and experience in the arts. Sponsored by Virginia Museum of Fine Arts. Supported by Woman's Council of the Virginia Museum, Virginia Commission for the Arts (VCA), NEA.

PHOTOGRAPHY SCHOLAR-SHIPS: Photography Study. Student Scholarships: up to $2000 to students to attend or will attend recognized undergraduate school of the arts; require monthly reports. Graduate Student Fellowships: up to $4000 to students who attend or will attend graduate school at recognized college or university; require monthly reports. Paid over 10-12 months. Submit 3 professional recommendations, transcript of academic record, work samples. Competition includes arts, crafts, architecture, color and Monochrome photography.

PHOTOGRAPHY GRANTS: Professional Work. Professional Grants:

up to $2500 to professional artists to aid in work or assist in project benefiting Virginians. **VCA Professional Grants:** 4 $8000 stipends to professionals for work on project. Paid over 10-12 months, except VCA Professional (paid in lump sum). Requirements same as for Scholarships.

ELIGIBILITY: Resident of Virginia for 5 of last 10 years.

JUDGING: Entry review and awards judging; finalists interviewed at museum. Based on highest artistic merit, most financial need. Partial awards at judges' discretion. May be terminated at any time for lack of diligence, sincerity, failure to submit monthly reports. Not responsible for loss or damage.

DEADLINES: Application, March. Notification, May.

247

Western States Film Institute (WSFI) Scholarship Program
Bonita S. Trumbule, Executive Producer
1629 York Street
Denver, Colorado 80206 U.S.A.
Tel: (303) 320-0457

Continuous

International; entry open to all; continuous; established 1972. Formerly called COMMUNITY FILM to 1977. Purpose: to provide community with media education and services. Sponsored by WSFI. Recognized by AFI. Have photography equipment. Also sponsor Apprenticeships, Training Programs.

PHOTOGRAPHY SCHOLAR-SHIPS: **Still Photography Study.** Partial scholarships available to those with talent and need. Competition includes color and monochrome photography. Also have film and video scholarships.

DEADLINES: Continuous.

SCIENTIFIC, TECHNICAL
Prints, Slides, and Slide Shows, including AVIATION-SPACE, NAVAL-MARITIME, PHOTOMICROGRAPH, SOLAR ENERGY. (Also see BUSINESS, INDUSTRIAL.)

248

Aviation-Space Writers Association (AWA) Journalism Awards
William F. Kaiser, Executive Secretary
Cliffwood Road
Chester, New Jersey 07930 U.S.A.
Tel: (201) 879-5667

Spring

International; entry open to all; annual. Sponsored by AWA. Also sponsor Robert S. Ball Memorial Award (space writing or reporting), Earl D. Osborn Award (general aviation writing or reporting), James J. Strebig Memorial Award (aviation writing or reporting).

PRINT CONTEST: **Aviation, Space Journalism Color,** published in previous calendar year; limit 1 per entrant. Submit 3 copies of 8x10-inch print, 3 copies of proof of publication, mounted on maximum 10x14-inch heavy paper. Categories: Aviation, Space. Competition includes monochrome prints. Also have print journalism, book, TV, radio sections.

AWARDS: $100 Honorarium and Scroll, each category.

JUDGING: Not specified. May withhold awards.

ENTRY FEE: None.

DEADLINES: Entry, December. Awards, Spring.

249

Naval and Maritime Photo Contest

U.S. Naval Institute
Patty Maddocks
Annapolis, Maryland 21402 U.S.A.
Tel: (301) 268-6110

February

International; entry open to all; annual; established 1961. Purpose: to award photographic excellence in naval and maritime field. Sponsored by U.S. Naval Institute. Average statistics (all sections): 900 entries, 700 entrants. Held at Annapolis. Publish *Proceedings Magazine* (monthly).

PRINT CONTEST: Naval-Maritime Color, 5x7 inches minimum. Competition includes monochrome prints and color slides.

SLIDE CONTEST: Naval-Maritime Color, 35mm minimum, no glass mounts.

AWARDS: $100 to 10 winners. Winning photos published in *Proceedings Magazine.*

JUDGING: By 6 judges. Sponsor may purchase nonwinning photos. Not responsible for loss or damage.

ENTRY FEE: None.

DEADLINES: Entry, December. Judging, winners announced, awards, February. Materials returned, March.

250

Nikon House International Small World Photo Contest

Nikon Camera Instrument Division
623 Stewart Avenue, Box SW
Garden City, New York 11530
U.S.A. Tel: (516) 248-5200

November

International; **entry open to scientific-industrial photographers;** annual. Formerly called NIKON PHOTOMICRO-MACROGRAPHY CONTEST. Sponsored by Nikon Camera Instrument Division, Ehrenreich Photo-Optical Industries. Held at Nikon House in New York City for 3 weeks. Second contact: Nikon House, 620 Fifth Avenue, New York, New York 10020; tel: (212) 586-3907.

SLIDE CONTEST: Photomicrograph Color, 2x2 inches, from 35mm cameras; any subject; limit 3 per entrant. Submit description of specimen, microscope, camera, technique, lens. No Ehrenreich Photo-Optical employees-families, individuals engaged in manufacture or sale of Nikon products.

AWARDS: Prizes including expense-paid vacations, sophisticated camera equipment.

JUDGING: Based on content, composition, color balance-contrast, originality. Sponsor owns all entries.

ENTRY FEE: None.

DEADLINES: Entry, September. Event, November.

251

Veynes International Solar Film Festival

Solar Energy Study Association
Madeleine Roux, Chair
Mairie de Veynes

05400 Veynes, FRANCE Tel: (92) 58-10-22

August

International; entry open to all; biennial (odd years); established 1981. Sponsored and supported by Solar Energy Study Association (founded 1975 to develop use of solar energy through education, exhibitions, experimental facilities), government agencies, environmental organizations. Average statistics (all sections): 3500 entrants, 10 countries, 30 finalists, 6 awards. Held in Veynes for 1 week. Have screenings, music, dancing. Publish *Architecture Solaire*. Also sponsor conferences, seminars, exhibitions. Second contact: Michel Chardon, Usine du Plan, 05400 Veynes, France.

SLIDE SHOW WITH SOUND: Solar Energy Color, 35mm, on unexplored, unpublicized aspects of solar energy. Submit brief biography. Request publicity material. Competition includes film, video sections.

AWARDS: 5000F First Prize, best technical, original work arguing for solar energy use. 3000F Sun of the Press Foundation of France Award. 2000F Popularization of Solar Techniques Award, best summary of research, innovation. Honorable mentions.

JUDGING: By photography, film, art, journalism, environmental specialists. Sponsor president votes if tie. Based on quality, interest, originality. May withhold awards. Sponsor keeps copy of winners for archival use. Not responsible for loss or damage.

ENTRY FEE: 50F plus postage.

DEADLINES: Entry, May. Materials, June. Event, awards, August.

SLIDES (General in U.S.)

CONTEMPORARY usually defined as creative, experimental, imaginative, and-or departure from realistic representation. However, this definition may vary. (Also see other SLIDE CATEGORIES.)

| 252 |

Central Pennsylvania Festival of the Arts (CPFA) Juried Color Slide Salon and Exhibition
Lurene Frantz, Managing Director
P. O. Box 1023
State College, Pennsylvania 16801
U.S.A. Tel: (814) 237-3682

July

International; **entry open to U.S., Canada, Mexico;** annual; established 1966 (exhibition), 1981 (salon). Sponsored by State College Color Slide Club. Held at Pennsylvania State University. Also sponsor CPFA Juried Photography Exhibition.

SLIDE CONTEST: General Color, 2x2 inches, mounted (glass preferred, no glass over cardboard); limit 4 per entrant.

AWARDS: $500 First, $300 Second, $100 Third Prizes. 20 $50 Honorable Mentions. 4 $25 prizes to sponsoring club members who receive no other prize.

JUDGING: By 3 judges based on point system. Not responsible for loss or damage.

ENTRY FEE: $5.

DEADLINES: Entry, judging, June. Event, July. Materials returned, August.

253

Chicago International Color Slide Exhibit
Chicago Camera Club
Doris M. Adair, Chair
1048 W. Ardmore Avenue
Chicago, Illinois 60660 U.S.A.

June

International; entry open to all; annual; established 1948. Sponsored by Chicago Color Camera Club. Recognized by PSA. Held at 3 locations in Chicago for 1 day each.

SLIDE CONTEST: General Color, 2x2 inches, glass mounts preferred; limit 4 per entrant. No cardboard between glass mounts.

AWARDS: PSA Gold Medal, Best of Show. PSA Medal, best contemporary. 10 Chicago Camera Club Gold Medals. Honorable Mention ribbons.

JUDGING: By 3 judges. Not responsible for loss or damage.

ENTRY FEE: $2.50.

DEADLINES: Entry, judging, May. Event, June.

254

El Camino Real International Color Slide Exhibition
Harry Sherwood, Chair
17031 Barneston Street
Granada Hills, California 91344
U.S.A. Tel: (213) 368-1984

April

International; entry open to all; annual; established 1948. Sponsored by El Camino Real Color Pictorialists Camera Club. Recognized by PSA. Average statistics: 1600 entries, 400 entrants, 20 awards. Held in various Southern California locations.

SLIDE CONTEST: General Color, 2x2 inches, glass mount; limit 4 per entrant. No slides too thick for standard projectors.

AWARDS: PSA Gold Medal, Best of Show. El Camino Gold Medal, best contemporary. 5 El Camino Gold, 10 Silver Medals. Honorable Mention ribbons. 1 Gold, 1 Silver, 1 Bronze El Camino Member Medal.

JUDGING: By 5 judges. Not responsible for loss or damage.

ENTRY FEE: $3, U.S., Canada, Mexico. $3.75, foreign. Additional for return air mail.

DEADLINES: Entry, February. Judging, notification, March. Event, April.

255

Farmers Fair Color Slide Exhibition
Farmers Fair of Riverside County
Marilyn M. Medore, Chair
P. O. Box 398
Hemet, California 92343 U.S.A.

August

International; entry open to all; annual; established 1969. Sponsored by Farmers Fair of Riverside County, PSA. Held in Sun City and Hemet, California for 1 day each, and daily at Fair in Riverside.

SLIDE CONTEST: General Color, 2x2 inches, glass or cardboard mounts; limit 4 per entrant. No entries too thick for projection.

AWARDS: PSA Gold Medal, Best of Show. Farmers Fair Awards, farm landscape, action, human interest, humor, general. Awards to best in Ramona tradition, by a senior citizen (over 60), by a member, humor.

JUDGING: By 3 judges. Not responsible for loss or damage.

ENTRY FEE: $2.50 ($3 foreign).

DEADLINES: Entry, judging, July. Event, August.

256

Greater Lynn International Color Slide Show
Greater Lynn Camera Club (GLCC)
Susan Mosser, Chair
173 Central Street
North Reading, Massachusetts
01864 U.S.A. Tel: (617) 664-2620

April

International; entry open to all; annual; established 1976. Motto: "The Spirit of '76." Sponsored and supported by GLCC. Recognized by PSA. Average statistics: 2400 entries, 600 entrants, 30 countries, 19 winners, 500 attendance. Held at GLCC, Saugus (2 days), South Shore Camera Club, North Quincy (1 day), and Foxboro, Massachusetts (1 day). Tickets: $1.

SLIDE CONTEST: General Color, 2x2-inch mounts (glass preferred); limit 4 per entrant. No glass-bound cardboard mounts.

AWARDS: PSA Gold Medal, Best of Show. NECCC Gold Medal, Panel Judges' Choice. 3 Individual Judges' Choice Gold Medals. 1 GLCC Gold Medal each, best contemporary, action, child (under 12), domestic animal, humor, landscape, nature, photojournalism, photo-travel, portrait, still-life, creativity, seascape slide. Special Gold Medal, best slide by member. Honorable Mention ribbons.

JUDGING: By 3 judges. Not responsible for loss or damage.

ENTRY FEE: North America, $3; others, $3.50, plus postage.

DEADLINES: Entry, February. Judging, March. Event, April.

257

Kenosha International Color Slide Exhibition
Kenosha Camera Club
Frieda Schurch, Exhibit Chair
3100 15th Street
Kenosha, Wisconsin 53142 U.S.A.
Tel: (414) 553-9703

May

International; entry open to all; annual; established 1965. Sponsored by Kenosha Camera Club. Recognized by PSA. Held at various locations in Kenosha, Wisconsin.

SLIDE CONTEST: General Color, 2x2 inches, mounted (glass preferred); limit 4 per entrant. No glass over cardboard.

AWARDS: PSA Gold Medals, Best of Show. Special Medals: best contemporary, natural landscape, industrial, portrait, humor, natural flower, tabletop, animal, human interest, night scene. 5 Judges' Medals. 50 Honorable Mention ribbons.

JUDGING: By 3 judges. Not responsible for loss or damage.

ENTRY FEE: $2.

DEADLINES: Entry, judging, April. Event, May.

258

Oregon Trail International Color Slide Exhibit
H. V. Ennor
P.O. Box 863
Tualatin, Oregon 97062 U.S.A.

Spring

International; entry open to all; annual; established 1956. Sponsored by

Forest Grove and King City Camera Clubs. Recognized by PSA. Held in Spokane, Vancouver (Washington); Eugene, Forest Grove, King City, Montebello (Oregon). Second contact: 16110 S.W. Queen Victoria Place, King City, Oregon 97223.

SLIDE CONTEST: General Color, 2x2 inches; limit 4 per entrant. No glass over ready mounts.

AWARDS: PSA Gold Medal, Best of Show. Contemporary Medal, best creative-experimental. 5 Oregon Trail Gold Medals. Mira Atkeson Memorial Medal, best nature slide. Charles Getzendaner Memorial Medal, best artistic permanence of traditional art. Special Mentions for best creative, human interest, humor, industry, portrait. First-time entrant special awards.

JUDGING: By 5-member selection jury. Not responsible for loss or damage.

ENTRY FEE: $3 ($3.50 outside North America).

DEADLINES: Entry, judging, April. Awards, May. Materials returned, June.

259

Pittsburgh All Color Exhibit
Ray Fleming, Co-Chair
206 Ennerdale Lane
Pittsburgh, Pennsylvania 15237
U.S.A.

October-November

International; entry open to all; established 1952. Sponsored by Natural Color Camera Club of Pittsburgh. Recognized by PSA. Held at locations on Pennsylvania and Ohio.

SLIDE CONTEST: General Color, 2x2 inches, cardboard or glass (preferred) mounted; limit 4 per entrant.

No glass over cardboard.

AWARDS: PSA Gold Medal, Best of Show. Lou F. Marks Memorial Award. Dr. Ralph Bailey Award, best documentary animal. Jules Levkoy Award, best travel. Five Natural Color Camera Club Awards.

JUDGING: By 3 judges. Not responsible for loss or damage.

ENTRY FEE: $2.50 ($3 foreign).

DEADLINES: Entry, judging, September. Notification, October. Event, October-November.

260

Richmond International Color Slide Exhibition
Camera Club of Richmond
Bernard B. Howell, Chair
2404 Buckingham Avenue
Richmond, Virginia 23228 U.S.A.

April

international; entry open to all; annual. Sponsored by Camera Club of Richmond. Recognized by PSA. Held at 2 locations in Richmond area.

SLIDE CONTEST: General Color, 2x2 inches, glass (preferred) or ready mounts; limit 4 per entrant. No entries too thick for projection.

AWARDS: PSA Gold Medal, Best of Show. 2 Silver Medals. Honorable Mention ribbons.

JUDGING: By 4 judges. Not responsible for loss or damage.

ENTRY FEE: $3 ($3.50 foreign).

DEADLINES: Entry, February. Judging, March. Event, April. Materials returned, July.

261

Springfield International Color Slide Exhibit

Springfield Photographic Society (SPS)
J. Owen Santer, Exhibit Chair
P. O. Box 255
Wilbraham, Massachusetts 01095
U.S.A.

February-March

International; entry open to all; annual; established 1951. Sponsored by SPS. Recognized by PSA. Average statistics: 2800 entries, 750 entrants, 23 countries. Held at different locations in Massachusetts, Connecticut, New York for 1 day each. Second contact: 15 Pleasant Place, East Longmeadow, Massachusetts 01028.

SLIDE CONTEST: General Color, 2x2 inches, glass or ready-mounted (no glass over ready-mounts); limit 4 per entrant.

AWARDS: PSA Gold Medal, Best of Show. SPS Medals, best nature, landscape or seascape, photojournalism, contemporary, slide of each judge's choice. SPS Douglas H. Wanser Trophy, best portrait. Newhall Silver Medal, best feminine portrait. NECCC Medal, best by a New England entrant. Nutmegger Medal, best travel. Honor award ribbons to high-scoring entries.

JUDGING: By 3 judges. Not responsible for loss or damage.

ENTRY FEE: $3 U.S. and Canada; $3.50 foreign. Entrant pays return postage.

DEADLINES: Entry, judging, January. Exhibit, February-March. Awards, March.

262

Tripod Camera Club Color Slide International Exhibition

Roger Houdeshell
3102 Catalpa Drive
Dayton, Ohio 45405 U.S.A.

December

International; entry open to all; annual; established 1981. Sponsored by Tripod Camera Club. Recognized by PSA. Second contact: Ernest H. Guenther, 83 Dale Ridge Drive, Centerville, Ohio 45459.

SLIDE CONTEST: General Color, 2x2 inches, cardboard or glass (preferred) mounts; limit 4 per entrant. No slides too thick for projection.

AWARDS: Tripod Camera Club Medals, Best of Show, best portrait, still life, by Ohio entrant, landscape, contemporary, seascape. 3 Judges' Choice Medals. Honorable Mention ribbons.

JUDGING: By 3 judges. Not responsible for loss or damage.

ENTRY FEE: $2.75 plus postage if airmail return.

DEADLINES: Entry, November. Event, judging, December.

263

Wisconsin International Salon of Photography

Image Makers Camera Club
Patricia A. Deuster, Chair
3402 North 60th Street
Milwaukee, Wisconsin 53216 U.S.A.

October

International; entry open to all; annual; established 1977. Sponsored by Image Makers Camera Club. Recognized by PSA. Held at 2 locations in Wisconsin for 1 day each.

SLIDE CONTEST: General Color, 2x2 inches, mounted (glass or ready-mounts); limit 4 per entrant. No glass over ready-mounts.

AWARDS: PSA Gold Medal, Best of Show. Wisconsin Trophies, nature, portrait, contemporary, judges' choice (3). Honorable Mention ribbons.

JUDGING: By 3 judges. Not responsible for loss or damage.

ENTRY FEE: $2.25 ($2.75 foreign) plus $1 for airmail return.

DEADLINES: Entry, judging, September. Event, October.

SLIDES (General Foreign)

See SLIDES (in U.S.) for definition of Contemporary. (Also see other SLIDE CATEGORIES.)

264

Northern Counties Photographic Federation International Exhibition of Color Transparencies
Jane H. Black, Chair
15, Southlands, Tynemouth
Tyne and Wear, ENGLAND

September-October

International; entry open to all; annual; established 1980. Replaced Stockton Photo Color Society International Exhibition (discontinued in 1978). Purpose: to promote competition among international color photographers. Sponsored and supported by Northern Counties Photographic Federation. Recognized by PSA. Average statistics: 2000 entries, 500 entrants, 36 countries, 330 finalists, 29 awards, 15 exhibitions. Held in towns in northern counties of England. Second contact: L. R. Hollingworth, 37 Alandene Avenue, Watnall, Nottingham NG16 1HH, England.

SLIDE CONTEST: General Color, 2x2 inches (5x5cm), glass mounts preferred; limit 4 per entrant. No glass over cardboard or plastic mounts.

AWARDS: Merit Certificates. Member and special awards.

JUDGING: By 3 judges. Not responsible for loss or damage.

ENTRY FEE: $3 (£1 U.K.). Foreign checks add 50¢; airmail return, add $1.50.

DEADLINES: Entry, judging, September. Event, September-October.

265

Royal Photographic Society International Slide Competition and Exhibition
RPS National Center of Photography
The Octogon
Milsom Street
Bath BA1 1DN, ENGLAND
Tel: 0025-62841

Fall

International; entry open to all; annual. Sponsored by RPS and Konishiroku UK. Also sponsor International Exhibition of Photography, Focus Convention, London Diaporama Festival, other exhibitons.

SLIDE CONTEST: General Color, 2x2 inches mounted; limit 4 individual, 1 portfolio. Group entries accepted (limit 10 members). No entries duplicated in concurrent London exhibitions. Categories: Individual, Portfolio (3 slides on same subject).

AWARDS: £250 and Konishiroku Trophy, best individual. £250 and

Sakura Color Film Trophy, best portfolio. £125 to runners-up, each category. Selection of winners for touring exhibition.

JUDGING: By 4 RPS members. Sponsor may retain for touring exhibition; reproduce for journal, other publications. Not responsible for loss or damage.

ENTRY FEE: £2 (individuals), £10 (groups). Non-Sterling payments, add £1 for bank charges.

DEADLINES: Entry, August. Event, awards, Fall.

266

Martigues International Week of Color Slides
Martigues Photo Club
Jean Dumas, President
26, Les Rayettes
13500 Martigues, FRANCE

March-April

International; entry open to all; biennial (even years); established 1974. Sponsored and supported by Martigues Photo Club. Recognized by PSA, FIAP, FNSPF.

SLIDE CONTEST: General, Contemporary Color, 2x2 inches, glass-mounted; any process; limit 4 per entrant. Categories: General, Contemporary.

AWARDS: PSA Gold Medal, Best of Show. FIAP Gold, Silver, Bronze Medals, 3 best entries. Martigues Photo Club Awards, best French entry, best human, nature, research slides.

JUDGING: By 3 judges. Not responsible for loss or damage.

ENTRY FEE: $3 (15Ff).

DEADLINES: Entry, February. Judging, March. Event, March-April.

267

Nantes International Salon of Color Slides
Nantes Photo Club
Marian Boyer
27 rue du Pontereau
44300 Nantes, FRANCE

January-February

International; entry open to all; biennial (odd years). Sponsored by Nantes Photo Club. Recognized by PSA, FIAP, FNSPF. Second contact: Yves Crespin, 38 rue du Havre, 44800 Saint Herblain, France.

SLIDE CONTEST: General Color, 2x2 inches; limit 4 per entrant.

AWARDS: FIAP Gold, Silver, Bronze Medals. Jury Gold, Silver, Bronze Medals. Honorable Mentions.

JUDGING: By club members. Not responsible for loss or damage.

ENTRY FEE: $2.

DEADLINES: Entry, judging, December. Event, January-February.

268

Vincennes International Color Slide Exhibition
Cine Flash Club (CFCV)
Claude Coureuil, Salon Secretary
34, rue des Vignerons
94300 Vincennes, FRANCE
Tel: 347-62-91

March

International; entry open to all; annual; established 1973. Formerly called COUPE CHARLES PATHE, established 1967. Sponsored by CFCV. Recognized by PSA, FIAP, FNSPF. Average statistics: 3300 entries, 850

entrants, 40 countries, 217 accepted, 40 awards.

SLIDE CONTEST: General Color, 2x2 inches, any process, limit 4 per entrant.

AWARDS: PSA Gold Medal, Best of Show. FIAP Gold, Silver, Bronze Medals. Gold, Silver, Bronze Medals, best club entries. CFCV Silver and Bronze Medals, best sport, reporting, portrait, landscape, humor. ACFC Honors, entrants with 10 acceptances. ECFC Honors, entrants with 25 acceptances.

JUDGING: By 3 judges. Not responsible for loss or damage.

ENTRY FEE: $3 (foreign checks add 50 cents), 15F.

DEADLINES: Entry, February. Judging, event, March. Materials returned, April.

269

Pforzheim Photo Club International Slide Competition
Dr. H. J. Hein
Baumstrasse 14
D-7536 Ispringen, WEST GERMANY (FRG)

May

International; entry open to all; biennial (even years); established 1980. Only competition for 6x7cm slides. Sponsored by Pforzheim Photo Club. Recognized by VDAV, FIAP.

SLIDE CONTEST: General Color, 6x7cm, unmounted (protected by transparent foil). Competition includes monochrome slides.

AWARDS: Medals.

JUDGING: By 5 judges.

ENTRY FEE: $5 each overseas.

DEADLINES: Entry, January. Acceptance, March. Judging, April. Event, May.

270

Hong Kong University International Color Slide Exhibition
HKUSU Photographic Society
Fong Tai Wai, Chair
University of Hong Kong Students' Union Office
Pokfulam Road, HONG KONG
Tel: H-468455

Winter

International; entry open to all; annual; established 1961. Sponsored by HKUSU Photographic Society. Average statistics: 500 entries, 250 entrants, 25 countries, 12 awards. Held at Loke Yew Hall, University of Hong Kong, and MTR Admiralty Station, for 7 days. Also sponsor Student Salon of Photography for monochrome, color prints.

SLIDE CONTEST: General Color, 2x2 inches (5x5cm), mounted; limit 6 per entrant.

AWARDS: Advisor's Cup, Best of Show. 1 Gold, 2 Silver, 3 Bronze Trophies. 5 Bronze Medals.

JUDGING: By 5 judges. Sponsor reserves right to reproduce, publish. Not responsible for loss or damage.

ENTRY FEE: $3.50 (HK$10 Hong Kong, Macau).

DEADLINES: Entry, judging, October. Awards, November. Event, December.

271

Howrah Color Salon International Exhibition
Society of Photographers (SOP)
60-2 Hriday Krishna Banerjee Lane
Howrah, INDIA

February-March

International; entry open to all; annual; established 1969. Supported by FIP, PSA, SOP (founded 1964). Held in Howrah, India for 1 week.

SLIDE CONTEST: General Color, 2x2 inches; limit 4 per entrant.

AWARDS: PSA Gold Medals, Best of Show, best contemporary. 3 SOP Plaques. 10 Honor Certificates. SOP Award, best club entry. Swati Dass Memorial Plaque. 100 Rs. Cash Award, best Indian entry.

JUDGING: By 3 judges. Not responsible for loss or damage.

ENTRY FEE: $3. Foreign checks, add 25 cents; additional for return airmail.

DEADLINES: Entry, judging, January. Event, February-March.

272

Chianciano Terme International Color Slide Exhibition
Sinalunga Photographic Group
Ariano Guastaldi
Piazza Garibaldi 37
53048 Sinalunga, ITALY Tel: (0577) 69480

June

International; entry open to all; biennial (odd years); established 1979. Alternates with S. Martino d'Oro National Photography Exhibition. Sponsored by Sinalunga Photographic Group. Recognized by PSA, FIAP, FIAF. Average statistics: 3900 entries, 1000 entrants, 43 countries, 273 finalists, 50 awards. Held in Sinalunga for 2 weeks. Second contact: Carlo Paolucci, Via Umberto I, 55, 53048 Sinalunga, Italy.

SLIDE CONTEST: General Color, limit 4 per entrant.

AWARDS: Peacock Trophies, FIAP Medals, Honorable Mentions.

JUDGING: By 5 judges.

ENTRY FEE: $3.

DEADLINES: Entry, January. Judging, notification, May. Event, June. Materials returned, July.

273

Color in Transparence International Competition
Azienda Autonoma Soggiorno Turismo Como (AAST Como)
Alfredo Mantovani, Salon Chair
Piazza Cavour 33
Casella Postale 311 (Centrale)
I-22100 Como, ITALY Tel: (031) 27-25-18; 26-55-92

June

International; entry open to all; biennial (even years); established 1964. Annual to 1972. Sponsored by AAST Como, Circolo Cinefotografico Como. Recognized by PSA, FIAP, FIAF. Average statistics: 315 accepted entries of 6011, 220 accepted entrants of 1500, 28 countries. Held in Villa Olmo Como for 2 days. Have photographic cruise on Lake Como for all competitors.

SLIDE CONTEST: General Color, 2x2 inches (5x5cm) or 2-3/4x2-3/4 inches (7x7cm), mounted (glass preferred); limit 4 per entrant. Categories: Portrait, Landscape, General Subjects, Nature, Contemporary (Special Techniques).

AWARDS: Individuals: FIAP Gold Medal, entrant with most accepted works. PSA Gold Medal, Best of Show. AAST Como Gold Medals, best each category. Gold Medals, 2nd-8th place each category. Clubs: 3 Gold Boat Trophies, best clubs. Silver Trophies, clubs with 3 admitted entries. Lucia D'Oro, First, Second, Third Prizes. Gold Medal winners (or club delegates are guests of Como Tourist Office for award ceremonies. Como silk products to entrants with 2 or more slides accepted.

JUDGING: By 5 international judges. Not responsible for loss or damage.

ENTRY FEE: Individuals: $5 (plus $1.50 for air mail return). Collective entry (6 members minimum): $4 each (plus 50¢ for air mail return). Foreign checks add 25¢.

DEADLINES: Entry, October. Judging, notification, May. Event, awards, June.

274

Cupolone Photographic Group International Color Slide Competition
Gruppo Fotografico Il Cupolone
Renzo Pavanello
Via dei Servi, 12 Rosso
50122 Florence, ITALY
Tel: 055-211927

November

International; entry open to all; annual; established 1981. Sponsored by Gruppo Fotografico Il Cupolone. Recognized by FIAP, PSA. Held in Florence for 1 day.

SLIDE CONTEST: **General Color,** 2x2 inches (5x5cm) glass mounts, normal frames; limit 4 per entrant. Categories: Portrait, Landscape, General Subjects, Contemporary.

AWARDS: 10 Gold Cupoloni, 10 Silver Cupoloni, 3 FIAP Medals, club prizes.

JUDGING: By 9 judges. Not responsible for loss or damage.

ENTRY FEE: $3 plus postage.

DEADLINES: Entry, judging, October. Event, awards, November. Materials returned, December.

275

Torrione d'Oro International Slide Contest
Cine Club William Barinetti
Renzo De Maestri, Chair
Casella Postale 2
17021 Alassio, ITALY

December

International; entry open to all; biennial (odd years); established 1959. Sponsored by Cine Club William Barinetti. Recognized by FIAF, FIAP, PSA. Held in Cine Club, Alassio, Italy for 1 day.

SLIDE CONTEST: **General Color,** 5x5cm, glass mounts; limit 4 per entrant.

AWARDS: Gold Torrione First Prize, Best of Show. 2 Silver Trophies. 3M Italia S.P.A. Gold Medal. 3 FIAP Medals. PSA Gold Medal, Best of Show. Silver Torrione, best portrait. Bronze Torriones, varied subjects, photojournalism, landscape, contemporary, sports.

JUDGING: By 6 judges. Not responsible for loss or damage.

ENTRY FEE: $4 (3500 lire).

DEADLINES: Entry, judging, November. Event, December. Materials returned, January.

276
Luxembourg International Color Slide Exhibition
Camera Luxembourg
Marc Wagner, Chair
B.P. 104
L-2011 Luxembourg, LUXEMBOURG
GRAND-DUCHY

October

international; entry open to all; annual; established 1952. Sponsored by PSA, FIAP. Held throughout Luxembourg and cities of neighboring countries.

SLIDE CONTEST: General Color, 2x2 inches; limit 4 per entrant.

AWARDS: PSA Gold Medal, Best of Show. FLPA Gold Medal. FIAP Gold, Silver, Bronze Medals. Camera Luxembourg Gold, Silver, 5 Bronze Medals. 10 Merit Certificates.

JUDGING: By 3 judges. Not responsible for loss or damage.

ENTRY FEE: $3.50 (100 Fr. lux). add $1.50 for foreign checks, $1 for air mail return.

DEADLINES: Entry, judging, September. Event, October. Materials returned, November.

277
San Fermin International Photographic Salon
Agrupacion Fotografica de Navarra
Manuel J. Pardos, Secretary
Calle Zapateria, 42-2
Pamplona, SPAIN Tel: (948) 222358

Summer

International; entry open to all; annual; established 1955. Formerly called SAN FERMIN LATIN SALON to 1977, SAN FERMIN EUROPEAN SALON to 1979. Purpose: to expand photographic art. Supported by Ayuntamiento de Pamplona, Disputacion Foral de Navarra, Ministerio de Cultura of Spain. Recongized by FIAP, Federacion de Agrupaciones Fotograficas del Pais Vasco. Average statistics (all sections): 5256 entries, 1508 entrants, 30 countries, 170 accepted, 13 awards. Held at Pamplona for 4 months (exhibition). Second contact: Pio Guerendiain, President, San Fermin International Photographic Salon, Agrupacion Fotografica de Navarra, Apartado 174, Pamplona, Spain.

SLIDE CONTEST: General Color, 5x5 to 7x7 inches; limit 4 per entrant.

AWARDS: "Trofeo Encierro", Best of Show (including monochrome prints). FIAP Gold, 2 Silver, 3 Bronze Medals. Honorable Mentions. Exhibition of winners.

JUDGING: All entries viewed in entirety by 3 different judges, each year. Not responsible for loss or damage.

ENTRY FEE: None.

DEADLINES: Entry, May. Judging, June. Event, June-September. Awards, September. Materials returned, October.

278
Siam Color Slide International Exhibition
Siam Color Slide Club
Lert Unhanand
P.O. Box 11-1190
Bangkok 11, THAILAND

October

International; entry open to all; biennial (odd years); established 1974. Held at AUA Language Center, and Photographic Society of Thailand in Bangkok. Sponsored by Siam Color Slide Club. Recognized by PSA.

SLIDE CONTEST: General Color, 2x2 inches (5x5cm), glass or ready mounts; limit 4 per entrant. No glass over cardboard.

AWARDS: PSA Gold Medals, Best of Show, best contemporary. 2 Silver, 3 Bronze Medals. Gold Medal, best by local entrant. 10 Merit Certificates.

JUDGING: By 5 judges. Not responsible for loss or damage.

ENTRY FEE: $3.50. Foreign checks, add 50¢; additional for return airmail.

DEADLINES: Entry, judging, September. Event, October. Materials returned, November.

SLIDES (General, Nature)

See SLIDES (in U.S.) for definition of Contemporary. (Also see other SLIDE CATEGORIES.)

| 279 |

Birkenhead International Color Salon
Birkenhead Photographic Association
D.G. Cooper, Chair
29 Fairview Road
Oxton, Birkenhead, Merseyside L43 5SD, ENGLAND Tel: (051) 652-4773

June-July

International; entry open to all; annual; established 1972. Sponsored by Birkenhead Photographic Association. Recognized by PSA, FIAP. Average statistics: 3500 entries, 750 entrants, 45 countries, 80 awards, 1500 attendance. Held at Birkenhead, Bury, Chester, Conwy, Liverpool, Nottingham, Oldham, St. Annes-on-Sea, Sheffield for varying periods. Second

contact: Val Jones, 17 Whitfield Lane, Heswall, Wirral, Merseyside L60 7SA, England.

SLIDE CONTEST: General, Nature Color, 2x2 inches (5x5cm), glass mounts preferred; limit 4 per category. No glass over ready-mounts. Categories: General (including contemporary), Nature.

AWARDS: PSA Gold Medal, best general; Silver Medals, best nature in controlled conditions, best authentic wildlife. FIAP Gold Medal, best contemporary; Silver Medal, second best general. Bronze Medals, general, nature, highest aggregate score in each category. Honorable Mention Certificates, each category.

JUDGING: By 3 judges each category. Not responsible for loss or damage.

ENTRY FEE: $3.50 (£1.25) per category. Additional for airmail return.

DEADLINES: Entry, May. Judging, June. Event, June-July.

| 280 |

Worcestershire International Exhibition of Color Photography
Malcolm Haynes, Chair
88 Christine Avenue
Rushwick Worcester WR2 5SR, ENGLAND Tel: 423167

March

International; entry open to all; annual; establisbed 1953. Sponsored and supported by Worcestershire Camera Club, founded 1896. Recognized by PSA. Average statistics: 3000 entries, 35 countries, 2000 attendance, 12 exhibitions. Held at Christopher Whitehead Girls' School, Bromwich Road, Worcester; Sutton Coldfield; Bromsgrove; Chippenham; Leeds; other locations. Second contact: L. R. Holling-

worth, 37 Alandene Avenue, Watnall, Nottingham NG16 1HH, England.

SLIDE CONTEST: General, Nature Color, 2x2 inches (5x5cm), glass mounts preferred (no glass over cardboard); limit 4 per category. Categories: Pictorial, Nature.

AWARDS: PSA Gold Medal, Best of Show. PSA Silver Medals, best authenticated wildlife, best nature (other than wildlife). Royal Worcester Porcelain Awards, best landscape, best contemporary (pictorial), best botanical. Honorable Mentions. Royal Worcester Porcelain Plate for highest total marks.

JUDGING: By 3 judges per category. Not responsible for loss or damage.

ENTRY FEE: $3 (foreign checks add 50¢), £1.25 per category. Entrant pays airmail return.

DEADLINES: Entry, notification, February. Event, March. Materials returned, April.

281

Spectrum International Color Slide Exhibition
Bridget Buckingham, Chair
Buck House
Les Croutes, Vale
Guernsey, Channel Islands, GREAT BRITAIN Tel: 0481-45956

May

International; entry open to all; annual; established 1973. Largest color slide exhibition in British Isles. Purpose: to promote photography and friendly contact among photographers. Sponsored by Spectrum, Guernsey. Recognized by PSA. Average statistics: 4600 entries, 1000 entrants. Held at St. Peter Port, Guernsey for 2 days. Tickets: £1.50.

SLIDE CONTEST: General, Nature Color, 2x2 inches (5x5cm); limit 4 per category. Categories: General (includes contemporary), Nature.

AWARDS: PSA Gold Medal, Best of Show. PSA Silver Medals, best wildlife, nature (other than wildlife). Genuine Guernsey Milk Cans, runners-up, Guernsey entrant with highest score, both categories. Tourist Committee Awards, best insect and slide chosen by each judge. Honorable Mention Certificates at judges' discretion. Certificates of Honor to entrants having 3 slides minimum accepted each year in same category for 3 consecutive years.

JUDGING: By 3 judges per category. Not responsible for loss or damage.

ENTRY FEE: $3.50. Additional for airmail return.

DEADLINES: Entry, judging, April. Event, May.

282

Paisley International Color Slide Exhibition
R. G. Paton, Chair
54 Irvine Road
Kilmaurs, Kilmarnock KA3 2RR, SCOTLAND U.K. Tel: 056-381-688

January

International; entry open to all; annual; established 1969. Sponsored by Paisley Color Photographic Club. Recognized by PSA, FIAP, PAGB, SPF. Average statistics: 3500 entries, 900 entrants, 40 countries. Held in South Scotland for 2 weeks. Second contact: D. L. McEwan, 73 Hazelwood Road, Bridge of Weir, Renfrewshire PA11 3DX, Scotland.

SLIDE CONTEST: Pictorial, Nature Color, 2x2 inches (5x5cm); limit

4 per category. Categories: Pictorial (Traditional, Contemporary), Nature.

AWARDS: PSA Gold Medal, best pictorial. FIAP Gold Medal, best contemporary. PSA Silver Medals, best nature, best authenticated wildlife. FIAP Silver Medal, best total entry. FIAP Medals, best botanical, zoological, general. 3 Paisley Medals. Honorable Mention certificates, Tartan Ties, FIAP ribbons for meritorious work.

JUDGING: By 3 judges per category. Entrants retain all rights. Not responsible for loss or damage.

ENTRY FEE: $3.50 each category.

DEADLINES: Entry, November. Judging, December. Event, January.

| 283 |

Welsh Photographic Federation International Color Slide Exhibition
W. A. Stuart-Jones
Bryn-Hafod, 52 Caswell Road
Mumbles, Swansea SA3 4SD,
WALES U.K. Tel: 0792-66742

August

International; entry open to all; annual; established 1976. Purpose: to foster showing of international photography. Sponsored by Welsh Photographic Federation. Supported by The Friends Fund. Recognized by PSA, FIAP, PAGB. Average statistics: 2500 entries, 650 entrants, 35 countries, 6 awards. Held at various locations in Wales for 2 weeks. Second contact: Mrs. J. M. Chatfield, 3 Cyncoed Close, Dunvant, Swansea SA2 7RS, Wales, U.K.

SLIDE CONTEST: **General, Nature Color,** 2x2 inches, mounted; limit 4 per category. Categories: General, Natural History.

AWARDS: PSA Gold Medal, best

pictorial slide; Silver Medals, best wildlife, best botanical. FIAP Gold Medal, best contemporary; Silver Medal, best natural history; Bronze Medal, best humor. Welsh Silver Awards each category. Honorable mention diplomas each category.

JUDGING: By 3 judges per category. May reproduce in exhibition catalog. Not responsible for loss or damage.

ENTRY FEE: $3 (foreign checks add 50¢) each category.

DEADLINES: Entry, June. Judging, July. Event, August.

SLIDES (General, Nature, Journalism)
Includes PICTORIAL, STEREO SLIDES. (Also see other SLIDE CATEGORIES.)

| 284 |

Colorama International Color Slide Exhibit
Arlene Bloom
1864 61st Street
Brooklyn, New York 11204 U.S.A.
Tel: (212) 259-3373

October-December

International; entry open to all; annual; established 1974. Sponsored by Colorama, Metropolitan Camera Club Council (MCCC). Recognized by PSA. Held in Brooklyn and Bethpage, New York for 1 day each.

SLIDE CONTEST: **General, Journalism Color,** 2x2 inches (5x5cm); limit 4 per category. Categories: General, Photojournalism.

AWARDS: *General:* PSA Gold Medals, Best of Show, best contemporary. MCCC Awards, second best of show, contemporary. 3 Colorama Medals. Special awards, third best contemporary, action, architecture, sports action, child, child action, close-up, creativity, dog, experimental, female portrait, figure study, friendship-understanding, humor, informal portrait, landscape, male portrait, nature, photojournalism, night scene, portrait, still life, technique, travel, seascape. *Photojournalism:* MCCC Medal, Best of Show. Colorama Medal, second best of show. Special awards, third best, salon theme, man at work, disaster, humor, child's world. *Both Sections:* Total Score Awards to entrant under age 26, PAI club member, U.S. entrant, non-U.S. entrant, club members, best Brooklyn, international relations in photography, others. Honorable Mention ribbons.

JUDGING: By experienced judges and exhibitors.

ENTRY FEE: $2.50 plus return postage.

DEADLINES: Entry, judging, October. Notification, November. Event, October-December.

285

Cornhusker International Exhibition of Photography
Lincoln Camera Club
Ruth Ternes, Chair
3441 South 39
Lincoln, Nebraska 68506 U.S.A.

March

International; entry open to all; annual; established 1980. Sponsored by Lincoln Camera Club. Recognized by PSA. Second contact: Steve Boeckman, General Chair, 3300 Franklin Street, Lincoln, Nebraska 68506.

SLIDE CONTEST: General, Journalism Color, 2x2 inches, cardboard or glass (preferred) mounts; limit 4 per category. May include sequence of 2 or more. No glass over cardboard mounts. Categories: General, Photojournalism.

STEREO SLIDES CONTEST: General Color, limit 4 per entrant.

AWARDS: General: PSA Gold Medal, Best of Show. Cornhusker Medals and $25, best nature, agriculture, portrait. Cornhusker Medal, best contemporary, best by Nebraska entrant. 3 Judges' Choice. Sten Anderson Memorial Award, best architecture. Photojournalism: PSA Gold Medal, Best of Show. Cornhusker Medal and $25, best human interest. Cornhusker Medal, best by Nebraska entrant. 3 Nebraska Medals, Judges' Choice. Sten Anderson Memorial Award, man at work. Honorable Mention ribbons, each category. Stereo slide awards not specified.

JUDGING: By 3 judges each category. Not responsible for loss or damage.

ENTRY FEE: $2.75 ($3 foreign).

DEADLINES: Entry, event, judging, March. Materials returned, April.

286

Houston International Exhibition of Photography
Harrell Rodgers, General Chair
5742 Stillbrooke
Houston, Texas 77096 U.S.A.

February-March

International; entry open to all; annual; established 1964. Recognized by PSA. Held at locations in Houston, Texas.

SLIDE CONTEST: General, Nature, Journalism Color, 2x2 inches;

limit 4 per entrant. Categories: General, Nature, Photojournalism.

AWARDS: PSA Gold Medals, Best of Show, best photo-journalism. PSA Silver Medals, best nature, authenticated wildlife. Houston Medals, scenic (general), nature (botany, sunset, zoology), photojournalism (action). Special Awards, general (still-life, contemporary portrait, adult portrait, judges' favorite, figure study), nature close-up, photojournalism (sports, spot news). Honorable Mention ribbons.

JUDGING: By 4 judges each category. May withhold awards. Not responsible for loss or damage.

ENTRY FEE: $2.50 ($3 foreign) plus postage.

DEADLINES: Entry, judging, February. Event, February-March.

287

Southwest International Exhibition of Photography
Southern California Association of Camera Clubs (SCACC)
A. Richman (Dick) Angelo
1925-1/2 30th Street
San Diego, California 92102 U.S.A.

September

International; entry open to all; established 1956. Nature section added 1965. Sponsored by SCACC. Recognized by PSA. Held at locations throughout San Diego.

SLIDE CONTEST: **General, Nature, Journalism Color,** 2x2 inches; limit 4 per category. No glass over cardboard. Categories: General, Nature, Photojournalism.

AWARDS: PSA Gold Medals, Best of Show (general), best contemporary. PSA Silver Medals, Best of Show (nature), best wildlife. 10 SCACC Medals. Photo Naturalists Camera Club Gold Medal, environment in nature. Western Photographer magazine Medals, each category.

JUDGING: By 3 judges each color and nature, 4 for photojournalism. Not responsible for loss or damage.

ENTRY FEE: $2.50. Foreign checks, add 50¢. Entrant pays return airmail.

DEADLINES: Entry, August. Judging, event, September. Materials returned, October.

288

New Zealand International Color Slide Exhibition
Feilding Camera Club
The Secretary
P.O. Box 161
Feilding, NEW ZEALAND

October

International; entry open to all; annual; established 1956. Sponsored by Feilding Camera Club, PSNZ. Recognized by PSA, FIAF.

SLIDE CONTEST: **Pictorial, Nature, Journalism Color,** 2x2 inches (5x5cm), standard or glass (preferred) mounts; limit 4 per category. Group entries accepted. No glass over readymounts. Categories: Pictorial, Nature, Photojournalism.

AWARDS: PSNZ Gold, Silver, Bronze Medals, Honor Awards each category.

JUDGING: By 3 judges each category. Not responsible for loss or damage.

ENTRY FEE: $4 ($4 NZ) each category.

DEADLINES: Entry, judging, September. Notification, event, October. Materials returned, November.

SLIDES (General, Nature, Journalism, Travel)

Includes PICTORIAL, SPORTS. (Also see other SLIDE CATEGORIES.)

289

Columbus International Exhibition of Photography

Central Ohio Camera Club Council
James A. Stull, General Chair
P.O. Box 16115
Columbus, Ohio 43216 U.S.A.
Tel: (614) 488-7382, 466-4974

November

International; entry open to all; annual; established 1946. Not held 1963-1978. Sponsored and supported by Central Ohio Camera Club Council. Recognized by PSA. Average statistics: 4400 entries, 1100 entrants, 25 countries, 15 awards, 500 attendance. Exhibited in Columbus for 2 weeks. Second contact: Wallace P. Cash, 5153 Bigelow Drive, Hilliard, Ohio 43206; tel: (614) 876-1066.

SLIDE CONTEST: Pictorial, Nature, Travel Color, 2x2 inches, glass or cardboard mounts (no glass over cardboard); limit 4 per category. Categories: General, Nature, Travel.

AWARDS: PSA Medals, best pictorial, nature, wildlife, travel. Judges' Choice Medals, best category; Honorable Mentions each category. Medal to best travel theme (varies yearly).

JUDGING: By 3 judges each category. Not responsible for loss or damage.

ENTRY FEE: $3 each category. Entrant pays return airmail.

DEADLINES: Entry, judging, event, November. Materials returned, December.

290

Motherlode International Color Slide and Phototravel Exhibition

Placer Camera Club (PCC)
James G. Standley, Chair
1330 Ponderosa Court
Colfax, California 95713 U.S.A.

March

International; entry open to all; annual; established 1955 (color), 1974 (travel). Sponsored by PCC. Recognized by PSA. Held in Auburn and Sacramento, California for 1 day each. Second contact: P.O. Box 990, Auburn, California 95603.

SLIDE CONTEST: General, Travel Color, 2x2 inches (glass mounts preferred); limit 4 per category. Categories: General (including contemporary, photojournalism), Travel.

AWARDS: PSA Gold Medals, Best of Show, best travel. PCC Medals, best contemporary, photojournalism, 4 others at judges' discretion. Honorable Mention ribbons.

JUDGING: Entry review by 1 judge. Awards judging by 3 photographer-lecturer-travelers per category. Not responsible for loss or damage.

ENTRY FEE: $3.50 ($4 foreign) per category. Additional for airmail return.

DEADLINES: Entry, judging, February. Event, March.

291

Orange Empire (OE) International Exhibition of Photography

Marilyn Carpenter, Chair
2371 Azure Avenue
Santa Ana, California 92707 U.S.A.

May-June

International; entry open to all; established 1973. Sponsored by OE. Recognized by PSA. Held at locations in Southern California for 2 days each category. Second contact: Corb Chrisie, Co-Chair, 12686 Morgan Lane, Garden Grove, California 92640.

SLIDE CONTEST: General, Nature, Journalism, Travel Color, 2x2 inches; 4 per category. No glass over cardboard mounts. Categories: General, Nature, Photojournalism, Travel.

AWARDS: PSA Gold Medals, general, photojournalism, travel. PSA Silver Medals, nature, authenticated wildlife. 28 Medals, traditional and contemporary. OE Gold Medal, contemporary. OE Silver Medals, general (11 traditional, 2 contemporary), 8 nature, 8 photojournalism, 6 travel. Orange County Camera Club Medal, best camouflage nature.

JUDGING: By 3 judges each category. Not responsible for loss or damage.

ENTRY FEE: $2.75 each category.

DEADLINES: Entry, April. Judging, notification, May. Event, May-June.

292

Southwest Michigan Council of Camera Clubs (SWMCCC) International Exhibition of Photography

Paul Champion Sr.
1332 Walwood Drive N.E.
Grand Rapids, Michigan 49505
U.S.A.

November-December

International; entry open to all; annual; established 1968. Sponsored by SWMCCC. Held at locations in Michigan and Indiana. Second contact: Donald Hillman, General Chair, 1037 Paradise Lake Drive S.E., Grand Rapids, Michigan 49506.

SLIDE CONTEST: General, Nature, Travel Color, 2x2 inches; limit 4 per category. Categories: General, Nature, Travel.

AWARDS: General: SWMCCC Gold Medals, Best of Show, best contemporary. SWMCCC Bronze Medals, best portrait, landscape, still life. Nature: PSA Silver Medals, Best of Show, wildlife. SWMCCC Bronze Medals, best zoology, botany, general nature. Travel: PSA Gold Medal, Best of Show. 2 SWMCCC Bronze Medals, best runners-up.

JUDGING: By 3 judges per category. Not responsible for loss or damage.

ENTRY FEE: $4 each category.

DEADLINES: Entry, judging, November. Event, November-December.

293

Tulsa Magic Empire Color Slide Exhibit

Tulsa Council of Camera Clubs
Eddie McInnes, General Chair
P.O. Box 52031
Utica Square Station
Tulsa, Oklahoma 74152 U.S.A.

October

International; entry open to all; annual; established 1946. Purpose: to further pursuit of photographic excellence Sponsored by Tulsa Council of Camera Clubs. Recognized by PSA. Average statistics: 4000 entries, 1000

entrants, 35 countries, 22 awards. Second contact: 712 West 46th Street, Sand Springs, Oklahoma 74063.

SLIDE CONTEST: General, Nature, Travel Color, 2x2 inches; limit 4 per category. Categories: Color, Nature, Travel.

AWARDS: Color: PSA Gold Medal. 3 Tulsa Magic Empire Best of Show Medals plus 1 each best contemporary, landscape, adult portrait, child portrait, unposed happy child, creative, Fall color, domestic animal, by member of sponsoring club. Nature: PSA Silver Medals, best nature, wildlife. 2 Tulsa Magic Empire Best of Show Medals plus 1 each best landscape, botanical, insect, seascape, sunset, natural forces, by member of sponsoring club. Travel: PSA Gold Medal. Tulsa Magic Empire Best of Show Medal plus 1 each best native craftsman, people in native environment, native costume, landscape, native children.

JUDGING: By 3 judges per category. Not responsible for loss or damage.

ENTRY FEE: $3 each category (U.S., Canada, Mexico); $3.50 each category (others).

DEADLINES: Entry, judging, awards, October. Materials returned, November.

294

Westchester International Slide Exhibitions
Color Camera Club of Westchester
Betty K. Bruce, Chair
50 Larchwood Road
Larchmont, New York 10538 U.S.A.
Tel: (914) 834-9099

April

International; entry open to all; annual; established 1957. Sponsored by Color Camera Club of Westchester. Recognized by PSA. Average statistics (all sections): 5196 entries, 1299 entrants, 31 countries, 28 awards. Held at various locations in Larchmont for 1 day each. Have workshops or programs (monthly).

SLIDE CONTEST: Pictorial, Nature, Journalism, Travel Color, 2x2 inches, ready-mounts or glass; limit 4 per category. No similar slides in 2 or more categories. Categories: Pictorial, Nature, Photojournalism, Travel.

AWARDS: PSA Medals, best each category, authenticated wildlife (nature). Pictorial: Ludwig Kramer Medal, human interest. Dara Medal, world of child. Redstone Medal, dog or cat. Bowron Medal, landscape or seascape. Charles Macchi Medal, portrait. Westchester Medals, best contemporary at judges' discretion. Nature: Audubon Award, birds or bird lore. Charles Morris Award, nonflowering plant. Westchester Medals, flowering plant, zoology, general. Westchester Medals, photojournalism, travel. Honorable Mention ribbons.

JUDGING: By 3 judges, each category. Not responsible for loss or damage.

ENTRY FEE: $3 ($3.50 foreign) each category.

DEADLINES: Entry, judging, March. Event, April.

295

Linz International Color Slide Salon
Udo Wiesinger, Chair
Kopernikus Strasse 22
A-4020 Linz, AUSTRIA

October

International; entry open to all; biennial (odd years); established 1969. Sponsored by Linz Camera Club,. Recognized By PSA, FIAP. Second contact: Linz Camera Club, P.O. Box 235, A-4010 Linz, Austria.

SLIDE CONTEST: General, Travel Color, 2x2 inches (5x5cm); limit 4 per category. Categories: General, Travel.

AWARDS: PSA Gold Medals, Best of Show, traditional, contemporary, travel. FIAP Gold Medal. 2 Linz Gold, 4 Silver, 6 Bronze Medals. 4 Club Trophies. 20 Silver Medals, 25 Honorable Mentions. Special U.S.A. Award.

JUDGING: By 5 judges. Not responsible for loss or damage.

ENTRY FEE: $3.50. Foreign checks, add 50¢ for travel, $1 for general per category.

DEADLINES: Entry, judging, notification, September. Event, October. Materials returned, November.

296

CPAC Worldwide Exhibition of Color Photography
Color Photographic Association of Canada (CPAC)
Gary Slingerland, Chair
9 Nottingham Court
St. Catherines, Ontario L2M 1L6
CANADA

May

International; entry open to all; biennial (odd years). Sponsored by CPAC. Recognized by PSA, FIAP. Held in 3 locations in Ontario for 1 day each. Second contact: P.O. Box 911, St. Catherines, Ontario, Canada, L2R 6Z4.

SLIDE CONTEST: Pictorial, Sports Color, 2x2 inches; limit 4 per

entrant. No glass over cardboard mounts, trade-processed slides. Categories: Pictorial, Sports.

AWARDS: Pictorial: CPAC Gold Crest Award, best pictorial. Silver Crest Awards, Second Place, best landscape, humorous. FIAP Gold Medal, best portrait. FIAP Silver Medal, best creative. FIAP Bronze Medal, best architecture. Sports: PSA Gold Medal, best sports. FIAP Gold Medal, best action. FIAP Silver Medal, best team sports. FIAP Bronze Medal, best juvenile sports. CPAC Silver Crest Awards, Second Place Sports, best individual sports, winter sports. Honor ribbons, each category.

JUDGING: By 3 CPAC and PSA members. 1 award maximum per entry. Not responsible for loss or damage.

ENTRY FEE: $3.

DEADLINES: Entry, judging, April. Event, May.

297

Bressan Photo Club (PCB) International Salon of Color Slides
Jean-Claude Menneron, General Chair
B.P. 1104 Maginot
01009 Bourg-en-Bresse, FRANCE

March

International; entry open to all; established 1982. Sponsored by PCB. Supported by Banque Regionale de L'Ain. Recognized by PSA, FIAP, FNSPF. Held in Bourg-en-Bresse, France for 3 days. Second contact: Maison des Societes, Boulevard Irene Joliot Curie, 01000 Bourg-en-Bresse, France.

SLIDE CONTEST: General, Nature, Travel Color, 2-1/4x2-1/4

inches (5x5cm), glass mounted; limit 4 each category. Categories: General, Nature, Travel.

AWARDS: FIAP, NIEPCE, PCB, PSA Medals and Honorable Mentions, each category (25 in all).

JUDGING:By 5 photographers. Not responsible for loss or damage.

ENTRY FEE: $3 (15F) each category plus postage for airmail return.

DEADLINES: Entry, February. Judging, event, March. Materials returned, April.

298

Modane International Salon of Color Slides
Photo-Club ASCO Modane (PCAM)
Roland Combaz
10, rue de Bellevue
Modane 73500, FRANCE

June-July

International; entry open to all; biennial (even years); established 1974. Sponsored and supported by PCAM. Recognized by PSA, FIAP, FNSPF.

SLIDE CONTEST: General, Nature, Journalism, Travel Color, 2x2 inches, glass-mounted, limit 4 per category. No glass over cardboard mounts. Categories: General, Nature, Photojournalism, Travel.

AWARDS: PSA Gold Medals, Best of Show, best travel. Silver Medals, best wildlife, best nature slide. FIAP Medals, best set in the 4 categories. PCAM Gold Medals, best contemporary, best photojournalism. Cup, best club. PCAM Plaques, best sport, reporting, portrait, landscape, humor. Honorable Mentions. FNSPF Medals.

JUDGING: By 7 judges. Not responsible for loss or damage.

ENTRY FEE: $3.50, 1 category; $6, 2 categories; $8, 3 categories; $9, 4 categories plus return postage.

DEADLINES: Entry, judging, May. Notification, June. Event, June-July.

SLIDE SHOW, DIAPORAMA
Slide Shows with Sound (Diaporamas), including AMATEUR, STUDENT, INDEPENDENT, HISPANIC, RAILROAD-TROLLEY, WIDESCREEN. (Also see SLIDES.)

299

National Student Media Festival
Association for Educational Communications & Technology (AECT)
Dr. William D. Schmidt, Chair
Instuctional Media Center
Central Washington University
Ellensburg, Washington 98926
U.S.A. Tel: (509) 963-1842

April

National; **entry open to U.S. students;** annual; established 1976. Purpose: to recognize creative activity by students in media production. Sponsored and supported by AECT. Average statistics (all sections): 200-300 entries, 45 awards, 450 attendance. Held at AECT convention for 5 days.

SLIDE SHOW WITH SOUND: By **Student Color,** produced by individual, group, class, or club; maximum 10 minutes; on single screen with sound on cassette tape (automatic advance optional); suggested limit 3 per category per school or college. Equipment limited to 2 carousel projectors, 2

trays, cassette tape recorder, dissolve unit. Require certification of student amateur status and production. Faculty-parent guidance acceptable if planning, production, subject selection by student. Categories: K-3, 4-6, 7-9, 10-12, College-University. Also have 8mm film, videotape sections.

AWARDS: Best of Festival (all sections). 3-5 framed Certificates, each category.

JUDGING: By 4-5 judges. Based on content, organization, technical quality, general effectiveness. Entries over 10 minutes penalized. Sponsor may make copies for future motivation, promotion, PBS television broadcasting.

ENTRY FEE: None.

DEADLINES: Entry, March. Event, April.

300

Northwest Film and Video Festival
Northwest Film Study Center
Bill Foster, Associate Director
Portland Art Museum
1219 Southwest Park
Portland, Oregon 97205 U.S.A.
Tel: (503) 221-1156

August

Regional; **entry open to Northwest U.S. and British Columbia;** annual; established 1973. Purpose: to survey moving image art produced in Northwest. Sponsored by Northwest Film and Study Center, Portland Art Museum, Alpha Cine Lab, Mayer Theaters, Teknifilm. Supported by Portland Art Association, Oregon Arts Commission, Washington State Arts Commission. Average statistics (all sections): 125 entries, 115 entrants, 10 finalists, 6 awards, 2000 attendance. Held at Portland Art Museum for 3

weeks. Have exhibition, circulating library, equipment access programs. Also sponsor Young Filmmakers Festival, Portland Film Festival.

SLIDE SHOW WITH SOUND: Independent Color, 35mm with tape-cassette sound, produced in previous year. Competition includes film, video sections.

ELIGIBILITY: Open to Washington, Alaska, Idaho, Montana, British Columbia college students, independents, professionals.

AWARDS: (includes all sections): 6 $200 Cash and Laboratory Services Awards. 10 $50 Honorable Mentions.

JUDGING: By 1-3 judges. Not responsible for loss or damage.

ENTRY FEE: None. Entrant pays return postage.

DEADLINES: Entry, July. Judging, event, August.

301

San Antonio Cine Festival
Oblate College of the Southwest
Ken Amerson, Director
285 Oblate Drive
San Antonio, Texas 78216 U.S.A.
Tel: (512) 736-1685

August

International; entry open to all; annual; established 1976. Formerly called CHICANO FILM FESTIVAL. Purpose: to recognize, promote excellence in film-video production within U.S. Hispanic community. Theme: Hispanic History, Experience and Vision. Sponsored by Oblate College of the Southwest. Supported by NEA, private organizations. Average statistics (all sections): 75 entries, 4000 attendance. Held in San Antonio, Texas, for 2-3 days. Have workshops. Also sponsor Emerging Artist Grants Pro-

gram.

SLIDE SHOW WITH SOUND: Hispanic Color, any language; no limit per entrant. Entrant must arrange for projection equipment. Require synopsis (maximum 100 words), credits. Request promotional photos. Also have film, video sections.

AWARDS: Noncompetitive.

JUDGING: May show excerpts for promotion. Sponsor insures up to $200 during event.

ENTRY FEE: None.

DEADLINES: Entry, July. Event, August. Materials returned immediately after event.

| 302 |

World Railway Film Festival
National Capital Trolley Museum
Robert H. Flack, Public Relations Chair
1909 Forest Dale Drive
Silver Spring, Maryland 20903
U.S.A.

February-March

International; entry open to all; annual; established 1972. Purpose: to promote trolley museum. Sponsored and supported by National Capital Trolley Museum, nonprofit educational museum of American, European operating antique trolley cars. Held at museum for 5 consecutive Sundays; 200 attendance per day. Second contact: National Capital Trolley Museum, P.O. Box 4007, Colesville Branch, Silver Spring, Maryland 20904.

SLIDE SHOW FESTIVAL-EXHIBITION: Railroad-Trolley Color, 30 minutes maximum. Also have film section.

ENTRY FEE: None.

DEADLINES: Inquiry, October. Event, February-March.

| 303 |

"BIDFEST" Brisbane International Diaporama Festival
BIDFEST Society
Eric Arch, President
P. O. Box 10
Brisbane Base Hospitals
Queensland 4029, AUSTRALIA
Tel: 61-7-36-7218

October

International; entry open to all; annual; established 1980. Sponsored by BIDFEST Society, Queensland government, Griffith University. Supported by photographic societies, camera clubs. Recognized by FIAP, APS. Average statistics: 84 entries, 56 entrants, 10 countries, 19 winners, 1825 attendance. Held at Bardon Professional Development Centre, Brisbane for 3 days. Tickets: $1 Aust. per session. Also sponsor $300 Cultural Activities Grant, workshops, meetings. Second contact: Eric Arch, Audio Visual Services, Australian Photographic Society, Inc., 72 Thomas Street, Torwood, Brisbane, Queensland 4066, Australia.

SLIDE SHOW WITH SOUND: General Color. Series for single or dual projection; 5x5cm; glass, plastic, metal or cardboard mounts; with reel-to-reel tape (2 or 4 channels), or standard cassette; 10 minutes maximum; unlimited entry. Require English translation or summary of foreign language entries. Categories: Tourism, Documentary, Natural History; Essay, Theme, Fiction; Music, Poetry, Song; Humor.

AWARDS: FIAP and APS Gold, Silver, Bronze Medals. BIDFEST Trophy. Kodak, Agfa, Ilfor Trophies. Best First, Second, Third of festival. First,

Second, Third each category. Best Australian entry. Top and Second student. Top and Second Queensland student. Best sound track, dissolves. Merit Certificates.

JUDGING: Entry review by 3-member preliminary juries. Awards judging by 6-member festival jury. Sponsor may change categories; exhibit winners. Not responsible for loss or damage.

ENTRY FEE: $4 Aust. each plus return airmail postage.

DEADLINES: Entry, August. Judging, event, October. Materials returned, December.

| 304 |

Mechelen International Slide Show Festival

Koninklijke Mechelse Fotokring
Jacques Denis, President
Auwegemvaart 81
B-2800 Mechelen, BELGIUM Tel: 015 20-24-30

April-May

International; entry open to all; biennial (even years); established 1968. Alternates with FESTIVAL OF EPINAL (France). Purpose: to encourage artistic and documentary productions of slides with sound. Sponsored by Koninklijke Mechelse Fotokring. Recognized by FIAP, FBCP. Average statistics: 150 entries, 100 entrants, 55 finalists, 25 awards, 12 countries, 4000 attendance. Held in Cultural Centrum of Mechelen for 2 weeks. Tickets: 50 Belgian francs (Bf). Also sponsor simultaneous national photographic exhibition. Second contact: M. De Vriendt, De Merodestraat 3, B-1850 Grimbergen, Belgium.

SLIDE SHOW WITH SOUND:
General Color, slide series with sound on tape (3.75 or 7.5 ips); 10 minutes

maximum; limit 3 per entrant. Require Dutch or French text; work to form coherent whole. Categories: Poetry, Music, Tourism, Essay, Song, Didactic, Humor, Documentary, Report, Theme, Series of Slides with Sound.

AWARDS: Cups, FIAP, BFFK Medals, marks of honor to best works. Awards and prizes to best each category. Special prizes. Certificates, all admitted.

JUDGING: Entry review by jury; awards by 5 international judges. Not responsible for loss or damage.

ENTRY FEE: $6 (250 Bf).

DEADLINES: Entry, February. Judging, notification, awards, April. Event, April-May.

| 305 |

Folkestone International Audiovisual Festival

Folkestone Camera Club
D. Bridges, Secretary
Shepway District Council Recreation Department
Civic Centre, Folkestone, Kent CT20 2QY, ENGLAND Tel: (0303) 57388, ext. 328

May

International; entry open to all; biennial (even years); established 1979. Purpose: to promote creative photographic skills. Sponsored by Shepway District Council, photographic organizations. Recognized by FIAP. Average statistics: 50 entries, 40 entrants, 6 countries, 1000 attendance. Held at Leas Cliff Hall, Folkestone, for 3 days. Have trade exhibitions. Tickets: £3. Second contact: N. Winter, 1 East Street, Hythe, Kent CT21 5ND, England.

SLIDE SHOW WITH SOUND:
General Color, slide series for dual

projection; 2x2 inches (5x5cm), plastic or metal mounts (glass preferred); accompanied by reel-to-reel tape (9.5 or 19cm per second, 5-inch minimum diameter); 12 minutes maximum; unlimited entry. Submit English summary with foreign language entries. Categories: Tourism, Documentary, Natural History; Essay, Theme, Fiction; Music, Poetry, Song; Humor.

AWARDS: Festival Trophy, other major prizes. FIAP Medals. Photographic equipment awards.

JUDGING: Entry review by preliminary jury. Awards judging by 5-member professional jury. May reclassify entries; withhold awards; exhibit entries publicly. Not responsible for loss or damage.

ENTRY FEE: £4 each.

DEADLINES: Entry, April. Judging, event, May.

306

Royal Photographic Society (RPS) International Audio-Visual Festival
A. R. Troman
11 Lyncroft Gardens
Ewell Surrey KT17 1UR, ENGLAND
Tel: 01-393-4094

November

International; entry open to all; biennial (even years); established 1975. Purpose: to encourage art of audio-visual presentation. Sponsored by RPS. Recognized by FIAP. Average statistics (all sections): 90 entries, 10 countries, 20 awards, 1300 attendance. Held in Bath, England, for 3 days. Tickets: £2 each 5 projection sessions.

SLIDE SHOW WITH SOUND: General Color, 35mm, 2x2-inch mounts; sound on reel-to-reel tape or standard cassette; any language; 12 minutes maximum; unlimited entry.

Submit English translation. Competition includes monochrome section.

AWARDS: Trophies and prizes, First, Second, Third Place. Special prizes, best photography, sound track, dissolves. Runner-up prizes. (Total value £2000.)

JUDGING: Entry review by nationally known judges who select best 50. Awards judging by 5 international judges. All entries viewed in entirety. Not responsible for loss or damage.

ENTRY FEE: £5 each.

DEADLINES: Entry, September. Judging, event, November.

307

Widescreen Association International Widescreen Slide Competition
Tony Shapps, Vice-President
48 Dorset Street
London W1H 3FH, ENGLAND
Tel: 01-935-2580

May

International; **entry open to amateurs, students, independents, semiprofessionals;** annual; established 1964. Purpose: to encourage use of panoramic formats. Sponsored and supported by Widescreen Centre. Recognized by International Widescreen Conference. Average statistics (all sections): 100 entries. Held in London for 1-2 days. Have exhibition, workshops, seminars, 3 cinemas, conference facilities. Tickets: average £1 daily. Also sponsor International Widescreen Film Competition, Widex-North (exhibition of winners). Publish *Amateur Widescreen Magazine.*

SLIDE SHOW WITH SOUND: Widescreen General Color. Slide series in widescreen format (wider than

1.5:1); any sync system; limit 6 per entrant.

AWARDS: Billington-Coban Trophy. Ivan Watson Cup. Ian Sage Shield. Special Grimes Ladies Trophy. Northern Yorkshire Trophy.

JUDGING: By 5 judges (includes one Widescreen Association member). Sponsor retains winners for yearly exhibition.

ENTRY FEE: Association members: none. Others: £2.50. Entrant pays return postage.

DEADLINES: Entry, March. Judging, April. Event, winners announced, May.

308

Image International Festival of Slide Shows with Sound
Club Noir et Couleur
Jacques Thouvenot, Secretary
44 rue Francais
88000 Epinal, FRANCE Tel: (29) 82-39-91

June

International; entry open to all; annual; established 1960. Purpose: to develop diaporama. Sponsored by Club Noir et Couleur. Supported by government, private sources. Recognized by FIAP, FNSPF. Average statistics: 180 entries, 150 entrants, 26 countries, 40 awards, 1000 attendance. Held in Epinal, France for 4 days. Also sponsor workshops, seminars, exhibitions. Second contact: A. Bercherand, 3 rue Cour Billet, 88000 Epinal, France.

SLIDE SHOW WITH SOUND: General Color, 2x2 or 2-3/4x2-3/4 inches, glass mounted, international norm ISOTC 42; 1/2 or 1/4 inch audio tape on 5-inch (13cm) minimum reel; length 10 minutes; limit 3 per entrant. Entrant may project own sequence.

Submit cue sheet. Categories: Tourism, Documentary, Instructional, Poetry, Music and Song, Humor, Analysis, Theme, Our Century, Professional Sequences.

AWARDS: European Cup, Special Honors. F3000 Grand Prize of Epinal. Other Grand Prizes, special prizes, each category. 3 FIAP medals.

JUDGING: Entry review by sponsor members, regional artists, musicians, producers, photographers, scholars. Awards judging by 5 international specialists of art, photography, sound. Sponsor reserves right to reproduce selected works, give public showing. Not responsible for loss or damage.

ENTRY FEE: 30F each.

DEADLINES: Entry, April. Entry review, notification, May. Event, June. Materials returned, July.

309

Vichy International Slide-Tape Festival
Vichy Cine Photo Club
H. Bardiaux, President
B. P. 200
03207 Vichy, FRANCE
Tel: 16-70-98-42-56

September

International; **entry open to amateurs, students, independents;** annual; established 1958. Sponsored by Vichy Cine Photo Club. Recognized by FIAP, FNSPF. Held in Vichy for 4 days. Tickets: 80 French francs (for all meetings). Second contact: H. Bardiaux, 15 Blvd Russie, 03200 Vichy, France.

SLIDE SHOW WITH SOUND: General Color, slide series, 5x5cm, glass mounts (49.8x50.8mm), 2.4-3.2mm thick; accompanied by magnetic reel audiotape, 2 or 4 track, mono

or stereo, 13cm minimum reel diameter, 19cm per second, 10 minutes maximum. Submit slide captions, technical and commentary script in French. Categories: Documentary-Tourism, Humor, Poetry-Song, Theme, Research-Contemporary, Educational, Musical Illustration, Scenario.

AWARDS: Ville de Vichy Prize (winning entries held for 1 year).

JUDGING: Entry review by jury; awards judging by 5 judges. Not responsible for loss or damage.

ENTRY FEE: 30 French francs.

DEADLINES: Entry, July. Event, September.

310

Pecs International Diaporama Festival
Pecs Youth House
Zsuzsa Kenenfi, Artistic Director
Szalai Andras U. 13
H-7622 Pecs, HUNGARY
Tel: 36-72-11511

November

International; entry open to all; biennial (odd years); established 1979. Purpose: to join international diaporama movement. Sponsored and supported by Pecs Youth House, Baranya Town Council, Cultural Affairs Ministry. Recognized by Union of Hungarian Photographers, Baranya County Department of Cultural Affairs. Average statistics: 55 entries, 45 entrants, 5 countries, 10 awards, 2500 attendance. Held in Pecs for 3 days. Have cultural programs; organized sightseeing, touring show. Tickets: $1 (30 Hungarian Forints).

SLIDE SHOW WITH SOUND: General Color, 2x2 inches (5x5cm), maximum length 10 minutes, glass mounted, sound on magnetic tape; limit 3 per entrant. Submit biographical sketch.

AWARDS: $200 (5000Ft.), Best of Show. $100-$200 Honoraria. Festival Plaquettes, outstanding works. Prize of the Public.

JUDGING: Entry review by 5 artists. Awards judging by 7 judges. Public prize selected by audience. All entries viewed in entirety. May withhold awards. Not responsible for loss or damage.

ENTRY FEE: None.

DEADLINES: Entry, September. Judging, event, awards, November.

311

Amsterdam Diaporama Festival
Diaporamaclub NVG
Peter Willems, Chair
P. O. Box 3273
1001 AB Amsterdam,
NETHERLANDS Tel: 01611-1805

September

International; **entry open to amateurs;** biennial; established 1975. Purpose: to show progress in worldwide amateur audiovisual productions. Sponsored by Diaporamaclub NVG. Supported by National Association of Art. Recognized by FIAP. Average statistics: 400 entries, 100 entrants, 15 countries, 12 awards. Held in Amsterdam for 3 days. Tickets: 5Df per performance, 15Df entire festival. Second contact: de Meerberg 15, NL-4849AH Dorst, Netherlands.

SLIDE SHOW WITH SOUND: Amateur Color, 10 minutes maximum; unlimited entry. Submit slide series with magnetic tape, brief description to be read to audience. No slide magazines. Categories: Documentary, Music, Tourism, Humor, Theme, Report.

AWARDS: Honorary Awards, Medals, photographic and audio products, each category. 1 or more prizes or special prizes, outstanding entries, each category.

JUDGING: By 5 judges. Not responsible for loss or damage.

ENTRY FEE: 10Df, 1 slide show, 7.50Df, each additional.

DEADLINES: Entry, July. Event, September. Materials returned, November.

SPORTS, RECREATION

Prints, Slides, and Slide Show, including FOOTBALL, PARKS-LEISURE, PHYSICAL EDUCATION, THOROUGHBRED RACING.

312

Best Sports Stories Photo Contest
Edward Ehre, Coeditor
1215 Westport Lane
Sarasota, Florida 33582 U.S.A.

Spring

International; entry open to all; annual; established 1944. Sponsored by *Best Sports Stories* (annual, published by E. P. Dutton, New York). Average 2 awards.

PRINT CONTEST: **Sports Color,** 8x10 inches; published during current year; glossy, captioned; limit 3 per entrant. Submit 50-word biography, permission to reprint. Categories: Action, Feature. Competition includes monochrome prints. Also have writ-

ing section.

AWARDS: $250 Cash Awards, best action, best feature. 20 published in *Best Sports Stories.*

JUDGING: By 3 judges. Sponsor retains entries.

DEADLINES: Entry, December. Judging, February. Publication, Spring.

313

Pro Football Photo Contest
Pro Football Hall of Fame
Donald R. Smith, Vice
President-Public Relations
2121 Harrison Avenue N.W.
Canton, Ohio 44708 U.S.A.
Tel: (216) 456-8207

July-August

National; **entry open to professionals;** annual; established 1968. Purpose: to honor professional photographers assigned to cover National Football League (NFL) games for outstanding achievements in pro football photography. Sponsored by Pro Football Hall of Fame, Canon Cameras. Supported by Canon Cameras. Average statistics (all sections): 900 entries, 175 entrants, 5 awards. Held at Football's Greatest Weekend Celebration in Canton, Ohio for 2 days.

SLIDE CONTEST: **Football Color,** 35mm, limit 12 per entrant. Categories: Action, Feature. Competition includes monochrome prints.

ELIGIBILITY: Photos taken on or off playing field during previous year's regularly scheduled NFL games, Super Bowl, AFC-NFC Pro Bowl, by professional still photographers for general circulation newspapers, magazines, television, or assigned to coverage by professional football team.

AWARDS: $500 First, $250 Second,

$100 Third Place Plaques, each category. $500 Photograph of the Year Award, personalized plaque, all-expenses-paid trip for 2 to Football's Greatest Weekend Celebration, best overall (including monochrome prints). Honorable Mention Plaques. First Place winners published in *PRO!* (official magazine of the NFL).

JUDGING: By 6 sports photography authorities. May reclassify entries. Sponsor keeps all entries, may reproduce for publicity; entrants retain copyright.

ENTRY FEE: None.

DEADLINES: Entry, February. Judging, March. Awards, event, July-August.

314

Thoroughbred Racing Associations (TRA) Eclipse Awards
Bill Christine
P.O. Box 3618
3000 Marcus Avenue, Suite 2W4
Lake Success, New York 11042
U.S.A. Tel: (516) 328-2660

February

International; **entry open to U.S., Canada;** annual; established 1971. Named after famous Thoroughbred of eighteenth century. Formerly called TRA JOURNALISM AWARDS. Purpose: to honor excellence in Thoroughbred horse racing photojournalism. Sponsored by TRA, Daily Racing Form, National Turf Writers' Association. Average 400 entries (all sections). Held at annual Eclipse Awards dinner in Miami, San Francisco, New York, or Los Angeles (rotates). Also sponsor Eclipse Awards for newspaper writing; magazine writing; local, national television, radio broadcasting.

PRINT CONTEST: Thoroughbred

Racing Journalism Color, 8x10 inches, glossy, published in newspaper in current year; limit 3 per entrant. Submit tearsheet and original bearing date, name of publication. Competition includes monochrome prints.

AWARDS: Eclipse Award Trophy, $550, awards dinner to winner.

JUDGING: By 6-member panel (2 from each sponsor).

ENTRY FEE: None.

DEADLINES: Entry, December. Event, February.

315

Wes Francis Audiovisual Excellence (WAVE) Contest
National Recreation and Park Association (NRPA)
Martha Nudel Winsor,
Communications Director
1601 North Kent Street, Suite 1100
Arlington, Virginia 22209 U.S.A.
Tel: (703) 525-0606

October

National; **entry open to U.S.;** annual; established 1977. Named after Mrs. George T. (Wes) Francis, Jr., of Philadelphia, NRPA trustee. Purpose: to encourage production, distribution of quality audiovisuals for use by park-recreation specialists for in-house training, community presentations. Theme: Park and Recreation Programs and Concepts. Sponsored by NRPA. Average statsitics (all sections): 40 entries, 50 entrants, 5 finalists, 10 awards, 7000 attendance. Held at University of Missouri-Columbia Media Center for Recreation for 3 days.

SLIDE SHOW WITH SOUND: **Parks, Recreation, Conservation, Leisure Color,** 25 minutes maximum, with tape; limit 2 carousel trays, 1 dis-

solve unit. Require script, technical information, signed release. Categories: General, Student, In-House, Commercial. Competition for some awards includes films and videotapes.

AWARDS: First, Second Place Plaques, Honorable Mentions, each category. Special awards, Best Student, In-House entries.

JUDGING: By 5-member panel. Based on contest, usefulness to park and recreation discipline, artistic achievement. All entries viewed in entirety. Sponsor may make copies for nonprofit rental. Not responsible for loss or damage.

ENTRY FEE: None. Sponsor pays return postage.

DEADLINES: Entry, May. Judging, August. Event, October. Materials returned, November.

316

Fotosport International Exhibition of Sport Photography
Enric Pamies
P. O. Box 300
Reus, SPAIN

June-July

International; entry open to all; biennial (even years); established 1970. Sponsored by National Delegation of Physical Education and Sports, Club Natacion Reus "Ploms." Supported by Spanish Olympic Committee. Recognized by FIAP. Average statistics (all sections): 2376 monochrome, 344 color entries; 171 monochrome, 56 color accepted; 845 entrants, 35 countries. Held in Reus, Spain for 1 month.

PRINT CONTEST: Sports Color, 40cm maximum per side (30x40cm suggested); limit 4 per category. Categories: Sports and Physical Education,

Football. Also have monochrome prints section.

AWARDS: 1 Gold-Plated, 1 Silver, 1 Bronze Medal, each category. Commemorative Medal, each exhibitor.

JUDGING: By 7 judges. Sponsor may reproduce entries in any media without payment. Not responsible for loss or damage.

ENTRY FEE: None.

DEADLINES: Entry, March. Judging, April. Notification, May. Event, June-July. Materials returned, November.

317

Guipuzcoa International Sport Photography Contest
Delegacion Territorial de Deportes de Guipuzcoa
Julian Lopez, Sport Activities Manager
Prim, 28 entlo
San Sebastian, Spain Tel: 45 67 23

January-February

International; entry open to all. Theme: Sports and Physical Education. Sponsored by Delegacion Territorial de Deportes de Guipuzcoa. Held for 6 weeks.

PRINT CONTEST: Sports, Physical Education Color, 30x40cm recommended, reinforced; limit 4 per category. Also have monochrome prints section.

AWARDS: First, Second, Third Prize trophies by sculptor.

JUDGING: Entry review, awards judging, by jury. Sponsor keeps and may reproduce winners. Not responsible for loss or damage.

DEADLINES: Entry, December.

Judging, notification, January. Event, January-February. Material returned, April.

STEREO SLIDES

Stereoscopic 3-Dimensional (twin-lens camera) photography. Includes AMATEUR. (Also see other SLIDE CATEGORIES.)

318

Hollywood International Stereo Exhibition
Bryan Riggs, Chair
6130 Coldwater Canyon
North Hollywood, California 91606
U.S.A.

February

International; entry open to all; annual; established 1958. Sponsored by Stereo Club of Southern California, Pasadena Stereo Club, Jewel City Camera Club. Recognized by PSA. Held in Los Angeles, Alhambra, and Glendale, California.

STEREO SLIDES CONTEST: General Color, 1/8-inch thick, 5 or 7 sprocket hole width, mounted between glass; limit 4 per entrant.

AWARDS: PSA Silver Medals, Best of Show, best contemporary. Hollywood Exhibition Gold, Silver, Bronze Medals. EMDE Award (100 stereo mounts), best landscape-seascape. Honorable Mention ribbons.

JUDGING: By 3 judges. Not responsible for loss or damage.

ENTRY FEE: $3.

DEADLINES: Entry, January. Judging, event, February.

319

Oakland International Stereo Exhibition
Oakland Camera Club (OCC)
John William Niemand, Chair
4263 Wilshire Blvd.
Oakland, California 94602 U.S.A.

February

International; entry open to all; annual; established 1956. Sponsored by OCC, Rossmoor Camera Club. Recognized by PSA, Northern California Council of Camera Clubs. Average statistics: 600 entries, 200 entrants, 16 countries, 150 attendance. Held in Oakland, Walnut Creek, other locations. Second contact: Russell Hilton, OCC, 4424 Howe Street, Oakland, California 94611.

STEREO SLIDES CONTEST: General Color, in 1-5/8x4-inch glass projection mounts; limit 4 per entrant (including 7-sprocket format). Categories: Contemporary, Transportation, Fall Color.

AWARDS: PSA Stereo Division Medal, Best of Show, best contemporary. OCC Medals First, Second, Third Places; best by OCC member; best fall color. Yerba Buena Club Medal, best transportation.

JUDGING: By 3 selectors. Not responsible for loss or damage.

ENTRY FEE: $3.

DEADLINES: Entry, judging, January. Event, February.

320

Potomac International Exhibition of Stereo Photography
Potomac Society of Stereo Photographers (PSSP)
Melvin M. Lawson, Secretary
1400 South Joyce Street (A-513)

Arlington, Virginia 22202 U.S.A.
Tel: (703) 521-3395

Spring

International; **entry open to amateurs;** annual; established 1981. Purpose: to promote expertise in, appreciation of stereo photography. Sponsored by PSSP. Recognized by PSA. Average statistics: 600 entries, 150 entrants, 8 countries, 25 finalists, 4-6 awards, 300 attendance. Second contact: Ernst Steinbrecher, 9122 Friars Road, Bethesda, Maryland 20034.

STEREO SLIDES CONTEST: **General Color,** in 2x2-inch slide pairs, standard (1-5/8x4-inch) mounts, or in View-Master reels (limit 4 views).

AWARDS: 2 PSA Medals, Best of Show, best contemporary view. PSSP Plaques, second best of show, contemporary view; other categories.

JUDGING: By 3 jurors. Based on point system. May reproduce entries in catalog. Not responsible for loss or damage.

ENTRY FEE: $3.

DEADLINES: Entry, judging, event, Spring.

| 321 |

San Bernardino International Stereo Salon
San Bernardino Stereo Group
Lester L. Lauck, Chair
56865 Ivanhoe Drive
Yucca Valley, California 92284
U.S.A.

November

International; entry open to all; annual; established 1964. Sponsored by San Bernardino Stereo Group, Pasadena Stereo Club, Jewel City Camera Club. Recognized by PSA, Southern California Council of Camera Clubs. Held at various locations in San Bernardino and Los Angeles Counties. Have TDC projector, 750-watt lamps, 70x70 screen.

STEREO SLIDES CONTEST: **General Color,** in 1-5/8x4-inch glass projection mounts; limit 4 per entrant. Categories: Flower Close-Up, Portrait, Nature (excluding landscapes), Full Color, Table-Top, Contemporary.

AWARDS: PSA Silver Medals, Best of Show, best contemporary. Category prizes. Honorable Mention ribbons.

JUDGING: By 3 judges. Not responsible for loss or damage.

ENTRY FEE: $2.75.

DEADLINES: Entry, October. Judging, notification, November. Materials returned, December.

| 322 |

Southern Cross International Stereo Exhibition
Sydney Stereo Camera Club (SSCC)
Deborah Laskie
5-39 Arcadia Street
Coogee Beach 2034 Sydney N.S.W.,
AUSTRALIA Tel: (02) 665-9960

November

International; entry open to all; annual; established 1980. Purpose: to exhibit, judge best stereoscopic slides. Sponsored and supported by SSCC. Recognized by PSA. Average statistics: 670 entries, 170 entrants, 8 countries, 250 semifinalists, 28 finalists, 15 awards. Held in Sidney for 1 week. Tickets: $A2. Second contact: Joseph P. Fallon, Jr., 1 Dalewood Way, San Francisco, California 94127.

STEREO SLIDES CONTEST: **General Color,** 1-5/8x4-inch standard mounts (preferably glass-

mounted), formats up to 7 sprocket; limit 4 per entrant. Categories: Contemporary, Action, Novice.

AWARDS: PSA Medal, Best of Show, best contemporary. Southern Cross Silver, Bronze Plaque, Second, Third Place. SIEP Bronze Plaque, best stereoscopic effect. Kodak Trophy, best action. H. A. Tregellas Plaque, best novice. Southern Cross Award, judges' choice for special merit. Kodak Silver Award, best SSCC entry. Honorable Mentions.

JUDGING: By 4 judges. Sponsor may display entries at 3 exhibitions prior to their being returned. Not responsible for loss or damage.

ENTRY FEE: $A3.

DEADLINES: Entry, October. Judging, awards, November.

| 323 |

Stockton-on-Tees International Stereo Exhibition
Third Dimension Society
Patricia Milnes, Secretary
83 Bishopton Road
Stockton-on-Tees, Cleveland TS16
4PG, ENGLAND Tel: 0642 68741

Summer

International; **entry open to amateurs**, annual; established 1963. Purpose: to promote expertise in, appreciation of stereo photography. Sponsored by Third Dimension Society. Recognized by PSA. Average statistics: 500 entries, 125 entrants, 8 countries, 150 semifinalists, 15-20 finalists, 3-6 awards, 200 attendance. Held at Stockton-on-Tees for 1-2 months. Second contact: Melvin M. Lawson, 1400 S. Joyce Street (A-513), Arlington, Virginia 22202.

STEREO SLIDES CONTEST: Amateur General Color, in 1-5/8x4-

inch standard stereo mounts, in 2x2-inch slide pairs or in View-Master reels; limit 4 per entrant.

AWARDS: 3-6 Medals or Trophies; include Best of Show, best contemporary. 10-15 Merit Certificates.

JUDGING: By 3 judges. Sponsor may reproduce entries for exhibition catalog. Not responsible for loss or damage.

ENTRY FEE: $4.

DEADLINES: Entry, judging, event, Summer.

STUDENT, YOUTH
Print, Print Portfolio, and Slide Competitions. (Also see other PRINT and SLIDE CATEGORIES.)

| 324 |

Los Angeles County Fair (LACF) Schools Exhibition of Photography
Aileen M. Robinson, Coordinator
P.O. Box 2250
Pomona, California 91766 U.S.A.
Tel: (714) 623-3111

September-October

National; **entry open to U.S. students**; annual; established 1956. Sponsored by LACF Association. Average statistics (all sections): 1064 entries, 420 entrants, 424 finalists. Held at LACF in Pomona, California, for 18 days. Tickets: $4. Also sponsor International Exhibition of Photography (open to all).

PRINT CONTEST: By Student General Color, 8x10 inches minimum, limit 4 per entrant. Hand-col-

ored eligible. No framed prints, wood or masonite mountings. Divisions: Elementary, Junior High, High School, College, Adult School. Categories: Animals and Pets, Commercial Illustration and Product Photography, Human Interest and People, Scenic and Pictorial, Close-Up Photography, Portraiture Photojournalism, Special Effects in Darkroom. Competition includes monochrome prints.

ELIGIBILITY: Students enrolled in photography, journalism classes, or active in camera clubs.

AWARDS: Grand Trophy, Best of Show. Memorial Award, Scholarship Award, Photojournalism Award. Gold Medal, best technical excellence (color). Gold, Silver, Bronze Medals. Honorable Mentions. Plaques to best each division. Certificates to best each category.

JUDGING: By photography instructors. All entries viewed in entirety. Not responsible for loss or damage.

ENTRY FEE: None.

DEADLINES: Entry, July. Judging, notification, August. Event, awards, September-October.

325

New York State Youth Film-Media Shows
New York State Education Department
James V. Gilliland, Administrative Director
Bureau of Visual Arts and Humanities Education
Room 681 EBA
Albany, New York 12234 U.S.A.
Tel: (518) 393-9230

January-March

State; **entry open to New York school-age youths;** annual; established 1969. Purpose: to provide training and viewing of creative photography, film, video, audio media. Sponsored by Bureau of Visual Arts and Humanities Education, Division of Humanities and Arts Education, New York State Education Department. Supported by NYSCA, New York State Art Teachers Association. Held in 7 New York regions. Allstate Show of regional exhibitors (established 1974) held at Towards Humanizing Education Conference. Have demonstration workshops. Also sponsor New York State Summer School of the Arts, School of Film Media-Scholarships for talented students.

PHOTO CONTEST: By Youth Color, prints and slides. Competition includes mixed media, film, video, audio, and monochrome prints.

ELIGIBILITY: Independent projects made with or without school or teacher involvement by New York State elementary or secondary school-age youth. No college, higher learning institution students or ex-students. Works in progress acceptable.

AWARDS: Scholarships to New York State Summer School of the Arts.

JUDGING: By film-media teachers, artists.

ENTRY FEE: None.

DEADLINES: Entry, regional event, January-March. Allstate event, April.

326

PSA Young Photographers Showcase
Photographic Society of America
Yolan Gray, Chair
1602 Bridgeview Drive
Tacoma, Washington 98406 U.S.A.
Tel: (206) 759-3344

October

International; **entry open to under age 25;** annual; established 1972. Sponsored by PSA. Average statistics (all sections): 630 entries, 55 accepted. Held at PSA International Convention. Followed by national tour for one year.

PRINT CONTEST: **By Young People Color,** 6x8 to 8x10 inches, mounted or unmounted; limit 4 per entrant. Divisions: Age 15 or younger, 16-19, 20-25. Competition includes monochrome prints.

AWARDS: $100 Best of Show. $75 First, $50 Second, 1-year PSA memberships to Third, Fourth and Fifth Places each division. Honorable Mention ribbons.

JUDGING: By 3 judges. Each division judged separately. Accepted works retained for 1-year tour; may be reproduced. Not responsible for loss or damage.

ENTRY FEE: $3.

DEADLINES: Entry, June. Event, October. Materials returned, one year later.

| 327 |

Scholastic Magazine Photography Awards
Scholastic, Inc.
50 West 44th Street
New York, New York 10036 U.S.A.
Tel: (212) 944-7700, ext 606

Spring

International; **open to U.S., Canadian students, 19 years and under;** annual; established over 50 years ago. Purpose: to encourage junior and senior high school students to display photographic skills. Sponsored by Scholastic, Inc., and Eastman Kodak Company. Recognized by National Association of Secondary School Principals. Held in New York City, followed by international tour. Also sponsor Scholastic Art, Writing Awards.

PRINT CONTEST: **By Student General, Experimental Color,** 5x6 to 16x20 inches; produced in previous year; on white mount or mat; limit various (regional), 10 (national). Hand-tinting accepted. May enter 10 works maximum directly to magazine if school has no regional sponsor. Submit original negatives, subject releases of recognizable people. No entries submitted in other competitions. Divisions: grades 7-9, 10-12. Categories: General, Experimental (grades 10-12 only). Competition includes monochrome prints and color slides.

PRINT PORTFOLIO CONTEST: **By Senior Student General, Experimental,** 5x6 to 16x20 inches; produced in previous year; on white mount or mat, 12 prints each portfolio (6 minimum to be monochrome); limit 1 per entrant. May enter directly to magazine of school has no regional sponsor. Competition includes monochrome portfolio.

SLIDE CONTEST: **By Student General, Experimental Color,** Restrictions, divisions, and categories same as for Print Contest.

AWARDS: Regional contests: Blue Ribbons, finalists. Gold Achievement Keys. Certificates of Merit. National contest: $100, $50 Award (grades 7-9). $100 and $50 Award, general, experimental (grades 10-12). 200 $20 Honor Awards. Kodak Medallions of Excellence, best each region. Traveling exhibit, prize-winning prints. Print portfolio contest: $2000, $1000, $250 Eastman Kodak Scholarship grants. $500 Scholastic, Inc., Grant, oustanding photographic ability. Medallions of Excellence.

JUDGING: By regional sponsors first. National judging by *Scholastic Magazine* photographic experts. After scholarship judging, portfolio entries judged in individual categories. Based on subject matter, style, technique. Sponsor owns winning entries and all rights. Not responsible for loss or damage.

ENTRY FEE: None.

DEADLINES: Entry, January (regional contest), February (national contest). Notification via school principals, Spring.

| 328 |

International Photography Gatherings Photo Competitions
Recontres Internationales de la Photographie (RIP)
Marie-Jose Justamond
B.P. 90
13632 Arles Cedex, FRANCE
Tel: (90) 96-76-06

July

International; entry open to all (eligibility varies by categories); annual; established 1970. Sponsored by RIP (nonprofit organization). Supported by government, arts councils, photo societies, publishers. Held in Arles Roman amphitheater for 3 weeks. Have workshops, exhibitions, symposia, lodging. Second contact: RIP, 16 rue des arenes, 13200 Arles.

PRINT CONTEST: By Young People Color, open to age 30 and under; 11x14 inches (24x30cm), unmounted; limit 6 per entrant. Competition includes monochrome photography.
Journalism Color, open to all; limit 12 per entrant. Competition includes monochrome photography.
Travel Color, made during trip in France or abroad; open to all; limit 10 per entrant. Competition includes monochrome photography.

AWARDS: *Paris-Match* Young Photographers Award, 22-day trip around the world, Paris to Paris. Bourse International *News Reportage Award*, 15,000F grant for research-creation in photojournalism on specific subject. *Pier Import* Voyage Award, 15-day trip to Asia, including transportation and accommodation. All exhibitors have opportunity to exhibit slides on Arles forum square.

JUDGING: Entry review, awards judging by photography professionals. Sponsor owns winners for publicity, archival purposes.

ENTRY FEE: 50F each category.

DEADLINES: Entry, May. Event, awards, July. Materials (nonwinners) returned, October.

BOOK CONTEST: Photography, 3000F to photographer, editor, or publisher of best photographic book published in previous year. Require description of photographer, project conditions. Competition includes monochrome photography. Judging by photography professionals, based on appropriateness to yearly theme, print quality. May award honorable mentions. Sponsor owns entries. Entry, May. Award, July.

| 329 |

Hong Kong University International Student Salon of Photography
HKUSU Photographic Society
Fong Tai Wai, Chair
University of Hong Kong Students' Union Office
Pokfulam Road, HONG KONG
Tel: H-468455

Winter

International; **entry open to full-time students;** annual; established

1959. Sponsored by HKUSU Photographic Society. Average statistics: 400 entries, 200 entrants, 20 countries, 12 awards. Held at Loke Yew Hall, University of Hong Kong, and MTR Admiralty Station, for 7 days. Also sponsor Color Slide Exhibition (open to all).

PRINT CONTEST: By Student General Color, 8x10 to 16x20 inches (20x25 to 40x50cm); Hong Kong and Macau entries mounted, others unmounted, limit 6 per entrant (including monochrome prints). Competition includes monochrome prints.

AWARDS: Patron's Cup, Best of Show. 1 Gold, 2 Silver, 3 Bronze Trophies. 5 Bronze Medals.

JUDGING: By 5 judges. Sponsor reserves right to reproduce, publish. Not responsible for loss or damage.

ENTRY FEE: $3.50 (HK$10, Hong Kong and Macau entries).

DEADLINES: Entry, judging, October. Notification, awards, November. Event, December.

☐ 330

Singapore International Students' Photographic Salon
National University of Singapore (NUS) Photographic Society
Yap Teong Keat, Salon Chair
NUS Students' Union
Yusof Ishak House
Kent Ridge, Clementi Road,
Singapore 0511, REPUBLIC OF SINGAPORE

April

International; entry open to students; annual; established 1980. Purpose: to promote photagahy as art among students worldwide. Sponsored and supported by various companies. Recognized by Photographic

Society of Singapore. Average statistics (all sections): over 900 entries, 20 countries. Held in Singapore.

PRINT CONTEST: By Student Color, 8x10 to 16x20 inches; overseas unmounted; limit 8 per entrant. Also have monochrome print section.

SLIDE CONTEST: By student Color, 35mm 2-1/2x2-1/2 inches, mounted; limit 8 per entrant. Also have monochrome print section.

AWARDS: Prints and slides: 2 Gold, 3 Silver, 5 Bronze Medals. 10 Merit Certificates.

JUDGING: By 3 international Judges. Not responsible for loss or damage.

ENTRY FEE: $2 (U.S.) each section.

DEADLINES: Entry, March. Judging, event, April. Materials returned, May.

TRAVEL

Prints, Slides, Slide Shows, including SWISS THEMES. TRAVEL usually defined as capturing feeling of a time or place, and portraying a land, people, or culture in its natural state (often excluding ultra close-ups which lose identity, studio-type model pictures, manipulated photos). However, this definition may vary. (Also see other PRINT and SLIDE CATEGORIES.)

☐ 331

Lake Erie Photo-Travel International Exhibition
Camera Guild of Cleveland
Charles W. Dillman, General Chair
1500 East 193rd Street, #E-643

Euclid, Ohio 44117 U.S.A.

September

International; entry open to all; annual; established 1980. Sponsored and supported by Camera Guild of Cleveland. Recognized by PSA. Average statistics: 900 entries, 275 entrants, 12 countries, 7 awards. Held at 2 locations in Cleveland each for 1 evening. Second contact: Fred Wolf, 20100 Detroit Road, Cleveland, Ohio 44116.

SLIDE CONTEST: Travel Color, 2x2 inches, glass mounts preferred; limit 4 per entrant. No ultra close-ups, studio-type models, manipulated slides.

AWARDS: PSA Gold Medal, Best of Show. Don Roof Memorial Award. Chair Award, highest accumulated total. President's Award, best depiction of U.S.A. Camera Guild Award by each judge. Honorable Mention ribbons.

JUDGING: By 4 judges. Not responsible for loss or damage.

ENTRY FEE: $2.25 plus return postage.

DEADLINES: Entry, event,September. Materials returned, October.

| 332 |

Maupintour Travel Photography Contest
Maupintour, Inc.
Mrs. Kerry Mueller
P.O. Box 807
Lawrence, Kansas 66044 U.S.A.
Tel: (913) 843-1211

Monthly

International; entry open to all; monthly; established 1978. Purpose: To encourage travel and lasting travel memories through photography. Sponsored by Maupintour, Inc. Held in Lawrence, Kansas.

PRINT CONTEST: Travel Color, 4x6 to 8x10 inches, cardboard mounted; limit 6 per month. Competition includes monochrome prints, color slides.

SLIDE CONTEST: Travel Color, 35mm or 2-1/4x2-1/4 inches, cardboard mounted (no glass mounts).

AWARDS: Monthly: $100 First, $75 Second, $50 Third Cash Prizes. $25-$50 cash Honorable Mentions. Yearly (Grand): $1000 First, $750 Second, $500 Third Prize discounts off Maupintours. Published entries (non-winners) receive $25 (prefer Maupintour guests or tour managers).

JUDGING: By qualified judges. Based on quality, originality in choice and treatment. Sponsor owns winning entries; reserves right to publish any entry. May withhold monthly awards. Not responsible for loss or damage.

ENTRY FEE: None. No entries returned.

DEADLINES: Open. Grand Prizes awarded, January.

| 333 |

Photo Travelers of Los Angeles International Exhibition
C.E. (Ed) Hickey
11106 Hortense Street
North Hollywood, California 91602
U.S.A.

June

International; entry open to all; annual; established 1981. Purpose: to promote color travel slides which capture feelings of time or place, portray land, people, or culture in natural state. Sponsored by Photo Travelers of Los Angeles, Camera Circle of Glendale Club. Recognized by PSA. Held in Los Angeles and Glendale for 1 day

each.

SLIDE CONTEST: Travel Color, 2x2 inches, mounted glass mounts preferred); limit 4 per entrant. No glass over cardboard, ultra close-ups, studio-type model pictures, obviously manipulated slides.

AWARDS: PSA Gold Medal, Best of Show. 2 Gold, 3 Silver Photo Travelers Medals. 1 Gold, 1 Silver Medal, best by members. Honorable Mention ribbons.

JUDGING: By 3 international judges. Not responsible for loss or damage.

ENTRY FEE: $3 (foreign $3.50).

DEADLINES: Entry, judging, May. Event, June. Materials returned, July.

| 334 |

Staten Island International Photo-Travel Exhibition
Color Photographers Club of Staten Island (CPCSI)
Betty Groskin, President
112 Oxford Place
Staten Island, New York 10301
U.S.A. Tel: (212) 442-4320

November

International; entry open to all; annual; established 1980. Purpose: to promote worldwide interest and skill in travel photography. Sponsored by CPCSI (founded 1955). Recognized by PSA. Average statistics: 1072 entries, 268 entrants, 10 countries, 14 awards, Held in Staten Island Museum, New York, and New Brunswick, New Jersey for 1 day each. Also sponsor print show, biennial (odd years). Second contact: Helen Trachman, Co-Chair, 130 Lander Avenue, Staten Island, New York 10314.

SLIDE CONTEST: Travel Color,

2x2 inches, glass mounts preferred; limit 4 per entrant. No glass over cardboard mounts.

AWARDS: PSA Gold Medal, Best of Show. CPCSI Gold Medal First, Silver Second, Bronze Third. Club Member Medals, scenic, night scene, architecture, headdress, U.S.A., people of land at work or play, highest total score, cityscape, first-placed member, second-placed members. Honorable Mention ribbons.

JUDGING: By 3 judges. Not responsible for loss or damage.

ENTRY FEE: $2.75.

DEADLINES: Entry, judging, October. Event, November.

| 335 |

Western Reserve International Photo-Travel Exhibition
Northeastern Ohio Camera Club Council (NEOCCC)
Box 17005
Euclid, Ohio 44117 U.S.A.

November

International; entry open to all; annual; established 1979. Sponsored by NEOCCC. Recognized by PSA. Held at Cleveland State University. Second contact: Charles W. Dillman, 1500 East 193rd Street, #E-643, Euclid, Ohio 44117.

SLIDE CONTEST: Travel Color, 2x2 inches, glass mounts preferred; limit 4 per entrant. No ultra close-ups, studio-type models, manipulated slides.

AWARDS: PSA Gold Medal, Best of Show. 3 NEOCCC Awards. Chair Award, highest accumulated total. Cleveland Photographic Society Medal, best scenic. Honorable Mention ribbons.

JUDGING: By 3 judges. Not responsible for loss or damage.

ENTRY FEE: $2.25 plus return postage.

DEADLINES: Entry, October. Judging, event, November. Materials returned, December.

| 336 |

Tarbes-Pyrenees International Tourism Slide Show Festival
Etienne Achille-Fould, President
2 Place Ferre
65000 Tarbes, FRANCE Tel: (62) 93-00-78

June

International; entry open to all; biennial (even years); established 1973. Recognized by IFPA, FNSPF. Held at Tarbes Hautes-Pyrenees, France, during Tarbes-Pyrenees International Tourist Film Festival (FIFT). Also sponsor International Competition of Tourist Posters.

SLIDE SHOW WITH SOUND: **Tourism Color,** 5x5cm, 24x36mm, glass mounted; edited into 12-minute maximum montage, with separate tape-registered sound or magnetic band tape (1/2, 1/4-inch; 9.5, 19cm-sec), mono-stereo; limit 1 per entrant. Require resume of commentary in French, captions, commentary script, French technical information. Categories: Monovision (single screen), Multivision (multiple screens).

AWARDS: FIAP Gold Medal. NIEPCE-FNSPF Medal. FIFT Prize. Other jury awards. First, Second Public Prizes. Other public prizes.

JUDGING: Entry review by selection committee. Awards judging by public voting, international jury of audiovisual-tourist personalities. May disqualify entries. Sponsor pays for intrinsic value of entry if lost or damaged while in possession.

DEADLINES: Entry, April. Event, June.

| 337 |

Swiss Grand Photographic Prize
Dr. Bruno Frick
Bureau d'Organisation
P. O. Box 76
CH-8702 Zollikon, SWITZERLAND
Tel: (01) 63-61-61

Winter

International; entry open to all; biennial (even years); established 1974. Purpose: to encourage cultural activities, reward meritous works. Sponsored by Union of Swiss Banks; Orell-Fuessli, Publisher. Held in Zurich, Switzerland. Publish newspapers, photomagazines. Second contact: Union de Banques Suisses, Bureau de Presse WIMA/PRPR, Case Postale, 8021 Zurich, Switzerland.

PRINT CONTEST: **Swiss Theme Color,** 18x24cm; unpublished; unmounted; limit 2 series of 3-6 photographs. Various themes relating to Switzerland. Competition includes monochrome prints, color slides.

SLIDE CONTEST: **Swiss Theme Color,** small format, 5x5cm commercial mount; 6x6 format, 7x7cm commercial mount; limit 2 series of 3-6 slides. Various themes relating to Switzerland.

AWARDS: First, 15,000 Swiss francs, publication, diploma. Second, 12,000 Swiss francs, publication, diploma. Third, 10,000 Swiss francs, publication, diploma. Fourth, 8000 Swiss francs, publication, diploma. Fifth, 6000 Swiss francs, publication, diploma. Sixth, 4000 Swiss francs, publication, diploma. Prizes of En-

couragement totalling 20,000 Swiss francs maximum, diploma.

JUDGING: By 6 judges. Based on realization of photographic plan for all or part of series, fidelity to theme, idea. Sponsor may reproduce entries, withhold awards. Winning entries become property of Union of Swiss Banks. Not responsible for loss or damage.

ENTRY FEE: None.

DEADLINES: Entry, October. Material returned Spring.

UNDERWATER
Prints, Slides, Stereo Slides, Slide Shows, and Audiovisual, including AMATEUR, SURFACE.

| 338 |

Cen Cal Underwater Photography Competition
Central Council of Diving Clubs
Steve Rosenberg, Photography Director
25 Neva Court
Oakland, California 94611 U.S.A.

October

International; **entry open to Cen Cal members (may join with entry); annual; established 1959. Purpose: to further interest in, quality of underwater photography. Sponsored by Central Council of Diving Clubs. Recognized by Underwater Society of America. Average statistics (all sections): 350 entries, 50 entrants, 30-40 awards. Publish** *Cen Cal Odyssey* **(monthly newsletter). Second contact: P. O. Box 779, Daly City, California 94017.**

PRINT CONTEST: Underwater Color, by Cen Cal members; mounted on 11x14 or 16x20-inch boards; limit 4 per category. No pool or aquarium shots. Divisions: Open, Novice. Categories: California Waters, Out of California Waters. Also have monochrome print section.

SLIDE CONTEST: Underwater, Above Water Color, by Cen Cal members; 2x2-inch mounts; limit 4 per category. No glass mounts; pool or aquarium shots. Divisions: Open, Novice. Categories: Underwater, (California Waters, Out of California Waters), Above Water Dive-Related (Scenery-People).

AWARDS: Plaques, each division. Honorable Mention certificates. Best of Show at judge's discretion (includes all sections).

JUDGING: Based on impact, artistic content, technical quality. Sponsor may reproduce entries. Not responsible for loss or damage.

ENTRY FEE: $5 each category plus return postage. Membership, $6.

DEADLINES: Entry, judging, event, October.

| 339 |

Florida Skin Divers Association (FSDA) Underwater Photography Competition
Brynn Howie, Co-Chair
3538 Woodsville Drive
New Port Richey, Florida 33552
U.S.A. Tel: (813) 847-9872

March

International; **entry open to amateurs;** annual; established 1969. Purpose: to promote diving, underwater photography among sport divers. Sponsored by FSDA, Inc. Average statistics (all sections): 450 entries, 120 entrants, 8 finalists, 4 awards, 600 at-

tendance. Held in Tampa, Florida for 2 days. Publish *FSDA Bulletin* (monthly). Tickets: $10 per person; split $50 a day; $5, evening. Second contact: Holly Wagner, 1587 Oakadia Lane, Clearwater, Florida 33516; tel: (813) 531-1998.

PRINT CONTEST: Amateur Underwater Color, exposed between December previous and December current year; 5x7 inches minimum, mounted on maximum 16x20-inch board; limit 4 per category. Categories: Freshwater, Saltwater, Creative (special processing). Competition for some awards includes monochrome prints and color slides. Also have film section.

SLIDE CONTEST: Amateur Underwater Color, 2x2 inches, mounted. Requirements same as for Prints. Categories: Freshwater, Saltwater, Macro (1:4 ratio close-up lens), Creative (special processing).

AWARDS: First, Second, Third, Fourth Place Trophies, each category. Trophy to FSDA member, Best of Show (includes monochrome prints, film).

JUDGING: By 3 judges. Based on technique, composition, color, quality, story. May withhold awards. Not responsible for loss or damage.

ENTRY FEE: $5 each category plus return postage.

DEADLINES: Entry, judging, February. Event, awards, March. Materials returned, April.

| 340 |

Ken Read Memorial Underwater Photo Contest
National Association of Underwater Instructors (NAUI), North Atlantic Branch
Tracy Tibedo

P.O. Box 303, Astor Station
Boston, Massachusetts 02123 U.S.A.

April

International; **entry open to amateurs;** annual; established 1973. Named after Dr. Ken Read, underwater photographer, professor, naturalist. Purpose: to give good underwater photographers exposure. Supported by local dive shops, underwater equipment manufacturers. Average statistics: 150 entries, 25 entrants, 3 countries, 8 awards, 1000 attendance. Held at Underwater Symposium in Boston for 1 day. Also sponsor Underwater Film Review. Second contact: Fred Calhoun, P.O. Box 291, Back Bay Annex, Boston, Massachusetts 02117; tel: (617) 283-4933.

SLIDE CONTEST: Underwater Color, 35mm; taken underwater; limit 4 per entrant. No aquarium or pool shots.

AWARDS: $25-$100 in dive equipment. Ribbons.

JUDGING: By 3 local, professional underwater photographers. Based on artistic and technical aspects of underwater photography. Not responsible for loss or damage.

ENTRY FEE: $4 plus return postage.

DEADLINES: Entry, March. Judging, awards, April.

| 341 |

Man in the Sea International Underwater Photo Competition
32015 First Avenue South
P. O. Box 4504
Federal Way, Washington 98003
U.S.A. Tel: (206) 952-2896

March

International; entry open to all; annual; established 1968. Sponsored by

National Association of Underwater Instructors (NAUI). Held in Seattle, Washington for 3 days.

PRINT CONTEST: Underwater Color, 16x20 inches maximum, mounted, unframed; limit 3 per entrant. Also have monochrome print section.

SLIDE CONTEST: Underwater, Surface Color, 35mm, mounted; limit 4 per category. No glass mounts. Categories: General, Northern Latitudes, Novice, Macro Underwater; Surface.

AWARDS: Prizes and ribbons.

JUDGING: By jury of photographers and symposium audience. Not responsible for loss or damage.

ENTRY FEE: $5 per unit per category (1 unit is 3 prints or 4 slides) plus return postage.

DEADLINES: Entry, event, March. Materials returned, April.

342

Miami-Dade Public Library Underwater Photography Festival
Karlinne Wulf, Coordinator
West Dade Regional Library
9445 Coral Way
Miami, Florida 33165 U.S.A.
Tel: (305) 553-1134

Summer

International; entry open to all; annual; established 1974. Inactive 1979, 1980. Purpose: to show people another aspect of the beach "scene" - the underwater world. Sponsored by Miami-Dade Public Library System. Average statistics (all sections): 50 entries, 15 entrants, 1 award per category, 600 attendance. Held at branch libraries throughout Dade County, Florida for 1 week. Second contact: One Biscayne Blvd., Miami, Florida 33132; tel: (305) 579-5001.

PRINT CONTEST: Underwater Color, 5x7 to 10x12 inches, mounted on 10x12-inch board; limit 5 per category. Underwater or above-water diving related. Categories: Adjustable Focus, Fixed Focus, Experimental. Competition includes monochrome prints.

SLIDE SHOW WITH SOUND: Underwater Color, in Kodak Carousel tray with English cassette sound; minimum 10 slides; limit 1 per entrant. Underwater or above-water diving related. Competition includes monochrome slides.

STEREO SLIDES WITH SOUND: Underwater Color. Requirements same as for Slide Show. Competition includes monochrome slides.

AWARDS: Trophies, prizes, ribbons, at judges' discretion.

JUDGING: By 3 judges experienced in photography. Sponsor may reproduce entries for publicity. Not responsible for loss or damage.

ENTRY FEE: None. Entrant pays return postage.

DEADLINES: Entry, June. Judging, notification, July. Event, Summer.

343

Oregon Council of Diving Clubs International Underwater Photographic Competition
Jaques Stapper
3508 Petticoat Lane
Vancouver, Washington 98661
U.S.A. Tel: (206) 695-2141

November

International; entry open to all; annual; established 1978, became international 1979. Purpose: to promote underwater photography. Sponsored by Oregon Council of Diving Clubs.

PRINT CONTEST: Underwater

Color, 8x10 inches minimum; mounted on 16x20-inch boards; limit 4 per category. No aquarium shots, duplicate entries in prints and slides. Categories: Close-up, Non-Close-up. Also have monochrome print section.

SLIDE CONTEST: Underwater Color, 2x2-inch or 2-1/4x2-1/4-inch mounted slides, no glass mounts. Categories and restrictions same as for Prints.

AWARDS: Each section: First Place, ceramic tile set in Oregon myrtle wood. Second, Third Place, Honorable Mention, ribbons.

JUDGING: By 3 professional photographers. Sponsor reserves right to reproduce entries for Underwater Society promotional purposes. Not responsible for loss or damage.

ENTRY FEE: $6 each category plus return postage.

DEADLINES: Entry, October. Event, judging, November. Awards, December.

| 344 |

Professional Association of Diving Instructors (PADI) Underwater Photography Search Competition
Jeff Nadler, Training Facility Operations Manager
1243 East Warner Avenue
Santa Ana, California 92705 U.S.A.
Tel: (714) 540-PADI

Spring

International; **entry open to amateurs;** annual; established 1979. World's largest underwater photography contest. Purpose: to promote underwater photography; provide an opportunity to win prizes and publication in National Dive Magazines. Sponsored and supported by PADI and PADI Training Facility members.

Average statistics: 1000 entries, 7 countries, 1 local award, 10 regional awards, 1 Grand Prize. Held at local PADI Training Facilities. Have diving seminars, annual diving sweepstakes. Publish *The Undersea Journal.* Second contact: Alex F. Brylske, Coordinator, 2064 North Bush Street, Santa Ana, California 92706; tel: (714) 953-7555.

SLIDE CONTEST: Amateur Underwater Color, mounted in plastic sleeves, unlimited entry.

AWARDS: Local: diver gear prizes, dive trips, entry in International Competition. Regional (9 U.S., 1 international region): Custom 16x20-inch color prints of winning slides, publication in *Skin Diver Magazine, The Undersea Journal;* exhibition at PADI's "Fluid Visions" exposition; entry in Grand Prize Competition. Grand: Deluxe 8-day dive vacation (includes air fare from Ft. Lauderdale, Florida to San Salvadore Island); slide projector; winning photo featured on cover of *The Undersea Journal;* publication in *Skin Diver Magazine;* exhibition at PADI exposition.

JUDGING: Local and regional: By PADI Training Facility staff members. International: By PADI Committee. Based on technique, lighting, composition, bonus points. Sponsor may reproduce entries for duration of contest. Entrant retains ownership. Not responsible for loss or damage.

ENTRY FEE: $4 each.

DEADLINES: Entry, September. Judging, October (local), March (regional). Notification, awards, November (local), Spring (regional).

345

Sea International Underwater Photographic Competition

Underwater Photographic Society of
Northern California
Tom Schiff
P.O. Box 326
Fairfax, California 94930 U.S.A.

May

International; entry open to all; annual; established 1963. Purpose: to promote interest, excellence in underwater photography. Sponsored by Underwater Photographic Society of Northern California (nonprofit group promoting concern for underwater conservation). Average statistics (all sections): 500 entries, 100 entrants, 10 countries, 2500 attendance.

PRINT CONTEST: Underwater Color, mounted on 16x16 or 16x20-inch cardboard (Open), 11x11, 11x14, 16x16-inch boards (Novice), unframed; exposed underwater; limit 4 per entrant. No wood, fiberboard mounts; aquarium shots. Divisions: Open, Novice. Categories: Close-Up (1:6 or smaller), Non-Close-Up. Also have monochrome print, film sections.

SLIDE CONTEST: Underwater Color, 2x2 or 2-3/4x2-3/4 inches mounted. Other requirements, restrictions, divisions, categories same as for Prints.

AWARDS: $150, Best of Show (includes all sections). First, Second, Third Place plaques, each division, category. Ribbons to all winners.

JUDGING: By 3 judges. Sponsor may withhold awards. Not responsible for loss or damage.

ENTRY FEE: $7.50 each category plus return postage.

DEADLINES: Entry, judging, April. Event, May. Awards, June.

346

Seaspace International Underwater Photographic Competition

Houston Underwater Club
Fran Scott
5709 Glenmont
Houston, Texas 77081 U.S.A.
Tel: (713) 661-6080

July

International; entry open to all; biennial (odd years); established 1969. Purpose: to encourage, promote underwater photography, share beauty of sea with others; profits provide ocean-related student scholarships. Sponsored by Houston Underwater Club, Inc. Average statistics (all sections): 550 entries, 120 entrants, 12 countries, 1000 attendance. Held as part of divers' seminar in Houston for 2 days. Also sponsor film contest. Second contact: Richard Zingula, Chair, 5134 Lymbar, Houston, Texas 77096; tel: (713) 721-4489.

PRINT CONTEST: Underwater Color, 8x10 inches minimum, mounted on 16x12-inch board; limit 4 per entrant. Exposed underwater. No aquarium or pool shots. Also have monochrome print section.

SLIDE CONTEST: Underwater Color, 2x2 inches; limit 4 per category (except series). No glass mounts, aquarium or pool shots (except surface). Categories: Open, Novice (never won public photo contest), Series (16 maximum, 75% minimum exposed underwater, 5 copies typed narration), Surface (must show diving relationship).

AWARDS: First, Second, Third Place, print section. First, Second, Third Place awards, slides, each category.

JUDGING: By 3 judges. All entries

viewed in entirety. Sponsor may reproduce entries for catalog or publicity. May withhold awards. Not responsible for loss or damage.

ENTRY FEE: $5 plus postage, each category or section.

DEADLINES: Entry, event, July.

347

Underwater Photographic Society (UPS) International Underwater Photographic Competition
Steve Ioerger, Chair
P. O. Box 7088
Van Nuys, California 91409 U.S.A.
Tel: (213) 367-7635

October

International; entry open to all; annual; established 1963. Purpose: to encourage amateur and professional underwater photographers; provide opportunity for display, evaluation, recognition of work. Sponsored by UPS (founded 1957), Los Angeles County Museum of Natural History. Supported by University of Southern California Sea Grant. Average statistics (all sections): 500 entries, 80 entrants. Have films, speakers, technical sessions, monthly boat dives.

PRINT CONTEST: Underwater Color, taken in natural environment by entrant; 8x10 inches minimum, mounted on 16x20-inch maximum lightweight cardboard; limit 4 prints per category (1 category per print). No aquarium shots. Categories: Close-up (1:3 or smaller), Non-Close-Up. Competition includes monochrome prints.

SLIDE CONTEST: Underwater Color, taken in natural environment by entrant; 2x2 or 2-1/4x2-1/4 inches, mounted; limit 4 per category (1 category per slide). No glass-mounted, aquarium shots. Categories same as for prints.

AWARDS: $100, Engraved Walnut Ceramic Plaque, Best of Show. Engraved Walnut Plaque, First Place. Engraved Walnut Medallion Plaque, Second Place. Bronze Medallion, Third Place. Honorable Mention and Judged Superior Certificates.

JUDGING: By 3 or more experienced judges at Los Angeles County Museum of Natural History. Sponsor may reproduce entries for promotional purposes. Not responsible for loss or damage.

ENTRY FEE: $5 each category plus return postage.

DEADLINES: Entry, judging, October. Materials returned, November.

348

Underwater Society of America Photography Competition
Paula M. Novotny, Photographic Director
9702 East 12th Street
Indianapolis, Indiana 46229 U.S.A.
Tel: (317) 899-3014

November-February

International; entry open to U.S., Canadian Underwater Society members (may join with entry); annual. Purpose: to promote diving, underwater photography. Sponsored by 50 manufacturers of underwater equipment. Supported by Underwater Society of America. Average statistics (all sections): 1000 entries, 300 entrants, 2 countries, 48 awards, 5000 attendance. Publish *Underwater Reporter* (quarterly).

PRINT CONTEST: Underwater Color, 8x10 inches minimum, mounted, matted on 16x20-inch white board (35mm photography); 4x5 inches minimum, mounted, matted on 8x10-inch white board (110 photography); unlimited entries. No aquarium

or pool shots. Divisions: Saltwater, Freshwater. Categories: Macro, Wide Angle, 110 Photography. Competition for some awards includes monochrome prints, slides. Also have film section.

SLIDE CONTEST: Underwater Color, 2x2-inch mounts; unlimited entries. No aquarium or pool shots. Divisions: Saltwater, Freshwater. Categories: Macro, Wide Angle.

AWARDS: Grand prize, camera and publication (includes all sections). First place winners each category, a major prize, magazine subscription, roll of film, publication. First-Third Prizes, Underwater Society Plaque, photographs exhibited at Our World Underwater Exhibition in Chicago. Various other prizes.

JUDGING: By 3 judges. Sponsor may reproduce for publicity, catalog. Not responsible for loss or damage.

ENTRY FEE: $3 plus return postage. Membership, $10.

DEADLINES: Entry, February. Event, November-February.

349

Vision 360 Underwater Photo Competition
National Association of Underwater Instructors (NAUI), Buffalo Chapter
Dallas Edmiston, Director
P.O. Box 842
Buffalo, New York 14221 U.S.A.
Tel: (716) 681-2932

September

International; entry open to all; annual; established 1978. Purpose: to promote scuba diving as recreation. Theme: Safety Through Education. Sponsored and supported by NAUI Buffalo Chapter. Average statistics: 150 entries, 50 entrants, 5 awards, 300 attendance. Held at Buffalo State Col-

lege for one day. Tickets: $7. Have seminars, film shows. Second contact: Fred Calhoun, NAUI North Atlantic, P.O. Box 291, Back Bay Annex, Boston, Massachusetts 02117.

SLIDE CONTEST: Underwater Color, 35mm. Categories: Freshwater, Saltwater, Macro, Pool.

AWARDS: First, Second, Third Place, each category.

JUDGING: By 3 professional photographers. Based on lighting, composition, subject, difficulty. Not responsible for loss or damage.

ENTRY FEE: $5 each category.

DEADLINES: Entry, August. Judging, event, awards, September. Materials returned, October.

350

Man and the Sea Underwater Photography Exhibition
Australian Underwater Federation
John Maynard, Organizer
P.O. Box 67
St. Lucia, Brisbane, Queensland
4067, AUSTRALIA Tel: 07-3793339

January

International; entry open to all; annual; established 1968. Purpose: to disseminate information on marine environment. Theme: Man and the Sea. Sponsored by Australian Underwater Federation, Australian Diving Industry. Supported by Sub-Aqua Dive Services. Recognized by CMAS. Average statistics (all sections): 100 entrants, 4 countries, 40 semifinalists, 20 finalists, 8 awards (photography only), 4300 attendance. Held in Brisbane for 3 days. Tickets: $16 Aust. Publish *Undercurrent, Diving, Down-Under* (bimonthly magazines). Also sponsor Underwater Trade Fair, Underwater Film Exhibition.

PRINT CONTEST: Underwater Color, 8x16 inches. Categories: Individual, Set of 3. Also have monochrome print section.

SLIDE CONTEST: Underwater Color. Categories: Individual, Set of 5.

SLIDE SHOW WITH SOUND: Underwater Color, set of 20, with sound track.

AUDIOVISUAL CONTEST: Underwater Color. Competition includes monochrome audiovisual.

AWARDS: Man and the Sea Awards.

JUDGING: By 5 judges. Sponsor claims all publication rights. Not responsible for loss or damage.

ENTRY FEE: None. Entrant pays return postage.

DEADLINES: Entry, event, January.

351

Aquaspace Underwater Photographic Competition
Aquatic Exploration and Research Associates (AERA)
Dale Woodyard, Director
Department of Psychology
University of Windsor
Windsor, Ontario N9B 3P4 CANADA
Tel: (519) 253-4232

October-November

International; entry open to all; annual; established 1977. Purpose: to educate public about aquatic world, AERA aquatic projects. Theme: Aquatic Education. Sponsored by AERA. Average statistics (all sections): 500 entries, 60 entrants, 2 countries, 30 finalists, 9 awards, 300 attendance. Held at University of Windsor. Tickets: $3.50. Have seminars, workshops, guest celebrities,

slide and film shows. Publish AERALOG Newsletter (bimonthly).

PRINT CONTEST: Underwater Color, 8x10 inches minimum, mounted on 16x20-inch mounting boards; exposed underwater; limit 4 per category (1 category only). Divisions: Amateur, Professional. Categories: Freshwater, Saltwater. Competition for some awards includes monochrome prints, color slides.

SLIDE CONTEST: Underwater Color, 2x2 inches; limit 4 per category (1 category only). Divisions, categories same as for Prints.

AWARDS: Jim and Cathy Church Award, best overall (includes monochrome). Trophies, prizes.

JUDGING: By professionals. May withhold awards. Sponsor may reproduce entries for publicity. Not responsible for loss or damage.

ENTRY FEE: $5 amateur, $15 professional plus return postage.

DEADLINES: Entry, October. Event, October-November. Materials returned, January.

352

NAUI Canada Underwater Photo Contest
National Association of Underwater Instructors (NAUI)
P. O. Box 510
Etobicoke, Ontario M9C 4V5
CANADA Tel: (416) 677-3817

November

International; entry open to all; annual; established 1970. Sponsored by NAUI. Held at International Conference on Underwater Education, Skyline Hotel, Toronto, Canada for 3 days. Have screenings, speakers. Publish *NAUI News*.

SLIDE CONTEST: **Underwater Color,** taken in open water; limit 6 per entrant. Also have monochrome print section.

AWARDS: Publication on back cover of *NAUI News* (open to all) or front cover (Canadians only).

JUDGING: Entry review by panel (selects up to 20). Awards judging by conference attendees. Sponsor owns entries. Not responsible for loss or damage.

DEADLINES: Event, November.

353

CPAS International Underwater Photography Contest
Portuguese Center of Underwater Activities (CPAS)
Rua das Janelas Verdes, 37
1200 Lisbon, PORTUGAL
Tel: 67-45-45

December

International; entry open to all; annual; established 1977. Sponsored by CPAS. Recognized by APAF. Held at CPAS head office in Lisbon, Portugal for 5 days.

PRINT CONTEST: **Underwater Color,** including creative and macrophotography, 18x24 to 30x40cm; limit 4 per entrant. No swimming pool or aquarium shots. Competition includes monochrome prints.

SLIDE CONTEST: **Underwater Color,** 5x5 or 7x7cm, plastic mounted; limit 4 per category (except Ecological 4 to 8). Submit commentary with Ecological entry. No swimming pool or aquarium shots. Categories: General, Macrophotography and Close-Up, Creative, Ecological Story.

AWARDS: CPAS Trophy, Best of Show (all sections). Gold, Silver, Bronze Medals each category.

JUDGING: By jury. Not responsible for loss or damage.

ENTRY FEE: $8.

DEADLINES: Entry, October. Judging, notification, November. Event, December. Materials returned, January.

OTHER
Includes BIBLE, CHRISTMAS, COLONIAL AMERICA, EXPERIMENTAL, FOLKLORE, HOLOGRAM, HUMOR, MINIATURE, THEME.

354

Cameo Art Gallery National Miniature Show
Patricia Lee Steele, Manager
7339 Parklane Road
Columbia, South Carolina 29204
U.S.A. Tel: (803) 788-1302

January-February

National; **entry open to U.S. artists;** annual; established 1981. Purpose: to establish tradition of annual miniature contest in South Carolina. Sponsored and supported by Cameo Art Gallery. Average statistics (all sections): 400 entries, 3 awards. Entries displayed in Cameo Art Gallery for 1 month.

PRINT CONTEST: **Miniature Color,** 10x10 inches maximum framed size (ready for hanging); completed in previous 2 years; subject 1/6 or less of life size; limit 3 per entrant. Competition includes monochrome prints, art, mixed media.

AWARDS: $500 First, $300 Second, $200 Third Place (include all media). Plaques, purchase awards, ribbons.

JUDGING: By 2 artists. Entry review selects top 400 entries for display. Sponsor charges 25% commission. Not responsible for loss or damage.

ENTRY FEE: 1 entry, $5; 2, $8.50; 3, $10. $5 additional shipping-handling charge (return via UPS).

DEADLINES: Entry, December. Judging, event, January-February.

| 355 |

Courage Center Christmas Card Competition
Fran Bloomfield, Coordinator
3915 Golden Valley Road
Golden Valley, Minnesota 55422
U.S.A. Tel: (612) 588-0811, ext. 216

April

International; entry open to all; annual; established 1970. Purpose: Christmas card sales help handicapped persons gain independence. Sponsored by Courage Center (formerly called Minnesota Society for Crippled Children to 1978). Supported by 15,000 users of Courage cards. Average statistics (all sections): 1000 entries, 200 entrants, 30 semifinalists, 14 finalists. Publish *Courage News* (5 times yearly).

PHOTO CONTEST: **Christmas Color,** suitable for reproduction, reduction to 4-3/4x6-1/4 or 5-3/8x7-7/8 inches; limit 10 per entrant. Submit slides or prints for entry review, entrant background, special-unusual conditions of production. Competition includes arts, crafts sections.

AWARDS: Media exposure plus credit on cards to winning entries.

JUDGING: By volunteer art selection committee. Based on artistic merit, suitability of subject, reproduction quality. All entries reviewed. Art-

ist donates 1-year exclusive reproduction rights (full credit to artist). Sponsor insures during possession.

ENTRY FEE: None.

DEADLINES: Entry, December-February. Awards, event, April.

| 356 |

Galerie Triangle Monthly Contests
Averille and Charles Jacobs,
Directors
1206 Carrollburg Place, S.W.
Washington, DC 20024 U.S.A.
Tel: (202) 554-7700

Monthly

National; **entry open to U.S.;** monthly (except January, February); established 1980. Purpose: to honor quality artists and photographers, and unknown professionals. Sponsored by and held at Galerie Triangle, Washington, D.C. Average statistics (all sections): 6 entries, 2 awards. Also sponsor national and east coast exhibitions. Second contact: P. O. Box 8232, SW Station, Washington, DC 20024.

PHOTO CONTEST: **Theme Color,** prints and slides. Submit biography or resume. Competition includes monochrome prints, fine art.

AWARDS: $50 Awards.

JUDGING: By gallery staff. All entries viewed in entirety.

ENTRY FEE: $2 plus return postage.

DEADLINES: Monthly.

| 357 |

Infinite Forum Visual-Recording Arts Exposition
Pro Arts Gallery
1214 Webster Street

Oakland, California 94612 U.S.A.
Tel: (415) 763-7880

April

International; entry open to all; annual; established 1978. Purpose: to present creative, unique works in film, video, photography, holography, multi-image, multimedia, alternative visual-recording. Sponsored by Pro Arts (nonprofit organization). Held at Oakland Auditorium Theater (10th Street, Oakland, California) for 2 evenings. Tickets: entrants, free with advance reservation; nonentrants, $5 in advance; $6 at door.

PHOTO CONTEST: Experimental Color, any size (over 20x30 inches requires preliminary contact in early March); made in previous 3 years; mounted. Competition includes monochrome photography. Also have film, videotape, alternative visual-recording sections.

HOLOGRAM CONTEST: Experimental Color, any format. Transmission holograms must be supplied with display. Competition includes monochrome.

MULTI-IMAGE CONTEST: Experimental Color, multiple projection of slides, film, video or combination.

MULTIMEDIA CONTEST: Experimental Color, single or multi-image in conjunction with other media. Competition includes monochrome multimedia.

AWARDS: Photography: 2 $75 First, 2 $50 Second, 2 $25 Certificate prizes. Holography, Multi-Image, and Multimedia: $100 First, 2 $50 Second prizes. Finalist photographs exhibited at Pro Arts Gallery for 2 weeks.

JUDGING: By 5 judges each section.

ENTRY FEE: $10. $5 per projector past 3 (up to 30 slide projectors available).

DEADLINES: Entry, March. Judging, event, April. Materials returned, May.

| 358 |

Laymen's National Bible Committee Color Slide Competition
Henry W. Wyman, Chair
815 Second Avenue
New York, New York 10017 U.S.A.
Tel: (212) 687-0555

November

International; entry open to all; annual; established 1979. Purpose: to promote interest in Bible through photographs with slogans reflecting its universality. Sponsored by Layman's National Bible Committee (LNBC), nonsectarian organization founded 1940. Held in New York during National Bible Week.

SLIDE CONTEST: Bible Color, 2x2 inches, mounted (glass preferred), with slogan; limit 4 per entrant. No glass over cardboard mounts, or sectarian viewpoints.

AWARDS: $350 and inscribed Bible, First Prize. Bibles to 9 runners-up. Winning entry goes to 3500 national newspapers.

JUDGING: By 3 judges, conducted by Color Camera Club of Westchester. Sponsor reserves right to use winning slide for promotional, other purposes; may require release from identifiable person(s). Not responsible for loss or damage.

ENTRY FEE: None. Entrant pays return postage.

DEADLINES: Entry, September. Judging, October. Event, November.

359

Society of Colonial Wars Awards
Joan Sumner, Executive Secretary
122 East 58th Street
New York, New York 10022 U.S.A.
Various

International; entry open to all; annual; established 1951. Purpose: to promote wider knowledge, encourage material on life and times of early America. Sponsored by Society of Colonial Wars.

PHOTO CONTEST: Colonial American Color, original or reproduction with description of first use, present location; 75% of content in American colonial period. Competition includes monochrome photography, arts, crafts, music, writing.

AWARDS: Honor Citation on parchment plus Bronze Medallion. Honorable Mention Citations.

JUDGING: By Special Awards Committee. May withhold awards.

ENTRY FEE: None.

DEADLINES: Not specified.

360

Suggin Folklife Society Art Show
Mildred M. Gregory, President
324 Walnut Street
Newport, Arkansas 72112 U.S.A.
Tel: (501) 523-6250

April

State; **entry open to Arkansas-born artists;** annual; established 1971. Purpose: to preserve the old through painting and photography. Sponsored by Suggin Folklife Society. Supported by State Matching Fund. Average statistics (all sections): 440 entries, 115 entrants, 12 awards. Held at First State Bank in Newport, Arkansas for 2 weeks.

PHOTO CONTEST: Folklore, Historical Preservation Color, 20x24 inches maximum (combined length, width); produced in previous 2 years; framed for hanging (glass optional); limit 3 per entrant. Categories: Landscapes, Historical Landmarks, Portraits, Sports-Animals-Wildlife, Still Life, special (different yearly theme). Competition for some awards includes monochrome photography, arts.

AWARDS: Cash and Purchase Awards, Best of Show. Ribbons, each category (includes monochrome photography). Purchase award, best (all sections).

JUDGING: By non-resident judges. Not responsible for loss or damage.

ENTRY FEE: $1 each (elementary students free). No commission charged on sales.

DEADLINES: Entry, event, April.

361

Gabrovo International Photo Jokes Competition
House of Humor and Satire (HHS)
Stefan Furtounov
P. O. Box 104
5300 Gabrovo, BULGARIA
Tel: 27229

May-September

International; entry open to all; biennial (odd years); established 1975. Purpose: to stimulate humor in service of progress and moral perfection of humankind. Theme: Human Smiles and Funny Situations in Front of the Camera. Sponsored by HHS, Bulgarian Photography, Committee for Tourism. Supported by Committee for Arts and Culture, Gabrovo Municipality, Bulgarian artists, and writers unions. Average statistics (all sec-

tions): 900 entries, 200 entrants, 24 countries. Held in HHS exhibition halls, Gabrovo, for 4 months. Tickets: Lv40.

PRINT CONTEST: Humor Color, 30x40cm minimum, unlimited entry. Competition includes monochrome prints.

AWARDS: Golden Plate, 5-day stay as HHS guest, 15-day rest in Bulgaria, First Prize. Silver Plate, 5-day stay, 10-day tour of Bulgaria, Second Prize. Bronze Plate, 5-day stay, 3 Third Prizes. 7-day stay to representative of best editorial office. Bulgarian Photography Award, Lv500. Bulgarian Photo Magazine Award, Lv200. Committee for Tourism Award, 14-day holiday in Bulgaria. Balkansko Zname Newspaper Award, Lv150. Prizes do not include travel to and from Gabrovo.

JUDGING: By 7-member jury appointed by Bulgarian Photography. Sponsor keeps entries for permanent exhibition, may reproduce. Not responsible for loss or damage.

ENTRY FEE: None.

DEADLINES: Entry, December. Judging, notification, January. Event, May-September.

362

Bordighera International Prizes for Humor
International Salon of Humor
Gigia Perfetto, President
Corsa Italia, 46
18012 Bordighera (IM), ITALY
Tel: 0184-261727

July-August

International; entry open to all; annual; established 1952. Purpose: to discover humorous works for development and wider renown of humor everywhere. Sponsored by Tourist Organization of Bordighera and Council of Europe. Average statistics (all sections): 6000 entrants, 12,000 entries, 51 countries. Held during annual Salon of Humor, Bordighera. Have exhibitions of drawings, pictures. Also sponsor contests for humorous drawing, illustrated literature, publicity; Rama Di Palma d'Oro Prize (established 1968) for journalists, radio-TV editors, entertainment people contributing to diffusion of optimistic humor.

PRINT CONTEST: Humorous Color, 26x35cm maximum; limit 5 per entrant. Submit entrant photo, biography. Competition includes monochrome prints, monochrome and color drawings.

AWARDS: Special Committee Prizes.

JUDGING: By international committee of previous winners. Not responsible for loss or damage.

ENTRY FEE: None. Sponsor pays return postage.

DEADLINES: Entry, July. Awards, event, July-August. Materials returned, December.

363

Europa Biennial of Photography
CPVA Personnel Association
Enric Pamies
Apartado Postal 410
Reus, SPAIN Tel: 31-53-10

June-November

International; entry open to all; biennial (odd years); established 1973. Sponsored by CPVA Personnel Association. Supported by Pension and Savings Bank, Cataluna and Baleares, Spain. Average statistics: 2299 monochrome, 299 color entries; 132 mono-

chrome, 49 color accepted; 819 entrants, 34 countries. Held in Reus and Barcelona for 5 months.

PRINT CONTEST: Theme Color, 40cm maximum per side (30x40cm suggested), unmounted; limit 4 per entrant. Various themes. Also have monochrome print section.

AWARDS: 1 Silver, 1 Silver-plated, 2 Bronze Medals. Special Classification Medals.

JUDGING: By 5 judges. Sponsor may reproduce entry in any media without payment. Not responsible for loss or damage.

ENTRY FEE: None.

DEADLINES: Entry, March. Judging, April. Notification, May. Event, June-November. Materials returned, December.

ALPHABETICAL
EVENT/SPONSOR/AWARD INDEX

Alphabetical index to each EVENT, SPONSOR, and AWARD (followed by identifying CODE NUMBER of the event).

D

E

SUBJECT/CATEGORY INDEX

Index to AREAS OF SPECIAL INTEREST (followed by identifying CODE NUMBER of each event).

HOW TO ENTER &
WIN CONTESTS
By Alan Gadney

The following titles are available in Alan Gadney's series on *How to Enter & Win Contests*. Each title is published in both hardcover and paperback. Most titles are available at your local bookstore.

To order directly, send a check or money order for $7.95 for each paperback copy and $15.95 for each hardcover copy to: Facts On File, 460 Park Ave. So., N.Y., N.Y. 10016. Be sure to add sales tax if your mailing address is in New York or California. We pay postage.

FILM Contests
VIDEO/AUDIO Contests
NON-FICTION WRITING Contests
FICTION WRITING Contests
COLOR PHOTOGRAPHY Contests
BLACK & WHITE PHOTOGRAPHY Contests
DESIGN & COMMERCIAL ART Contests
FINE ARTS Contests
*FABRIC & FIBER CRAFTS Contests
*JEWELRY & METAL CRAFTS Contests
*CLAY & GLASS CRAFTS Contests
*WOOD & LEATHER CRAFTS Contests

*Available in late 1982

HAVE WE MISSED A CONTEST/EVENT?

Please let us know so that we may
correct our future editions. Thank you.

FESTIVAL PUBLICATIONS
P.O. Box 10180
Glendale, California 91209 U.S.A.